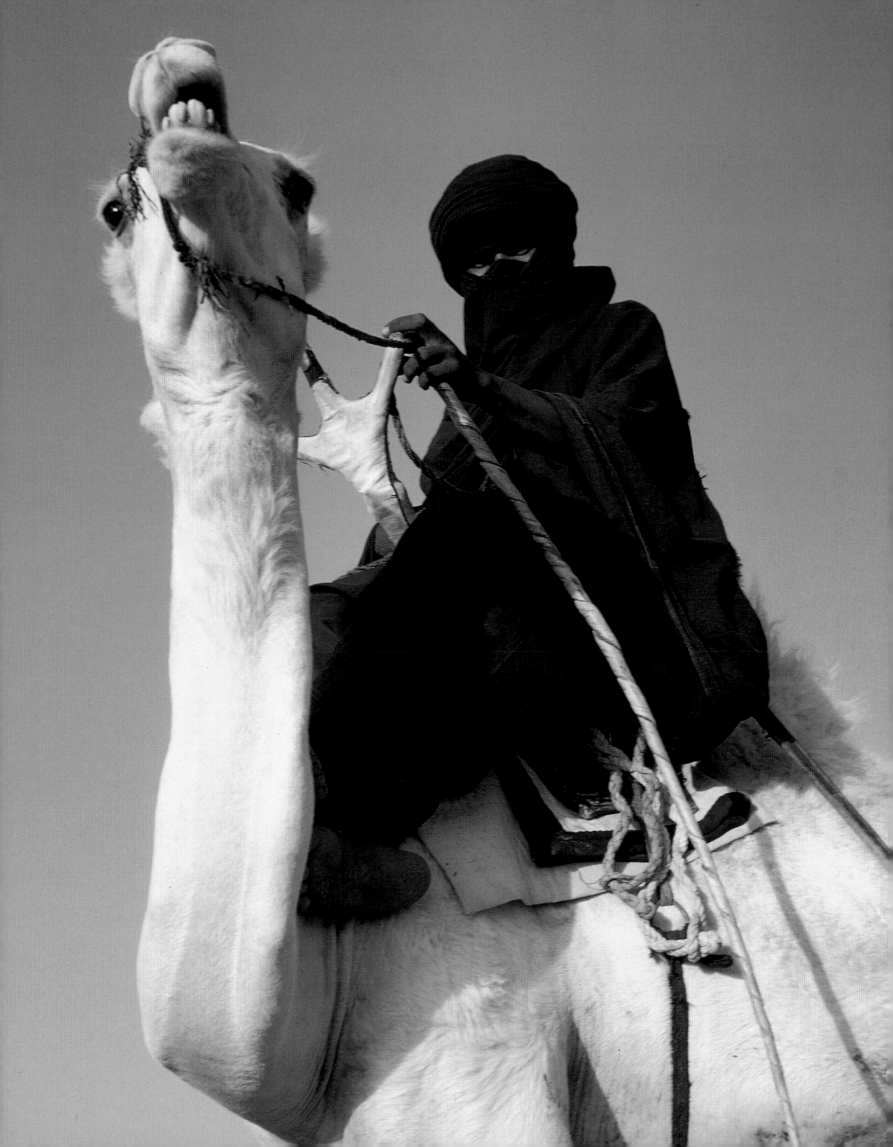

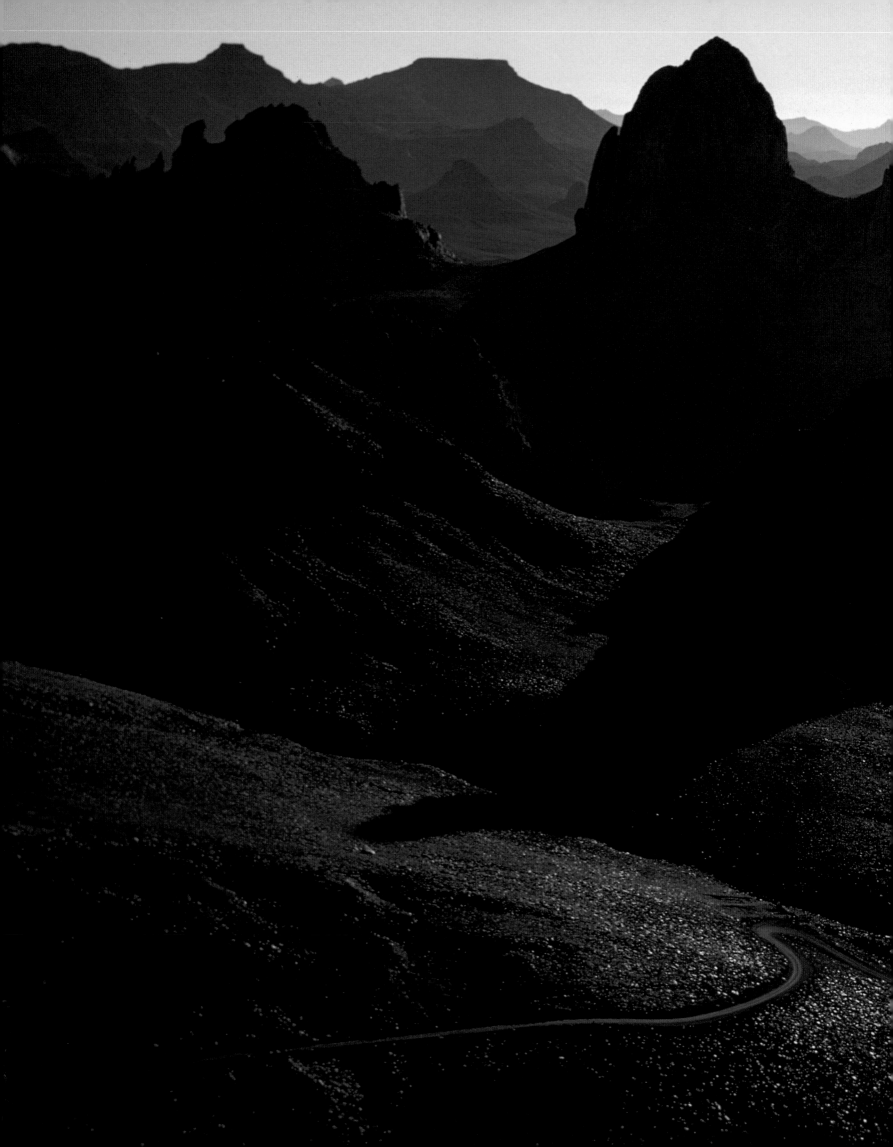

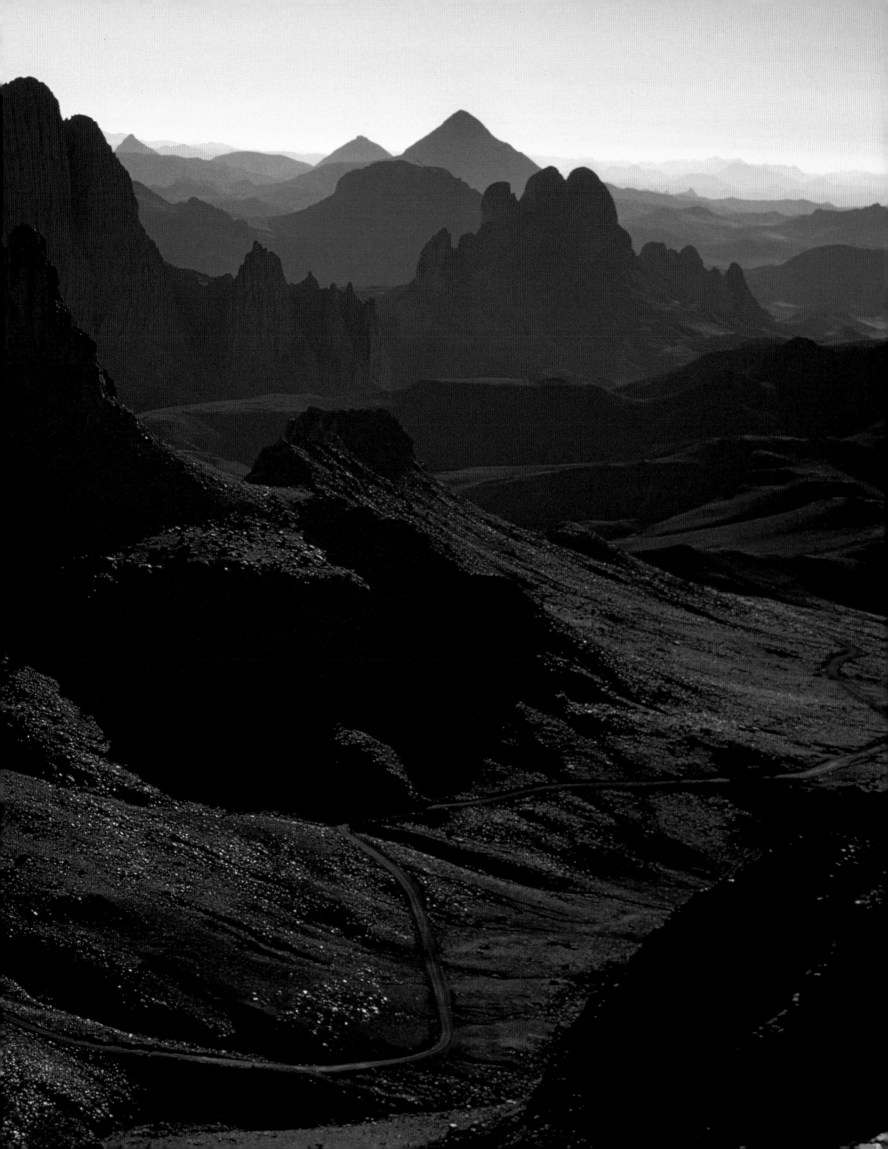

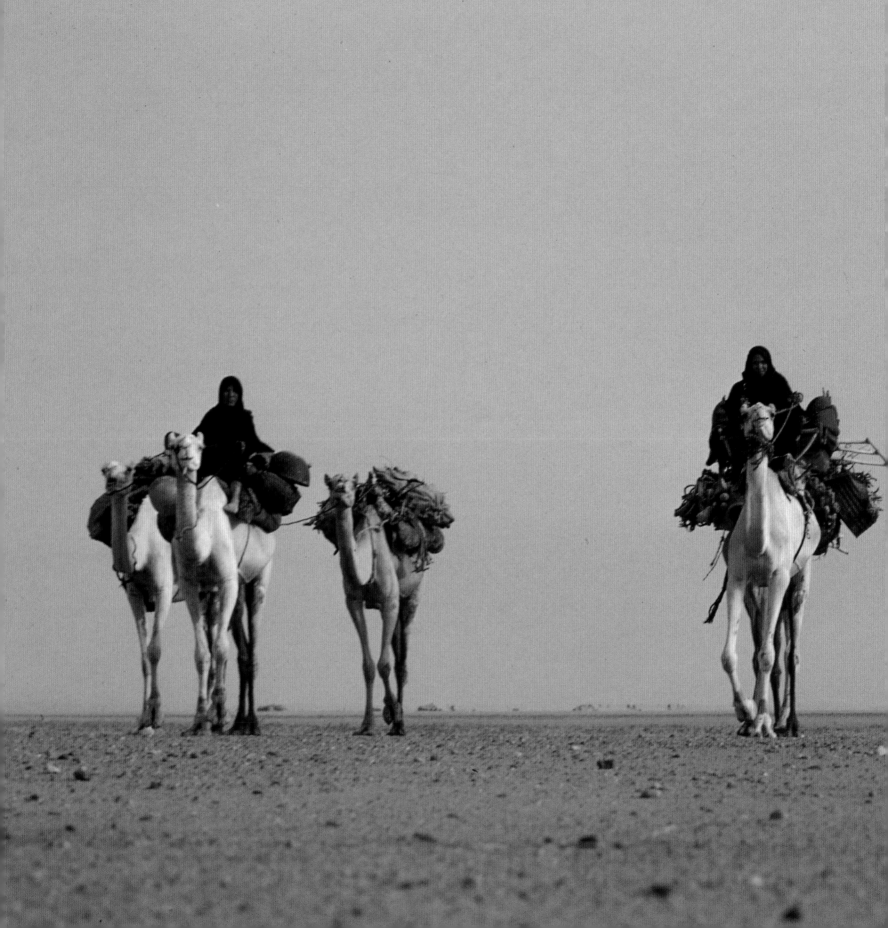

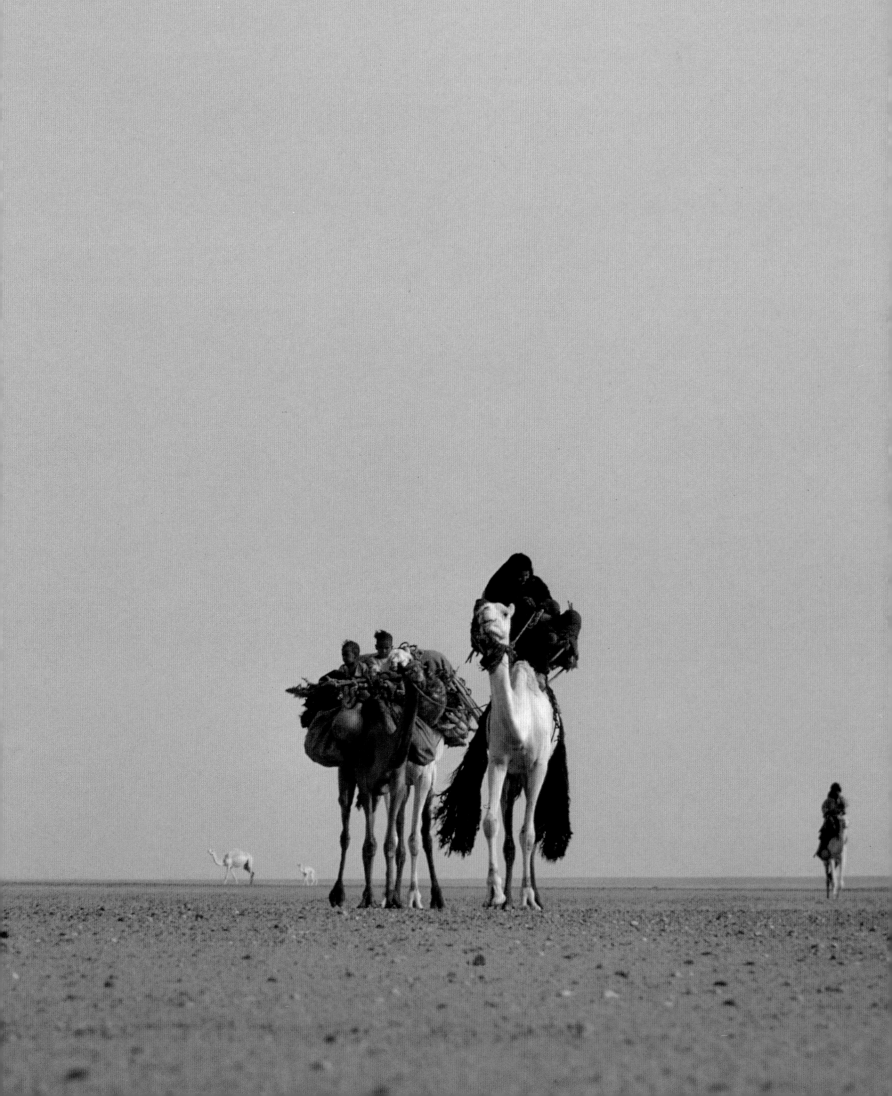

WIND, SAND & SILENCE

Travels with Africa's Last Nomads

Text and photographs by Victor Englebert

Chronicle Books San Francisco

Library of Congress Cataloging-in-Publication Data

Englebert, Victor.
 Wind, sand, and silence : travels with Africa's last
nomads / Victor Englebert.
 p. cm.
 ISBN 0-8118-0010-5 (hardcover)
 1. Nomads—Africa, North. 2. Nomads—Africa, East.
3. Africa, North—Description and travel—1951–
4. Africa, East—Description and travel—1981–
5. Englebert, Victor. I. Title.
 GN646.E54 1992
 305.9′0693—dc20 92-3083
 CIP

A YOLLA BOLLY PRESS BOOK

This book was produced in association with the publisher at
The Yolla Bolly Press, Covelo, California, under the supervision
of James Robertson and Carolyn Robertson, with assistance
from Diana Fairbanks, Renee Menge, and Mary McDermott.
Composition by Wilsted & Taylor, Oakland, California. Map
by David Fuller, Northridge, California.

Distributed in Canada by Raincoast Books,
112 East Third Avenue, Vancouver, B.C. V5T 1C8

Printed in Hong Kong.

10 9 8 7 6 5 4 3 2 1

Chronicle Books
275 Fifth Street
San Francisco, CA 94103

Parties interested in commercial use of the images in this book
should direct inquiries to The Yolla Bolly Press, P.O. Box 156,
Covelo, California 95428.

To my friends
the nomads, who gave me
the keys to Africa's
great deserts.

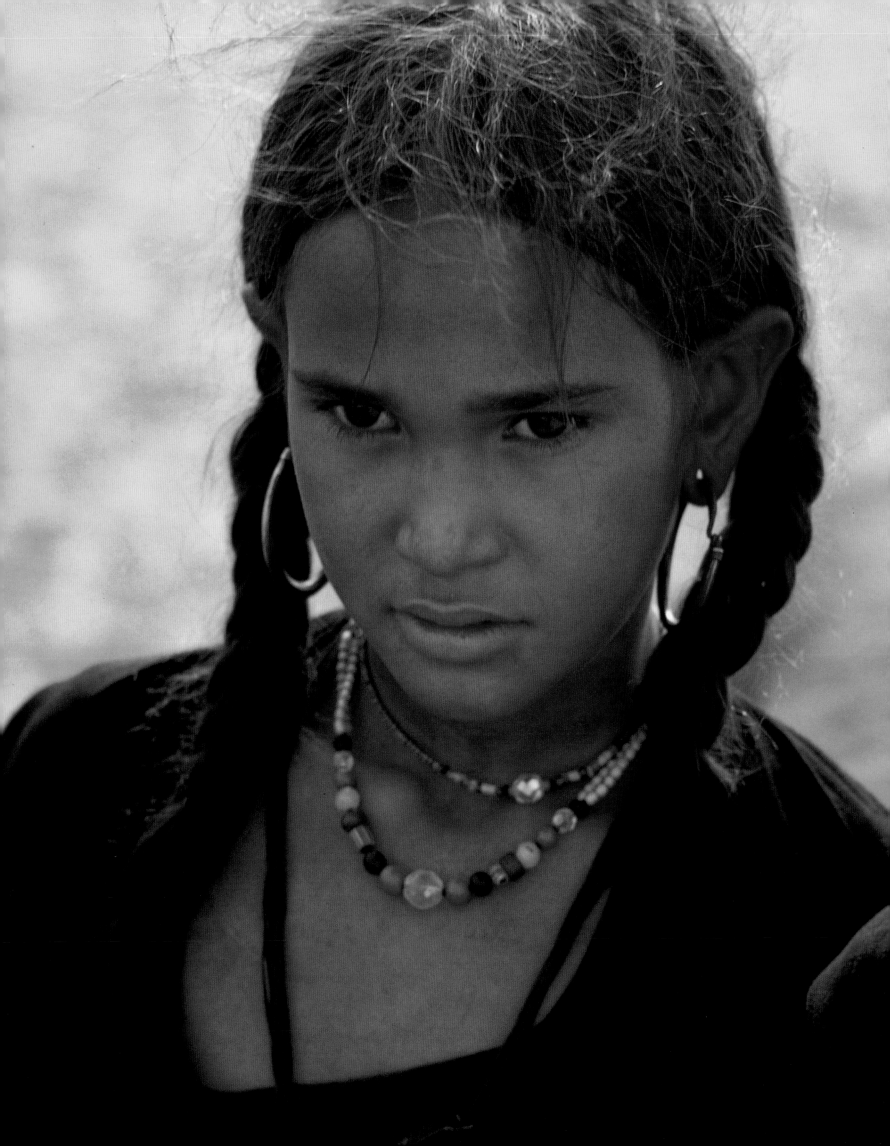

Introduction

My fifth-grade teacher in Belgium had a genius for capturing his students' attention. Although, I later learned, he had never traveled, he held us spellbound with the tales of his invented journeys on horseback across windy Patagonia or above dizzying Bolivian cliffs, by canoe down treacherous rivers in Borneo and the Amazon, and in caravans across the Sahara. He instilled in me a desire to become an explorer, and as an adult I have followed in a very real world the travels he took in his imagination.

I have trekked by mule among the High Atlas's Berbers, walked with a Kuchi nomad migration down the Hindu Kush mountains in Afghanistan, crossed Borneo by canoe and on foot in search of the remotest Dyak, journeyed through the Amazon to meet the Yanomami and other Indians, ridden horses up and down the Peruvian Andes and across Patagonia, and photographed over thirty tribes in the most secret recesses of the world. In the process, I have watched extraordinary customs, admired people's adaptation to hostile environments, and in the end marveled at man's humanity. No matter where I traveled, I have always found plenty of common ground on which to deal with people. Always, however, I have been attracted most by the nomads—by their noble and aloof bearing, their generous and easy hospitality, their marvelous freedom of movement, and the vastness and luminosity of their world.

The nomads may have acquired their noble traits through the military superiority that their mobility, audacity, and bravery gave them over less-hardened villagers. No doubt these traits also resulted from a life of deprivation and from an indifference to anything not easily packed on a camel, an ox, or a donkey. In Arabia the desert used to be considered a purifying place. The lean nomads symbolized ascetic and noble virtues and the fat city dwellers, the corruption that comes with an easy life. Their situations were interchangeable, however, for conquering nomads one day reclined on the fat Arabs' cushions to grow fat themselves, and the fat Arabs learned to survive in the desert where they had been pushed. The purifying fasting and hardships of subsequent generations led to new excellence, until they earned the new nomads, by the force of arms, the privilege to lie once again on the fat Arabs' cushions.

The supremacy of the Tuareg only a few decades ago allowed them to take from their sedentary neighbors what they wanted, including slaves, and to this day they get from them deference. All the nomads referred to in this book have at one time or another prevailed on their settled neighbors. And no matter how we may resent their highhandedness and consider them a step behind settled agriculturists on the civilization scale, do not most of us envy them their marvelous freedom? Have not most of us, at one time or another, fancied the romance of their lives, as in grammar school, when we studied the conquests of Genghis Khan and Attila?

I discovered my fascination with nomads in 1957, when I was twenty-four, after crossing Africa on a Vespa scooter, riding from Brussels, my native city, to the Cape of Good Hope. Though I saw many lands and people, I remembered most clearly the awesome Sahara and the Tuareg. Crossing the great desert at the peak of the summer, in relentless sandstorms that dried my throat and erased my trail, was so disquieting that for many days I had lived only to see myself on the other side of it. And yet

when it was over I longed for its challenge and thought obsessively of going back to it. Endlessly, I pondered the mystery of the veiled Tuareg nomads that along my way had appeared from nowhere atop high camels to trot free of the tyranny of trails to any point of the vast horizon. Avidly, I read every available book about them.

I had been a nomad myself on that scooter trip. I had moved every day, leaving long before daybreak to escape the loneliness of my bivouacs in the thicket; waiting to reach a village (when there were any to cross in the following hours) to breakfast with the naked and unintelligible people that unconsciously gave me needed solace as they curiously gathered around me. I had been a nomad, at least spiritually, before that, when working in the Belgian Congo and dreaming that one day I would not have to return home from my weekend excursions in the bush, but instead, would always go on, ever curious of what the next hill was hiding. I was a nomad at heart even as a poor twelve-year-old boy scout when, with a dyed pillowcase as a backpack and two broken shoes, I walked every day fifteen or more kilometers with my friends to set up our tent in a different place each night. And even at nine, when I learned about Christopher Columbus, I wanted one day to discover another continent. Movement always seemed to me the easiest way of breaking a repetitive, predictable, and boring life, to force fate to take heed of me.

I had to wait until 1963 for an opportunity to return to the Sahara. Having reached the Algerian oasis of Tamanrasset, I approached a group of Tuareg. Through an interpreter I told them I wanted to buy camels and, with a couple of cameleers, cross the Aïr mountains to Agadès, in Niger. That they found the idea preposterous, laughed, and turned their backs on me only reinforced that desire. Two months later I was back in Tamanrasset; I had just spent a month riding a camel from Agadès and visiting Tuareg along the way.

Loving nomadic life, it was only natural that I pursued it among other tribes. Though I could never avoid comparing other nomads to the Tuareg, who always remained dearest to me, I was never disappointed, for the living pattern was always similar. And each tribe had so much to teach me. There is much to learn from *every* people. Even from so-called "primitives,"

whom I have found everywhere to be every bit as intelligent as we, and often possessing knowledge and truths that have escaped us.

Though I am giving in this book the story of only two of my visits to the Tuareg, I visited them many times in the following years. Not only had I found among them the best friends and the most pleasant life off the beaten track, but I also owe them my photojournalistic career, which started with a *Venture* magazine story on my 1963 Agadès-Tamanrasset camelback trip and a *National Geographic* story on the salt caravan that I am retelling in this book.

I stopped seeing the Tuareg after the great 1973 drought, which pushed so many of them into relief camps and a vegetative life, and wiped so many others and so many camels off the face of the Sahara. Watching the beginning of the demise of a culture I had enjoyed so much was such a traumatic prospect that I could not bring myself to go back to sit at what I saw as their deathbed. I wanted to remember them as I had loved them. I went to live and travel in South America, and for seventeen years my fear of the change that was coming to Africa did not free me to go even to other parts of that continent.

Only in 1991, having accepted the inevitability of change, did I finally return to Africa. But I stayed away from the Tuareg and ventured instead in the desert of northern Kenya, among the Turkana, whom I knew from a previous trip. I knew these people's cultures to have suffered less than that of the Tuareg. They had changed in many small ways, but not all of them negative. Africans, obviously, have to evolve like the rest of us, even if this involves great hardship, and I am glad I went back to Africa. I do not think, however, that I could return to the Tuareg.

The stories I am offering here span twenty-six years, from 1965 to 1991. Rather than telling them chronologically, I put them in geographical order, going from west to east, and then south. This allowed me to make from the beginning a more thorough presentation of the Tuareg and to introduce the Tuareg's neighbors, the Bororo, immediately after them rather than after a trip to Ethiopia's Danakil. Chronologically, however, the order of my stories would have been the following: Caravan (1965), Danakil (1967), Tuareg (1970), Bororo (1970), Turkana (1991).

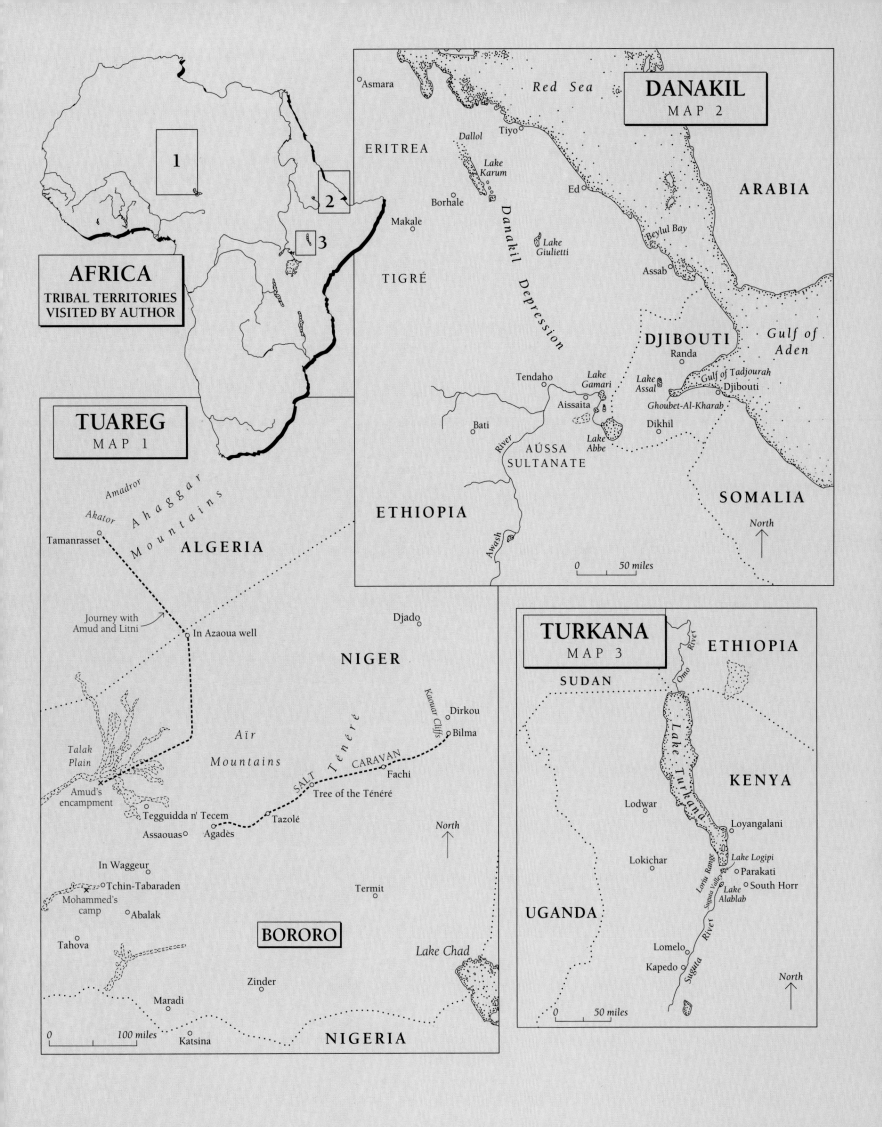

AFRICA
TRIBAL TERRITORIES
VISITED BY AUTHOR

1

2

3

TUAREG
MAP 1

Amadror

Akator

Ahaggar Mountains

Tamanrasset

ALGERIA

Journey with
Amud and Litni

In Azaoua well

NIGER

Djado

Talak
Plain

Aïr
Mountains

Kaouar Cliffs

Dirkou

Bilma

SALT Ténéré CARAVAN

Amud's
encampment

Tegguidda n' Tecem

Tazolé

Fachi

Tree of the Ténéré

Assaouas

Agadès

North

In Waggeur

Tchin-Tabaraden

Termit

Mohammed's
camp

Abalak

Tahova

BORORO

Lake Chad

Zinder

0 100 miles

Maradi

Katsina

NIGERIA

Asmara

Red Sea

DANAKIL
MAP 2

ERITREA

Dallol

Tiyo

*Lake
Karum*

ARABIA

Borhale

Ed

Makale

Danakil Depression

Beylul Bay

*Lake
Giulietti*

Assab

TIGRÉ

*Gulf of
Aden*

DJIBOUTI

Randa

Tendaho

*Lake
Gamari*

*Lake
Assal*

Gulf of Tadjourah

Djibouti

Aissaita

Ghoubet-Al-Kharab

Bati

River

AÚSSA
SULTANATE

*Lake
Abbe*

Dikhil

ETHIOPIA

SOMALIA

Awash

North

0 50 miles

TURKANA
MAP 3

ETHIOPIA

Omo River

SUDAN

Lodwar

Lake Turkana

KENYA

Loyangalani

Lokichar

Loriu Range

Lake Logipi

Parakati

Suguta Valley

South Horr

*Lake
Alablab*

UGANDA

Lomelo

Suguta River

Kapedo

North

0 50 miles

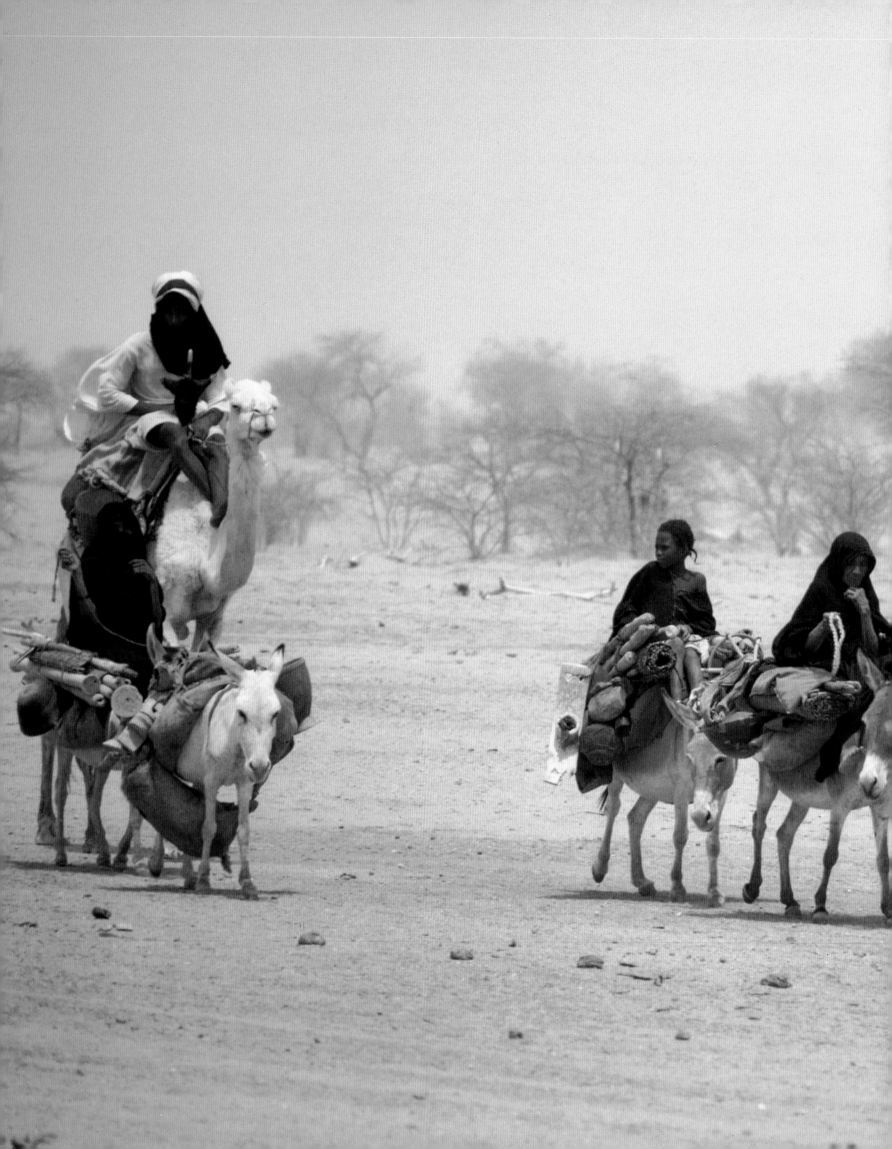

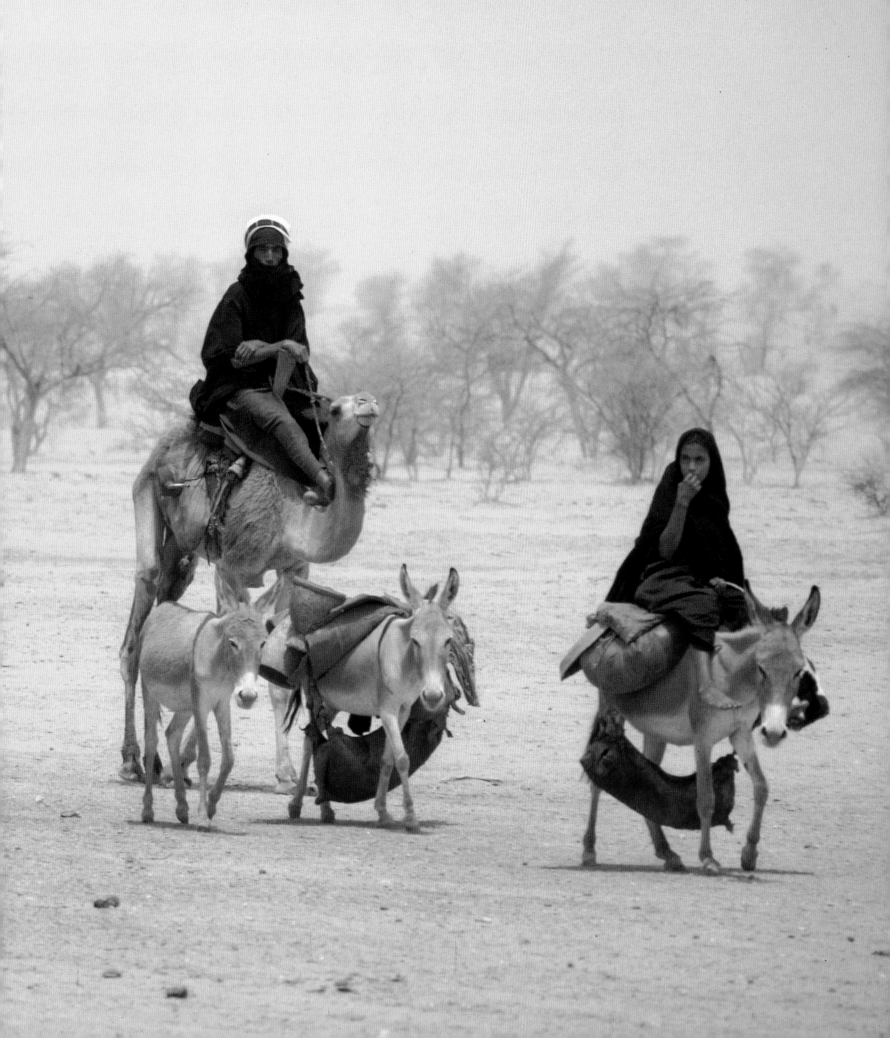

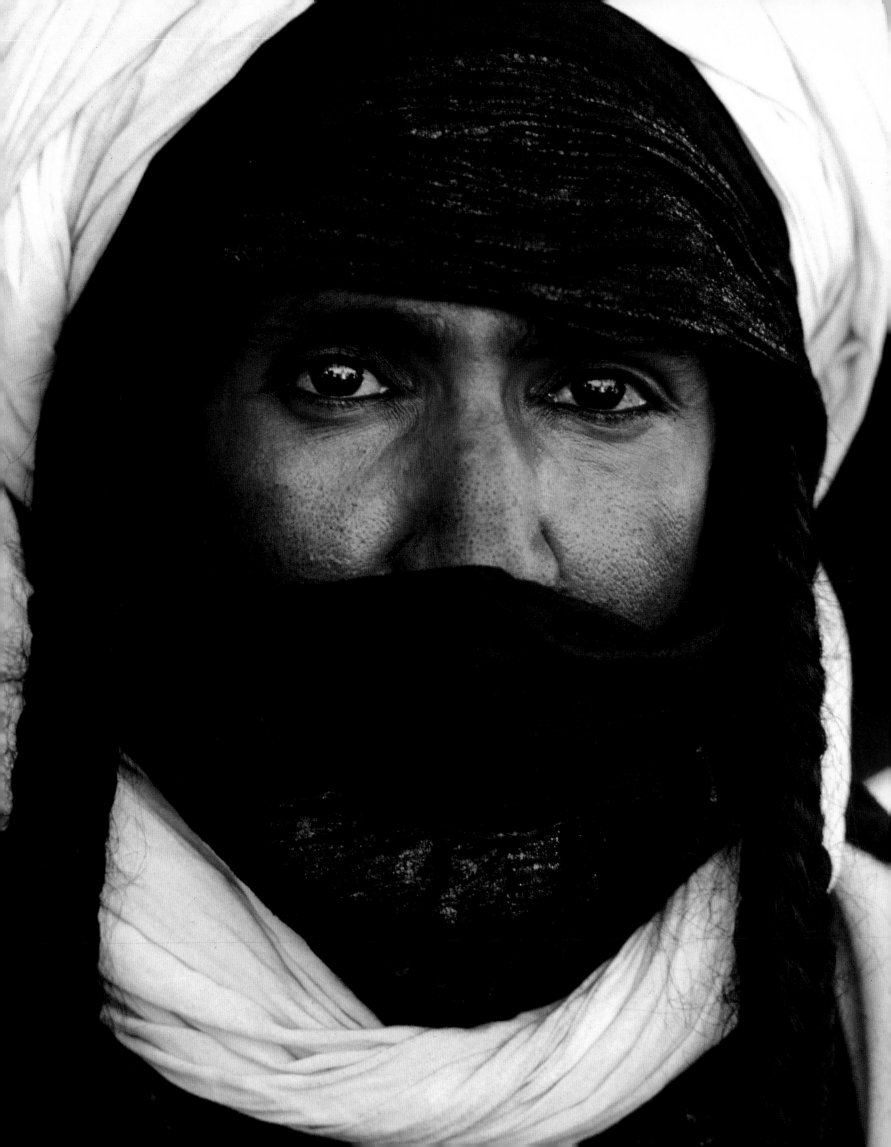

Part One: The Tuareg

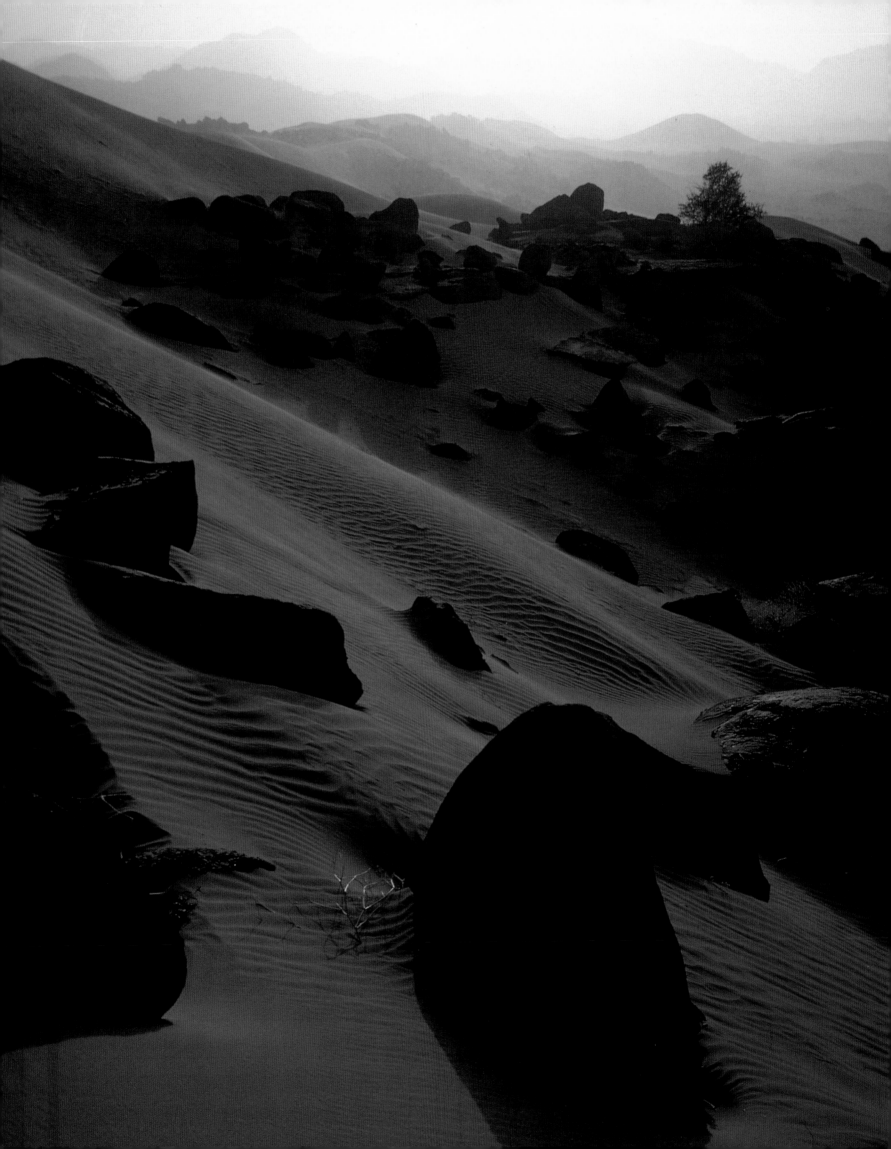

OPPOSITE *Sahara. Aïr mountains. Seen against the rising sun, a sand dune is slowly engulfing a rocky slope.*

July. An implacable sun. An immeasurable land. No horizon. We are riding in the void. Not a landmark to measure our progress. Not a stone, not a blade of grass. Only the sand—white, smooth, and blinding. Soon the wind will sweep away our tracks, granting the dunes a new virginity. Our small caravan stretches silently, mechanically, as insignificant in this ocean of fire as the grains of sand it treads. Miles—abstract like the hours.

All the camels have the same air of assurance and disdain. It is said that they alone know the hundredth name of Allah. My two companions, veiled to the eyes as the custom of their society requires, seem without expression.

Amud and Litni are Tuareg of the Central Sahara—Berber nomads. For centuries this desolate magnificence has divided the Mediterranean world from the lesser-known lands of Africa, but the caravans of cameleers like these have sustained commerce between them.

In this journey we follow Tuareg ways—as clear to these people, and as complex to outsiders, as the star patterns and dune shapes that guide us in a land of no roads. Amud and Litni are Ihaggaren, members of the federation of the Ahaggar mountains in Algeria. Amud keeps that identity even though insufficient pastures drove his family south a few decades ago to the Talak, a region of sparse grass and scrub in the west central portion of the Republic of Niger. He keeps his Algerian nationality as well. Litni and his family still live in the Ahaggar, but let most of their camels browse in the Talak under the guard of a trusted *akli*, a black servant.

We are ambling across an arm of the great Ténéré, an uninhabited desert, which spreads like a sea of sand around the Ahaggar and the Aïr. From it both massifs rise like islands. At times alluring mirages re-establish the horizon. Images of fresh pools dance in my mind, but I ignore them, for one cannot have everything. Here is peace, silence, purity. Here I can see to the bottom of my soul.

On this march we are walking full south. Early in the day we project immense shadows on our right. They shorten progressively, disappear under the bellies of our camels and reappear on our left, lengthening now. We shall not eat before night, for there is no shade in which to prepare a meal, and above all nothing for the camels to nibble. A Tuareg nomad does not stop to eat when his camels fast.

A hot wind keeps the sand suspended in the air, joining the earth to the sky without a seam. It rushes into my companions' robes, spreading them wide, giving them all manner of weird shapes. The veils give more remoteness to my faceless friends.

I too am veiled to the eyes. I know, having lost skin to the sun, the uses of the long *tagilmust*, the Tuareg turban-veil. Its cover helps prevent the mouth from drying; like sunglasses, it reduces the glare of the sand. No doubt Tuareg men began veiling themselves on long marches in the desert; in these women took no part, and to this day they have not adopted veils, though they may occasionally protect their faces with their head clothes. Ages went by, and the veil, I suppose, acquired supreme importance for the modest man. Elaborate custom governs the adjustments of the *tagilmust*. No well-bred Tuareg would remove it before women, old people, or strangers within his own society, least of all before his wife's parents. To eat and drink he will often pass his glass or spoon under it.

The sun has reached the end of its course. In half an hour, nothing will remain of its wrath but a little blood in the sky, which night will drink. It is the serene hour. Amud and Litni, as good Moslems, prostrate themselves to the east for the fourth prayer.

CHORES ARE NOT FOR NOBLEMEN

We go on, late into the night. When we stop, Litni hobbles our five camels, leads them into a circle, and dumps a bundle of grass in their midst. He lights a fire and prepares tea and *tagila*, a flat whole-grain wheat bread baked in the ashes. Wood as

well as food and fodder are carried by the camels in these empty wastes.

Amud, lying on his back, sings at the top of his voice. Chores are not for him. He is an *amahar*; he belongs to the noble Kel Rela tribe. *Amahar* (*imaheren*, in the plural) may designate any person of Tuareg culture and language—and the name Tuareg (Targi and Targia, in the singular), which is Arab, is not used. But in its strict sense *amahar* means "one in full possession of freedom and political rights, one who is noble." Amud is a noble while Litni is an *amrid* (*imrad*, in the plural), a man from a vassal tribe.

To almost any generalization Tuareg society offers exceptions; but usually a noble tribe may claim dues of millet from its vassals, with livestock and butter in times of good grazing. It might claim services in war against other tribes, as in European feudalism. The Tuareg recognize many social groupings. The *inislimen* are religious tribes, scrupulous in Islam. *Enaden* are smiths and craftsmen. *Imrad* are of mixed Arab-Tuareg descent and have special rank.

Iklan—the so-called slaves—are born into the role of servants, but their position follows patterns of kinship. They cannot be sold. If one chooses to, he can change "masters," and the first "owner" loses much prestige. Today some *iklan* are starting herds of their own; many seek a new life as laborers in uranium mines, oil fields, and towns.

Now the *tagila* is cooked. Litni pulls it out of the embers, scrapes its crust free of ashes with his nails, washes it in a little water, breaks it into pieces in a copper basin. I add the contents of canned meat, and we eat. Later, stretched out on the soft sand, I gaze at the most beautiful sky in the world, a perfect dome luminous with stars. A few paces away, the dying fire casts intermittent glimmers.

It is crackling again when I awake at dawn. Amud and Litni sit near it, watching the kettle. They rose long before first light, to say the first prayer, and a new *tagila* has been cooked. When the sun rises we are already in the saddle.

We have been in the saddle for fifteen days—since we left Tamanrasset, the last Algerian oasis on the road from Alger to Agadès, an important stop in the middle of nowhere. As a matter

of fact, Amud had already been riding from the Talak when I met him and Litni at Tamanrasset's market. He had traveled there with a cousin to sell some camels, and they were about to return home. I knew them; I had spent some days in their encampments five years before. I remembered enough Tamachek, their language, and Amud speaks a little French. Litni, who also knew them, like me, had come across them at the market, where he was making purchases for a trip to an encampment in the Aïr mountains to the south.

I wanted to accompany both Amud to the Talak and Litni through the Aïr mountains, a wild and spectacular region that I had once traversed on camelback. Fortunately for me, Amud gracefully accepted my company as well as the detour through the Aïr that I proposed. Litni, who had planned to spend a few days with his family before his trip, was ready to leave immediately to go with us. Because he had to change mounts, get his travel gear, and inform his family of his early departure, however, we had to travel first to his camp.

I had a saddle and only needed a camel. In a noble gesture that revealed the fullness of his long indigo robe, Amud showed me a tall white camel. "It is yours for as long as you will remain with me," he declared. "I have another one for your luggage. My cousin will not need them. He will gladly hitch a ride back on an Arab truck."

IN THE LAND OF FEAR

We left Tamanrasset in midafternoon. The chaotic structure and stark nudity of the black Ahaggar, looming ominously three thousand meters above the surrounding sea of sand like a gigantic fortress, suggested tremendous past cataclysms. Domes, needles, steeples, battlements, sphinxes, rock piles, and twisted reddish lava ropes looked from a distance like the ruins of cathedrals, castles, buildings, bridges, and rusted cables—like the wreck of a huge city brought down by an atomic holocaust.

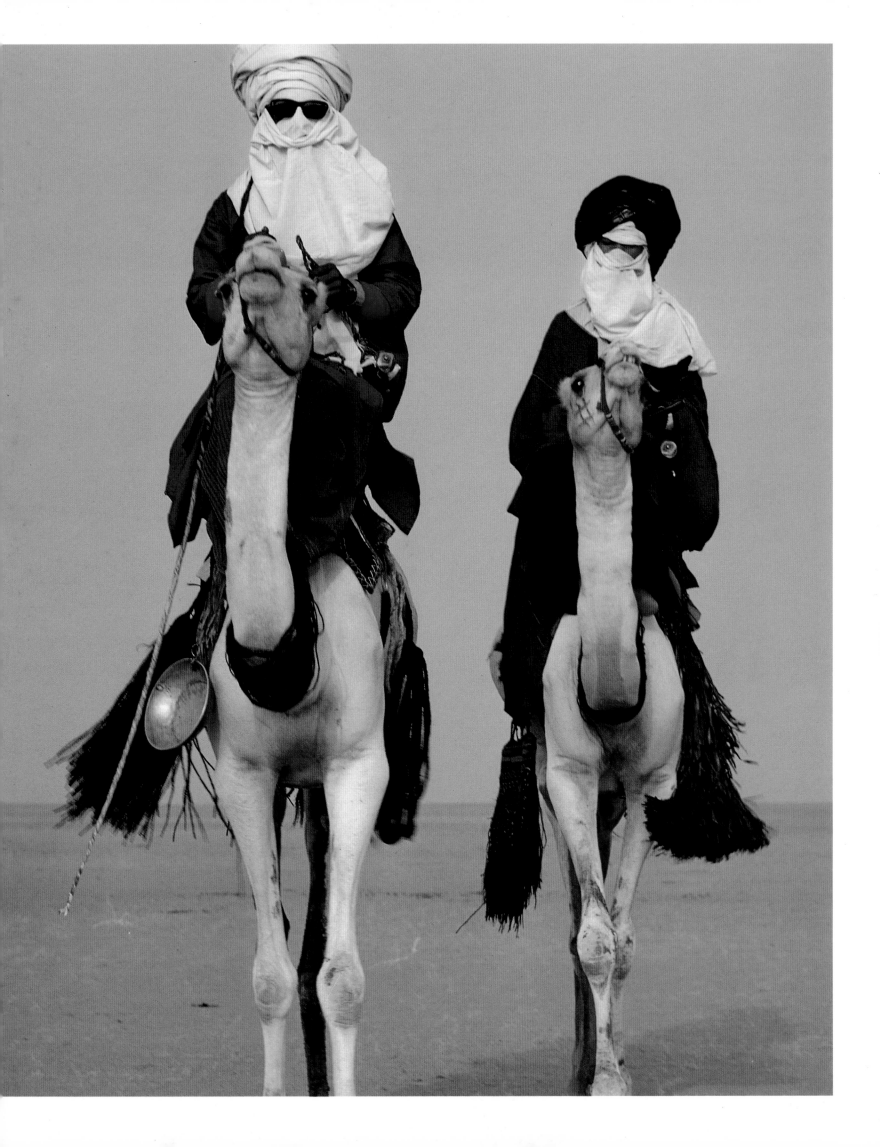

The Arabs once called the Ahaggar the "Land of Fear," and it is easy to understand why, mostly if one's imagination for a minute raises against the cloudless sky, above the sinister landscape, the dark faceless silhouettes of a Tuareg raiding party.

That blood-chilling sight in the past often spelled the doom of Arab caravans and French military missions. One French expedition, which in 1881 was picking through the Sahara a path for a Trans-Saharan railway that would unite France's possessions in North and Central Africa, met an especially tragic end there. A book by Joseph Peyré that I read perhaps thirty-five years ago still stands vividly in my memory. Its title skillfully summed up that dramatic Saharan episode, *La proie des ombres* (Prey to the Shadows).

Within minutes of being ambushed by the Tuareg, thirty-two of the eighty-two-man expedition—including Colonel Flatters, its leader, four other Frenchmen, and twenty-seven Chaamba Arab infantry men—lay dead. The remaining fifty-two men, seven of them French, had lost all their camels and horses, and faced a more horrible death. Meanwhile, walking twelve to fourteen hours a day, burdened with water and food, they retreated to the north under agonizing conditions. When they ran out of food, they soaked the parched skin of a long dead camel and ate it. Later they bought four sheep from the Tuareg who claimed innocence in the massacre. Deceived by the nomads, they also accepted poisoned dates, which drove them to near insanity.

One Chaamba had not touched the dates. He knew the cure against the poison. Making his companions drink warm water, he induced their vomiting. The poison only killed a Frenchman, but it had the rest of the mission still running amok when it reached the next water hole, where the Tuareg had preceded them. Out of their minds, the men threw themselves carelessly on the nomads' bullets and spears. Thirteen fell dead and more were captured. The Tuareg forced the prisoners to climb above a high cliff, from where they hurled them down to crash at the feet of the mission's survivors. The Tuareg, from then on, let the desert finish their work. They knew that it would every day kill more men. Only a handful of Chaamba made it back to civilization, though only after feeding on their dying companions.

Fear in the Ahaggar penetrates the hearts of even the toughest warriors, for in their imagination they people it with *djinnen*, or *kel-asuf*—evil spirits. Such is their fear of them that they do not hesitate, against Allah's commandments, to protect themselves against them with amulets. These are often pieces of paper, sugar wrappings, on which a *marabout*, a holy man, has painstakingly transcribed Arabic sentences from the Koran, the Moslem holy book. They sew these into leather pouches and hang them from strings around their necks. When a Tuareg dies, his family or friends quickly remove them.

I myself was often afraid in the Ahaggar, though not of raiding Tuareg or *djinnen*. Constantly stopping to take pictures, I frequently fell behind far enough to get lost in the broken desert. Too proud to cry for help, I anxiously probed the ground for fresh camel droppings, and soft spots for camel footprints.

THE TUAREG DO NOT TEACH CAMEL RIDING

I had learned to track Tuareg companions on my first camel trip, between Agadès and Tamanrasset. The difficulty of my ground deciphering was compounded then by my scanty knowledge of camels. Riding a camel is easy enough, at least at a walk, but there are things one should know about that animal if one is to deal with him far from a helping hand. The Tuareg do not teach these things. They believe they are evident, as it is to them evident that we must all live in tents.

The first time I got lost in the Aïr mountains, I was very nervous, for my *gerba*, my goatskin water bag, was on the pack camels with the Tuareg. I had dismounted and could not get back in the saddle. Each time the camel felt the weight of my right leg, which had to be lifted very high even over the kneeling animal, he rose and made me fall back. I had not learned to hold his head on a short rope, twisted to the side until I was well seated, and after several falls I began to suspect him of making fun of me. I became so sure of it that I thought I could detect a snicker on his face. But do not camels always snicker?

I could have walked, but feared to get too thirsty too soon. Besides, the ground was littered with *cram-cram*, prickly grains, which hurt my cracked feet. Thus, shamefully losing my temper, I raised my leg again, though this time to kick the poor animal in the jaw with my bare foot. Seeing him stunned, I jumped in the saddle. He needed no encouragement to take off. This

time, *he* was mad, and as I well deserved, he took me on a fantastic gallop.

To ride a galloping camel can be awkward for the neophyte, the more so if he is trying at the same time, as I was, to keep two cameras from banging against each other on his chest. In southern Morocco, the nomad sits on the camel's hump, and in the Arabian peninsula, behind it—in both cases the nomad straddles the camel like a horse, which gives him a firm hold on his mount. A Tuareg nomad sits in front of the hump, with nothing to squeeze between his legs but the pommel of his saddle, a large decorative cross which breaks if you hold on to it. He rests his feet on the camel's neck and uses them to control his mount as no other nomad can. That riding mode has made him the best cameleer on earth.

I was no cameleer, however, and had no idea how long I would hold my balance on an animal whose neck was too far to hold on to and who tossed me left and right as he moved his legs on one side at a time. Fortunately, he found my friends without my help and refrained from dumping me, cameras and all, until after passing them, so that they could lower me from the thorny umbrella of an acacia tree where I ended my mad race.

FORMALITY REGULATES THE USE OF THE *TAGILMUST*

We reached Litni's encampment the next afternoon. Long before we saw it, I knew we had arrived because Amud and Litni partially unwound their *tagilmusts* to rewind them formally. Fifty paces from the three tents, we circled them until someone caught sight of us, then we stopped and dismounted. Quickly rearranging his own *tagilmust*, an old man came to greet us. He was Litni's father.

> "*Saláam Aleikum.*"
> "*Aleikum es Saláam.*"
> "*Mattulid.*"
> "*El Kher ras.*"

Soon, two women followed him. They were carrying thick wood poles and an *asaber*, a long and strong tent wall artistically woven from leather strips and straw. While we hobbled our camels and pushed them to pasture, they drove the poles into

NEXT PAGE *Sahara. Aïr mountains. Biga's caravan hits a flat stretch en route to Libya.*

the ground, raised and tied the *asaber* against them to form a three-sided shelter against the wind, went back for a rug, which they placed in the middle, and lit our fire. We sat down on the rug—Amud somewhat back, as fitted his rank.

One of the women brought us curdled milk. As usual with Saharan nomads, who use precious water only to drink, the bowl was filthy. A filter of sand covered the curds, and dirt floated and swam in them. But that was what my hosts themselves consumed, and I could not refuse it. Thus I drank, filtering the liquid through clenched teeth, but then, failing to find an opportunity to discreetly spit out the dirt, swallowed it too.

Litni prepared tea, and for a time, while answering his father's questions, kept pushing his veil respectfully up his nose. Formal exchanges over, however, he rewound his *tagilmust* in a careless way. Now he was at home. Not Amud. Occult in Litni's shadow, cast over him by the fire, he sat like a Buddha, straight, aloof, and mysterious.

Litni filled the miniature enameled teapot with green tea leaves and a big lump of sugar, which he broke from a rock-hard loaf with a precise knock of a small tea glass bottom. The tea glasses, which he had pulled from a leather bag, were disposed in a line in the sand in front of him. After the tea was brewed, he poured it into the glasses from a height to make it foam, then back into the teapot. He thus poured the tea back and forth three or four times, let it boil once more, then served us each a glass— a bigger one to Amud. My friends passed the little glasses under their veils, and we sipped noisily, they with obvious delight. Green tea is the only sweet the Tuareg know, and they can rarely afford it. For that matter, I always bring the Tuareg enough sugar and tea, as well as tobacco, which both men and women are fond of chewing, to last them long after I am gone.

Litni added sugar and water to the teapot and replaced it on the embers. As is the custom, he brewed and served us tea three times. As the Tuareg say, the first glass tastes bitter, the second one just right, the third one a little weak.

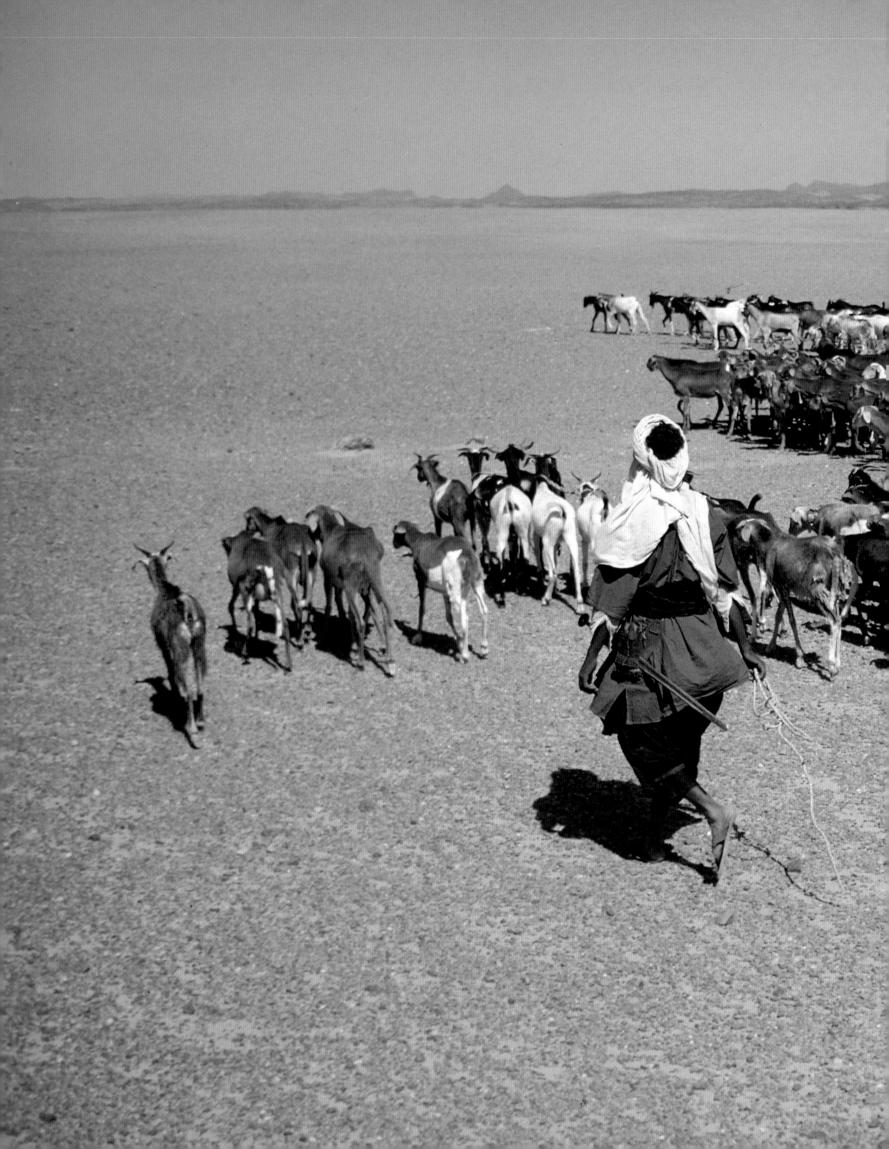

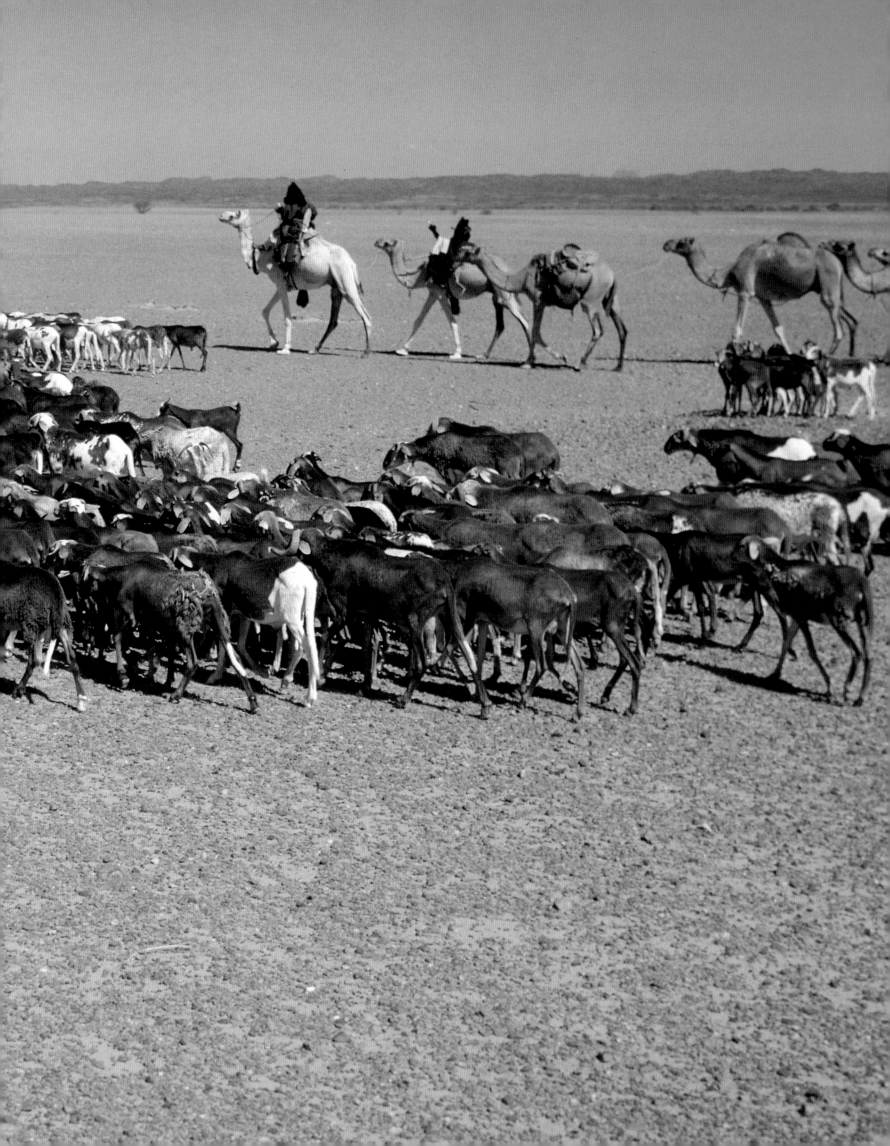

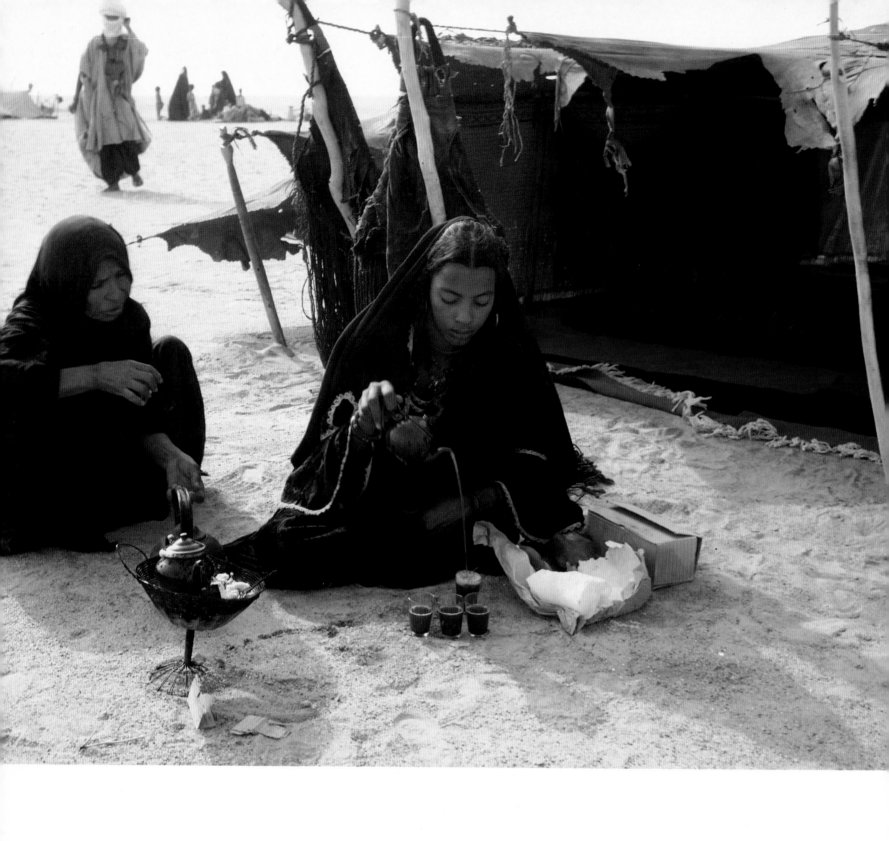

Having tended first to his widowed father and guests, Litni got up and walked to his tent to greet his wife and baby boy. Though an *amrid*, he strode regally. He is so tall that he towers over Amud and me; both of us are about six feet tall.

He soon returned. One of the women brought us in a copper basin four brochettes. A young goat had been sacrificed in our honor, and while it roasted, our hosts had cut up its liver and heart, wrapped the pieces in fat, and broiled them over embers for an appetizer. Litni passed a brochette to Amud, who remained immobile in his corner, unskewered the others in the basin, and the rest of us ate from the common pot.

Battle Scars Mark an Old Warrior

As Litni's father picked morsels of meat, I noticed the missing fingers on his hand. Litni caught my glance and grinned. "*Takuba* fight," he said. "Sword fight. Look!" and he showed me his father's feet, which had missing toes. Like the missing fingers, they had once been slashed away by a long Tuareg sword. He asked his father to uncover his breast and pointed to more ugly scars. "French bullets," he said. Litni's father shrugged his shoulders. "Today we live like women," he complained.

When that conversation took place, in 1970, Litni's father was about seventy, and the Tuareg had submitted to the French only fifty years before. Even after that, for some years, they occasionally raided an Arab caravan, a Black African village, or another nomad camp. To this day the Tuareg wear *takubas*, and I have seen the proof of their present use, occasional as it may be, written in the flesh of young men. As far back as history reminds them—long before Arab invasions in the 7th and 11th centuries pushed them into the Sahara from the Libyan littoral, when they called themselves Garamantes and served Egyptian pharaohs as mercenaries, or raided Carthaginian and Roman towns—they were always warriors.

We ate goat ribs and legs as well as *tagila*, then retired, Litni and his father in their tents, Amud and I behind the *asaber*. Cau-

tiously, the dogs came for our meal's bones, which littered the ground around us, and their gnawing was the last thing I heard that night. For a long time, however, I could not totally surrender to sleep, for once in a while a warm breath on my face, like that of a famished dog, pulled me back. It was only the breeze, but I could not be convinced.

The camp woke up before sunrise. The women, in their long indigo tunics, milked countless goats, then chased them away, again and again, under a hail of stones when they tried to enter the tents.

Litni and his father came to light our fire and prepare tea. We ate the rest of the goat. Later, Litni went to gather our camels, and I followed to give him a hand. We found them half an hour away, grazing in a wadi, a dry river bed, and not happy at all to see us. Using all our cunning, we cornered them one by one. As usual, they lifted their heads high above our heads when we tried to attach the ropes to the nose rings. We brought them within our reach by throwing the ropes over their snouts and pulling both ends down or by tugging at a hair tuft in their throats, which seems to grow there just for that purpose.

On our way back we passed a young black shepherd herding the goats of Litni's family to the water hole. A few years ago, he would have been an *akli* (singular of *iklan*). Today he was free, and Litni paid him two goats a month besides his upkeep. He had been with Litni's family for only eleven days, but he already knew which goats would start his own herd. Shamelessly, he reserved for them all the delicate tidbits he could find. "Knu, knu, knu!" he cried, and they ran to him bleating happily.

We loaded the camels and slowly pulled them away. Litni's father and the women walked with us for a few hundred meters while we exchanged the last words. One by one, without a farewell, they turned back and left us alone to mount and face the desert again.

Sinister or not, the Ahaggar mountains around us were indescribably beautiful. Sharp black summits cut against hazy ones in the distance, and the light sand in the wadis seemed to borrow the color of the pink sky. To satisfy my curiosity, my friends left the wadi to ride up the mountains. We climbed cyclopean stone stairs, up and down, but in the end rising to great heights swept by tempestuous winds. We skirted abysses and, balanc-

ing on my saddle over the void, I felt my stomach rise to my mouth. But my mount was amazingly surefooted, and I understood why Ahaggar camels are so coveted by Saharan nomads. When the danger became obvious even to my companions, one of them dismounted to reconnoiter the way on foot.

AN APOCALYPTIC GALLOP

We descended again into a wadi, and suddenly Amud and Litni jumped down from their camels. Frantically, they released the pack animals and unloaded a few things from their mounts. Using the knuckles and necks of the camels as ladder rungs, they nimbly climbed back in the saddle without making the animals kneel, and with great whoops they whipped their mounts toward two Tuareg who were racing in our direction on their own galloping camels. The action had been so swift that only now was I beholding the runaway camel that the two men were pursuing. For a moment, I had thought they were charging us, and that Amud and Litni were reacting to the attack. Veils and robes flapping in the wind of their apocalyptic gallop, the four Tuareg quickly disappeared together around a bend of the wadi, leaving me to wonder whether I had been dreaming.

The Tuareg returned two and a half hours later—unfortunately empty-handed. While Amud and Litni recovered the things they had so hastily abandoned, I greeted the other two Tuareg, two old men of the Isekkemaren, a mixed Tuareg-Arab *imrad* tribe of special status.

We followed them to their encampment. The camels were blinking from their race against the wind. To relieve them, the Tuareg spat tobacco juice in their eyes before setting them free. Behind a new *asaber*, our hosts treated us to the same generous hospitality as had Litni's family. This time, however, Litni was a guest too, and while waiting to be served he assumed the same remoteness as Amud.

To be a guest also meant that Litni did not have to go in search of our camels the next morning. When an Isekkemaren youth brought them in, Amud showed me the swollen sides and buttocks of those he and Litni had to whip the day before. The oldest of the two Isekkemaren, who was well into his sixties, made Amud and Litni laugh heartily by vividly mimicking for me the pain he felt that morning in his own buttocks. As even the

OPPOSITE *Sahel. Azaouak region. Anislim woman at the entrance of her tent. As is often the case with people of this caste, her skin is white and her features are Semitic.*

Tuareg are not every day called upon to endure such exertions, yesterday's adventure fueled our breakfast conversation.

We rode all day through the varied and spectacular, though sterile, landscape. Sometimes, the wind brought me shreds of my companions' songs, and they were so outlandish and beautiful, so much in harmony with the singers and their fantastic surroundings, that they bewitched me into wishing to remain forever part of this magnificent world.

We camped in a wadi as the sun hid behind the mountains. Though its yellow rays still kindled the summits to the east, the dim blue veil of dusk had settled on the deep stone corridors below. Using a single match against the tempestuous wind, Litni lit a fire, put on it the kettle, and kneeled down near Amud to say his fourth prayer.

Now Litni crushed garlic, savory grains, and a lump of Saharan salt between two stones to prepare a *shorba*, a thick Arab soup composed mainly of dried meat and tomatoes, oil, and spaghetti. While our meal was on the fire, he poured hot water from the kettle over a handful of dry dates in his copper basin to soften them, and passed them around. Then he drank the sweetened hot water left in the basin.

I never tire of observing the remarkable economy and precision of Tuareg movements. My friends had, as usual, left their luggage right where they had unloaded them, in apparent disorder. Yet once Litni had sat among them, in front of the fire, he would not once have to get up again. The water, the pot, the food, anything he needed was within his arm's reach—even the flower he likes to add to the third glass of tea.

Litni always adds something to our last glass of tea: a flower, mint, or some other herb. When he finds nothing, he pulls from the seams of his leather bag some old cloves. Once when the tea effluviums nearly choked me as I opened my mouth to sip it, I asked him what he had put in this time. "This!" he said, proudly showing me a little can of mentholated vaseline.

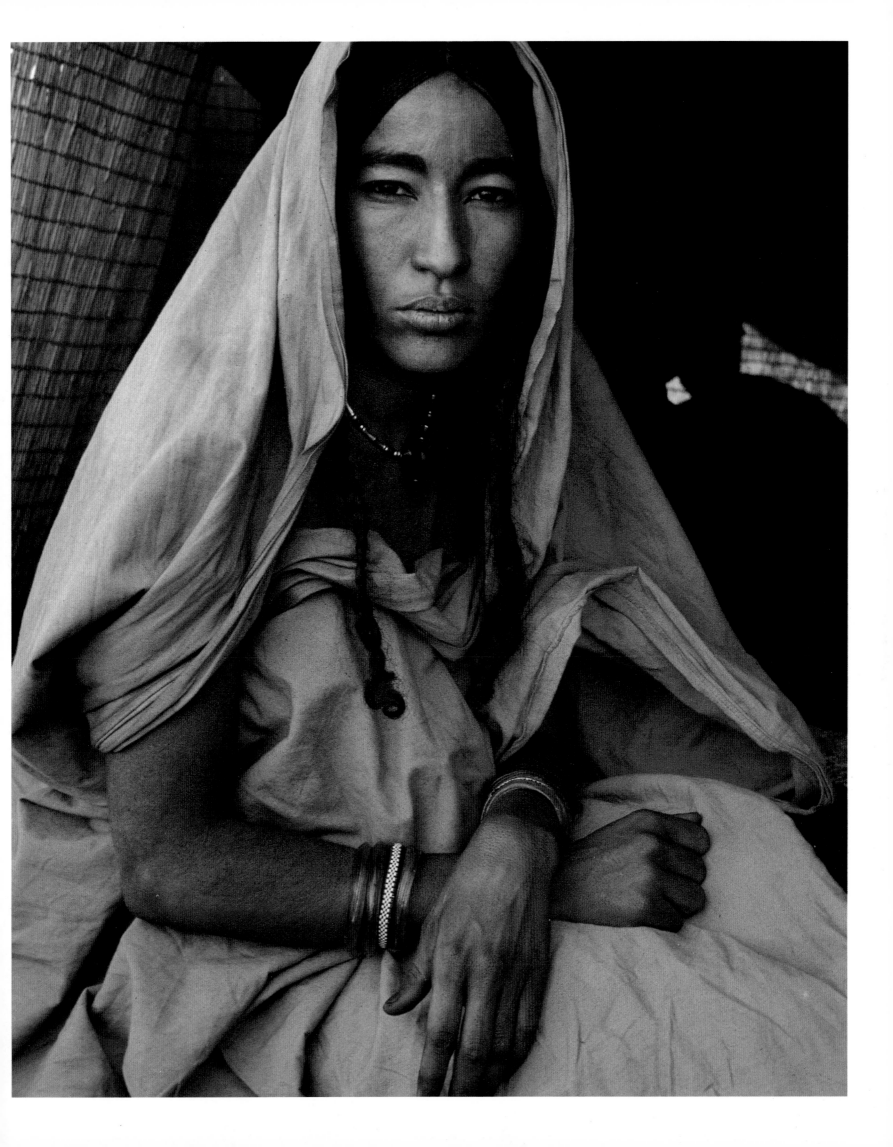

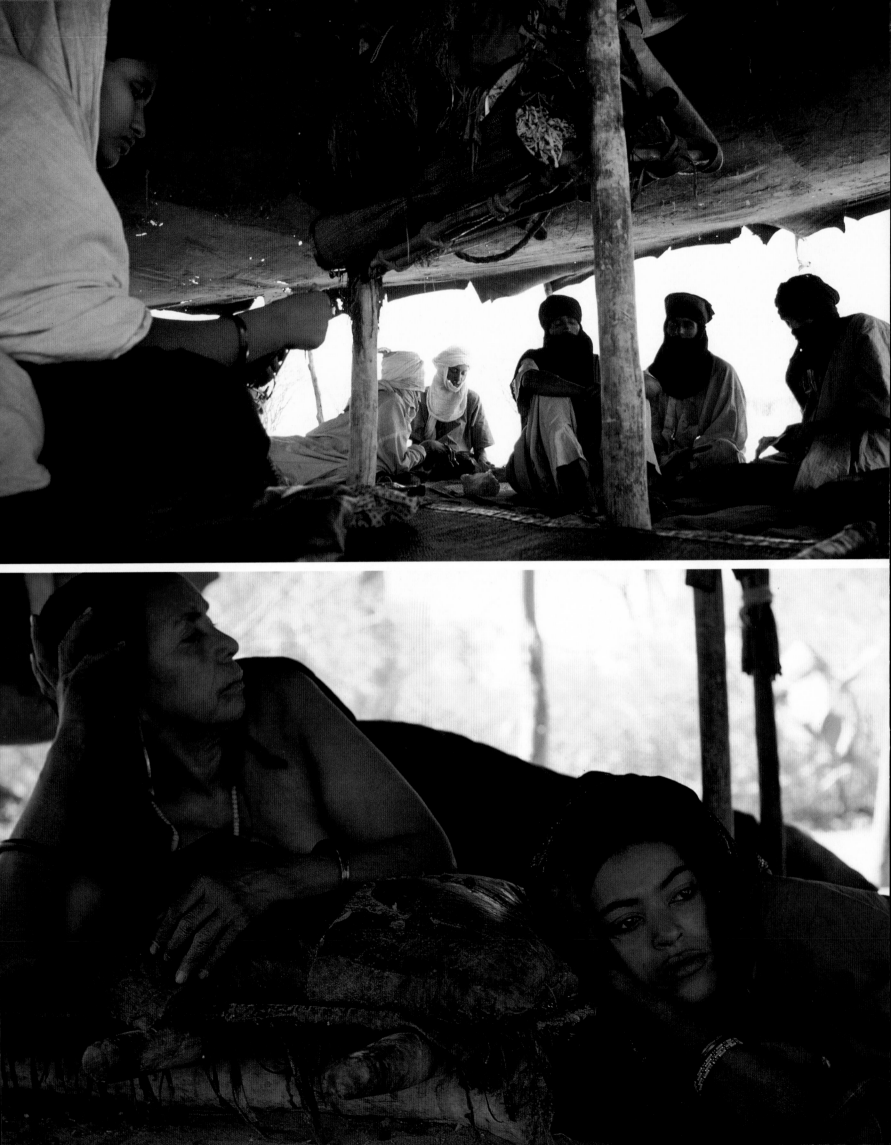

OPPOSITE TOP *Sahel. Azaouak region. Under a leather tent, three Iullimiden Tuareg noblemen and two lower-caste satellites chat at the feet of chief Mohammed's daughter-in-law.*

OPPOSITE BOTTOM *Sahel. Azaouak region. Relieved of chores by their iklan, mother and daughter, Ilbakan* imrad, *rest on leather cushions on a bed under their tent. The dye of their head clothes, shiny and loose as that of carbon paper, has come off on their arms. Not only does its color please the Tuareg, who have been called "the blue people," but, like the dirt that often cakes them, it may also protect their light skins against sunburn.*

AMUD AND LITNI PLAY WITH FIRE

It was somewhat cold tonight, at the bottom of our canyon, and my companions, who were sitting near the fire, had rolled up their pants to warm their legs to it. Perhaps because of the methodical way they went about it and the smell of burned hair, the scene so ridiculously suggested they were roasting their own legs for dinner that I was suddenly overcome by an irrepressible fit of laughter. First surprised, then delighted, they got up to clown. Now they deliberately passed their whole legs through the fire, then turned around and squatted in it. The flames licked and enveloped their wide desert pants and should have ignited them like torches, but they moved in them like devils. They too laughed, and the more I did, the more they did too. By the time they pressed, for interminable seconds, their hard-soled feet on the embers, even *their* mirth, which now was drawing tears from their eyes, had become silly. We calmed down finally, but my friends wanted more fun.

"Is it true," they asked, "that French couples walk hand in hand and kiss on the mouth?"

The Tuareg believe that all Westerners are French, and find some of our customs silly or disgusting. Not that we could teach them anything about love, quite the opposite. Contrary to the Arabs, and even to many Westerners, they treat their women as equals. Their code of honor also prohibits them to harm in any way the women of routed enemies. Like most tribal people, they could also teach us a few things about educating children. But

love to the Tuareg is not something to expose in public. Although they do kiss, they do not do so on the mouth, as they find more appealing the sniffing of each other's nostrils.

In any case, the Tuareg are very proud of their madonna-faced women, and my friends lose no opportunity to tease me about them. "Did you like the millet?" they may ask after a meal in an encampment. I hate millet, but say, "I loved it." "Marry a Tuareg girl, and you will eat it every day."

TUAREG CASTES MAY HAVE DIFFERENT RACIAL ORIGINS

Between two glasses of tea, I asked Amud whether he thought *imaheren* and *imrad* belong to the same race. "Yes." he answered. "In the beginning we were all the same, but the strongest tribes subjugated the weakest ones."

An Iullimiden noble of Niger, to whom I once put the same question, thought differently. "*Imaheren* and *imrad* have different origins," he said. "Every Tuareg caste has." They may both be right. There are, indeed, *imaheren* tribes that became *imrad* after losing a war. But otherwise, I believe the great differences between the various castes corroborate the Iullimiden thesis. Obviously, the Central Sahara was occupied at different times by different people. The fact that the *imrad* miscegenate more freely than the *imaheren*, walk with no haughtiness, and dress less elegantly is enough to set them apart from them.

Scholars, who base their opinions on the writings of Herodotus, Ptolemy, Leo Africanus, Ibn Batutah, and Ibn Khaldun, agree that the *imaheren* originated in Libya and migrated to the Sahara directly or by way of Morocco. Moving there on camelback, they found white tribes that had occupied the land for centuries. More primitive, owning only donkeys, goats, and dogs, they were conquered by the invaders.

The oral traditions of the Kel Rela, Amud's tribe, have them descended from Ti-n-Hinan, a noble Moroccan Berber woman, and their *imrad* from Ti-n-Hinan's servant Takama after they arrived in the Ahaggar several centuries ago. The Kel Rela's lineage starts with Ti-n-Hinan's daughter Rella. Being matriarchal, the Tuareg inherit their rank from their mother, and because they are not concerned with their male ancestors, we do not know who *they* were. The Ihaggaren say that Ti-n-Hinan was a Mos-

lem, but excavations of her grave in the Ahaggar showed it to be pre-Islamic.

"If you could dig into our history far enough," Amud said, passing a finger on his skin and then on mine to signify that they are of the same color, "you would discover that long before my ancestors settled in North Africa they were French." That is the Kel Rela's snobbishness, of course. If the Tuareg ever came from another continent, archaeology tends to point instead to the Greek islands and, beyond, to Palestine.

Amud's claim, however, is not as ridiculous as it seems, for if he were dressed like a Frenchman he could pass for one. Impressed by the cruciform design of the Tuareg's saddles, swords and daggers, and jewelry; the shape of their *tagilmusts*, similar to that of medieval helmets; and the chivalrous way they treat women, some early travelers wanted to see in them the descendants of crusaders.

Amud and Litni no longer hesitated to unveil themselves in front of me. Perhaps because of his European look, Amud's fair features surprised me a little the first time I saw them. But when Litni bared his face, his darker complexion, eagle profile, black mane, and thick long beard above his tall frame seemed to come straight from an Assyrian fresco. Most Tuareg look better with their *tagilmusts* in place, however, probably because it puts so much emphasis on their bright piercing eyes.

Amud and Litni were never as joyous in the morning as in the evening. Their thick, uncombed hair standing up on their heads from their eternal fights against lice, they looked morose as if resenting the new day. But as the sun rose, so did their spirits. On camelback we never talked much, but later around the fire we brought forth all the questions that had accumulated in our heads during the long ride. Then we did our best to communicate, for we were ever eager to learn more about each other. At those moments, a small French-Tamachek dictionary that a French catholic missionary had once given me was of invaluable help.

A Tuareg Nomad Does Not Eat While His Camel Fasts

One evening it rained, and Amud and Litni laughed exuberantly at the thought of the pastures that for a few days would soon

green the desert. We did not camp that night in a wadi, for if it rained hard enough the ephemeral torrent running down the mountain could sweep us away in our sleep. As the rain persisted, my friends became despondent. They lit a fire, but did not cook or even brew tea. Under the temporary shelter of a blanket, they just stared into the flames.

"How could we eat while our camels fast?" they asked, when I wanted to know why we did not cook. The camels would not eat because of the rain, and as my friends would not touch food either, I went to sleep on my own empty stomach.

No flood carried me away that night, but I became wet enough to find sleeping uncomfortable. I got up and lit the fire again, and soon was joined by Amud and Litni, who looked as pitiable as I. We silently sat around the fire and did not move when for lack of wood it died.

Eventually it was time for prayer. Then the sky lightened to the east, and we went for our camels. They were nearby; they had not moved from where we had left them the night before, and I could read despair in my friend's eyes. But the sun rose as fierce as ever, and in no time it had licked the last drop of water sparkling on the granite.

One day, just before starting across that arm of the dreadful Ténéré where my story started, we reached the well of In Azaoua. Two long waterless marches, and possibly more, lay ahead of us, and we filled our *gerbas* and stocked up on fodder and firewood. Amud and Litni, who never wash, except for a ritual rinse of the hands before kneading the *tagila*, even took an expeditious bath.

We crossed the sand channel and landed in the Aïr. Now we are riding through chain after chain of mountains, whose cavities are filled with sand. We climb up and down and around heaps of boulders, and at every rise and turn take in fantastic vistas. Savanna alternates with desert as we follow a green wadi, cut across black wastes, and descend once more into the lush

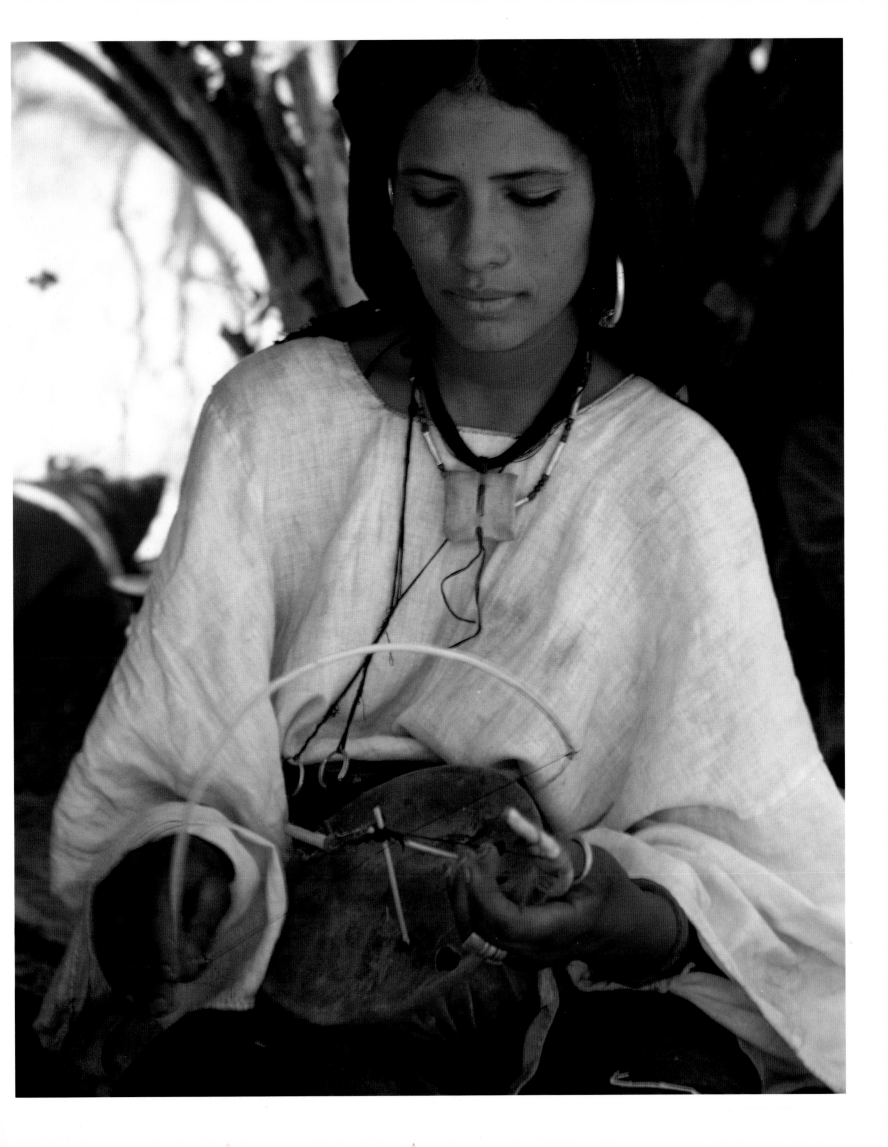

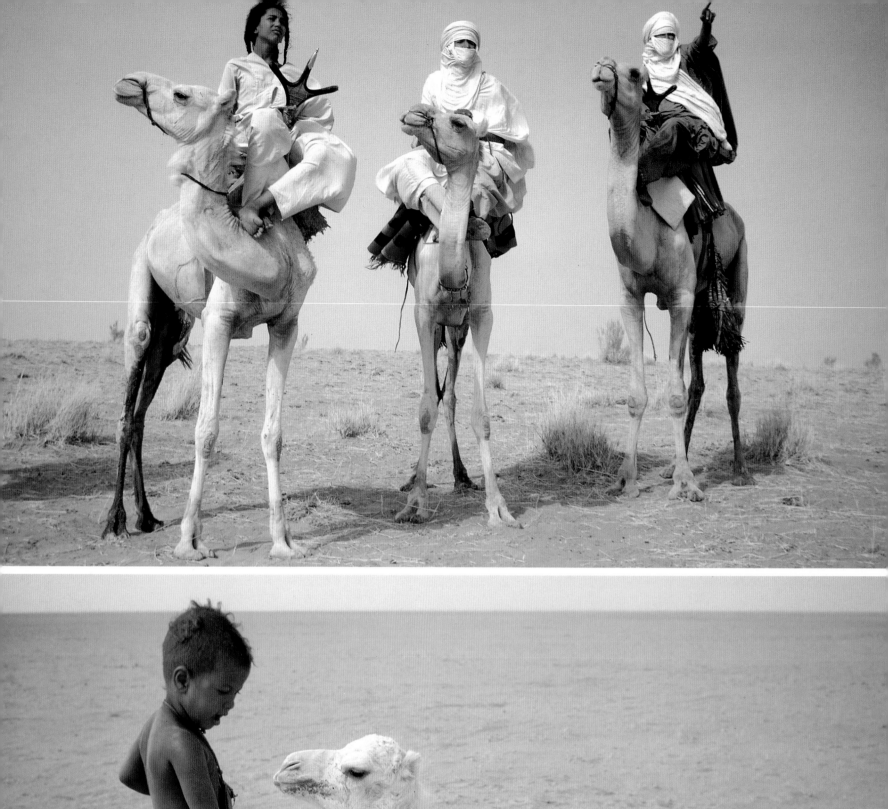
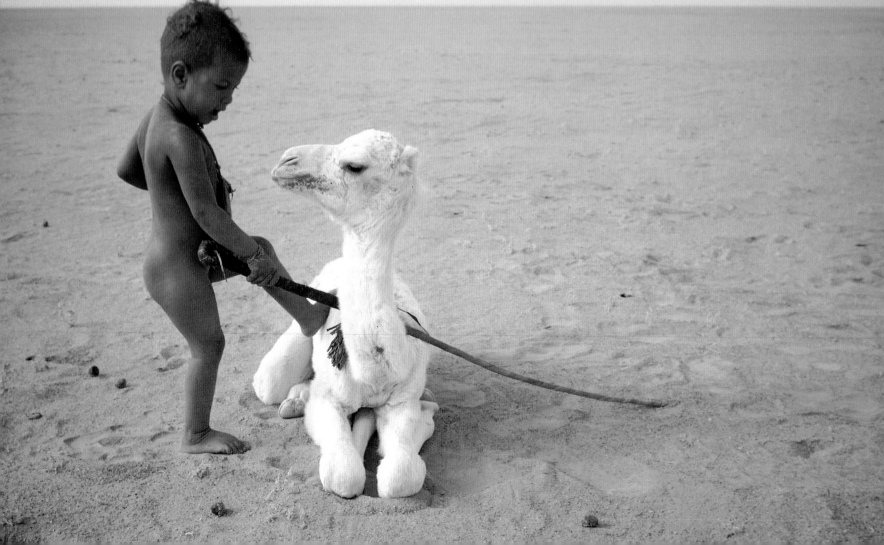

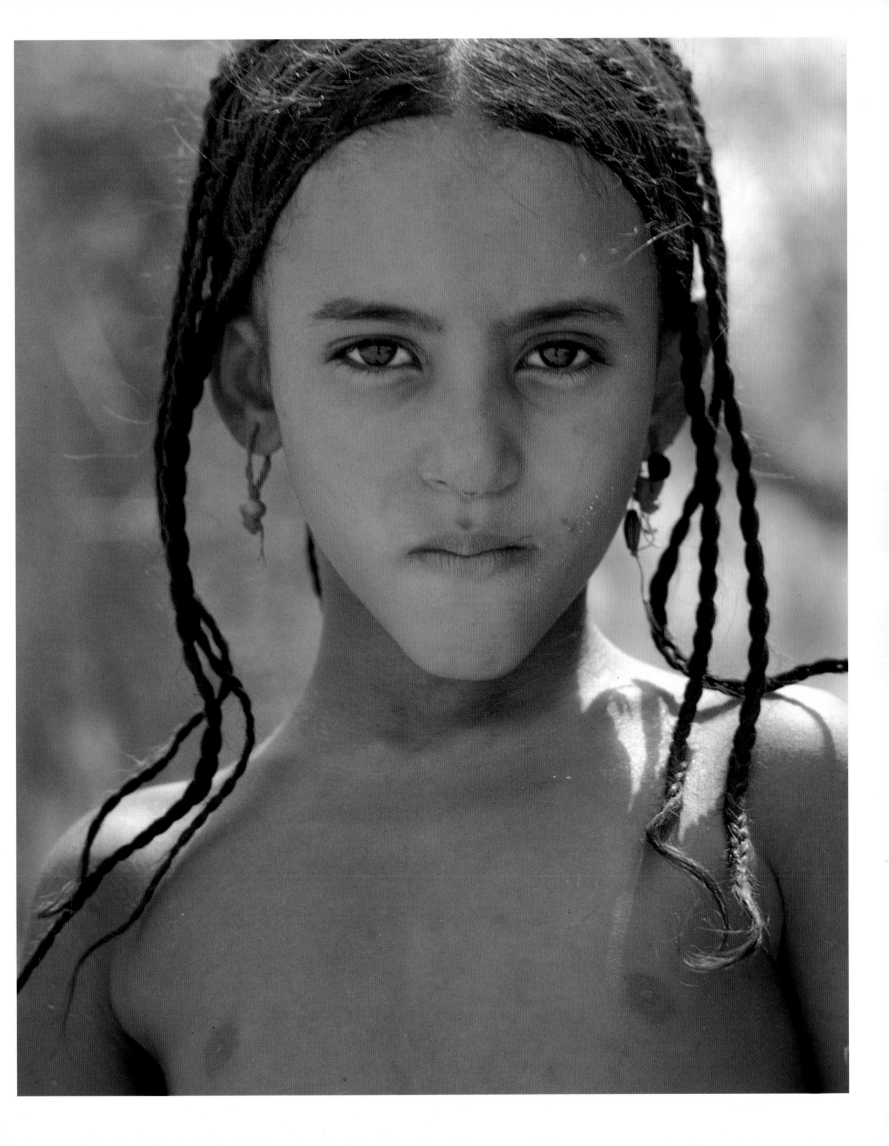

PRECEDING PAGES LEFT TOP *Sahel. Azaouak region. Noble Iullimiden Tuareg brothers, sons of chief Mohammed, on an inspection tour. The youngest of them has not yet donned the* tagilmust.

PRECEDING PAGES LEFT BOTTOM *Sahara. Talak plain. Holding a leather whip, Abela, Amud's fearless nephew, plays with a baby camel.*

PRECEDING PAGES RIGHT *Sahel. Azaouak region. Amrid girl of the Ilbakan tribe.*

The Kel Aïr are much more elaborate than their northern brethren in their endless salutations, which Amud impatiently cuts short. "They are mad!" he says laughing as they repeatedly slide their hands out of mine, first slowly, then, as if my fingers were burning, suddenly, while interminably going through a verbal ritual of questions.

> *Mattulid!*
> How is your health?
> And how are your parents?
> And your encampment?
> And on and on . . .

Halfway through the Aïr, we reach a large encampment—at least eight tents visible through the scrub—Litni's destination. Men help us unload our camels, and we sit in comfort on straw mats. A boy goes for tea and sugar while other men join us, among them the clan's headman, called Biga.

While Litni exchanges news with them, I watch our hosts closely. Their profiles are less sharp than those of my friends. Their limbs are short and powerful, their hands square and strong. "They are *imrad* of an Iforas tribe," Amud tells me, "originally from the Adrar mountains in Mali. They fled that massif a few decades ago—their *imaheren* were becoming too greedy." Such action has long been a pattern among the Tuareg, and helps explain the dispersal of various tribesmen.

Nomadic Tuareg wander over an area roughly defined by Reggane in Algeria, Ghadames in Libya, Tombouctou in Mali, and Zinder in Niger. Traditionally, tribesmen remained within territories defined by the leaders of their federation. The federation—there are five of these—would assign grazing to its members to assure that they would remain peacefully apart most of the year. Even today many Tuareg respect these boundaries; national borders mean less to them. The most important distinction of all is that between the rigorous country of the Sahara proper and the more hospitable savanna south of it.

Livestock sells for a good profit in Libya, where oil revenues increase wealth, and some of the Iforas are planning a long journey to sell sheep there. I have never traveled in the Sahara with flocks. I tell Biga of my interest in this. "You are welcome to join us," he says. "We shall leave on the twenty-seventh day of the

dry river bed. Less high, less black, less forbidding than the Ahaggar, the Aïr mountains are, in places, almost parklike.

Gazelles, ostriches, and guinea hens watch us go by; sometimes they are so close as to exasperate my friends. When the gazelles frenetically wave their stubby tails, Amud and Litni frighten them away with cries of disgust; their swords are useless for a hunt. Or, as a game, they dismount behind a rock, use the uneven terrain to crawl unseen toward the animals, but only to eventually watch them flee.

The sun bears down cruelly on our shoulders, and now, when we find an acacia tree at noon, we stop under it. We put the kettle on the fire, and the three little glasses of hot syrupy tea calm our thirst better than a gallon of cool water. Then we try to nap in the thin lacy shade of the tree, but it moves with the sun, which drills into our eyes and forces us to constantly roll over.

CUSTOMS SET APART THE TUAREG FROM
AHAGGAR AND AÏR

Customs and language in the Aïr differ somewhat from those in Ahaggar. Influences come from the south rather than from the north, from the black Hausa rather than from the Arabs. The women no longer wear long indigo tunics but, above an indigo wraparound, a small poncholike piece of indigo or white cotton cloth that allows glimpses of their breasts. The men wear their *tagilmusts* shorter and tighter, eliminating the bulk in vogue among Ihaggaren. Working harder, they also put much less stress on elegance. Their tents are smaller, and wheat and couscous have no place in their diet, which is based almost exclusively on millet and milk.

tenth Moslem month. Be here a day before." I promise that he can expect me that day.

AMUD AND I PART FROM LITNI

Litni will stay here a few days before returning north. I do not really know what he came for. He was a marvelous companion, and I am very sad to leave him behind. Amud and I are now heading west toward the Talak. As usual, we are walked out of camp by a few men, including Litni and Biga. Litni walks so long with us that I would like to believe he changed his mind, but he would not go with us without his camels. We ride for five days more, and one morning, seeing Amud put on his newest robes, I know that our journey will end today.

Amud's younger brother Bukush comes out to welcome us when we reach a group of three tents. We enter the largest. An old woman sits in a corner—Amud's mother. Amud, who tells me she is a widow, addresses her respectfully. After ten minutes, he goes to his tent and returns with his wife, tall and lively Fati, who carries their baby daughter Shina. Amud loosens his *tagilmust*, and we all sit comfortably.

Amud, Fati, and Shina share one tent; his older brother Talem, Sata, their three daughters, and little son, another. The mother's tent also houses Bakush, who is a widower, his daughter Ataka, age nine, and an unmarried sister called Maunen. I vehemently refuse Amud's tent, which they insist on giving up to me. They move it twenty paces—a suitable distance for a visitor. I argue that I prefer to sleep under the stars, but to no avail. I come to feel somewhat better, however, when I realize that this tent helps me to be a good host. Visitors call frequently, and I can serve tea "in my own house."

Conversations turn as usual on the differences between our cultures. I explain that there are no camels in France, that a Frenchman pays no bride-price. I learn that an *amahar* must pay his parents-in-law four she-camels for his bride, besides feeding wedding guests. *Imrad* may get away with some sheep or goats. While a Tuareg man is responsible for the welfare of his family, his wife does not have to share with him any of her possessions. When I give Fati or Sata tea and sugar, they share it only with the other women. Thus they get richer than their husbands.

Wedding arrangements are complicated. The Tuareg man, who is monogamous, thinks it best to marry his mother's brother's daughter. His father's sister's daughter is also a proper bride. Such cousins always enjoy a special joking relationship; they become good friends, and can expect a stable marriage. Women speak their opinions freely. A wife may chat with a former suitor, and society would reprove the husband if he showed any jealousy.

The Tuareg, however, have less consideration for people of lower castes. When I get up to greet a group of men, Amud commands loudly, "Remain seated, they are only *imrad*." His *iklan* have left him, but he forced a couple of them to leave him their son. One day, when their economic situation improves, they may come back to claim him. Judging from the stories of similar cases that I have heard, they will not find it easy.

THE TUAREG LOVE CHILDREN

The story is different when it comes to children. The Tuareg love children so much that they make no difference between theirs and those of their *iklan*, and they will wipe a small runny nose whether it is white or black. The children themselves are adorable: respectful and easy to handle, though if a parent gets a little too severe, which is rare, the child will spit or throw sand and will not run away from blows. Then somebody else usually takes the child up to soothe it, and the trouble disappears. Children often go naked until the age of four or five, unless they are dressed for protection on desert marches.

It is touching to observe Ataka's love for her father. She helps him in everything, even the saddling of his camel—normally a boy's chore. When he is sitting or lying in the tent, she leans against him. Bukush tells me that after he lost his wife, he nursed Ataka from babyhood, even carrying her in his arms on camelback.

Abela, Talem's little son, is the only boy in the family. About three years old, he is strong and fearless, ready to grab anything he can reach, including insects of the most repulsive kind. When he frightens the older girls with them, his father and uncles look on with pride. "A real *amahar*," they say with a smile of satisfaction. Though he is too young for clothes, they let him wear a man's dagger at his waist, and he plays with it freely.

An *amahar* does not herd sheep or goats. Therefore Amud

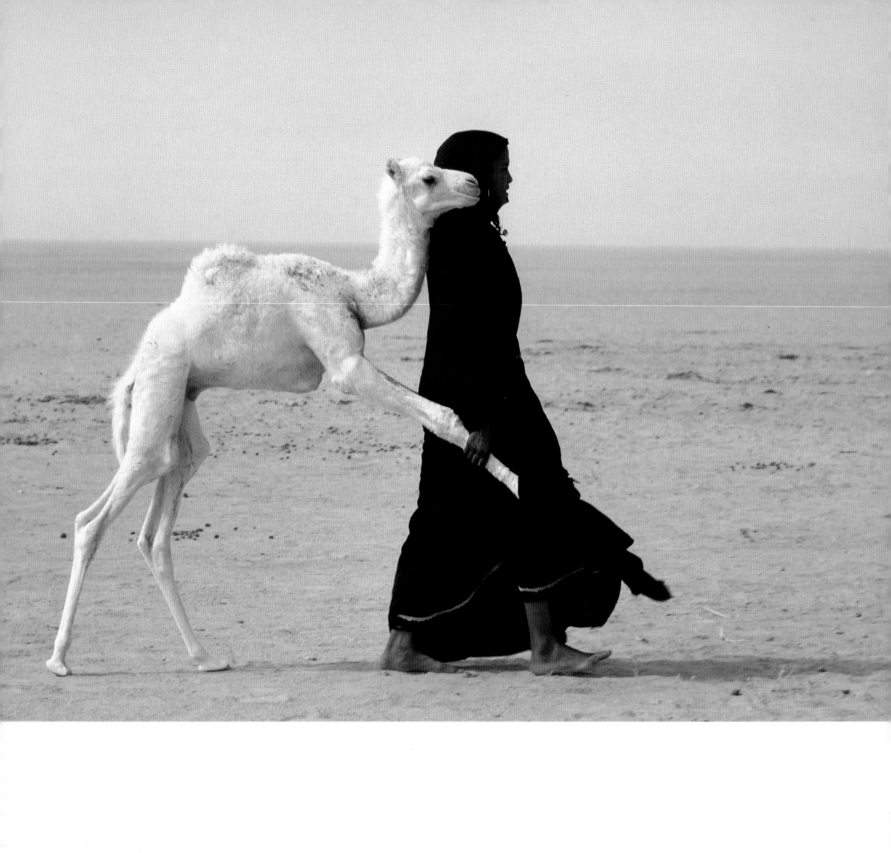

OPPOSITE *Sahara. Talak plain. Doing the work of the* iklan *her family has lost, Raisha, Amud's niece, pulls a baby camel away from its mother after nursing. While one of the women milks the she-camel, Raisha will tie the baby animal by the ankle to a stake near their tent.*

and his brothers keep no flocks. If they did, the family would take the animals to the well daily to water them; as it is, the women make this trip, some three or four miles each way, about every five days. They can bring water enough for two or three days, and when the supply is used up we fall back on camel milk.

Only a few years ago, Amud's family had gardens in the Ahaggar, cultivated by *harratin*, black sharecroppers. These yielded tomatoes and figs, and enough wheat to barter some for dates from the Algerian oases of the Tidikelt. Once a year, during the winter months, the family's *iklan* went to the Amadror plain, to the northeast of Ahaggar, to cut salt slabs to barter for millet in the markets of the Damergou region, south in the Sahel. Today there is nobody to do that work. Times change, though days keep a familiar rhythm.

With their mournful moans, the sixteen or seventeen young camels tethered near the tents wake everybody up long before dawn. Bujimra, the young servant, brings the dams to them. Thanks to my tea supply, a teapot sings on a bed of embers before every tent; women and children sit around, still only half awake. In better times, the three brothers would have been around too, but with their *iklan* gone they are usually off in the pastures watching the camels against thieves.

A man may help himself to a camel he needs, provided he notifies someone, and not be considered a thief; but outside his own federation all rules are off. The Tuareg, who used to think plundering the noblest of activities, find it hard to live by other ideals. In August, when short strong rains in the Sahel allow the concentration of great herds on salted pastures, some Algerian *imrad* travel south to steal. A single man may then make away with as many as forty animals. *Imaheren* take camels by force— or at least they used to.

While children play or watch, women spend the morning ti-

dying up the tents, tanning and dyeing skins before sewing them into colorful bags and cushions, spinning wool, weaving a new *asaber*, or sewing skins into a new tent. Sometimes at noon the wind rises and blows sand. The Tuareg close the *asaber*, and we cover our heads and doze for a couple of hours.

CAMELS DANCE UNDER THE STARS

Most evenings, a drum sounds: invitation to an *ahal*, a gathering of the young. I wind my *tagilmust* closely, saddle my camel, and follow the sound in the moonless night. I find young women seated on the ground, beating a drum, clapping their hands, and singing songs of elaborate rhyme schemes and subtle rhythms. Closely veiled men, armed with spears and swords and mounted high on elegant camels, make their animals dance around the girls, the gaits changing in patterns to fit the cadence of the songs.

On one occasion, showing off like a young Tuareg nomad and drawing from the women cries of surprise and satisfaction, I join the riders wheeling around the seated women in an ever faster and tighter circle until one of us, leaning low in the saddle, snatches the head cloth of a girl, and we all gallop after him to try to recover it.

Otherwise I sit near the women while the immense silhouettes turn around us high on the sky, and the whole beautiful starry dome seems to turn with them. A girl improvises praise of men she likes: their clothes are dark as the night, their camels white as the moon . . . through the blue *tagilmust*, as long as six spears, shine eyes of embers . . . they come to torture the heart. In fact they come to pay tribute to the girls, for beautiful they are. Tuareg women often have the strange and wild beauty—unexpected and ravishing—of flowers growing in hostile places.

The moon has risen and is high in the sky. One by one the men dismount and come to sit with us. Now the women stop singing, and we all draw very close together. Lyric poetry has given way to prosaic jokes, some obscene, but only because we are far from respected ears. Couples form and whisper, impress with their fingers in each other's palms secret messages, or breathe each other's nostrils. Later the men drift back into the night. Those invited by their ladyloves to return will be back when everyone is asleep.

But I must leave this harsh country, this fascinating life, to see something of the southern Tuareg, by far the most numerous, who live in savanna areas. With rich and wider pastures, they own larger herds, including many cattle. Their life differs accordingly. I can journey as far as Agadès with an *amrid* from a neighboring camp; he has business there, and will lend me a camel.

While I pack, my friends seem unusually quiet. The women and children sit at a distance; Amud helps me to load my camel. It would be so easy to remain with them forever. I distribute little presents to everyone without saying goodbye. The Tuareg do not speak of the end of a sojourn but of the beginning of a journey; their words of partings are devout words for an enterprise begun: *Bismilláh*, in the Name of God. *Inshalláh*, as God wills. Amud walks with us for half a mile. Then, *Bismilláh!* We mount our camels and leave without looking back.

In Agadès I rent a Land Rover and hire a man to introduce me to the people. I want to meet Iullimiden nobles who wander in the Azaouak region of Niger.

If custom is prized among the Tuareg, so is adaptability. For some eight centuries tribespeople have settled in villages and towns, as some are settling today. My new companion is a sedentary Tuareg; a turbanless man whose father—in the French Army for years—named him Carbochi after a Corsican adjutant. Brought up in Agadès, Carbochi never went to school but learned French.

Scattered trees and patches of grass had begun to change the face of the desert on the way south to Agadès. Farther south, I notice green leaves more and more often. We are leaving the Sahara behind, entering savanna country. Without difficulty one afternoon we reach the encampment of the Iullimiden, guided from the well of Tchin-Tabaraden by a smith of theirs. The whole savanna is dotted with tents, but the smith takes us to the largest, the chief's. Some thirty by fifty feet, this is the largest tent I have yet seen.

No Word Uttered by an *Amrid*
Could Soil an *Amahar*

Mohammed, the chief, a man of about forty-five, and his wife, Fatimatu, receive us cordially. Yet hardly are the greetings over

OPPOSITE Sahel. Azaouak region. Iullimiden chief Mohammed's imrad *and* iklan *pull water from holes to fill gerbas and water the flocks.*

than Carbochi starts ridiculing the figures of Fatimatu and her daughter-in-law Raishatu, "You are as big as a Berliet"—a huge French truck. True, they are enormous, but I urge him to shut up.

"I am an *amrid*," he explains to me. "None of my words could soil a noblewoman. If I was an *amahar*, Mohammed might already have killed me. In her youth many men died for Fatimatu's sake. Mohammed himself almost died for her. See those scars on either side of his waist? In a duel with another *amahar* who was too attentive to her, he was nailed to the ground by his rival's spear. His older brother, who was the chief then, but died since, had to kill the contender himself." And indeed the ladies show nothing but amusement at his words.

Perhaps his remarks pass as compliments, for noblemen want their women as fat as possible. In Amud's family women were slim because they had to work. But the Iullimiden still have many *iklan*, great herds of camels and of cattle, and their women can loll about all day. From the age of eight or nine girls are gorged with milk, and by the age of twelve they already look adult. The fatter a woman, the richer her husband appears, the greater his prestige. "Their women," the great Arab traveler Ibn Batutah wrote of the Tuareg in 1352, "are the world's most beautiful. In no other countries have I seen them as fat." The men remain lean, trim enough to handle the swords that made their supremacy.

Fatimatu, who sits in her tent like a queen, is very proud of that superiority. "Even the French," she says, "would not have beaten us without their firearms. Before they came we were invulnerable, as powerful as de Gaulle. We, the Iullimiden, ruled and plundered from Tombouctou to Lake Chad. Everything bent before us. We took slaves and anything we wanted. When an *amrid* died, we inherited all his possessions."

Unfortunately for the *imaheren*, when the French demanded from them a quota of schoolchildren, they thought it smart to send them their *iklan's* or *imrad's* offspring. According to Car-

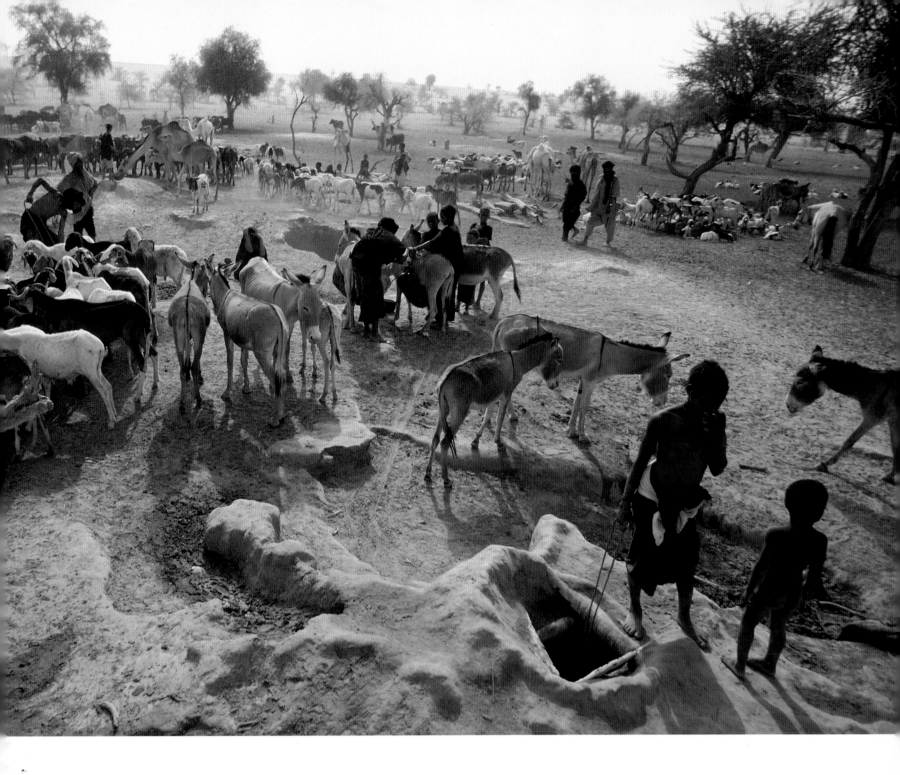

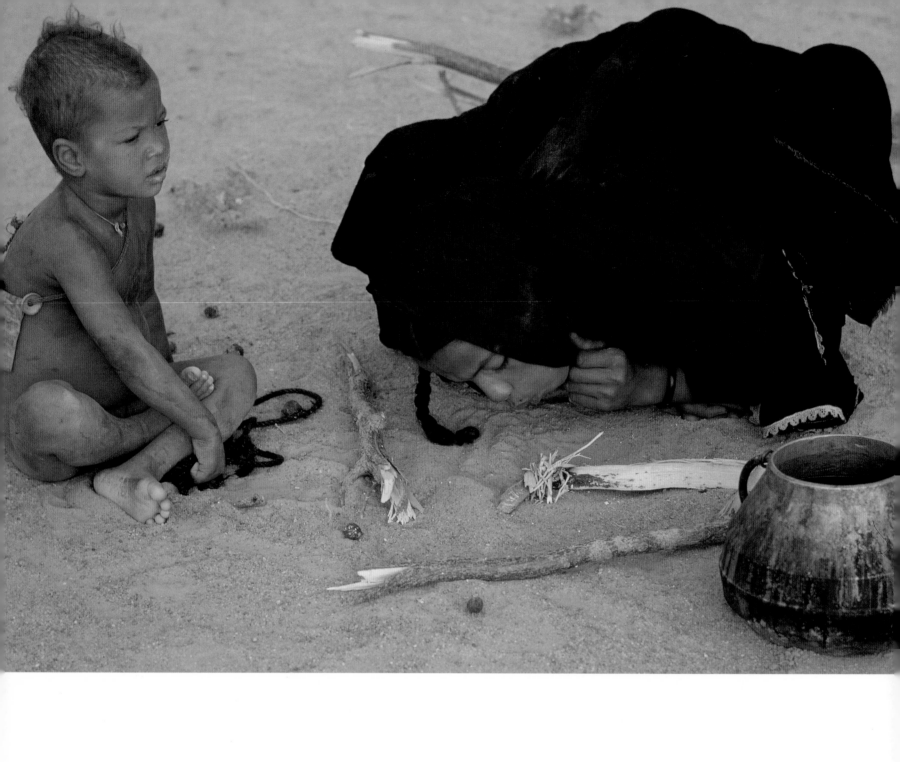

bochi, in 1970, the only Tuareg minister in Niger is an ancient *akli*, while the few Tuareg *sous-préfets* and deputies are all *imrad*. Uneducated by the standards of today and decimated by endless wars, the *imaheren* have retained little of their ancient power, but they are still people to be reckoned with. The government does not interfere with them, and they are pretty much the masters of their territory.

This was evident to me one day that I accompanied Mohammed to the well. Several Fulani were watering their herds of zebus and Mohammed strode majestically to them. "Who is in charge?" he asked. And after the man identified himself, he caught up the man's lower lip between two fingers and lifted his face like that of a naughty boy. "My own herd is on the way," he told him, "stop and wait until it has been watered first."

While we converse with Mohammed and Fatimatu, their son Radwane—Raishatu's husband—orders one of his father's men to place our luggage in his own tent. This, though half the size of his father's, is large compared to those of the vassals.

A sheep is slaughtered in my honor and, to my surprise, I am also served macaroni. But this family is very rich, Carbochi tells me, and often eats macaroni or rice or couscous. They eat gazelle or bustard too, for the men spend some of their leisure time hunting. All these *imaheren* have rifles and pistols in their tents.

After our lavish meal a noblewoman gives a recital on the *anzad*, a one-stringed violin. In our midst sits the musician, amazingly expert at pulling varied sounds from that simple instrument, with two men singing. The airs, with a twelve-tone scale and leaps of melody, would swiftly break European voices. We clap hands to the beat. Moving and lovely, the songs escape one by one to the stars.

THE TUAREG GATHER IN PECKING ORDER

Mohammed's uncommonly large tent is packed with many dozens of people who have come to meet me. In the center sit the *imaheren* and close to us sit their *inislimen* chaplains. In outer circles, roughly in pecking order, press *imrad*, *enaden*, and *iklan*.

While the *imaheren* and I converse, the others whisper or observe in respectful silence. Thick long braids fall on the *imaheren*'s shoulders through bulky *tagilmusts* of interwoven indigo and blue bands. Their aquiline profiles and piercing eyes give them the expression of eagles. One of them, a tall nephew of Mohammed called Rumer, has an unbearable gaze. Though he is thin, the lower castes seem in awe of him. "He does not fear the devil himself," explains Carbochi. The *inislimen*, by contrast, tend to keep their eyes down. They are very white, more so than the *imaheren*, and their attitudes betray faintheartedness. But their women, who appear to enjoy a very special relationship with *imaheren* women, are exceptionally beautiful. Like the *imaheren*, the *imrad* are handsome and virile, but they show none of the *imaheren*'s overbearing haughtiness. The *enaden*, black but sharp-featured, glow with intelligence. Their origins are mysterious. Some authors believe they descend from Jewish artisans who, centuries ago, fled persecution by Moroccan Arabs and intermarried with black Africans. In a mixed society like that of the Tuareg, even many *iklan* betray Caucasian blood streaks.

The next morning I try to count the tents, but they are scattered in the bush in every direction. Mohammed himself is not sure how many there are: "Maybe seventy or eighty," he says. What a fine sight it must be when all these people are moving together! But I will not have a chance to see it. With *iklan* to tend the herds it does not matter how far the pastures are, and the tents may stay as long as four months at the same site. Amud, by contrast, sometimes left a site after only a week, and two months was a long stay for him.

Mohammed can say that only eight of these tents belong to *imaheren*, all close relatives of his. The rest belong to his satellites. The *enaden* alone occupy thirteen tents, so rich are the Iullimiden to support such an army of artisans. The men forge spears, swords, and knives, or silver jewels; they make camel saddles and wooden beds; carve wooden bowls and spoons. The women weave beautiful *asabers* or produce artistic leather work—wallets, amulets, bags, cushions.

The *imaheren* despise the *enaden* as they do all working people, but they hold them in wary respect because of their arcane connivance with fire, their dangerous mystic power called

ettama, and their sharp wits, quick to compose a song of ridicule. They use them, however, as middlemen in their love affairs.

Although little action seems to take place, life here is not at all monotonous. People visit from group to group. I spend most of the time among the women, for it is they, teachers of the children, who also teach language and custom to the stranger accepted as worthy of learning. The language here differs from that of the north, slightly in vocabulary and considerably in pronunciation. Often we write and decipher *Tifinagh*, an ancient Libyan script which most Tuareg know. It has only one symbol for all vowel sounds and can be written left-to-right-right-to-left or up-down-up-down, which does not simplify it for beginners. Words are spelled letter by letter, in a chanting voice, then guessed. It goes like this:

$$ O \; \mathsf{5} \; || \; + $$

errer (r), eyer (y), eller (l), etter (t), which results in "Riyalette," a woman's name.

The women also catch the lice that have colonized my head since I have lived among the Tuareg. They braid my hair and paint my face. When it is Raishatu's turn to do it, she occasionally utters a deep sigh. Raishatu, who is only fourteen but looks twenty because of her plumpness, and another girl always insist that I make myself comfortable using one of them as a pillow, and I oblige. Once my head is in a girl's lap, and she can play with my hair, they all relax and I have an excellent viewpoint to take pictures. When I spend too much time photographing other girls in other tents, Raishatu and her friends sulk for a while, then forgive me. At night, around the fires, we play games. Their favorite one consists of throwing each one glowing embers. Caught with bare hands, the embers are quickly thrown on to another.

On one clear night when I cannot sleep, I see a man slip out of a tent. Intrigued, I watch his strange behavior. Walking backwards, he is erasing his tracks with his robe, then disappears into the night. The next morning, when I tell an old *amrid* what I have seen, he laughs heartily. It is obvious to him that I have caught a young man at the end of a romantic date. Such a rendezvous always takes place in the girl's tent, next to the sleeping parents, long after the camp has fallen silent, and involves nothing more than sniffs of the nose, petting, and love words. It is, of course, all a game, but a game played very seriously. I ask the *amrid* what happens if the lover is detected by the parents.

"Ah," says he, "I can tell you, for I was caught twice in my dating days. Once the mother of the girl awoke and, thinking I was a goat, spat on me. 'Out, evil beast,' she cried. I bleated and lay still, but she sensed I had not gone and began beating me with a stick. It hurt, I can tell you, and I could barely contain words of pain, but I left—fast. On the other occasion, I was visiting a girl for the fourth consecutive night. Having slept so little, we were both dead of fatigue and fell asleep. When the father pulled me out of the tent by the feet in the morning, I thought I was dreaming, but not anymore when he lashed me with a whip. You should have seen me run away."

The aristocratic Iullimiden sleep late in the morning and do not even know what time the she-camels are milked. But every day, each poor child who appears before Mohammed's tent is fed, and so are some twenty or thirty adults. The haughty chief will give a man clothes, or a she-camel to milk for a year. He turns no one away, but when he asks a favor, he expects to receive it without hesitation.

I Am Mistaken for a *Djinn*

Much as I have learned about the Tuareg, they keep surprising me. One evening, for example, having carried a canvas bucket of water into a thicket at the bottom of a dry pond to bathe, I see an *amrid* squat at fifteen paces and watch me intensely as I undress, hang my clothes on a branch above my head, wash, and dry myself. I could ask him the reason for his conduct, but I am so intrigued that I decide to wait and see. He is so absorbed by his observation that he remains immobile as a statue during the ten minutes that the operation lasts. As I turn around to grab my clothes, a thick branch hits me on the head, almost knocking me out. My first impression, as I try to understand what has happened to me, is that the clothes branch fell on me, but it is still there. The *amrid*, on the other hand, has disappeared. Obviously, the branch was thrown by him, though for what reason I cannot fathom. Having dressed, I go look for Radwane to tell him about the "voyeur" and his aggressive behavior. "Let's find him and beat him up," he says.

48

"Victor!" suddenly cries a terrified voice. "You gave me the fright of my life. I was passing through the scrub when I descried that tall unearthly silhouette (in the darkness the clothes above my head added to my height) moving under a tree. Fear paralyzed me, and when I heard water running, where there had been none for months, I had no doubt I was facing a *djinn*. At last, summoning my courage, I grabbed a thick branch and threw it at the *djinn* with all my strength." He concludes that to dare to dwell in dark thickets at night without absolute necessity I either must be a super *amahar* or be protected by powerful gris-gris. "But do not laugh, Victor," he scolds, "Had I had a spear, I would not have thrown you a stick."

All too quickly, the days slip by. I have made new friends and it hurts to leave, but we are nearing the twenty-seventh day of the tenth Moslem month, and far to the north Biga and his people will be setting out with their flocks on their long journey to Libya, the caravan of dune and mountain and plain, on the march as in time immemorial. Promising to return with the help of God—Inshalláh—I climb into the Land Rover with Carbochi and we speed to the mountains of Aïr.

On the appointed day we reach the Iforas' encampment. Biga declares I am a man of my word. Now I notice the tents with more interest: little things of canvas or leather hardly covering a bed—smaller even than those of the *iklan* in the Azaouak. The Iforas keep most of their possessions in trees next to the tents. Although Ifora tents are unimpressive and clothes almost ragged, the herds are large. Considering the trade these people carry north and south, they must be much less poor than they look. At any rate, the men are all quite well dressed next morning for the departure. Today is exceptionally auspicious to begin a journey and Biga's people are preparing three different caravans.

Caravans to Libya, Algeria, and Southern Niger

The men going to Libya will have the hardest and longest march, more than six hundred miles one way, three months at least for the trip. A second group will go to the Amadror Valley about five hundred miles north to mine salt. Theirs will be a forty-day trip. Later, they will barter salt for millet, south in the Damergou re-gion. The third group is going south to Zinder, about five hundred miles away, to buy millet—another forty-day trek.

Around 9:30 A.M. the camels are brought to the tents and loaded. Helped by some women and children, two men gather the sheep and goats. All is done without haste, shouts, or flurry. When this work is finished, the men sit down around two *marabouts*, holy men, who read aloud from a pocket Koran and blow in turn on the muddy water in a small enamel teapot. The water thus blessed, the pot is passed around and each traveler drinks from it. This protects them from getting lost, losing animals, or dying of thirst.

Now one of the *marabouts* sacrifices a kid and all the men, standing, say a prayer. The *marabouts* shake every man's hand, and our caravan gets slowly under way for Libya while he chants: *Lá Iláh Illá Alláh; Muhammad rasul Alláh*—There is no god but God; Mohammed is the Prophet of God. Women standing nearby watch the men disappear, none glancing behind him. I follow on camelback. Guided by a man of the Iforas, Carbochi will take the Land Rover ahead and meet us every night.

Three men drive the flock before them: some thirty goats and ten times as many sheep. Half a dozen men follow on camels, each leading four camels or more. Before crossing the great plain of desert sand they will spend two days cutting wood and grass. Each will load one camel with wood, two with fodder, one or two with water.

The flock is somewhat difficult to keep together during the first few hours. Some of the sheep belong to Tuareg who are not going on this journey, but will pay the caravaneers twenty-five percent of their animals' market value—one leg per animal, to speak like the Iforas. These sheep would like to turn back to their own flocks, and to solve the problem the caravaneers have attached them neck to neck to other animals.

Biga, riding at my side, says he will turn back after a few days. "I am along only to help at the start and to show the men my concern," he says. He explains that they will stop for a couple of days at Djanet, in Algeria, and sell any animals too weak to go on. It will take a month to reach Ghat, in Libya. There stock brings ten times the price in Agadès: $50 per sheep, say, instead of $5. Even the few donkeys trotting along, despicable animals worth a dollar or two in Niger, fetch $15 or $30 at Ghat. The

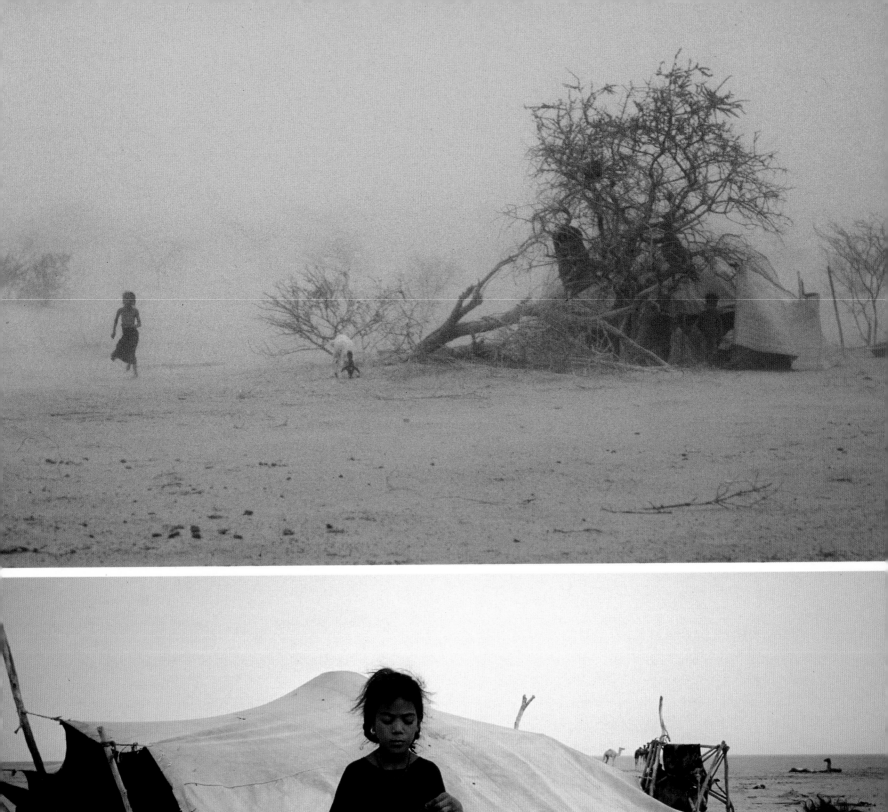

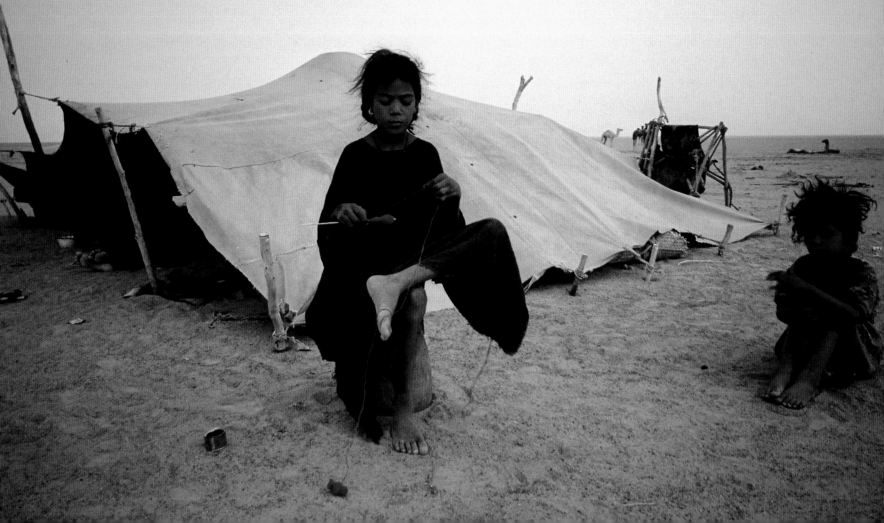

OPPOSITE TOP *Sahara. Talak plain. A light sandstorm envelops a Tuareg tent set up next to a rickety acacia tree. Like other African nomads, whenever possible the Tuareg use such trees as furniture. In them they store camel saddles and wooden mortars and hang clothes.*

OPPOSITE BOTTOM *Sahara. Talak plain. Sitting on an upturned wooden mortar before her leather tent, her big toe keeping the yarn taut, Ataka, Amud's niece, spins wool.*

NEXT PAGES *Sahara. Aïr mountains. Biga's caravan travels to Libya.*

men will remain a few weeks in Ghat to make purchases and let the camels rest. They will return with clothes and fabric, wheat, dates, sugar, tea, and other goods, part to be sold in neighboring encampments.

Late in the day we reach a place appointed for meeting caravaneers from other camps. We unload the camels. The men who have driven the flock on foot sink down to rest and two others take the animals to pasture for the night. Each man has a precise job, the same for the whole journey. The three youngest pound millet every morning and evening, and are responsible for wood and water. The three next in age drive the flock. Two others take the animals to graze after each day's march. The rest will take care of the camels.

THE DJINNEN STRIKE AGAIN

While we sit around the fire that evening a man walks into the edge of the circle of light. Some of my companions had lowered their veils somewhat; quickly each raises the *tagilmust* again to his eyes, and the man comes forward. We see he is a stranger. Politely he exchanges greetings with us. Finally he says that his

water bag is empty and he has been thirsty for an awfully long time. A bowlful of water is poured, and he gulps it down after pronouncing the ritual praise to God.

"Since sunset," he says, "I have been following sounds of pestles hitting mortars and of children crying, but every time I thought I was reaching an encampment, the sound stopped suddenly—only to start somewhere else."

"*Djinnen*," the men murmur, and the man nods.

Though I do not believe in evil spirits, I am not in the least skeptical of the dangers our guest faced while he was lost.

Again at sunrise the sheep and goats are led forward, browsing along the way until the caravan has caught up with them— much later, for camels have to feed *before* the march. Our guest gone, we make our way through the mountains, passing heaps of basalt that rise like pyramids. We thread narrow canyons or broad wadis overhung with trees. We pass dozens of gazelles. They observe us with wonder, then spring into a graceful gallop. When they are not too far away, Biga dismounts with a rifle and stalks them from behind his camel. Once he aims, a gazelle can be counted dead. These men need meat, and cannot afford to kill many of their flock.

Days later, we reach the arm of the grand Ténéré that I crossed with Amud and Litni many weeks ago. Now my other life claims me again. Carbochi and I accompany our friends on foot for half a mile; we exchange the ritual *Bismillâh*. The men of the caravan go on alone and I watch them shrink in the distance with a pinch of the heart.

I wonder how many years are left to the caravans, to the herds of the desert, to the nomad's life. But Carbochi, impatient to get back to town, is pulling at my sleeve; and did Biga ever really exist? Already the wind is blowing away his tracks and those of his companions, and like ghosts they are walking in the void, far away, toward no horizon.

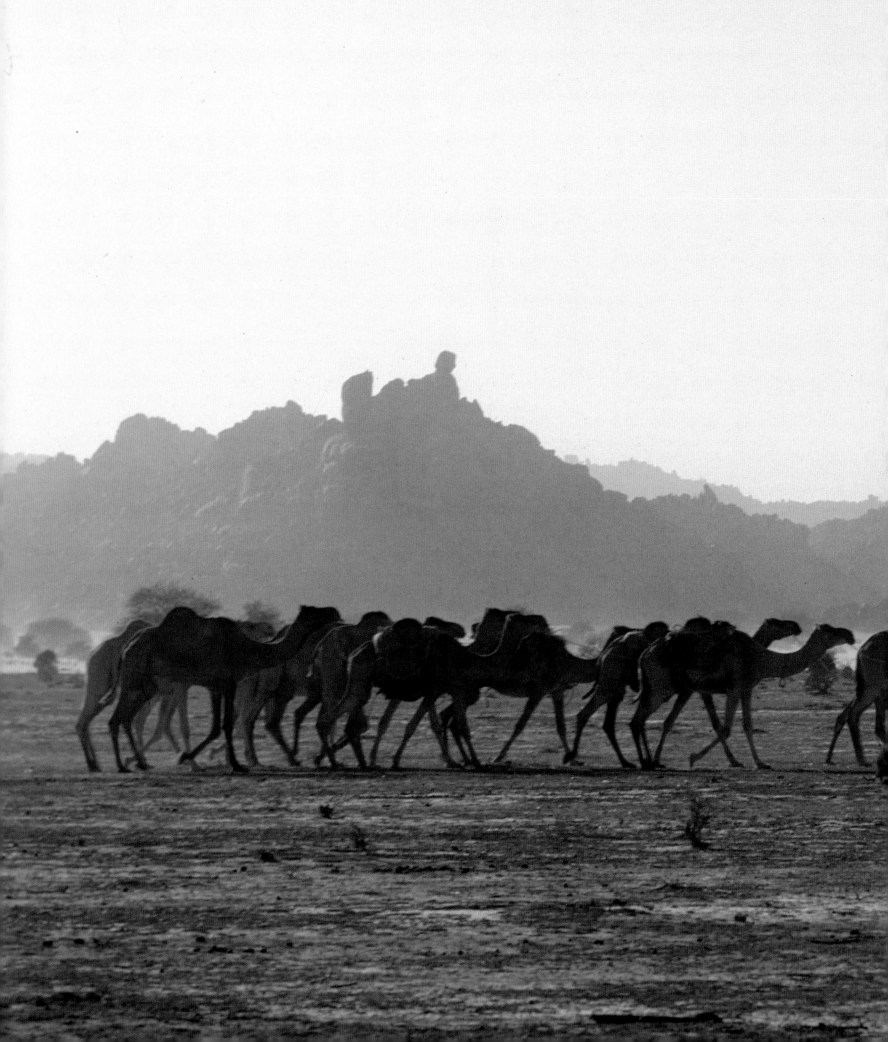

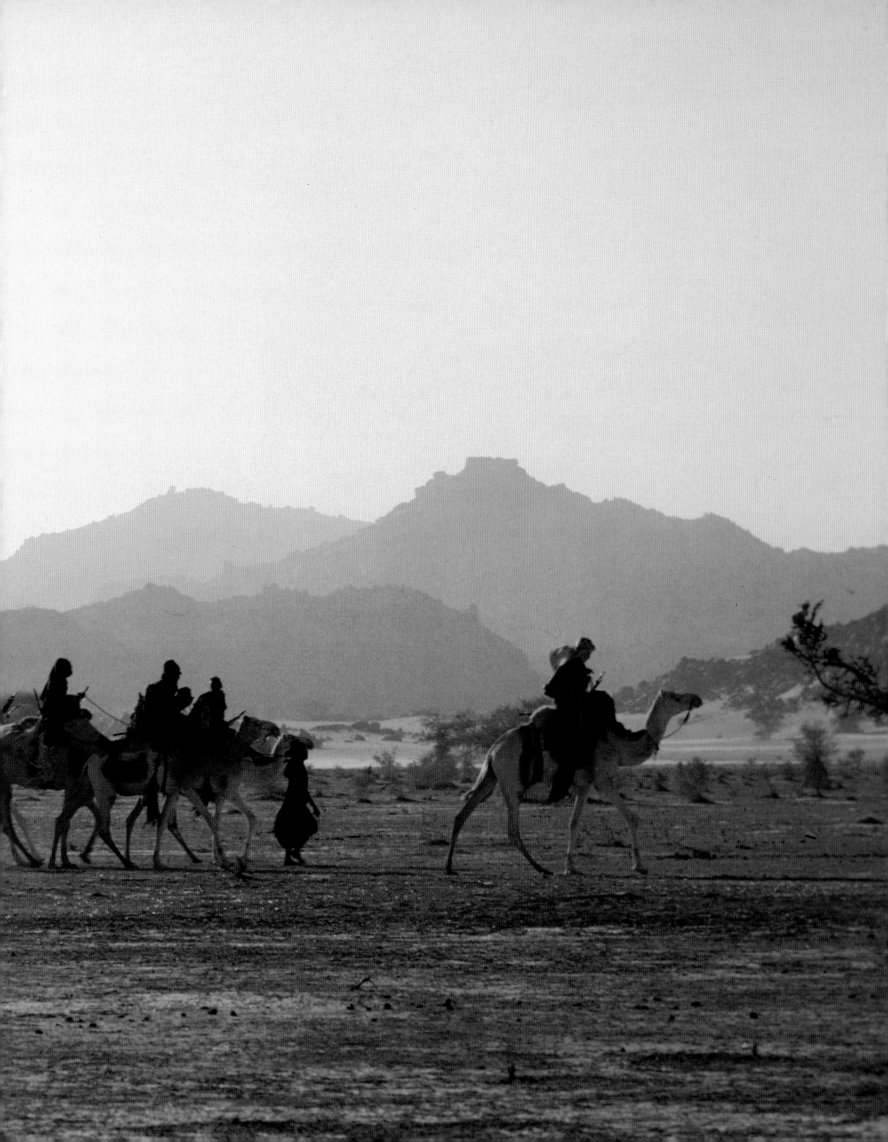

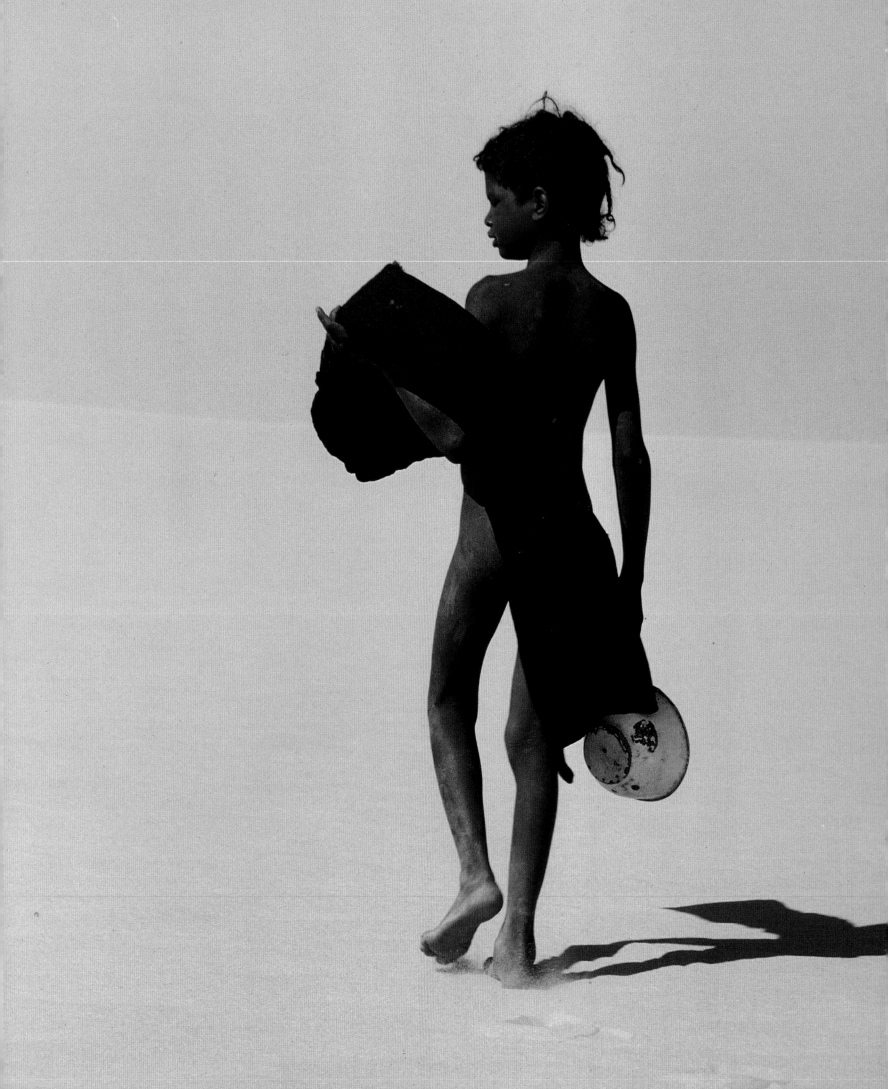

Part Two: The Salt Caravan

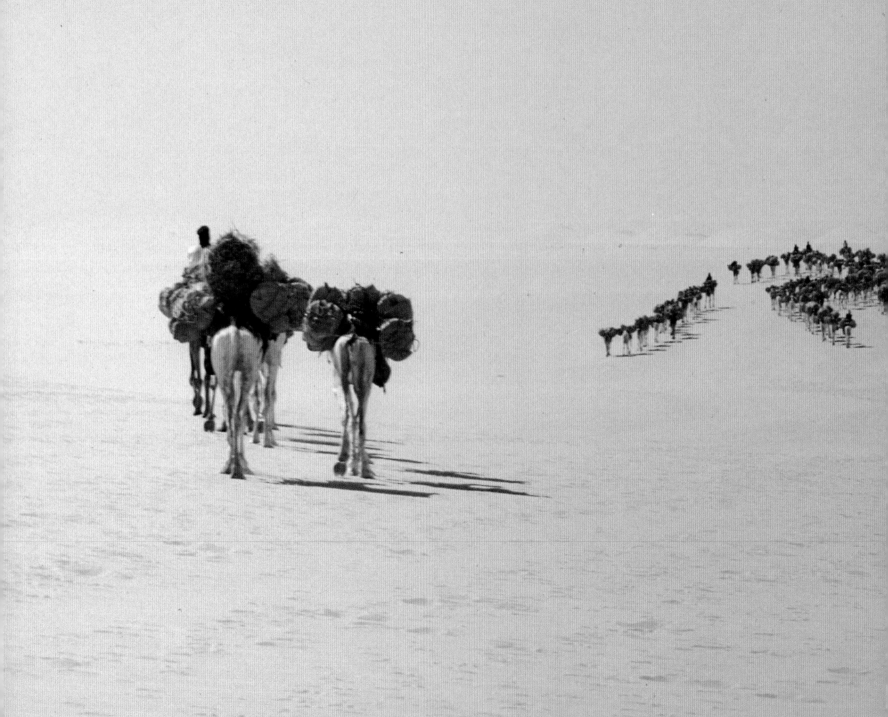

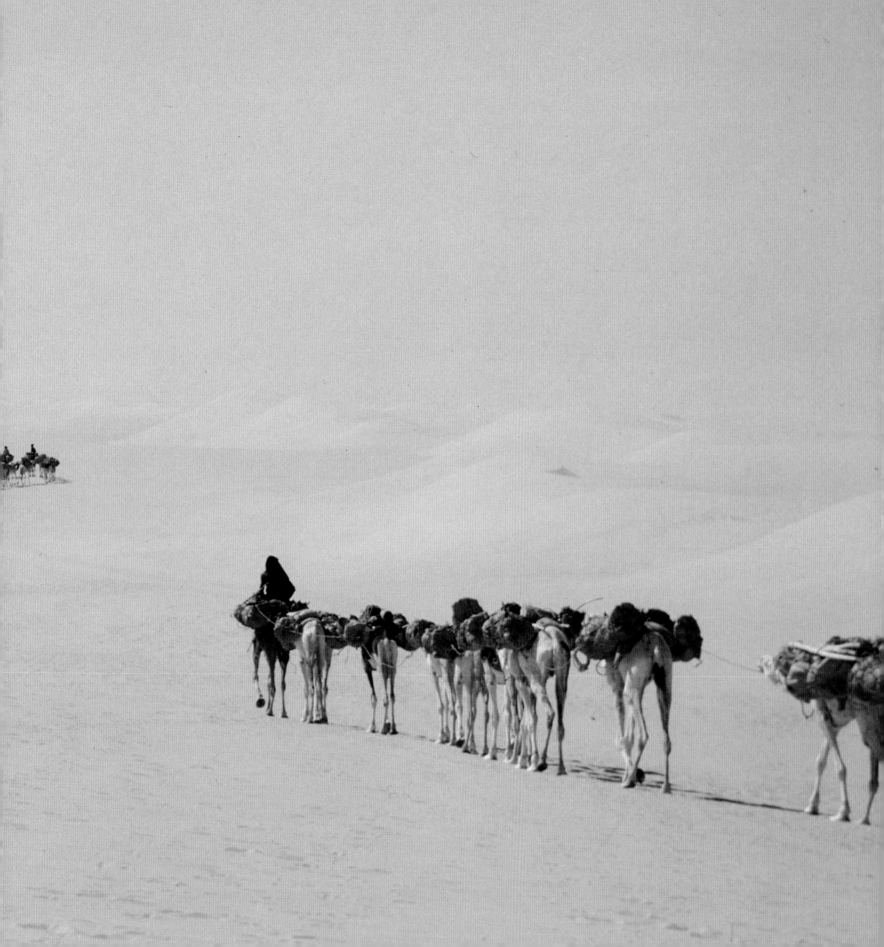

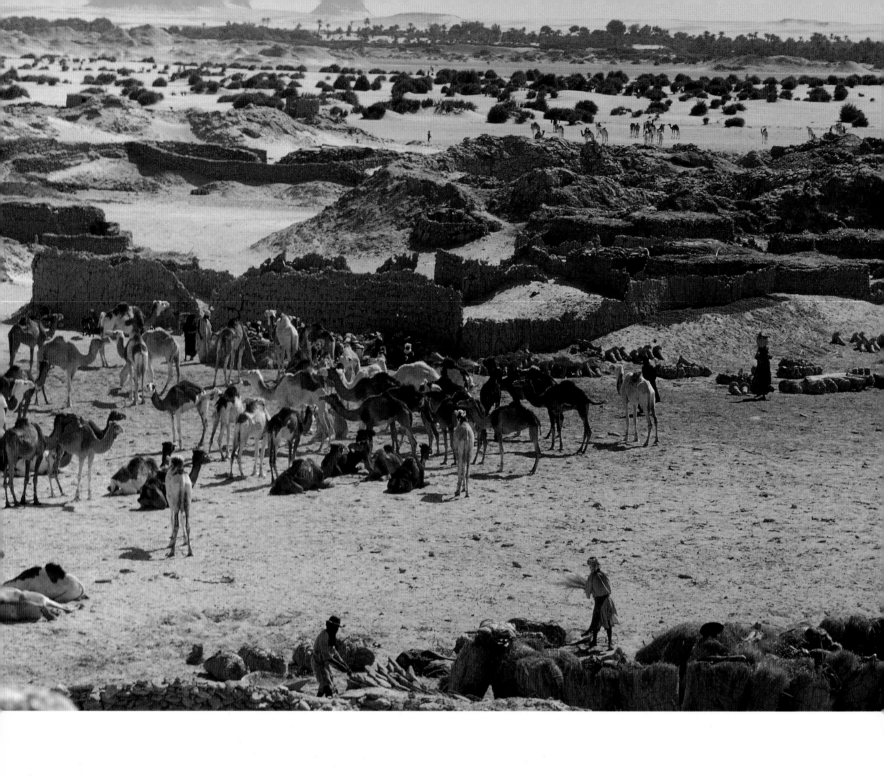

the forage and firewood they would not find in the Ténéré; weeks weaving the hundreds of straw mats and plaiting the endless ropes they would need to pack the salt and tie it to the backs of camels.

Like Bilma and other oases between Jado and Lake Chad, Kalala owes its existence to the abundance of good subterranean water that collects at the foot of the Kaouar cliffs. Salt-bearing rivers may once have emptied into that depression. A complex network of ancient rivers, now dry but still perfectly visible from the air, testify to a once humid period in the Sahara several thousand years ago. Most rivers, however, including the Niger, emptied into marshes and lakes rather than into the sea. Lake Chad, which partially survived the desertification of the Sahara, is one of those ancient lakes.

From time immemorial Kanuri Negroes have obtained salt by digging to the water table two meters below the salt-saturated earth, giving the landscape a fantastical character. The plain that spreads away from the base of the Kaouar cliffs is riddled by holes and studded by hillocks of excavated dirt; it looks as if it had been bombarded. The thousands of camels and hundreds of Tuareg nomads scattered across the landscape in large groups, like refugees, only reinforce that impression. The Tuareg have come in large numbers because this is the least hot time of the year, and it will not last long.

The holes hold water stained red by natron (a hydrous sodium carbonate) that the Kanuri use to remove impurities from the salt. Crystallizing at the surface of the water, the salt sparkles in the sunshine like gems. The Kanuri sell those crystals on the local market for human consumption. At the bottom of the pits they labor, bare-limbed and ragged, to scrape out a harder, coarser salt for animal use, treading it with bare feet to separate it from the sediment, and scooping it out, glistening. Mixing it immediately with an equal amount of dry salt, they cast it into conical molds made of palm staves covered with camel hides until it dries in concretelike blocks of perhaps twenty kilos. Shaped like long-stemmed, thin-capped mushrooms, those brittle and unwieldy blocks are what the Tuareg barter for. Why the Kanuri do not cast them into more convenient shapes, nobody can tell me.

The Kanuri live at some distance from each other, each family

M y muscles are hurting from holding at arm's length, off the dusty ground, the *tagilmust* that I am attempting to wrap properly around my face. It has been two years since I last dressed like a Tuareg nomad, and I have lost my ease in handling the twenty-foot band of blue cotton cloth. Exasperated in the end, I scissor it in half. Now it adjusts readily, and I feel that, were my clothes not so new, I could not be told apart from the Tuareg with whom I am about to embark on a three-week expedition through one of the bleakest places on earth. On camelback, from Bilma to Agadès in the Republic of Niger, we will cross the Ténéré, a desert within the Sahara.

For the Tuareg it will be a return trip. They have ridden from Agadès and the Aïr mountains beyond to get salt here in Kalala, three kilometers from Bilma, to trade on the cattle markets of the Negro south, where it is eagerly sought. Now they will return to their encampments in the Aïr, three days' march west of Agadès, to make repairs to clothes and gear and prepare for the next leg of their long journey.

Careful planning is necessary to avoid trouble along the way, for a Saharan journey can be dangerous even for the experienced Tuareg. Before leaving the Aïr, the Tuareg spent weeks cutting

in a hovel of crude salt blocks surrounded by salt pits and an encircling salt wall. Next to the walls camp the caravans with which each Kanuri family is trading. Sitting among bellowing camels and strewn salt blocks behind walls of piled-up pack saddles protecting them against the hot sand-laden wind, the nomads are pounding millet, plaiting new ropes, mending torn clothes, or brewing green tea. Mostly they are wrapping the salt blocks in straw mats, padding them with some of the dry grass they brought as forage, for broken salt blocks lose value.

Salt is a West African currency, and has been so since before recorded history. With it the Kanuri acquire the trade articles the Tuareg bring—cotton cloth, clothing, tools and arms, millet, dried meat, tomatoes and red peppers, green tea, sugar, chewing tobacco, and even live goats and sheep. In a few weeks, on the markets of Zinder, Maradi, and Kano, it will buy the Tuareg clothes for their families, spears and swords, camel saddles, and groceries. The farther from Bilma the salt travels, the higher its value. By the time it reaches Kano it may be worth fifty to sixty times its original price. Still, when the Tuareg have discounted the camels they lose to starvation or fatigue and the many months they spend in preparations, hard work, interminable rides, and general suffering, the ten to fifteen camel loads averaged by each man will earn them a pittance.

In ancient times, before commercial salt became available, salt brought by Arab caravaneers from Morocco and Algeria could fetch its weight in gold. The journey took several grueling months, however. Water holes were extremely far apart, and Tuareg bandits were a constant menace. Such expeditions were so dangerous that a caravaneer was never sure to live to enjoy his fortune.

The Tuareg, who ruled over a great part of the Sahara then, considered the caravaneers' occupation below their dignity. They preferred to tax the caravans heavily, and, when the caravaneers refused to pay, to attack them. Sometimes, having received protection money, they waited for the caravans to leave their territory and attacked them on another tribe's land. Thus the Arab merchants often chose to postpone departure until enough of them could join forces and even contribute to the salary of an armed guard. The Frenchman René Caillé, who in 1828 visited the forbidden city of Tombouctou, traveling

OPPOSITE *Sahara. Igdalen caravan encampment in Kalala, near Bilma. While two Tuareg repair clothes in the lee of an improvised windscreen, Rabbedu, the little* akli, *pounds millet.*

from Senegal as a Moslem, returned to France by way of Morocco with a caravan of fourteen hundred camels and four hundred men.

January 3

When I arrived this morning I left my luggage in the house of a Kanuri and went from bivouac to bivouac to chat and make friends with the Tuareg. My broken Tamachek (Tuareg language) delighted them, and my clothes, styled after those of the Kel Ahaggar, Tuareg of the Ahaggar mountains, surprised them by their elegance, even though one of them had to rewind my *tagilmust*. No doubt because of the hard work their clothes encounter, but also because of their lack of vanity compared to their brothers of other areas, the Tuareg here are almost ragged. My Kel Ahaggar friend, Amud, used to deride the Kel Aïr's inelegance. Haughty nobleman that he is, he despises their hard-working habits, "only fit for slaves."

When I mentioned my plan to cross the Ténéré with them, the Tuareg's smiles suddenly gave way to expressions of incredulity and concern. A European, they said, would not survive such a trip. I did not insist, however, until finding a group ready to leave the next day. Then I rode one of their camels bareback around them and solemnly promised to help them with caravan chores all the way to Agadès. They must have been shorthanded, for they accepted instantly.

Having fetched my luggage, I brew sweet green tea for my new friends, which pleases them much. Though the Tuareg are keenly addicted to heavily sweetened green tea, it is to them a luxury. Knowing this, I have brought enough sugar and tea to entertain them during the whole trip.

As I serve tea, I take stock of my companions, who number ten—seven men, one teenager of perhaps fifteen or sixteen years

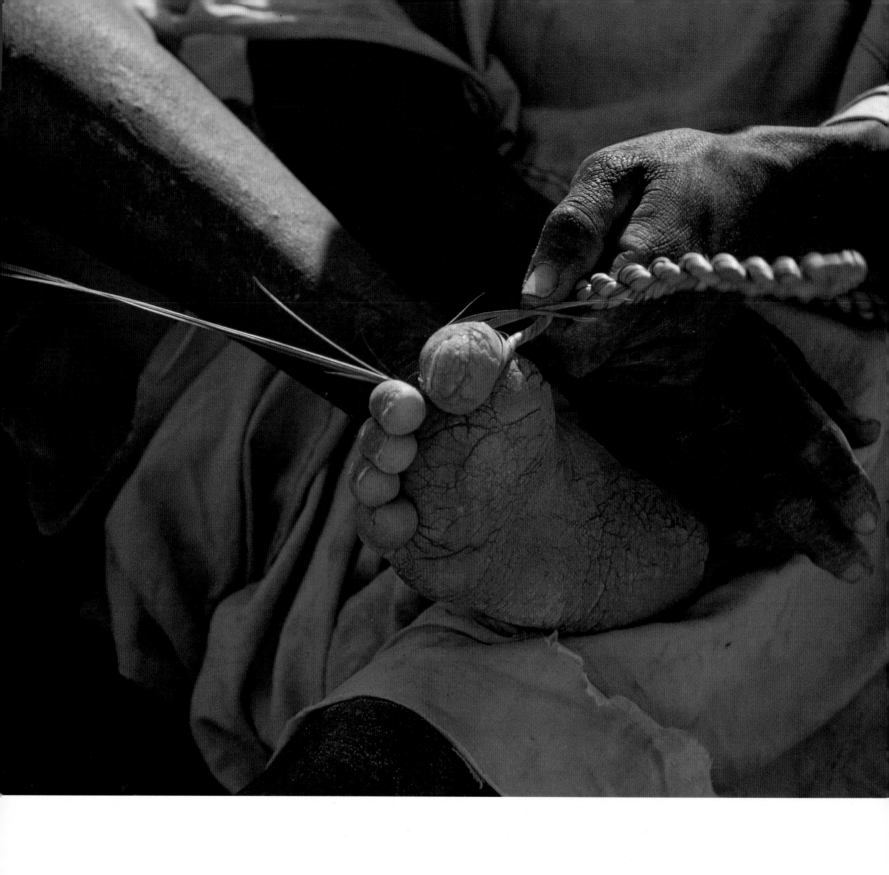

OPPOSITE *Sahara. Ténéré. Using his big toe for support, an* akli *of the salt caravan plaits a new rope.*

who has not yet donned the *tagilmust*, and two boys of nine and ten. The boys and one strong man are black. They are the *iklan* (black slaves) of two of the Tuareg. The others, though deeply bronzed, show white foreheads when, overwhelmed by the intense heat, they briefly push back their *tagilmusts*. Unlike most of the Tuareg I have known, they look to me strikingly Semitic. They tell me that they belong to the Igdalen tribe, which dwells around the well of Assaouas, seventy-five kilometers west of Agadès. They are *inislimen*, men versed in the Koran, the Moslem holy book. From their caste, which ranks second to that of the *imaheren*, or noble, come the *marabouts*, or holy men. Because they hide their women, unlike the Tuareg of other castes, they do not want me to go with them all the way to Assaouas.

The Igdalen do not demand that I plait ropes or pound millet. They correctly guess that my acculturation does not stretch that far. They watch me closely, if casually. They approve of my Tuareg clothes and of my love for camels, evident from my enjoyment of their antics. They do not find the camels funny, however. Having grown up with them, they could hardly detect anything odd about them, since they depend on these animals for their very survival. But they laugh when I trip on my robe and fall on my face, or when a camel, unexpectedly swinging its long flexible neck around, grabs my forearm in its teeth and does not let it go until drooling on it a mouthful of loathsome egestion.

JANUARY 4

I had an exhilarating night. As always in the Sahara, the stars shone so brightly that they seemed much closer than elsewhere. Though the Milky Way reminded me of my insignificance, its lights blinked at me as if in connivance. "We will be with you every night," they seemed to express. Stretched on my back in the soft sand next to the Tuareg, I was too overwhelmed to sleep,

too fearful of sacrilege to shut the cosmos from my vision. I could not forget that this sky taught me why some of the world's greatest religions were born in the desert, and why, to pray, the Moslems humbly prostrate themselves in the dust.

The camels, noses up like supercilious old ladies at a tea party, also vied for my attention. Heads moving at the end of long necks like balloons at a festival, they sat in circles of ten animals around piles of forage. Once in a while, inadvertently dropping its head to one side or the other, away from its position at the communal table, a camel was instantly reprimanded by a sharp nip even before tasting a neighbor's share of the fodder. And as its head automatically recoiled, so did all the other heads in the circle, with one roar, as if triggered by the same spring.

The Tuareg were not sleeping either. Even at eleven o'clock at night they were still working. Finally I stopped hearing the Tuareg's conversations and was lulled to sleep by the camels' rhythmic munching. Later a donkey belonging to the Kanuri came stumbling into our camp, waking us all. A Tuareg threw a pot at his head, the others cheered, a dog barked. It was three o'clock. The camels had not moved and were also awake.

I rise at 4:45 A.M. to find the Igdalen already praying. After that they throw forage to the camels. Though at this time of year these animals can walk for three weeks without drinking, they must eat abundantly every day to fuel the energy necessary to carry to Agadès their 150- to 180-kilo loads. While the Tuareg sort the cargo, the *iklan* boys—Ylla, the shy skinny one, and Rabbedu, the plump cheerful one—pound millet. Mixed with pounded dried goat cheese, dates, and water, it will provide the Tuareg with *aragira*, a liquid lunch.

Then we nine men drink tea out of four little glasses produced from a metal box kept with tea and sugar in a leather bag. Sitting in a circle like the camels, we wait interminably for the water to boil. Under the teapot the Tuareg burn only two little sticks, on which they blow incessantly to keep the fire alive. The firewood they have brought from the Aïr mountains must last several weeks; they cannot waste it, or even use as much as they need. Having drunk the three ritual glasses, we pass the sweet, wet tea leaves to the boys to eat.

Not until nine o'clock in the morning, after the camels have filled their stomachs, are we ready to start packing. Like the Ig-

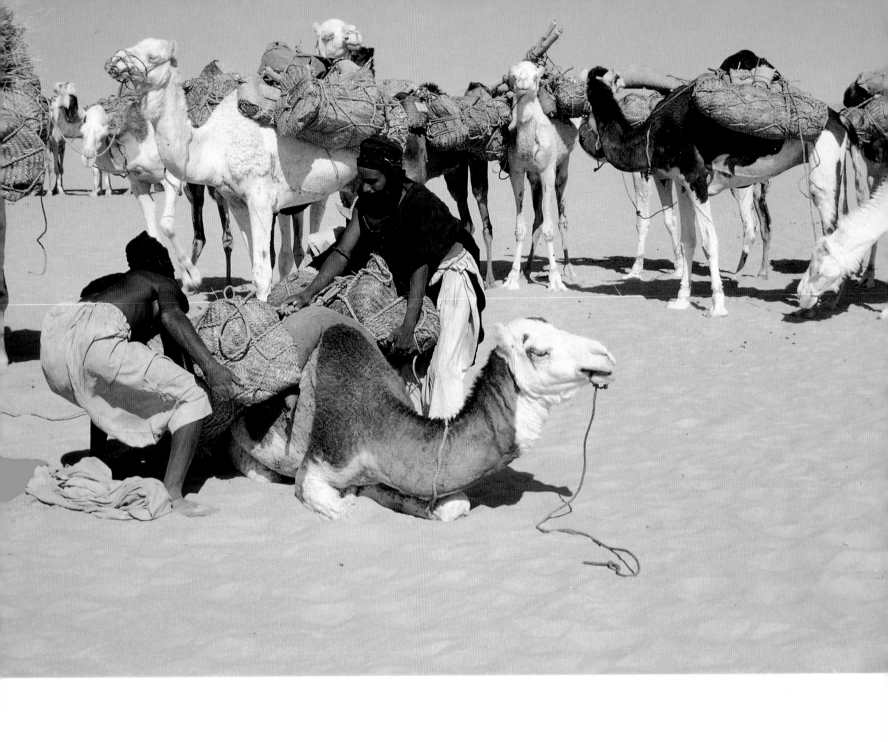

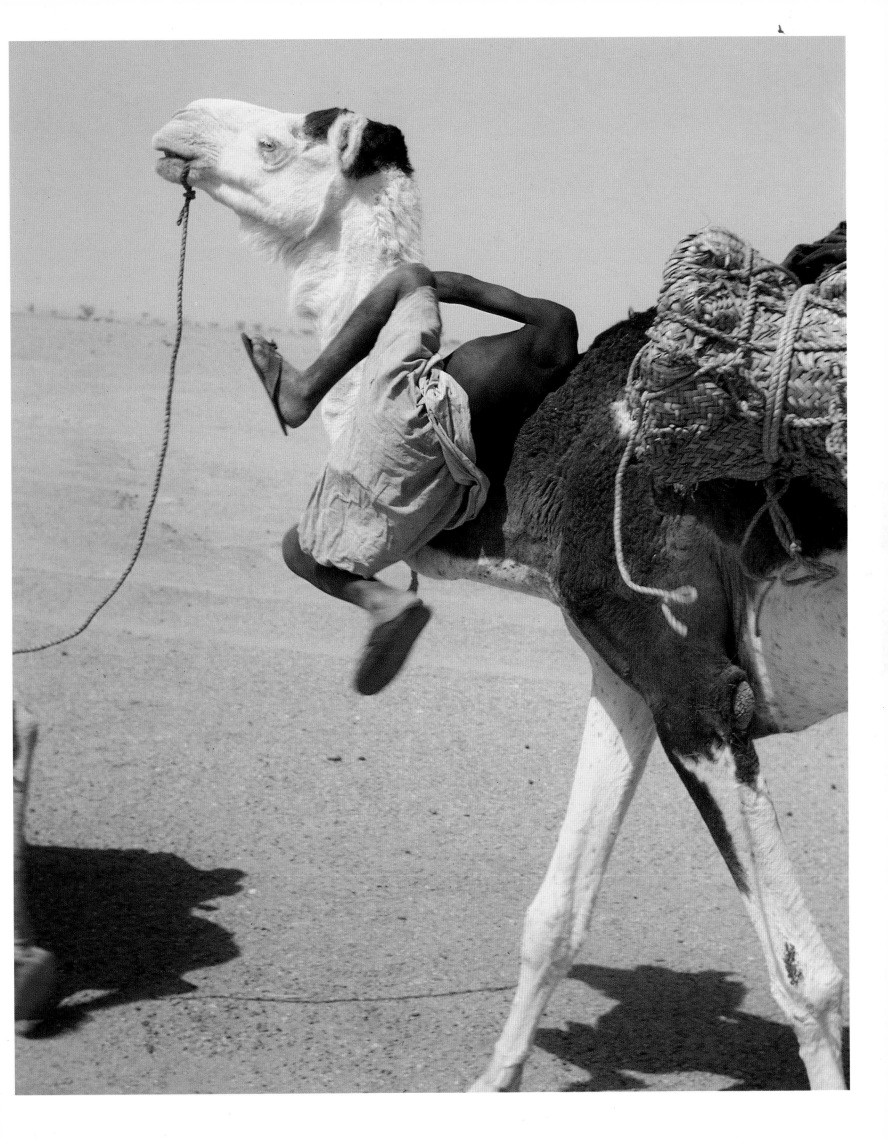

PRECEDING PAGE LEFT TOP *Sahara. Ténéré. Saidu (right) and Akundes load their camels in the morning. The camels' lengthy breakfast and the caravaneers' time-consuming labor make early departure impossible, even though the men got up long before sunrise to say the first Moslem prayer.*

PRECEDING PAGE *Holding himself aloft by hooking his head on the other side of a camel, Rabbedu, one of the Igdalen's two little iklan, climbs on board. The caravan must never stop, so all mounting and dismounting is made without interrupting its progress.*

dalen, I pick up ropes, tie each one to the lower jaw of a camel, pull it up, and free its hobbled legs. A Tuareg takes the camels from my hands, leads each one to a prearranged pack, and makes it kneel. The stronger camels will carry the heaviest loads.

The lumpy packs may weigh eighty kilos each, and to lift and fix them on the backs of the camels requires the combined efforts of three men. Two men lift one pack on one side, and while one of them holds it up against the camel under its loud recriminations, the other one switches sides to help the third man lift the second pack and tie it to the first one. The 102 camels I count mean 204 packs to lift and tie, besides firewood, bales of forage, goatskins of water, mortar and pestle, and personal luggage.

I make team with Saidu. While he leads a string of sixteen camels, I will watch from the rear to see that he loses none. A camel that is not led forward immediately stops. Saidu is the man who gave me permission in the name of his group to join the caravan. Though he is not the chief, his experience in crossing the Ténéré gives him symbolic authority over the others. For our safe arrival at the water holes, and, eventually, at our destination, we will all depend on his knowledge of the sky, the color of the dunes, and the direction of the wind. About thirty-five, the oldest of us, he is good-looking and gentle. To load the camels, Saidu and I gang up with another team, that of wiry, aquiline, and handsome Akundes and of woolly-headed, Jewish-looking Herca.

The salt packs are so rough that within an hour they have transformed my new desert pants into rags. Protected by leather aprons, the Tuareg now look better dressed than I. Unfortunately this is not the time to switch to dungarees. As if I had already become indispensable to them, the Igdalen protest as I move away in search of my luggage. I see it on the back of a camel being pulled away and understand that to change I will have to wait until tonight.

This tremendously amuses the Kanuri women who came to collect camel dung for their fires. They do such a thorough job that they lift each animal's tail to clean under it. I know that my torn pants cause only part of the fun, however. To watch a European do the work of a caravaneer is even more entertaining to them, and I know they are wondering what extraordinary misfortune pushed me to seek such hard employment. They would not believe me if I told them I am doing this out of curiosity, and even for fun.

The loaded camels are made to stand. They are roped one behind the other from pack to head—loosely enough to avoid a bolting animal pulling the others along in a mad race—while Ylla and Rabbedu, the boys, slowly pull them forward to keep them from rubbing sides and dumping the fragile salt. As more lines form, Tuareg men, too, start pulling them away.

The loading of the caravan lasts three hours. With the sun overhead and cheered on by the Kanuri, I lead the last string of camels into the Ténéré. Walking behind me, Saidu rearranges a pack, perfects its balance, tightens a rope. Ahead of us the other caravaneers do the same.

Our caravan stretches from horizon to horizon, but the rear walks faster and progressively catches up with the vanguard. Soon we walk abreast. We march without order. Depending on the terrain our strings of ten to fifteen camels walk side by side or behind one another.

By one o'clock in the afternoon Saidu considers the packs finally safe, for he takes his place at the head of our line and calls Herca to bring lunch. The Igdalen now walk side by side to pass each other the *aragira*, which they gulp without slowing down. Herca carries it in a small goatskin bag that hangs from his shoulder. He shakes it before serving and pours it into a dirty enamel bowl. Adambo and Ahmed, two other Igdalen, do the

same for the rest of our group. Though tasty and nutritious, the *aragira* is also replete with dead flies, wasps, and beetles, once trapped in the drying goat cheese and later pounded with it. When the bowl comes my way, however, I can hardly refuse it.

To spare their animals, the Tuareg do not mount them during the first four hours. Sinking in the deep soft sand, in spite of my wide-soled Tuareg thongs, which extend an inch around my feet, tires me prematurely, and I am glad to see Saidu finally jump on the head camel, imitated soon after by the other Igdalen. Doing the same, I walk alongside our last camel, pull its head down by the left ear, and, without slowing our march, jump on its neck and scramble to the top of the load.

I am riding comfortably. I can change position more easily than on a saddle camel, but I have no control of my mount. He is being pulled, and I with him. You could say that I am riding the train rather than driving my own car with the advantages and disadvantages that this entails. In any case, and whether threading sandy troughs or crossing dune crests, I command a superb view.

The mood of my companions is as sunny as the sky. They laugh easily and sing at the top of their voices beautiful eerie songs which I would love to learn but whose high-pitched, minor-keyed, whining quality my vocal cords could never emulate. When a camel suddenly gets loose and bolts, they cheer it with shrills and whoops, and catch it in an instant.

Except for short intervals to relieve Saidu at the head of his animals or to shoot photographs, I do not leave my moving roost for six hours. After that I am glad to stagger once more in the deep sand until we stop at eleven o'clock at night.

Lit solely by the stars, we first lower our precious *gerbas* (goatskin water bags) and hang them out of harm's way on crude wooden tripods carried by the Tuareg for this purpose. Although today we covered only a quarter of the way to Fachi, our next water hole and the only oasis on our itinerary, we have already lost to leaks, evaporation, and Tuareg prodigality half our water. None of the Igdalen seems to worry about it, or even to notice it.

We unload the camels, arrange them in circles, and throw forage in their midst. I gather my dispersed luggage. Ylla and Rabbedu take turns in pounding the millet.

I do not like millet, and have nearly broken my teeth on the minute stones that often accompany it. I like even less eating out of the Igdalen's never-washed pot, whose inside feels like unpolished rock. Having found out how long it takes to pound and cook enough millet for ten on a diminutive fire, I am glad to have decided to eat my own food. I cook rice, and in spite of the ridiculously small amount of firewood allotted me, I am eating before the Tuareg even start to cook. I am lucky to dig my bed in the hot sand by two o'clock while the Tuareg endlessly blow on the tiny flames under the millet.

JANUARY 5

I get up at six o'clock to find the Tuareg long awake. When I ask Saidu when he went to sleep, he shows me Polaris's position at that time, which does not tell me much. I suppose that he did not sleep more than two hours. The children cough terribly. Dressed in a rag, sleeping under an extra one, they are ill protected from the cold nights. Yet they smile. They always do.

We sit for tea while the camels take two hours to chew a mountain of hay, and we spend the next three hours loading them. The dungarees to which I switched resist the rough work but do not keep me cool. Like yesterday, we leave under the eleven o'clock sun. My arms ache, both from the effort of lifting the heavy packs and from chafed skin.

We walk for three and a half hours. Though tempered by a slight breeze, the weather today is especially hot. My exposed feet are cracking at the heels and toes, and blood oozes deep inside the cracks. Socks and shoes would relieve them, but the sand would fill the shoes and make walking even more painful. Anyway, I do my caravaneer's and photographer's jobs. Sometimes, perched on a distant dune, I hear Saidu calling. He always needs me when I am farthest away and most busy with my own work. I run to him when I can, and hide behind my camera when I cannot. But he is not patient, and through piercing shrills and much arm waving he makes sure I cannot ignore him long.

From the crests of the dunes my eyes embrace the whole distant circle of the horizon. Within it, and endlessly beyond, the sand rises and falls in sharp yellow waves that turn white under the midday sun and orange at sunset. The immensity of this petrified world, which stretches even farther beyond Bilma, is so

mind-boggling that, had I not seen its edges from the sky, I would not believe there could be any.

While on the move the caravan never stops. When the slipping load of a camel cannot be fixed on the move, the animal is quickly separated from the others, who go on. If a man must leave his camels to worship or to satisfy a natural urge, his teammate takes his place. I learn the times Saidu must pray and run forward to replace him. I feel so close to God myself that at times I would like to prostrate myself next to Saidu and, like him, rub my forehead in the sand.

To drink, I do like the Tuareg. Walking beside a camel, I untie the neck of the water bag on its side, pour about a liter of water into a bowl, swallow it while holding the skin closed with the other hand, then tie up the neck again. After that I can resist thirst for several hours.

The water is black and hairy, but deliciously cool because of evaporation through the porous leather. Its unappetizing look results from the constant rocking in the goatskin, waterproofed with vegetable tar, from the camel hair with which the Tuareg constantly plug the bag's holes, and from the goat's hair itself. Dirty or not, this water is all we have to survive, and I worry at watching the Tuareg waste it. They always pour more water than they can swallow and let the sand drink the leftover instead of returning it to the skin. I had thought that my three *gerbas* would save me from thirst, but the Tuareg incorporated them into their water pool and my parsimony will be of little help to me.

We stop at six o'clock in the evening after coming upon scattered tufts of grass. These tufts were born no doubt after a miraculous sprinkling from the sky gave sudden life to seeds possibly dormant for the past ten years; they will help us save dry forage. After unloading and hobbling the camels, we release them to browse.

Since I had rice last night, I now cook spaghetti. Except for sardines and dates, rice and spaghetti are my only alternatives each night. I could find hardly anything else in the shops of Agadès, and I hate shopping, anyway. To further vary the menu I flavor my spaghetti with canned tomato paste and my rice with sweetened condensed milk. Since there is no water with which to wash my pot, I also get extra flavor from the preceding meal.

OPPOSITE *Sahara. Ténéré. Holding the* aragira *in a goatskin under his arm, Herca passes a bowlful of it to Saidu. To keep the camels from throwing their precious loads of salt, the Tuareg drink the thick liquid lunch without slowing the march.*

By ten I am in my sleeping bag. The Tuareg are only starting to blow on their fires.

JANUARY 6

Though up before sunrise as usual, the Tuareg do not start before eight o'clock to round up the camels that have scattered three-legged into the desert, and then only two men go for them. The other Igdalen check and recheck pack saddles, salt packs, and ropes. Ylla and Rabbedu, coughing and laughing, warm their bodies and spirits by tobogganing down the dunes. My own body aches in every muscle.

Until midmorning the sky is cloudy, veiling the sun, but by 10:30 A.M. when the camels finally amble in, the heat has become oppressive. It must affect the camels, for they are in a rebellious mood. More than ever they bellow, try to bite, throw their loads. The Tuareg react with laughter, then patience, finally with blows on the camels' rubbery noses. Still we manage to be gone by a little past noon.

We walk for only an hour before mounting. We do not go far this day, as if the camel bones we pass along the way reminded my friends to spare their animals. Resisting thirst, I drink little. Heedless, the Igdalen keep squandering the water.

At 4:15 P.M. we find more scattered grass and stop to release the camels. Soon after more Tuareg arrive from Bilma and camp next to us to pasture their own hundred camels. Saidu tells me that they are of the Kel Ferwan tribe—*imrad* (vassals) who live to the north of the Aïr mountains. They are taller, stronger, and slightly darker than my companions.

JANUARY 7

Even the little water in our minute teapot takes forever to boil. The Tuareg cut bunches of grass to replenish their stores. Casually, Herca shows me the last deflated goatskin still hanging

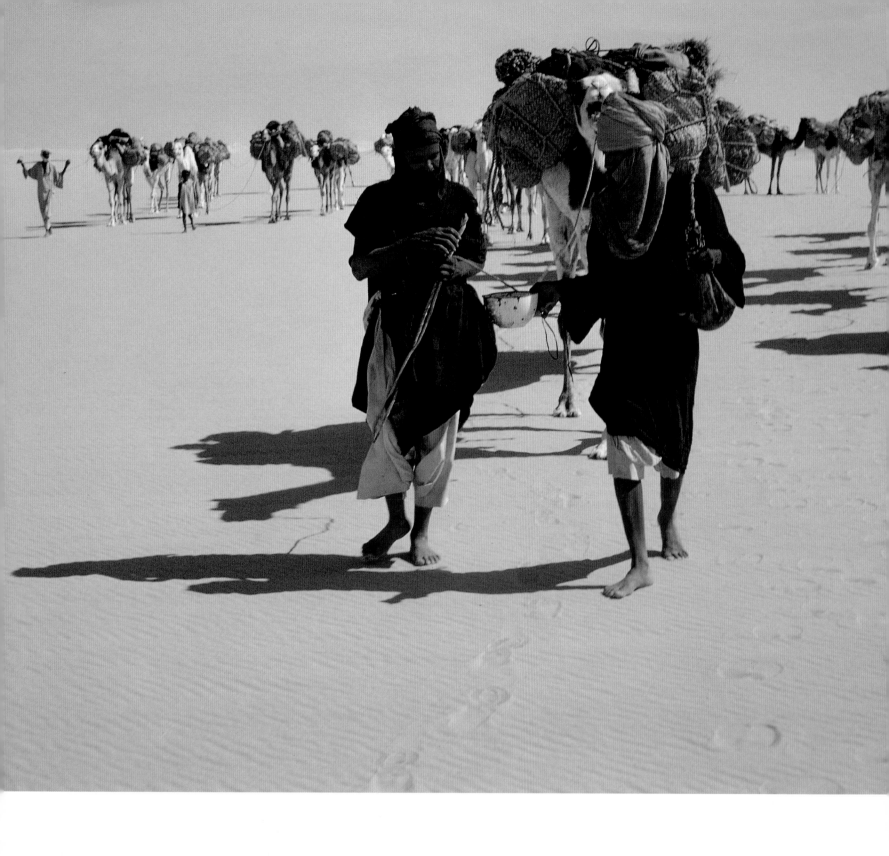

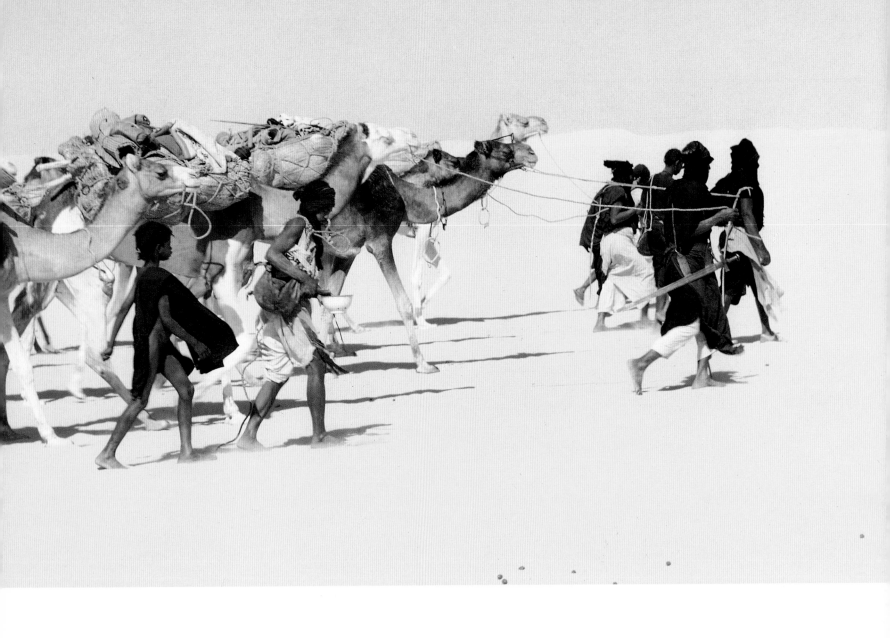

OPPOSITE *Each pulling his own line of camels, the members of the caravan walk side by side at noon to take turns gulping the liquid lunch that the man at right holds in a goatskin bag.*

on a tripod, and I clench my teeth to suppress anger. Why should he show it to *me*? But I am happy. Today I feel rested. My muscles have adapted to the hard work, and I know that I will be equal to the Tuareg in our hardship.

Both caravans leave together today, though only around one o'clock, as a result of having to gather today twice as many camels. But what an impressive sight we make! At the beginning of this century it was not unusual to see twenty thousand camels marching together. Truly an awesome spectacle.

Because of our scarce water reserve, we spare efforts that would further dry our throats and mount our camels after an hour of walking. But if riding helps my thirst, it seems to make me think about water more, and I cannot erase from my mind images of running faucets and cool streams. Except for breakfast's syrupy green tea, I drink only a few drops of water in early afternoon and a few more before sunset. As far as I can tell, after tea the Tuareg do not drink at all.

They do not sing or yell either. They do not laugh. We walk in great silence. Fortunately our mechanical march through the vast desert goes unhindered. Though riding for eight consecutive hours, my back no longer hurts and I do not even feel tired; but the hours after sunset, when the eyes can only turn inward on a mind plagued by the obsession of water, seem interminable.

We stop at 10:30 P.M. With no water for cooking, my friends eat their pounded millet raw, mixed with pounded dates in small balls. I open a can of sardines, which my companions refuse with disgust because of a taboo on fish. I eat them with raw pounded millet.

After dinner, for once, I postpone sleep for the sake of three little glasses of tea. They are the last liquid I will drink before

reaching Fachi tomorrow. And how delicious they taste! Not only because of my thirst, but also because of the human comfort I seem to absorb through them. In spite of our dangerous situation, my friends tonight still find the spirit to joke and laugh. Always tolerant of my ways and what to them must seem like my extravagance, they have obviously become fond of me.

JANUARY 8

I wake up long before dawn to find the Tuareg already up, even though they do not need to say their first prayer until just before daybreak. At night when I wake up to pull from my neck, belly, or thighs the ticks that leave the camels to visit me, I seem to always find them awake. When do they sleep then?

The Tuareg sit silently, even morosely—so solemnly that at first I think they are praying. But they have long said their prayer, and probably with more fervor than usual. Dejectedly, they breakfast on dry dates. No fire glows in their midst, no tea is brewing, or they would not be so melancholy.

I am not joyous either. My tongue feels thick and my throat tight. I lack saliva to swallow dry dates, and instead grease my throat with sardines. Still I am optimistic. I feel strong and healthy, and since the camels spent the night with us, I trust we will leave early.

Our water shortage changes nothing in our habits, however. The camels must eat first and well if they are to carry their loads all the way. Leaving nothing to chance, the Tuareg move with the same cautious deliberation. Still we leave at the exceptionally early hour of 9:45 A.M.—all two hundred camels of the Igdalen and the Kel Ferwan.

We walk for half an hour—only as long as packs take to settle. Exacerbated by the effort of loading the camels, our thirst has condemned us to silence. Ours has become a phantom caravan, whose muffled human shapes could be those of corpses.

Twice, at the thump of a falling salt pack, the caravan comes briefly back to life. A shrill cry warns the men in front, some camels roar, bare feet rush noiselessly on the soft sand. The others go on; the caravan must never stop. Noises, like the grains of sand raised by the camels' soles, quickly settle again.

Early in the afternoon Saidu turns toward me and points to the distant rock wall ahead of us. "Fachi," he announces.

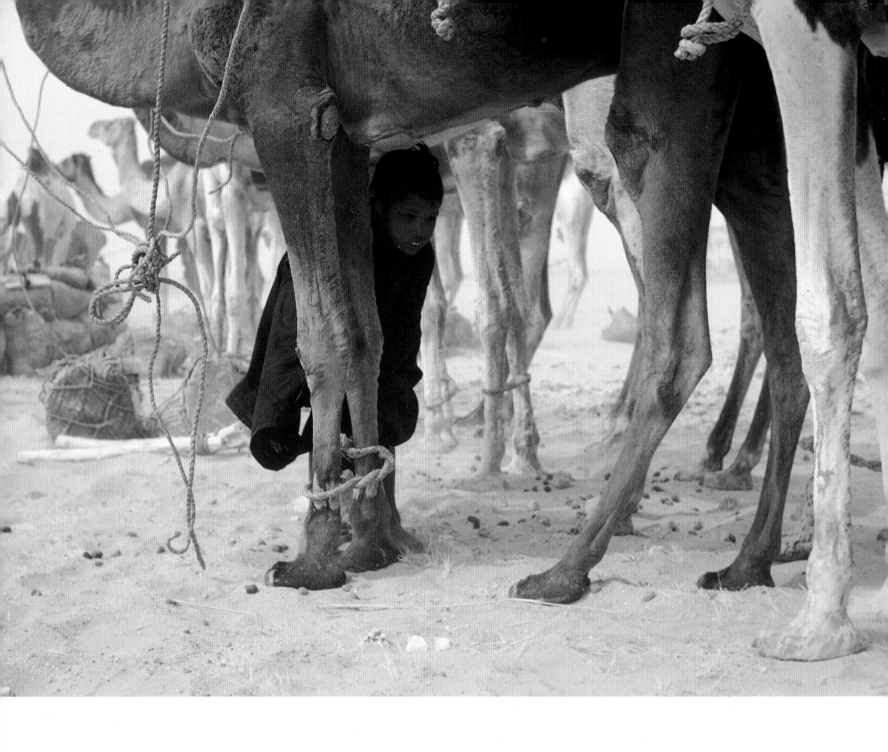

OPPOSITE *Sahara. Ténéré. A young Kel Ferwan hobbles a camel at the start of a sandstorm. Perhaps because of the unusual cold, the camels release urine, which the wind blows in his face.*

The hours go by and the wall gets higher, but we do not seem to get closer to it. I understand now it is a cliff like that of the Kaouar, and that we will pass through the notch that I start discerning. Except for that geological feature on our horizon, the landscape has not changed since we set out five days before. The sand in its stillness is more monotonous than the water of the ocean. The sky is blue, cloudless, frighteningly empty. Only the sun moves—charming us, teasing us, tormenting us.

Hours later, an infinity later, the night envelops us. Black and confining, it isolates me from my companions and robs me of all sense of time and space, for no longer can I, by the ground or by my watch, check our progress. I brought no light, and, were it not for the stars, I would feel like a prisoner in a forgotten dungeon. By midnight I feel almost worse, because the discomfort and fatigue that have overtaken me are so excruciating that they almost succeed in diverting my mind from thirst. Ah, to close my eyes, to go to sleep! But I would soon fall from my camel. And who then would tend a broken bone? In my shopping phobia, I did not bring as much as a gauze band.

More hours later we turn sharply to the left, and I realize we have crossed the rock wall. Soon we enter a palm grove. Jubilantly I leap from my camel. My legs are so benumbed by the long ride that they yield under me like rubber. Gathering myself up, I toddle after the caravan and, with blood returning to my legs, slowly catch up with Saidu.

"Fachi?" I ask.

"No," he smiles wearily, "but we are near."

For a while we walk through the oasis, and hope gives me back my strength. But we reenter the emptiness, and despair drains it once more. Why did I take Saidu literally, knowing how different our values are? Only he knows how near is, to him, near, and I must resign myself for the worst. I should get back on my camel, but I feel too weak for even that effort. Sinking into the deep sand, I walk on heavily, each step more strenuous than the last. When I start losing ground, I hold on to my camel's neck and let him pull me. But even that is now too much. With groans of pain I try to get back on board. After several attempts I finally balance on my camel's neck and scramble up.

And three hours more may go by. The pale light of a camel dung fire in the distance at last signals Fachi. Rewinding his *tagilmust* formally, Saidu tacitly confirms it. As we plod into the village, Kanuri men present us with large wooden bowls full of water. They must know the Tuareg always stretch Allah's mercy.

We dismount, and by the light of the fire I see on my watch that it is past three o'clock in the morning. Saidu takes a bowl from the hands of a Kanuri and hands it to me. Dismayed, I hear myself inviting him to drink first. Though he is gulping the water, my turn to do so seems long to come. When I drink, I feel as if my veins are filling with a potent medicine, as if I could now jump on my camel and urge it in a gallop for the rest of the night. More than the long march, it was dehydration that had weakened me so. The water is cool and delicious, and I do not tire of drinking. With ever longer pauses, I down several liters. And then the taste of the water becomes horrible and gives me nausea. Bringing it to the fire, I see that it is thick and green.

We camp outside the village walls, and, with my energy partly restored, I cook and even endure the long wait for tea.

JANUARY 9

Protected against the wind by walls of pack saddles, we camp in the full sun. A procession of Kanuri villagers comes to greet us. As in Bilma, the women clean our camp of camel dung. Others peddle dates. Though some of them are pretty, the Igdalen do not seem to notice them, which may explain the racial purity of their tribe. A man unsuccessfully tries to sell my companions a pack saddle. Some of theirs are broken, spilling their dry cameldung filling, but they are hard at work repairing them.

When not moving, the caravaneers are always absorbed by repairs. To mend clothes they pull threads from the garments themselves, while to sew leather they cut thin strips from leather pieces they carry with them. Herca is plaiting ropes, and Ylla pounding millet. A short distance away, the Kel Ferwan are doing the same things.

Akundes is cauterizing camel blisters, and Rabbedu is helping him by holding the camel still. This he does by clutching the delicate nostrils and lower lip of the animal being treated. He stands squarely on his legs while, under the camel's loud protest, Akundes applies the red iron to the animal's flesh.

Saidu brews tea. Leaning on his elbow, he tirelessly fans with his sandal the glowing embers under the teapot. Having brought nothing else to sweeten my diet, I now enjoy tea almost as much as the Tuareg. It tastes even better once I discover that the green water we must drink comes from a dirty pool where our camels wade to drink while releasing bladders and intestines, and where the Tuareg, unwashed for weeks, slosh knee-deep to moisten the straw mat wrappings on which they have daily wiped their hands after blowing their noses into them.

Constantly saving water, the Tuareg have lost the habit of bathing. It is true that because their sweat is instantly absorbed by the dry air, they do not develop strong body odors. Water is so scarce in the encampments that once, having persuaded a Tuareg mother to bathe her feverish, dirty little boy in a big wooden bowl, I saw her later pour the water back into the *gerba* for drinking.

My own little chores—taking a bath, washing clothes, and scrubbing my pot—take only an hour, and I am free to roam about and take pictures.

My visit surprises the Kanuri greatly, mostly their children. Obviously, they are not used to seeing Europeans. At first the children stare at me with mixed terror and interest. But when one daredevil touches my hand and gets away with it, they all want to hang on to my fingers, of which I do not have enough for all of them. Guided by them, I visit the oasis.

Because Fachi used to be raided by the arch rivals of the Aïr Tuareg, the Tubu, a black nomadic people racially akin to the Kanuri and dwelling to the east in the natural fortress of the forbidding Tibesti mountains, the oasis is surrounded by walls and bulky square towers that lend it a striking appearance. The high towers, apparently built of blocks of coarse salt plastered with adobe, look down on similarly built low houses and the hairy heads of palm trees that seem to have strayed from the groves outside the walls. No longer threatened, the oasis today is peaceful.

Muffling the sounds of feet and hooves, the sandy, biblical lanes of the oasis are animated by the giggles and colors of brightly clad women carrying water on their heads; the trilogy of donkey, horse, and camel staked individually before small piles of fodder in the middle of the way; and the aimless stroll of sheep and goats. While curiosity pulls me ahead, robed Kanuri men, yielding to the heat and the charm of the site, recline on the clean sand in the shade of walls and palm trees.

Back at the bivouac, I find the Igdalen short of a spoon to eat their millet, but they refuse mine. "Too small," says Akundes disdainfully of my metal soupspoon. Unlike other Moslems, the Tuareg do not eat with their hands, which they cannot wash, and their wooden spoons are quite big. To solve their problem they prefer to rotate the spoons around the circle. That is, each man with a spoon uses it only once before passing it to the man on his right and waiting for another one to come from his left—and continuously so until the pot is empty. That spectacle would be comical enough, but the Igdalen's lack of self-consciousness and the solemnity with which they push the big spoons under their veils make it downright hilarious.

JANUARY 11

Even after spending two long days in Fachi for repairs, the Tuareg are still at work this morning. Saidu and I, along with Rabbedu, who is pulling a camel loaded with our empty *gerbas*, go to get clean water from a shallow hole dug out of a wadi and encased by palm trunks that I discovered in my wanderings. It is the Kanuri's water hole, and the women, filling their jars at it

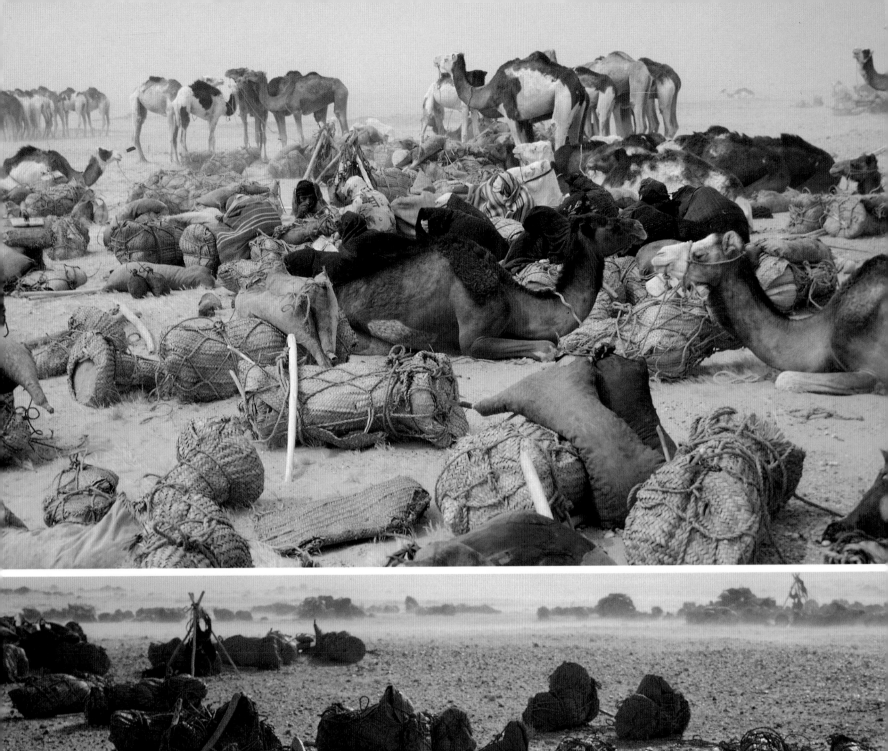
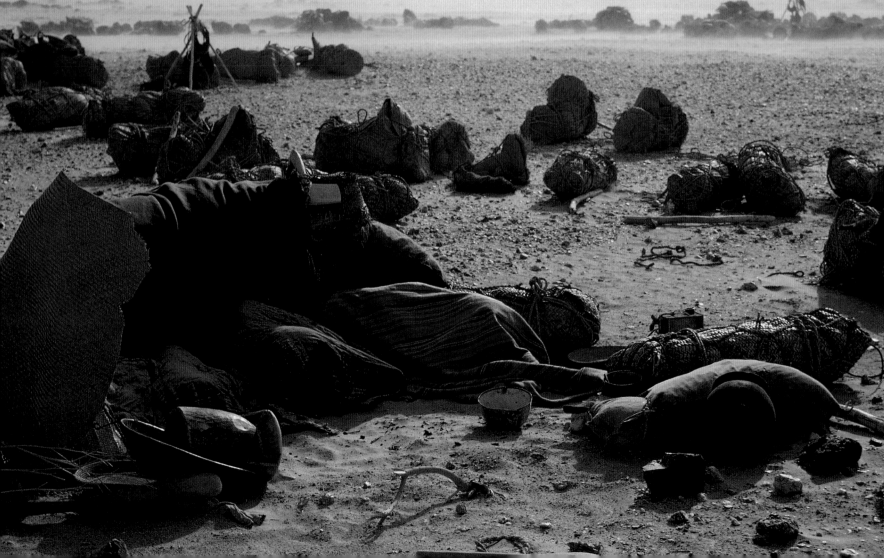

or meeting us along the way, must find our presence there highly unusual, for they burst out laughing at us and mock us brazenly. Perhaps because of my own constant goodwill with him, Saidu weathers their abuse as serenely as he accepted the half-hour round trip.

We get back to camp, and, if the other Igdalen think me unreasonable, they do not say so. Only the smile in their eyes betray their thoughts, which Herca translates blithely.

"Nothing wrong with the water here," he teases. "Wait till we get to the Tree of the Ténéré."

The Tree of the Ténéré, a small acacia, the only tree for hundreds of miles around, is so important a landmark that it figures on the map. The well at its foot makes it doubly vital to those who pass by it. We owe it to French sergeant Henri Lamotte, who, in 1939, reasoning that where there is a tree there must be water, rode to it with a crew to start digging. What he never imagined is that the tree's roots extended so deeply. He found water only four months later, at a depth of thirty-six meters. And that water is so full of sodium that it plays havoc on intestines.

As in Bilma, preparations are long, for the caravaneers collected all our cargo to revise it, and it must now be redistributed among the camels. It seems as if all the villagers have gathered to watch me work. Probably with more surprise than admiration, they cheer each time I display vigor with the loads or skill with the camels. My friends frown at the tumult, but when several men, perhaps to make a show of their own, break from the crowd to give us a hand, their eyes light up.

Reinforced by four Kanuri men who have business in Agadès, we leave around eleven in the morning. With baskets, the Kanuri women fall on our camels' intestinal fuel like vultures. For a while the children accompany me. The Kel Ferwan leave later and eventually overtake us and walk over the horizon ahead of us.

It feels wonderful to get going again, to walk for three hours before mounting. Riding, later, gets monotonous. When we slow down much, after eight in the evening, it gets downright boring, and I envy the little *iklan* who can sleep on their camels while being tossed about like salads.

In bad French, one of the Kanuri tells me that a caravan of Kel Gress Tuareg has transported the dates of his palm grove to Ter-

mit, three hundred kilometers south, and that, after enjoying in Agadès the festivities that will soon climax the Ramadan, the long Moslem fast, he will hitch a truck ride to retrieve his dates and then travel to Nigeria, where he will sell them.

At 10:15 P.M. the roar of camels ahead announces that we have caught up with the Kel Ferwan, who are already camping. The little boys wake up, slip down from their camels, and are soon hard at work. They will be pounding millet long after I have lain down to sleep. The *gerbas* that I help hang from their tripods are already half empty.

JANUARY 12

Thanks to the help of the Kanuri, the two hundred camels of the Igdalen and Kel Ferwan are leaving at 9:15 A.M.—early enough to help get us today fourteen hours closer to the well. Our fast-dwindling water leaves us no alternative to the forced march.

Why the Tuareg drink and waste so much water at the beginning, only to ration it later, is to me a mystery. Are they trying, as always, to lighten the loads of their poor beasts of burden, or to drink the water, part of which constantly drips from the goatskins, before the sand does? Whatever the case, they drink much more than I.

If they drink much, they sleep little. They hardly rested even in Fachi, and Herca asked me this morning whether I carry no pills to cure fatigue. Tonight he is pounding the millet, and his weariness does not keep him from joking and laughing. I observe the same good humor among the Kel Ferwan.

JANUARY 13

Again we leave early, both caravans together. Shining fiercely, the sun weighs heavily on us. While the caravan plods forward ever more slowly, the Tuareg take turns resting. They sprawl on the ground for a while, then hurry after the caravan.

But the camels give us trouble. They too are tired, and many drop to their knees without warning. When one does, it stops its line and irks the others, who roar in protest. Unless a man is near enough to quickly hold on to the pack and pull the animal up as it jerks downward, the salt will fall and break. Perhaps a disastrous chain reaction will ensue.

The afternoon is eerily silent. The air, thick with the palpable

heat, seems to absorb all sounds. The Tuareg sleep on their camels, and I wonder what their thoughts are. My own mind wanders aimlessly through the world I left behind, though with no longing. Here I have put my life in perspective and learned the futility of much of modern life. Here I am content.

Mirages shimmer in the distance, reminding me of my first Saharan adventure, in 1957, during the Algerian War. I was crossing Africa on a 125 cc Vespa scooter, and at that particular time had the company of a friend who was riding his own scooter. To avoid being knocked down by the wind, we leaned against it until, abruptly dropping, it pulled us down with it. Our water, uncontrollably swinging in a *gerba* at the back of my scooter, felled me many times more. The fierce sun of June bred mirages all around us, and generated constant sand storms. Except for a short stretch with a Foreign Legion convoy and another one with four Germans, we were alone to find our way in the sandstorm, to fall in an ambush, to be blown up by one of the mines the Fellagha, the Algerian rebels, buried in the tracks we had to follow, or to die of thirst.

Ironically, it was during our brief stay with the Foreign Legion that we were shot at by the Fellagha, and because of a good gesture by one of the Germans that I came to suffer agonizing thirst. It was my first brush with thirst. Early one morning my friend had stopped to help two of the Germans repair their big motorcycle. Trusting he would soon finish and overtake me, he had told me to go on with the others, a couple in a Mercedes car. The couple had relieved me of my cumbersome *gerba*, and then, forgetting they had my water, had drifted ahead at a faster speed. Unsuccessfully trying to catch up with them on my Vespa, hoping they would eventually stop to wait for me, I had chased my water all day. The Mercedes did not stop until dusk, and my friend and the other two Germans arrived much later. Meanwhile, I had kept just enough good sense to not leave the tenuous trail for the deceptive, beckoning puddles and ponds in which I wanted so hard to believe.

Sparse grass once more entices the Tuareg to camp before dusk at the end of a ten-hour march, and we release the camels on it after unloading and hobbling them. If they are tired, they must be even hungrier, for they soon drift away grazing. The Tuareg are so exhausted that some fall asleep after the first glass of tea. They wake up at the unfamiliar sound their pestle is making tonight, and for a while delight in watching me awkwardly break the millet grains and sometimes hit the ground instead. But when I spill a few grains, they jump to their feet and pull the pestle unceremoniously out of my hands.

JANUARY 14

The Tuareg this morning move more slowly than ever. Prayer, tea, verification of the cargo. . . . Otherwise there is hardly anything to do while awaiting the return of Akundes with the camels. Gone at sunrise, he is back only shortly before noon.

We leave at one o'clock under a deadly sun. Our last water is gone with the tea; we are once more thirsty.

Saidu, whose careful and methodical working habits have saved him much of the time from falling loads, today is plagued with them, though not for any negligence of his. Exhausted, his camels pull on their ropes, dip on their knees, and, fast as I rush to avoid the mishap, I arrive too late. Saidu's own lead camel sinks under him at various times, and we slowly fall back from the rest of the caravan. Irritated, Saidu exchanges his camel with mine. He mumbles incomprehensible words and scolds me. He even pushes me. Irked by his unusual attitude, I overreact. "Watch your ways," I warn him. "You are not dealing with an *akli*."

Dismayed, he begs forgiveness. Sorry, I beg him to excuse *me*. Our nerves are on edge, but we laugh and forget the incident. Still, Saidu seems unable to overcome his anguish. And all he can say is, "*Termad, Termad!*" ("Quickly, quickly!")

His camel now slouches under me. We relieve him of some cargo, which we redistribute among other animals, and again change its place in the line. Ideally, we would need four men to do that, and under the circumstances we cannot avoid more accidents.

The horizon has long swallowed the others, and we are all alone. For hours the caravan had spread in a wide front, and before it disappeared from our sight it was opening even more broadly.

"Were they striving not to miss the Tree of the Ténéré?" I ask Saidu, suddenly struck by a possible explanation for an unusual behavior.

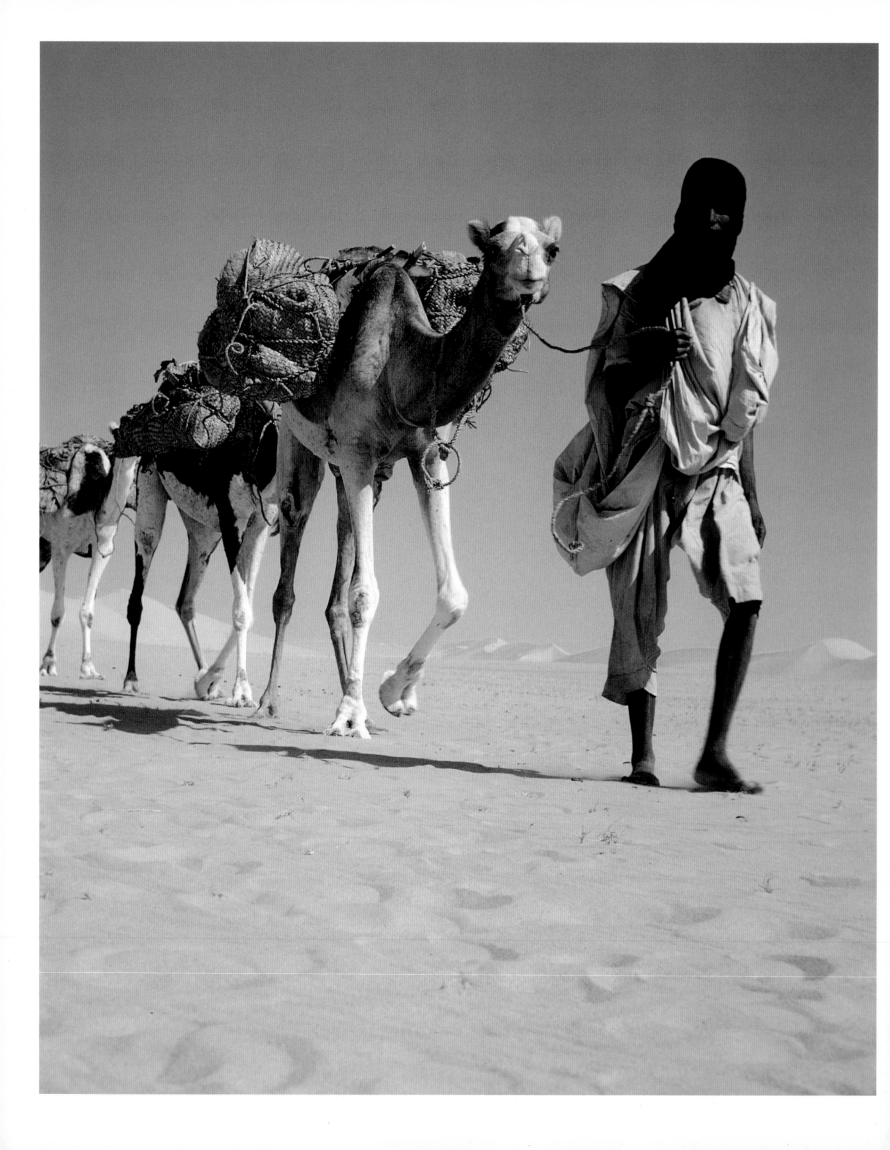

OPPOSITE *Sahara. Ténéré. An Igdalen caravaneer pulls a line of camels over a dune. For comfort, he has pulled up the left leg of his pants into his belt.*

"Yes," he says with a shrug, "but if night traps us before we catch up with the caravan, we may not drink today."

Now I understand Saidu's alarm, and I am getting scared myself. We cannot spread out like the rest of the caravan, and if the Igdalen fear to miss the Tree of the Ténéré by daylight, how will he see it at night?

I remember watching the salt caravans from the sky as I flew from Agadès to Dirkou, and how I shuddered at the thought of one missing a turn in the labyrinth of dunes. It would be so easy for a caravan in the Ténéré to miss a water hole and go on slightly off course until exhaustion and thirst annihilated it. The caravans, which followed each other at intervals of various days, looked so tiny in the frighteningly bleak immensity, that they could have been armies of ants crawling over the frozen waves of a mineral sea. They looked so unreal that for a moment I wondered whether they really existed. My fellow passengers, soldiers and government employees, did not see them because they were sleeping. Or was it the other way around? Were they sleeping because there was nothing for them to see? Was it possible that the pilot was not seeing them either, that I alone did, that they belonged to a parallel world of which no one else was aware, one which shared our space but not our time? Such a strange sight they were, so late in our century, that my doubts could have assailed anyone. One thing was sure: once I entered the Ténéré with the Tuareg, I was as lost to the world as if I had strayed into a past century.

The sun sets on rocky outcroppings which, ahead of us, are changing the face of the desert. Later a thin crescent of moon rises behind us. Its tenuous light hardly pierces the veil of sand hanging over us, but we go on by it. We have been walking side by side, following in the footsteps of one of the camel lines. Now Saidu crosses virgin sand. He must know what he is doing. Half an hour later he points ahead of us. "The Tree of the Ténéré," he says.

Though for many minutes I cannot discern it, his word suffices, and so strong is this suggestion of water that I can almost feel saliva returning to my sticky mouth. Incredibly, the Tree stands right across our path, which testifies to Saidu's exceptional sense of direction.

As we plod in at 11 P.M., our friends get up to give us water and help us unload. Though clear, the water smells of rotten eggs. Disappointed, I sit down to drink more slowly. The bundle under me turns out to be a sleeping Kanuri, but he does not move, and the Tuareg laugh good-heartedly at my mistake. "He's dead," quips Akundes. "We'll bury him tomorrow." Dead or not, he is impossible to wake up for tea or dinner.

JANUARY 15

Like a great red balloon, the sun pops over the horizon under the umbrella of the Ténéré Tree where, like biblical figures, three Igdalen are pulling water from the well underneath and loading the *gerbas* on a camel. At a distance, flat on my belly and camera in hand, I am taking a few quick pictures while the Tuareg, who must think I am oversleeping, are crying for my help with growing shrillness. Because this important tree, a small acacia much mangled by the axes of men and the teeth of camels, is so dreary, I have lain long, waiting for the sun to give it a deserved aura. But the sun is fast rising out of my picture, and I run to help my friends. At the foot of the tree the orange light is revealing countless camel carcasses, but they are not what make me gasp.

"What! You are not filling all the *gerbas*?" I ask Saidu, appalled to see the Igdalen fold and pack some of them. The foul-smelling water last night gave me dysentery and kept me from sleeping, but I would not be without it.

"No," he answers, "They're getting too heavy for the camels, and our next water hole is only three days away."

"But Saidu!" I protest, "You know we'll be thirsty again, and you cannot indefinitely keep depending on Allah's help. Sometimes he is busy elsewhere, and he needs *your* help."

He laughs good-heartedly, and the others echo him, but they will not change their minds. Trying not to taste the water, I drink until nausea stops me.

We leave with the Kel Ferwan at ten o'clock in the morning. The driving sand obscures the sky and even the sun, slows our

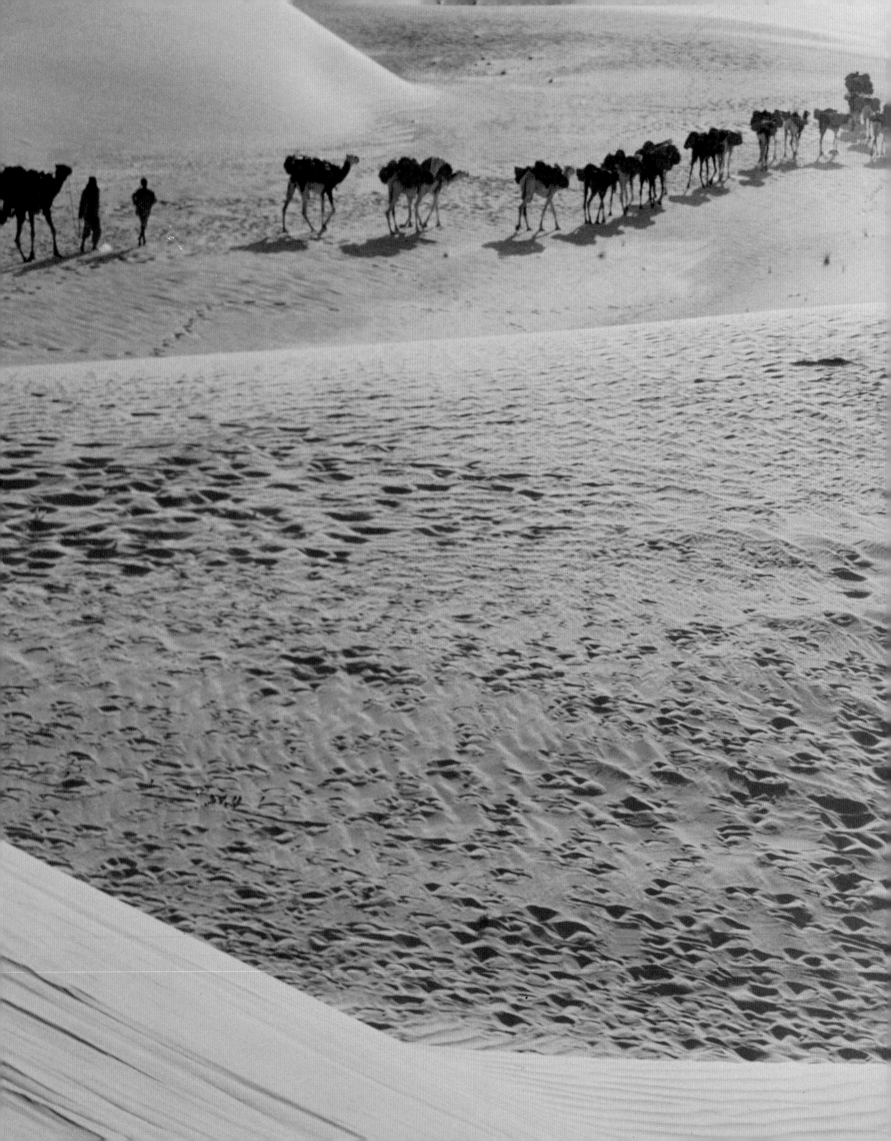

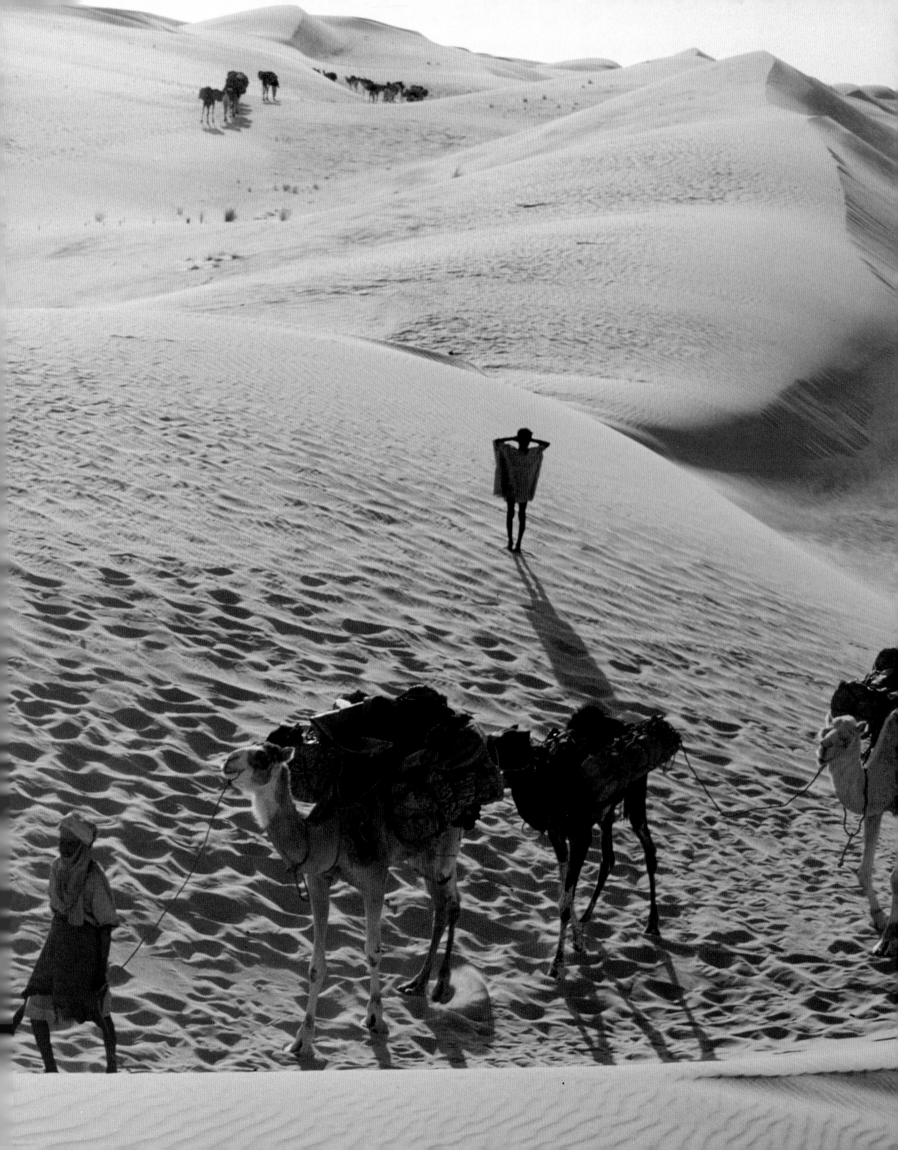

progress, and causes us much discomfort. We have come out of the dunes on a flat land studded with small rock outcroppings. Half a day's ride from the Ténéré Tree, the Aïr foothills rise over the horizon ahead of us. Saidu turns around toward me, and the smile in his eyes says more than he would allow. "The Land of Thirst is now behind us," he says.

"But the Ténéré is not out of me yet," I answer, and he knows what I mean. It has not yet left him or the other Igdalen either. As Herca had warned in Fachi, the water of the Tree is draining our bowels, and to seek relief we are constantly walking away from the caravan. The flat land offers no hiding place. At the beginning of the day I sought isolation, letting the caravan walk far ahead of me. But my bowels would not wait, and I had to learn from the Tuareg how to gain a measure of privacy by curtaining myself in my robe. I have an extra reason today for drinking as little as possible.

By the end of the afternoon we reach the first rocky hills. Wadis cross our path and stones dot it, contributing to a more hospitable landscape.

We stop at 10:30 P.M., before catching up with the Kel Ferwan, who outdistanced us, and on scattered pasture we unload in silence. The men are all drained.

JANUARY 16

Gone at eight o'clock in the morning to gather the grazing camels, Herca and Akundes return only at noon. The sun is so fierce that the other Igdalen use their cotton blankets to improvise little tents over their heads.

We leave at three o'clock in the afternoon and walk for only two hours, until catching up with the Kel Ferwan, who did not move today. Was it worth all the trouble?

JANUARY 17

Another morning goes by gathering the camels, only to find after they are herded in that two are missing. Good-humoredly, Herca and Akundes release them and ride out in search of the lost ones. A cold sandstorm pushes the rest of us under our blankets. The Kel Ferwan nearby go through the same motions.

Herca and Akundes return with the missing animals at 4:30 P.M. They and the others are in such a pleasant mood that I do

PRECEDING PAGES *Sahara. Ténéré. On its way to Agadès, the salt caravan winds its way through lofty dunes. A young akli pauses to watch it go by.*

OPPOSITE TOP *Sahara. Ténéré. Sunrise finds caravaneers crowding around a tiny fire. Saidu cuts firewood with an ax, and Akundes pours green tea. Sitting in circles around their forage, the camels are eating their last bites.*

OPPOSITE BOTTOM *Protected from the hot, sand-blowing wind by a wall of pack saddles and salt packs, three caravaneers rest and repair clothes. Saidu drops his veil to drink tea.*

not resist its contagion. They have heard about strange French customs and tease me about them. They think all Westerners are French.

I learn that after returning home from selling their salt in Kano they will once more journey across the desert, this time to herd sheep and goats north to the market of Tamanrasset, in Algeria.

JANUARY 18

This morning an icy gale blows over the bivouac, and nothing else moves under the pale nascent sun. Covered up to their eyes in their blue cotton blankets—ragged robes laminated together by sewing—the Tuareg sit shivering. Later, as if suddenly awakening, Saidu sends a quivering Ylla for dry grass and lights a small fire with it. Then he calls me over to share the sand-laced *aragira*, which absorbs the last of our water. In no position to cook or to refuse a little liquid, I accept gladly.

Dimmer and dimmer the sun rises, and with it the violence of the sandstorm. I wonder how the Tuareg will find the camels. The dark sand screen hides even the two that sit next to us.

Akundes drives in part of the camels at ten o'clock in the morning. They tremble and urinate as we hobble them, and the tempest whips their urine in our faces. Backs to the storm, eyes closed, and looking miserable, they crouch in eerie silence.

An hour later Herca brings in more camels—the last ones. We unshackle them and tie their ropes to lead them to their loads. But before we have loaded many of them the sandstorm

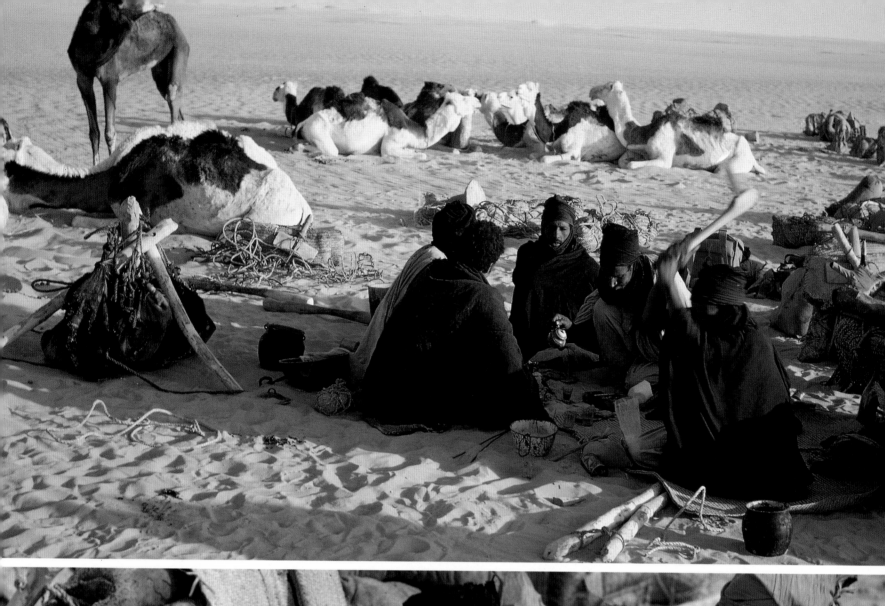

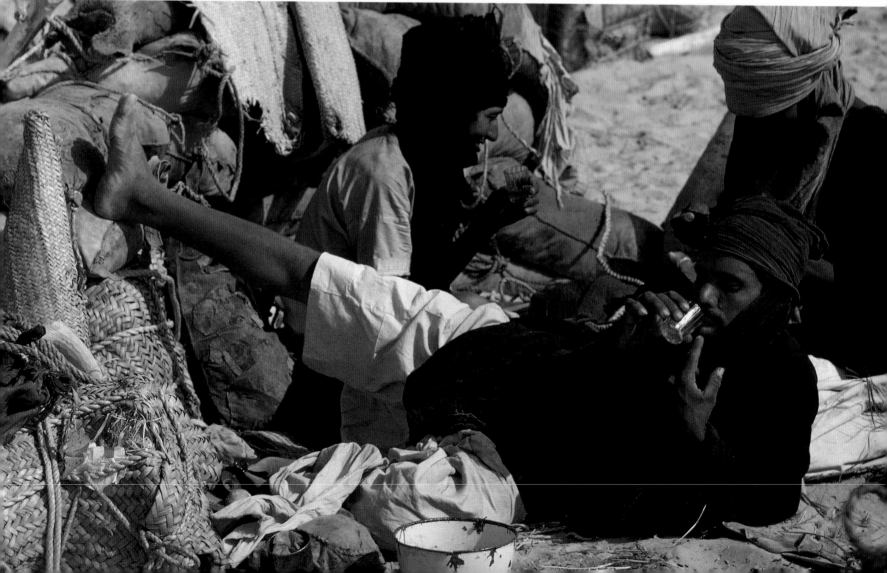

blows with renewed violence, forcing us to unload and push the shivering animals back to pasture.

Huddling under our blankets, we wait for the storm to end. Time passes and hunger and thirst nag. With the last of my sardines and dates gone, I crunch raw spaghetti.

At 1:30 P.M. four *iklan*, three of the Kel Ferwan and the Igdalen one, leave on foot to butcher one of the Kel Ferwan's camels who was found this morning with a broken leg. Tired of waiting out the storm under my blanket, I shake the sand off me and go with them. It takes the *iklan* only an hour to butcher the poor animal and load the pieces onto three camels, but the round trip lasts five hours, which shows how far a hobbled camel can move during a night of grazing.

We get back to camp after dark. The Igdalen have already retired, but they call me over to give me a little liquid mud for cooking. One of them went out this afternoon to dig it out of a wadi somewhere. I drink it all, and forgo dinner.

JANUARY 19

I wake to find Saidu waiting for me with a bowl. He wants me to go to the Kel Ferwan, who camp nearby, and ask them for some water. If he thinks it less shameful for a European to beg other thirsty people for water, he is wrong, but I cannot refuse him that favor. The Kel Ferwan, who must be less wasteful, graciously fill the bowl for me. Thanks to them, we all drink one little glass of tea. We will have to wait until tonight, or perhaps tomorrow, to be able to drink again. If the Tuareg at the Tree of the Ténéré said that our next water hole was only three days away, Allah decided otherwise and added three more.

The Igdalen seem as eager to be gone this morning as I am. The camels are brought in by eleven o'clock, and we leave before the Kel Ferwan. In late afternoon we find in our path a small *gerba* half full of water. Though hard to believe, a caravan that went before must have dropped it. We sip some and keep the rest for the evening.

The sun sets, but contrary to their usual practice, the Igdalen do not dismount to pray. Wrapped to the eyes in their flimsy blankets, they must feel too cold to do so.

We walk until eleven o'clock at night and release the camels on sparse scrub, which we now do every night. Feeling rested

by our days of inactivity, I propose to cook spaghetti for all of us, an offer that my companions accept gratefully and to which they contribute a piece of the camel neck the Kel Ferwan gave them for the help of their *akli* in yesterday's butchering. It is as tough as leather, but a welcome change from our monotonous fare. Having given me water for the cooking, Saidu divides the rest among our group, which results in one cup per person.

JANUARY 20

At noon three Kel Ferwan ride through our camp with empty *gerbas* they will fill at the Tazolé well—a ten- to twelve-hour round trip—while their friends are finding some missing camels, and Herca gives them one of our own skins to fill. The Kel Ferwan stayed behind last night and did not camp with us.

For no apparent reason the heat returns today with a vengeance, and my friends are uncharacteristically worried about my thirst, but I am fine, and in fact grateful that they finally decided to help Allah.

We leave at two o'clock in the afternoon, and Akundes goes off our path to fill our *gerbas* at Tazolé. At sunset we meet the three Kel Ferwan riding back with water. They give us our *gerba*, and we drink. The muddy water is so thick that I can hardly swallow it. The Tuareg drink it like camels. We camp at eight, long before Akundes returns.

JANUARY 22

We leave at eleven o'clock in the morning in hellish heat. The sun and the glare, constantly in my eyes, give me a headache. To try to shake it off I walk most of the time, but to no avail.

We cross a caravan of Kel Owey on its way to Bilma. The Kel Owey have interbred with their slaves so much that they are more Negro than Tuareg. Their caravan looks different from ours, too, for at this point they are not transporting salt but hay, firewood, articles of trades, and live goats. We camp at six o'clock in the evening.

JANUARY 23

Our pace is getting ever more leisurely. With pasture and firewood readily available and water nearby, the Tuareg now spare their camels. There may be another reason for slowing down.

This is the time of Ramadan, when the faithful must refrain from eating and drinking during the day. Caravaneers enjoy a dispensation from such harsh fasting, however. I wonder whether the Tuareg are stretching that dispensation.

At 3:30 P.M. we reach Torayet, an encased water hole in a wadi. Akundes and I run ahead to fill the *gerbas*. I bathe and scrub my pot, which surprises my friends. "You already bathed in Fachi and at the Tree," they remind me.

Our caravan divides here. We already lost the Kel Ferwan, who have not caught up with us and must have altered their course toward the north of the Aïr. Now half of our men will stay here to water their camels. Following the wadi through bushy vegetation, only Saidu, Akundes, Herca, the Kanuri, and I go on. We camp at sunset.

JANUARY 25

The last four days were slower than ever, with late departures and early stops, but I did not mind. The landscape of the Aïr mountains, parklike and cut by lush wadis, was beautiful and teeming with life. Caravans went by in both directions. We passed a couple of Kel Owey men on a zigzagging course behind a capricious calf. They were taking the calf, three sheep, three goats, and two camels loaded with salt to the market of Agadès. An *enad* (artisan) appeared from nowhere with a couple of pack saddles for sale, which the Igdalen examined without slowing the march and bought for a block of salt each. Passing a tent, I bought goat cheese and milk from a Kel Owey woman to supplement my dwindling provisions. Cattle and goats were everywhere, and an occasional gazelle stopped grazing to watch us pass.

NEXT PAGES *The caravan walks toward the setting sun. Boundless space encourages the camels to walk side by side.*

Yesterday my friends took so long to gather the camels that not enough time was left to travel anywhere. Instead they decided to water their animals. Before going to the well, Saidu asked me for my soap. If he was going to wash, I knew we had to be very close to Agadès.

This morning, just as I was going to give my blanket to Saidu, I found it half eaten by termites. Saidu found one of his camels ill and had to abandon it in a Kel Owey encampment. He will return for it and its load in a week or two.

The time has come to part from my friends, and I suddenly feel a greater anguish returning to the other world than I ever experienced entering the Ténéré. With "civilization" at hand, my past journey no longer seems real. Was it all a dream, a beautiful dream that I will remember with ever greater tears as I grow older? Or did I really live for a while in a parallel world? I cannot say. All I know for sure is that I am extremely sad.

The Kanuri are leaving. Agadès is only a two-hour march away, and I will follow them there. The Igdalen will bring my luggage later to the house of one of the Kanuri's friends.

Through the slit of his veil, Saidu's eyes are warm with friendship as he takes my hands in his. A knot in my throat stops me from saying much, but we understand each other. "*Bellafia*," he says. "Farewell." I walk away in Tuareg fashion without looking back, but a shrill cry forces me to stop.

"You're good with camels," yells Saidu, "but your *tagilmust* is too short."

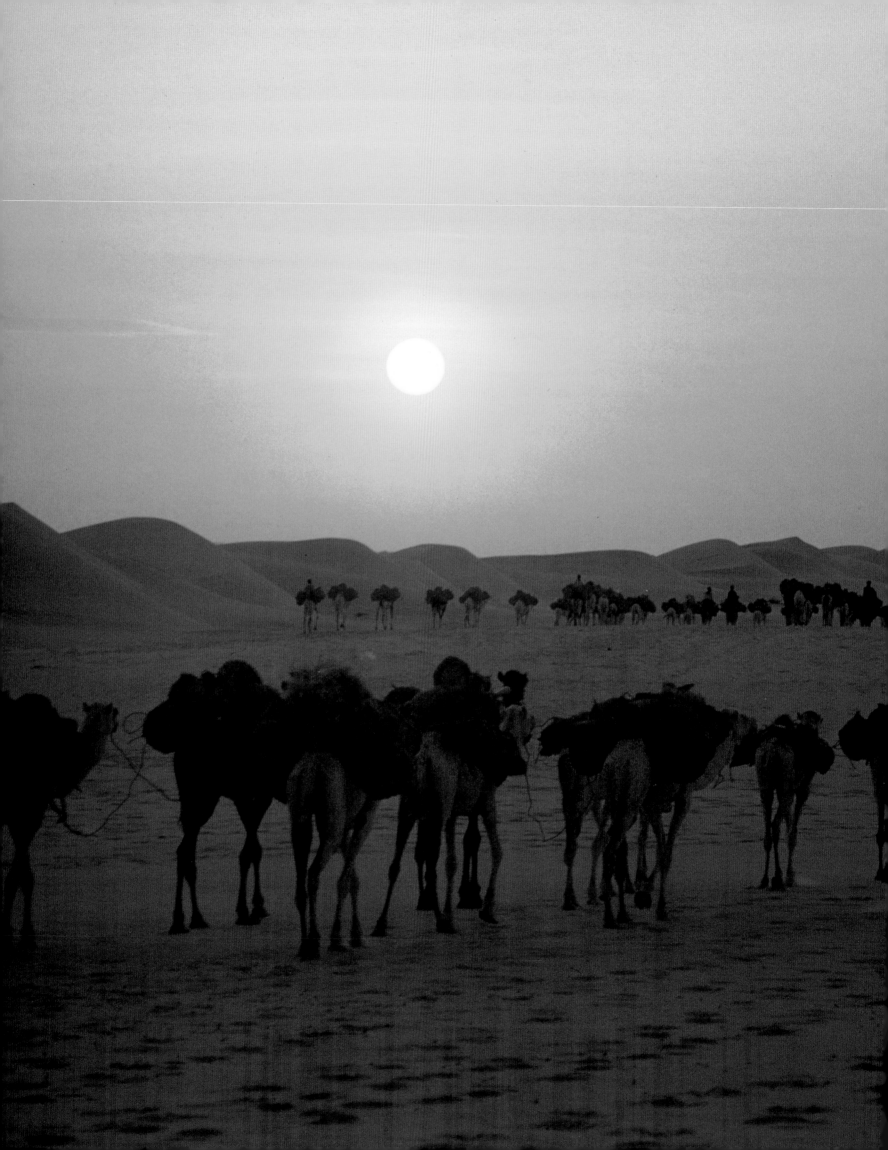

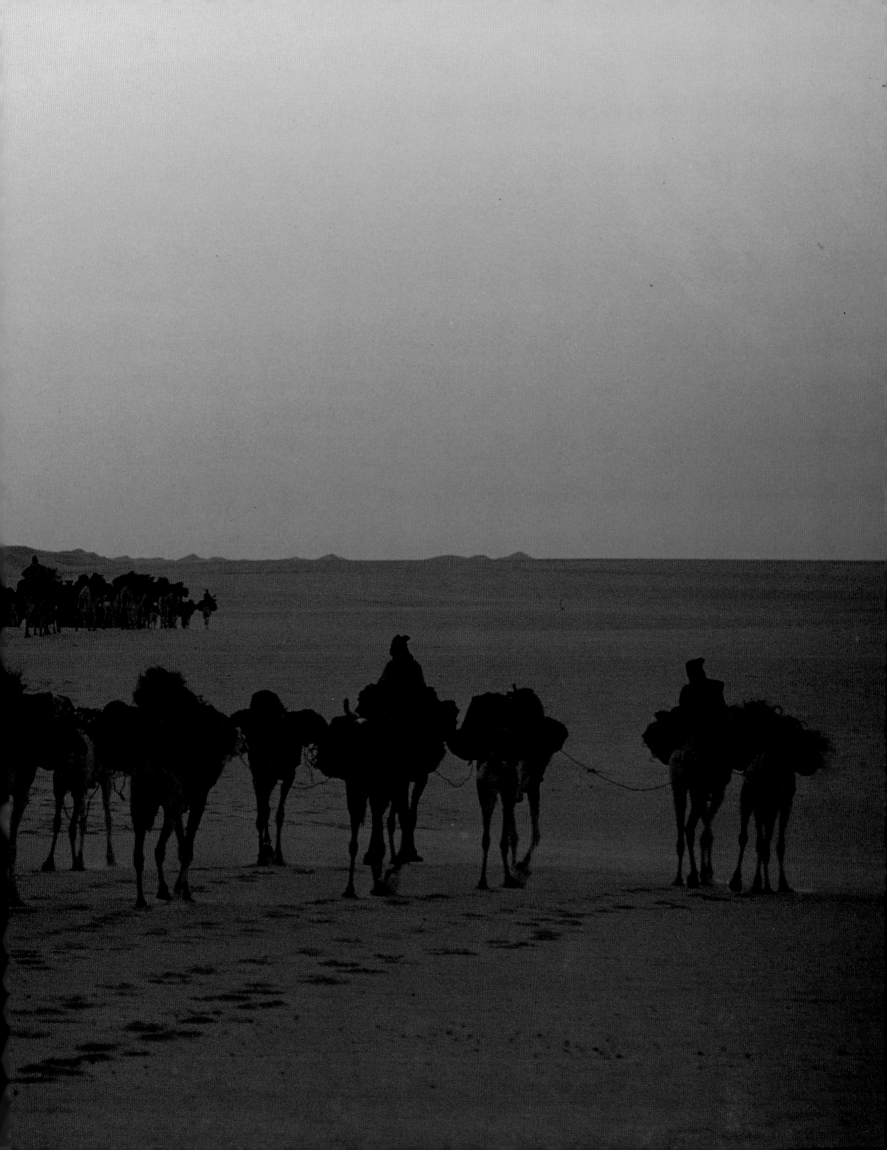

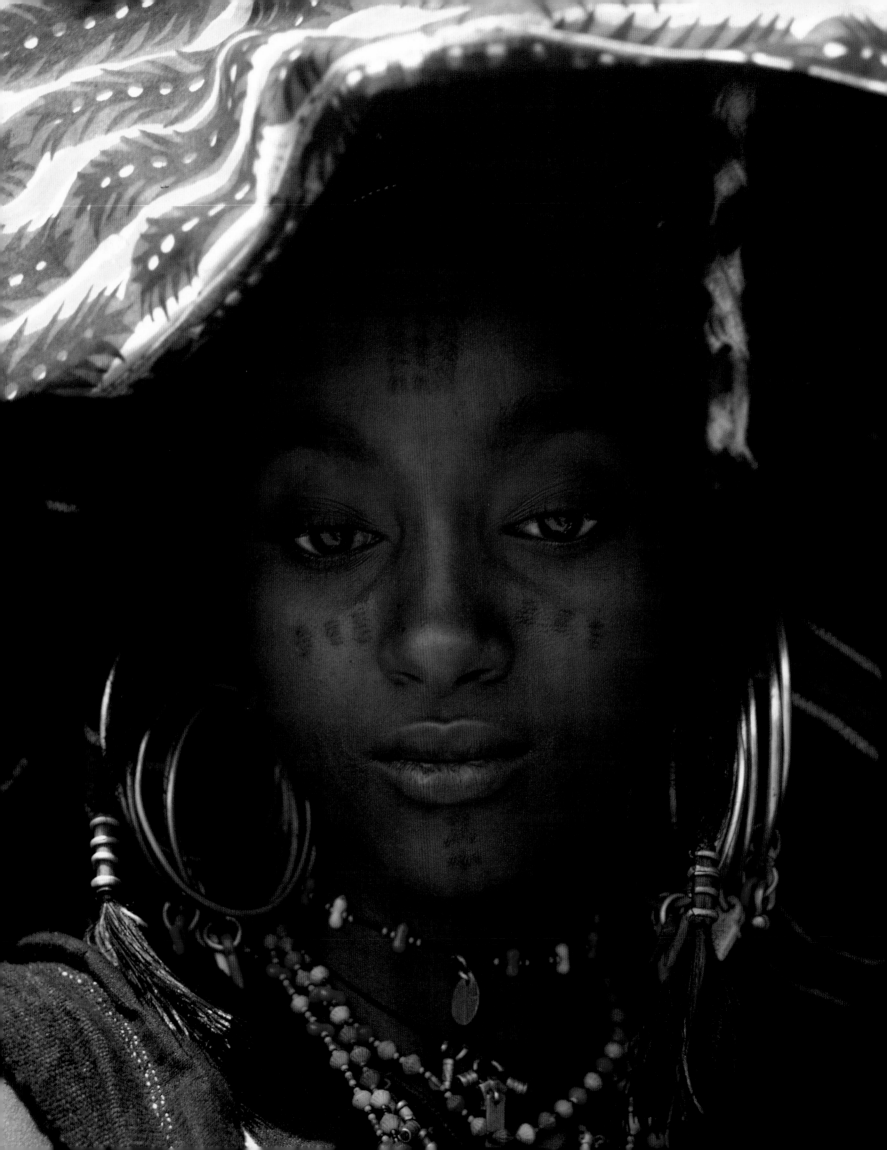

Part Three: The Bororo

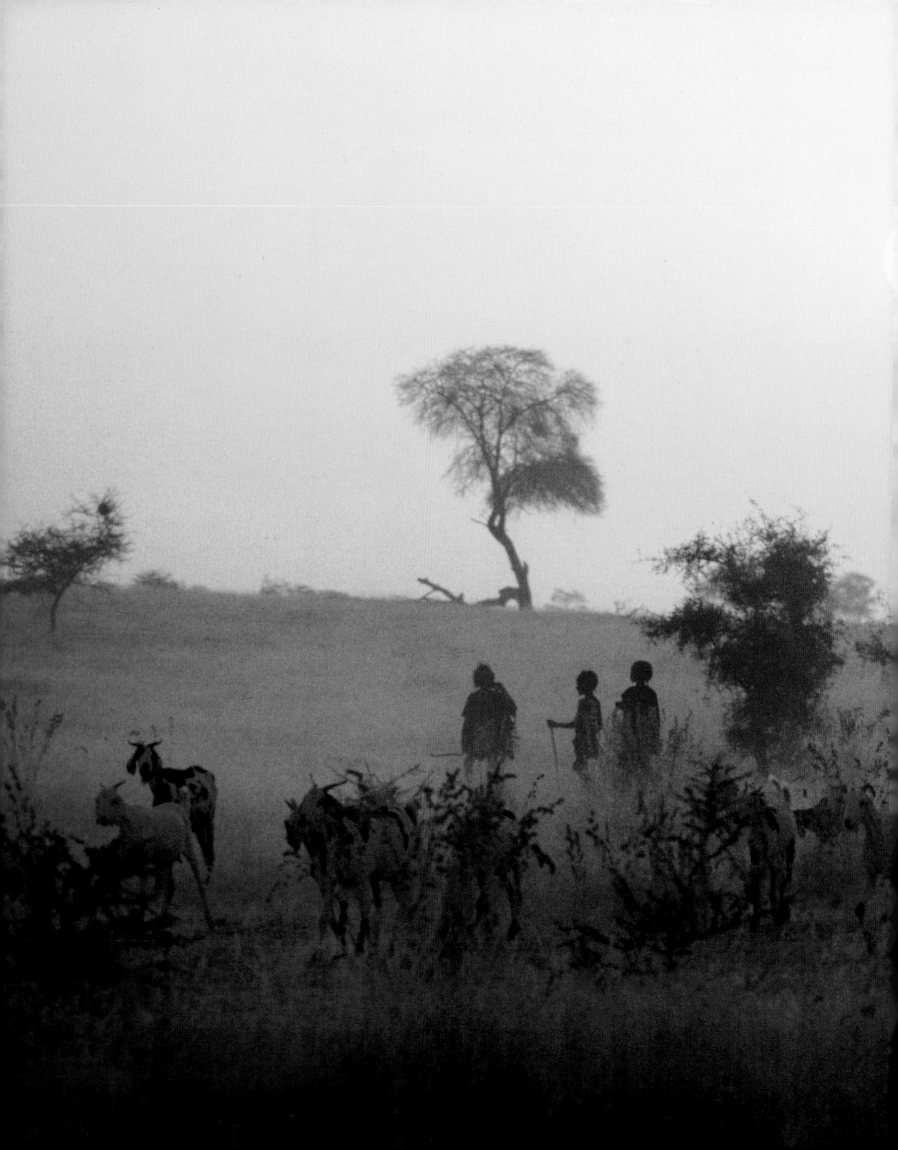

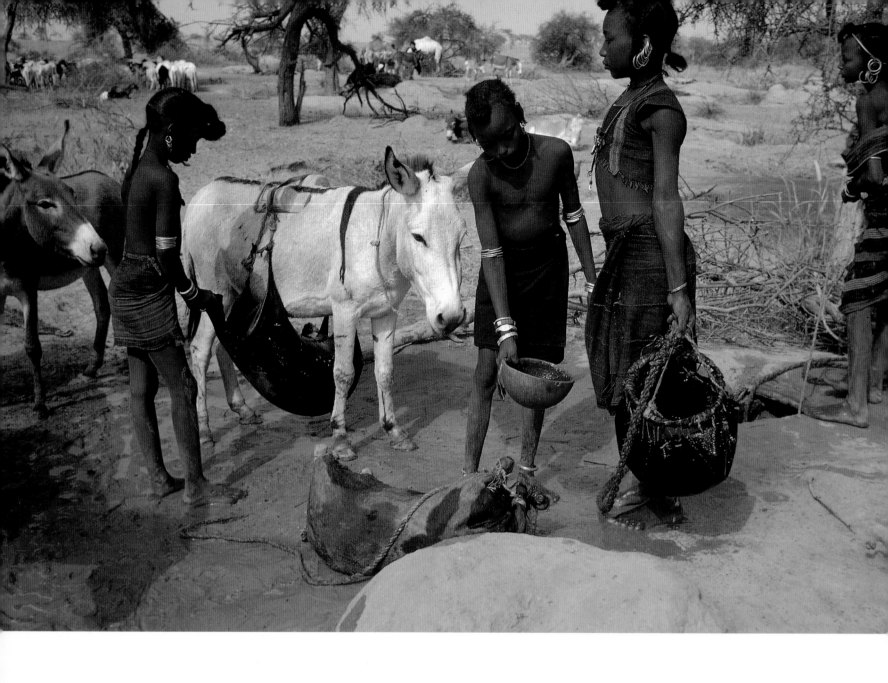

Profiled against the canopy of stars, a circle of heads slowly turns around me. Of the hands clapping and of the feet sliding over the ground I see nothing, for it is night. The bodies move shoulder against shoulder, up on toes and down again, and on each head quivers a black ostrich feather. From the darkness of the earth, slowly wrested from the guts, mounts a deep chant. Born from the solitude of herdsmen under a boundless sky, it fills my head, displacing all thought.

Beyond the heads and the black ostrich feathers, through the moonless sky, the Milky Way stretches its vaporous scarf sewn with diamonds and pinned with constellations, Scorpio and Orion. The clear voice of a dancer rises to the stars, alone. He sings a few words, repeated by the others, and resumes his solo before the chorus dies away, so that his voice seems to be reborn each time from the dying clamor. He sings with his heart, as seriously as if he were praising God, and with equal fervor the others echo him, exalting in me everything I have ever loved.

But next to me an old woman points a finger at one of the dancing men. Obediently, I light him with my flashlight. She scrutinizes him while he feigns complete indifference, then she utters a shrill *yu-huu* to spur the circle into a better performance. To the unfortunate men whose appearances do not meet the criteria of the race—figure tall and slim, elongated limbs, forehead high and convex, nose and lips thin—she throws sarcastic words. These ideal features, long tainted by miscegenation, are not the lot of every Bororo, yet their want can be redeemed only by brilliant wit. Thus nobody laughs, for many could be ridiculed. Instead the dancers raise their heads higher and move with new vigor.

Imperceptibly the rhythm has changed, the dancers have passed to another chant. Half of the circle now sings something which the other half answers. The chants, a few syllables interminably repeated since midafternoon, will resume tomorrow. And the next day, and the next. But their monotony is moving and beautiful.

Night has swallowed the old crone, and my friend Mokao, who had left me alone in the middle of the circle, has come back. Silently he takes my hands in his. He looks up at the sky, and I wonder whether, like me, he is noticing how far during his absence Orion has traveled through the sky. Though married, he must have been hiding in the dark with a vibrant maiden. So many Bororo couples, during the dances, disappear into the night. Now the fires are out. Already the savanna is dotted with bodies resting coiled on straw mats. Soon the last dancers will disperse. I too retire and go lie under my tent, which the rainy season has forced upon me.

We are near the well and settlement of Tchin-Tabaraden in the Republic of Niger, camped in the Azaouak, a savanna region bordering the Sahara, where recently I was living with Mohammed, chief of the noble Iullimiden Tuareg, and his family. The Iullimiden and other Tuareg tribes temporarily migrated north, to salted pastures near Tegguidda n'Tecem, and the Bororo, like air filling a void, have moved in.

RAINS BRING TEMPORARY RELIEF TO A LONG MISERY

In this beginning of August the immense steppe, so hopelessly dry the rest of the year, is swept by storms that will last a few weeks and then rapidly die. Puddles and ponds glint in every depression, and a soft breeze makes the short green grass shiver in the cool mornings following nights of tornadoes. The acacia trees have hidden their long thorns—thin little bone reminders of the skeletons that will litter the savanna during the dry season—under a profusion of tiny green leaves.

The rains mark for my nomad friends a respite from a long labor, from a quest as unrelenting as it is disappointing, sometimes from a long misery. With grass and water everywhere, they no longer need to endlessly pursue the horizon, each family on its own, in search of ever rarer water and scorched pastures. In fact, the grazing is rich enough to let the nomads gather to-

gether with all their herds. No longer must they draw the parsimonious water from wells for the thirsty cattle, which may now drink unassisted right from the ground. The time is for rest, transactions in cattle, reunions, dances, and marriages.

Visiting my Tuareg friends of the Azaouak, for years I have been intrigued by these Bororo, so strange in their ways and dress, so appealing in their shy gentleness. Sooner or later I had to get to know them a little better.

THE SCATTERED ONES

From a stock scattered between the Atlantic and Lake Chad and speaking a language called *Fulfulde*, they are distinguished from the tribes among whom they live by their stiltwalker elegance, their sharper features, the copper skin of many, and, most of all, their association with herds of large reddish zebus of a race only raised by them and bearing their name. Even their origins seem tied to their herds. Their oral history starts with the adoption of their first cows, as they emerged from a large sheet of water somewhere to the east, perhaps Lake Chad or the Nile. More probably the Red Sea.

Their insistence in seeing themselves as Caucasians, using all the artifices of makeup to lighten and sharpen their appearance, and the occasional emergence of Caucasian features among them, suggests an ancient past in which their ancestors possibly crossed the Red Sea from Arabia. It is a past so remote, however, that they might also be the dark cattle herders of the frescoes painted several thousand years ago on the cliffs of the Tassili-n-Ajjer, in Central Sahara, when the greatest desert on earth was still a humid savanna inhabited by all the wild animals now found in the grasslands of Kenya. The prehistoric artists who recorded on the rocks their daily life portrayed a pastoral people amazingly similar to the Bororo.

The Bororo belong to the great population known in English as Fulani, six or seven millions in all. They call themselves *Fulbe* (singular, *Pullo*), which might mean "the scattered ones," but every tribe among whom they live has for them a different name. Some of their forebears in the tenth century founded pagan kingdoms; others, converted to Islam, ruled Moslem states that rose to the dignity of empires. Many settled in cities or villages or farms; but others, the pastoral Fulani, remained nomads.

Among them, custom and prejudice set the Bororo apart as a distinctive people.

Today the Bororo, who wander in the merciless sun of Azaouak, halt during the dry season at village markets to trade milk and butter for millet or millet bran. In the rainy season, as the Tuareg retreat to the north, they move into their land. Faithful to their ancestors' ways, they stubbornly reject outside influences. They feel threatened, however. The Tuareg, no longer able to live from plunder, are slowly pressing south in search of greener pastures. Hausa agriculturists to the south, each year turning more bush into millet fields, are slowly edging northward. After the harvest in September they welcome cattle to graze in the millet stubble, for manure enriches the land; but if the rains fail and the nomads invade the standing grain, quarrels arise and the farmers invoke the law. Although the government of Niger tries to keep peace and protect both groups, the Bororo mistrust it.

ELUSION KEEPS THE BORORO OUT OF HARM'S WAY

Because they fear spirits and intangible powers and the malevolence of man, and believe they must at all cost avoid giving any of them a hold upon them, anything to work magic or sorcery upon, be it a name, information on kinship and animal ownership, or even some hair or a rag, the Bororo protect themselves through constant elusiveness. This makes the outraged Tuareg call them "liars." They hide their feelings, their thoughts, their knowledge, and their projects. They do not call their children by their real names, which they keep secret, and they never give a son the name of his father. A child who would call his parents "mother" or "father" would be told bluntly that he is not their child, that he was found in the bush. And only in the greatest isolation and the darkest night will a mother show a child her love. Many other taboos impose upon the Bororo restrictions and silence. They avoid outsiders, who may not easily establish with them any kind of relationship.

My first attempt at gaining the Bororo's acceptance met with

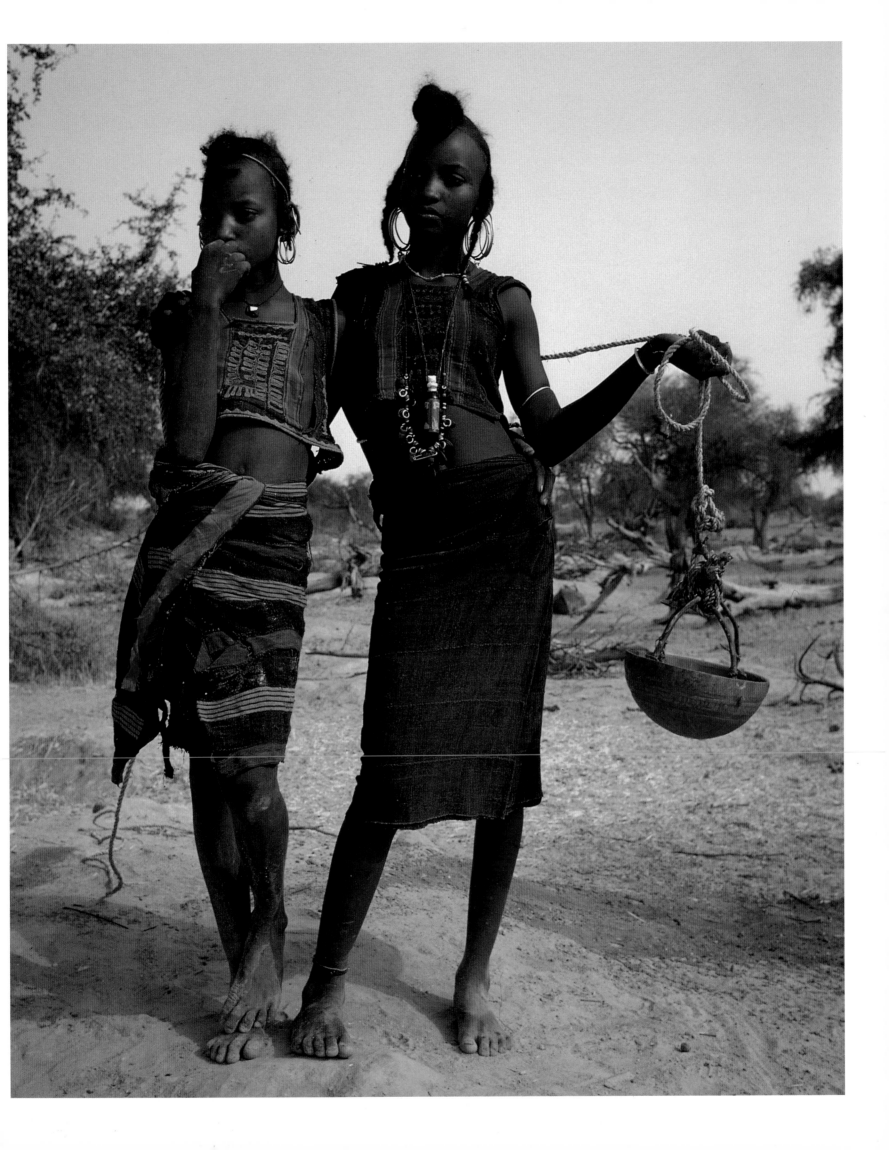

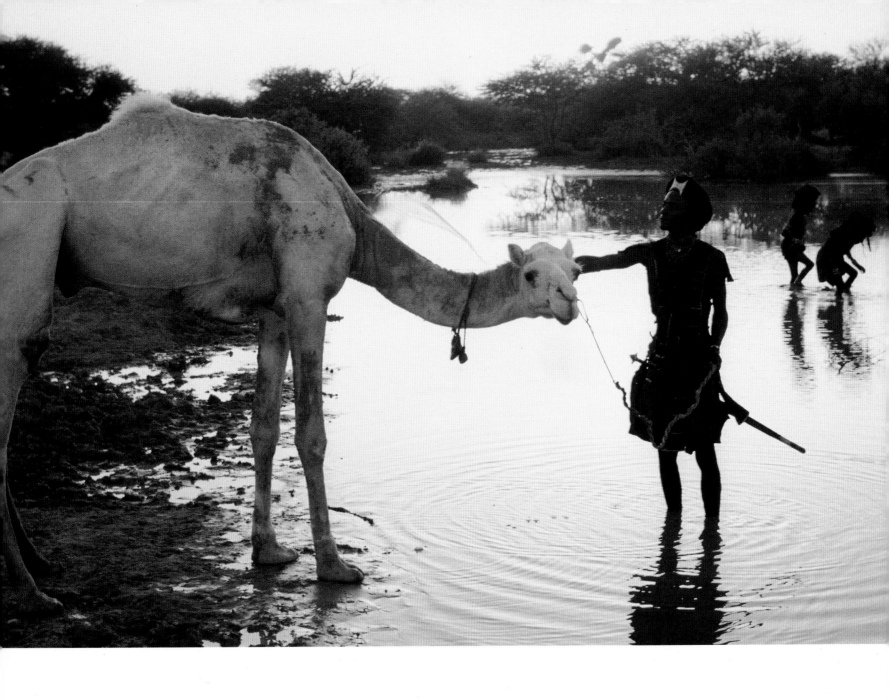

complete failure. To look after my five camels and serve me as guides and interpreters, I had unwisely hired in the little administrative post of Abalak two young Tuareg. Knowing so many of those nomads, it was the easy thing to do, mostly since many Bororo speak the Tuareg language.

One Tuareg, Mohammed, was a bright thirteen-year-old boy who had learned French in school; the other one, Ruumer, a sixteen-year-old relative of his. Gentle and kind, his face always lit by a bland smile, Ruumer was uncharacteristically indolent, and I had hired him more to keep Mohammed company than to take care of our camels. On seeing us off, his family had jokingly recommended that, to remind him of his duties, each morning I deal him two blows on the face. And from the first night he had proved his family right by falling asleep over the meat he was cooking for us and letting it run away between the teeth of a dog. Both of these young Tuareg were wary of the Bororo.

Having wandered through the Azaouak for a couple of days, we had met two Bororo I knew from a previous trip. They had led us to their camp, where the elders had timidly let us pitch nearby. At dawn they had disappeared—people, animals, huts, and all. They own so little that in a few minutes they can load it all on a carrying ox and be gone (I once saw a so-called Red Fulani whose total possessions—bow and arrows, straw mat, calabashes, plaited straw bag, rope, a small bundle of clothes—hung at the ends of a stick he was carrying across his shoulders). I could have followed their tracks, but thought better of it. So I returned to Abalak, and exchanged my Tuareg companions for two settled Fulani.

Bamo, who thinks he may be sixteen or seventeen, recently finished grammar school. Abdullah, perhaps ten years older, never sat in a classroom, but like Bamo speaks broken French. He even taught himself to read somewhat, and he carries with him a school reading book to decipher in his spare time. They are not caravaneers; they take forever to load our camels, but when, four or five hours out of Abalak, we reached a new Bororo encampment, I got a very different welcome. Abdullah knows

so well how to behave with the Bororo, that the chief brought us a sheep to roast, and others gave us huge calabashes of milk that they expected us to empty, which nearly gave me indigestion. I returned the courtesy with a distribution of tea, sugar, and medicine.

Bamo and Abdullah speak of themselves as "Red Fulani." Like all the so-called Red Fulani, who are the "regular" Fulani, they see themselves as racially purer than the Bororo. So much purer that they consider themselves of the same color as Europeans, who to them look "red" rather than "white." Though I will not question that they may be a shade lighter than the Bororo, something often obvious only to them and their prejudiced brethren, they are as close to me in color as grizzlies and polar bears are to each other. Against all evidence, the Fulani, red and black, who have not forgotten that some of their ancestors, hundreds or thousands of years ago, were white, still like to think of themselves as Caucasian.

CHILDREN OF INCEST

In spite of the warm reception we got, Bamo and Abdullah despise the Bororo. "We call those people *Wodaabe*," Bamo told me while we journeyed, "which means, 'Those that one avoids, the isolated, the rejected.' They have a shameful origin—they are children of incest."

That the Bororo are incestuous is in the Sahel common gossip, though to what extent this is true is hard to tell. I know of other regions of the world where people often marry their cousins, and as a result are hiding in their houses Mongolian idiots. Though the Bororo are accused of more shameful unions, and have no place to hide anyone, I have in a few months discovered among them nothing more abnormal than one midget. In any case, the stories of their promiscuity abound, and concerning their origins Abdullah told me the following story: A noble Fulani girl used to visit the family's black slaves to milk the cows they herded on distant pastures. One night, delayed and unable to return to her encampment, she was raped by one. With the baby and the slave she traveled very far, to where nobody knew them, and the slave gave her a second child, a baby girl this time. Because the union that had given birth to those children was suspicious, however, they were so ostracized that when the chil-

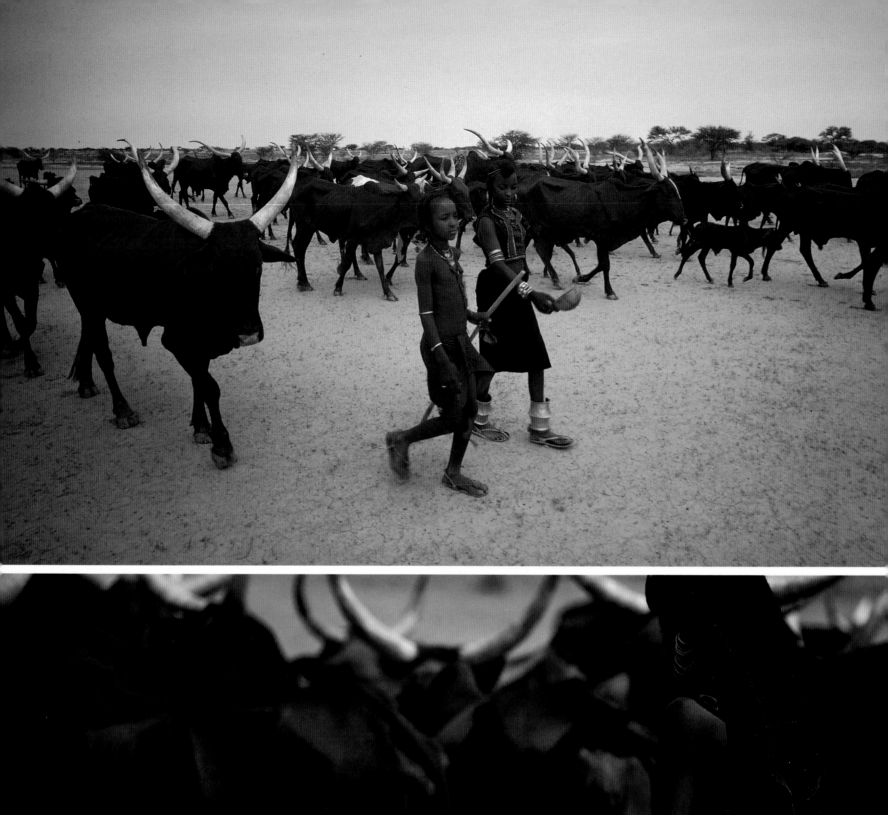

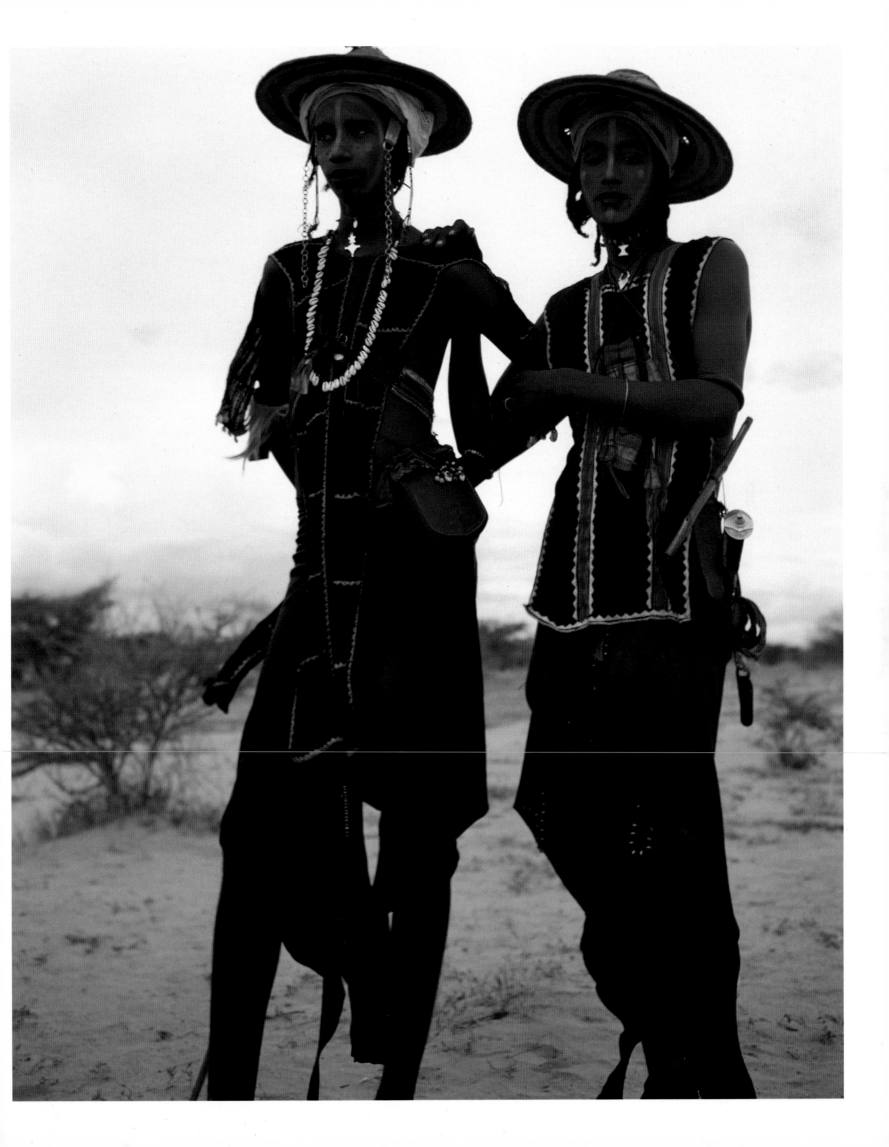

dren grew older they had no alternative but to marry each other. When the great Moslem conqueror Uthman dan Fodio heard about that, he summoned the Fulani, and before them ordered the girl to go back to her father and ordered the brother to stop seeing her. But they would not comply, and Uthman dan Fodio exiled them forever, saying, "You will be the Wodaabe, the untouchables." From that day the women were condemned to wear seven large brass rings in each ear.

Marguerite Dupire, the French anthropologist (*Peuls nomades*, 1962), tells an even more extraordinary story: A Fulani died in the Katsina region, leaving a wife and a son. Handsome, the young man was sought after by every woman. One night, his mother slipped in his bed next to him. She did not know he was her son, nor did he know she was his mother. But to recognize her later, he made in her arm a slight knife cut, and the next morning asked his friends to help him find her. But he found her himself, as she was sweeping. Ashamed of what he had done; he fled. He traveled to the Bornu, and learned the Koran from a holy man. Meanwhile his mother gave birth to a daughter, who grew up to become a beautiful girl. As she was reminded constantly of her parents' crime, she went to hide her shame far from home, and coincidence led her to the same region that had attracted her father (brother) before. As he had not married yet, his friends suggested he take her for his wife. He did, and later questioned her on her origins. He learned that she was from the same village; he asked her the name of her mother and recognized that she was also his own. He inquired about her father, but she would not tell him his name, only that she had heard that he was also her brother. Jolted with shame for his

double incest, he went to confess it to his master the holy man, who told him, "Such action is damned by God. Leave with your wife and cattle." They had a son, who became the ancestor of the Wodaabe.

Our hosts belonged to the Godje lineage, rich in cattle but not very good-looking by tribal standards. Certainly not by those of Abdullah, who prizes beauty over everything else. Constantly, with despicable comparisons, he attracted my attention to someone with "bird legs" or "as black as a dung beetle." Though not particularly handsome himself, he is so vain that, not content with devoting excessive time and attention to his appearance, he also refuses to hang on his camel any unsightly baggage.

While with the Godje I met Mokao, a pleasant man in his mid-forties, who had come visiting. I accepted his invitation to stay with his family, and the next day we followed him to his encampment, a six-hour march farther on. To find his family, who had moved during his absence, he had to find their tracks. The day before he had made, in the opposite direction, the same six-hour walk only to assist at a dance, and he had done the same thing two days earlier. Of the handsome Binga'en lineage, "sons of Nga," Mokao's family comes much closer to ideal beauty.

MORNING UNFOLDS FROM SALUTATION TO ENDLESS SALUTATION

The sound of voices awakens me at dawn. The small groups of people that have scattered to sleep in the bush, and are now rising one by one, call to mind etchings of ancient military camps with plumed musketeers strolling among seated soldiers. Some old men, wrapped in blankets and seated on straw mats near an extinct fire, are waiting for the sun to chase the chill of the night. At some distance, still adorned for yesterday's dance, a few girls retouch their makeup for the new day. Beyond, among the acacias, couples are stretching, rising from their mats. Young men in leather pants and wide conical hats adorned with ostrich feathers, armed with spears and swords, walk by twos or threes from one group to another.

And the air resounds with interminable salutations. "*Foma, foma*? How are you, how are you? And how is your health, your family, your herd? Where are your children? Have you spent a good night, a good week?"

"*Sago, sago*. All is fine, all is fine," the others answer.

"*Baraka, baraka*. Blessings, blessings."

The long list of polite questions answered, the parts are reversed and the salutations started again. These greetings are exchanged as if with total indifference, eyes averted in deference and respect.

Mokao, whose family is especially likable, greets everybody. His gentle and dignified wife, Mama, and one of his daughters, Bebe, a pretty girl of fifteen, help distribute large calabashes of creamy milk to visitors from other households. Mokao serves the men; Mama, the women of ripe age; Bebe, the young women. When the women have returned to their respective camps to work, the men palaver in the shade of trees. And the greetings, endlessly recited in monotonous singsong, are followed by many invitations of "*Leste*. Sit down."

The morning unwinds from "*Foma*" to "*Foma*." The sun climbs relentlessly, making the air as thick as wool and slowing down all activities, then starts its descending course.

By midafternoon the young women have come back. They sit in the shade of trees to beautify themselves. Under other trees, which, for all the swords, hats, and rags hanging from them, look like coat stands, the men have been fussing over their appearance for some time. They spread ocher powder on their faces to lighten them, trace a white line on the ridges of their noses to sharpen them, and blacken their lips with charcoal to enhance the whiteness of their teeth. They adorn themselves with all the beads and *cauri* shells, all the bits of fabric, plastic, hardware—bespangle their clothes with all the buttons, coins, rivets, curtain rings, safety pins, paper clips—their shopping trips to the markets of the savanna have reaped and which their amazing creativity transforms into fineries. Eventually five or six young men, coming out into the sun, form a circle. Resting nonchalantly against each other, elbows on shoulders, they timidly strike up a song.

THE *RUUME* IS DANCED IN A SWORD-BRISTLING CIRCLE

With smiles of satisfaction on their painted faces, other young men detach themselves from the shade and come to join the first, little by little. Their circle bristles with swords that little naked boys caress with respect, and their chant has taken shape.

The circle turns, the hands and the feet mark the rhythm; it is again the most popular dance, the *ruume*.

Foreheads shaved high to enhance their convexity, and all their jewels of brass and copper shining in the late afternoon sun, the young women come later. They observe the performers with reserve, eyes slightly lowered, some sewing to pretend indifference. But they bring on their heads, neatly folded, the blankets they will share in the bush after the dance with the men of their choice.

The slenderness of the dancers' bodies is accentuated by long and narrow blue tunics tightened at the waist or across the chest by elaborately decorated belts of leather, cotton, or plastic, and falling over or inside leather pants, if one may call so the whole tanned sheepskins wrapped around their waists and thighs. The girls' femininity is enhanced by narrow knee-length blue skirts and short tight-fitting blue waistcoats.

Again an old woman derides those dancers whose physiques fail to glorify the race, and old men reprimand the circle for its lack of energy and enthusiasm. Impassive but hurt, the dancers step faster, sing louder. The earth trembles with the beat of their feet and the clapping of their hands tears the air. Their song rises and widens, overwhelming all the other sounds of the savanna, and it seems that nothing exists but the Bororo and their song.

"Fff . . . ," sighs Mokao with relief the next morning as he greets me in the lengthy manner of his people. "They're all gone. Now I can give you more milk again." As on other quiet days, he and Mama put down at my feet two immense calabashes, which they stabilize by digging a small hole under each. One calabash contains about three gallons of fresh foaming milk; the other, as much milk from last night on which floats a thick cream. "Milk: drink! Cream: eat! All!" he urges me.

I, who never drink milk at home, absorb milk and cream for breakfast, buttermilk at midmorning after butter has been made, curdled milk in the afternoon, and again fresh milk at night. Now I believe that one can, like the Bororo in this season, feed exclusively on this liquid and not go hungry.

ZEBUS NEED CONSTANT MOVEMENT

Today we are moving. We move every two or three days, and sometimes we stay only one night at a given spot. Sometimes we walk for an hour or more, sometimes we only go over the next

dune. Sometimes we move with all our neighbors, sometimes with only a few or none of them. Much excitement rises when Mokao's family travels with the rest of the Binga'en and even the Bikoro'en, "sons of Koro," another lineage. Then, with streaming herds dotting the whole area, the march looks like an exodus. This happens on certain auspicious days, days of good omen when every Bororo in the Azaouak loads his carrying ox.

Often it is not clear to me why they move. We never seem to leave less grass behind, and we abandon a relatively clear pool shaded by trees full of singing birds for a dirty puddle. It seems as if the zebus need this movement and the Bororo, like the white cattle egrets, like any of the cows' parasites, just follow. Abdullah says: "Cows are like people. If you give someone much sauce with his millet, he eats the sauce and leaves the millet. So with the cows: When they have eaten the best grass they want to move on."

Except for Mokao, who goes around socializing, everybody is busy packing. Mama and Goshi, her eighteen-year-old daughter, dismantle and pack the wooden beds and the little shelter, roll straw mats, wrap calabashes in special straw covers, gather spoons and ladles, mortar and pestle, and wooden bowls. They load a carrying ox and donkeys fetched by Bebe and another sister, thirteen-year-old Kassa. Kabo, their eleven-year-old brother, helps a bit, watching the cattle from the corner of one eye and quick to throw his stick at a straying cow. This is the time—about 10 or 11 A.M.—when the cows come back from what the Bororo call the "small pasture," the area around the camp, to feed their calves, and they must be kept together until it is time to leave.

THE BORORO LOVE THEIR COWS LIKE PETS

While the ox, the donkeys, and a camel are being loaded, Bebe and Kabo start driving the cattle away. Kabo walks in front, a man's sword at his side and his hands resting on a stick laid across his shoulders. He talks to the cattle and calls them, and they follow like well-trained dogs. A cow even comes to his side and licks his hand, then his face. He laughs with pleasure.

The Bororo love their cows; they treat them like pets, giving each a name—they sometimes name their children after favorite cattle—and letting them die of old age. They only cull a bad milker or an old bull to pay tax to the *goumiers* (a corps of

OPPOSITE *Azaouak region. At a rain pond, a Bororo maiden cleans her brass anklets and earrings with wet sand.*

mounted police composed of Tuareg and a few Red Fulani). The sacrificed beast for a wedding or a birth must be of good quality. They love their cows so much that they center their whole life on them—every move, every decision, every dream.

Bebe brings up the rear. She watches that no calf strays. With two heavy brass anklets on each leg, which she will not discard until she has borne two children, she cannot run as fast as Kabo. Once in a while Kabo stops to let the cattle graze. Then, with voice and stick, he gathers them together again and moves on. In a mood for mischief he jumps on the back of a calf and, laughing heartily, spurs it to a trot. Bebe runs after him and pulls him off, for calves are not for riding. Without ill-feeling he resumes his place ahead of the herd and starts improvising a song at the top of his voice: "I walk before my father's cows / They eat grass / Nobody bothers me / And I am happy / When I will be a man / I will also have a herd. . . ."

Now the others have left the camp and a few vultures have taken it over. They may find a little strip of leather. Dung beetles scavenge every trace of dung. They have been maintaining the camp clean of it, rolling it piece by piece to their holes tirelessly, day and night, as if it were gold nuggets. Nature loses nothing. Soon grass will hide the ashes of the fire and there will be no sign of the Bororo's passage, which is how the Bororo wish it to be. They mark no grave either, and never return to one.

Along the way the cows cross a pond spreading around tall acacias and in the middle stop to drink. The women and children who follow, and the donkeys, stop after them to drink the same warm water, which blandly tastes of mud and cow manure.

Mounted on a camel, Mokao overtakes the herd and shouts instructions to Kabo. A little later the boy and his sister find Mokao's camel saddle under a tree: the new campsite. Mokao has already disappeared to a new palaver tree. Kabo and Bebe separate the cows from the calves, chasing the former to pasture and taking the latter to drink at the new water hole. The others arrive—Kassa on a donkey, with a baby goat in her lap; Goshi on

102

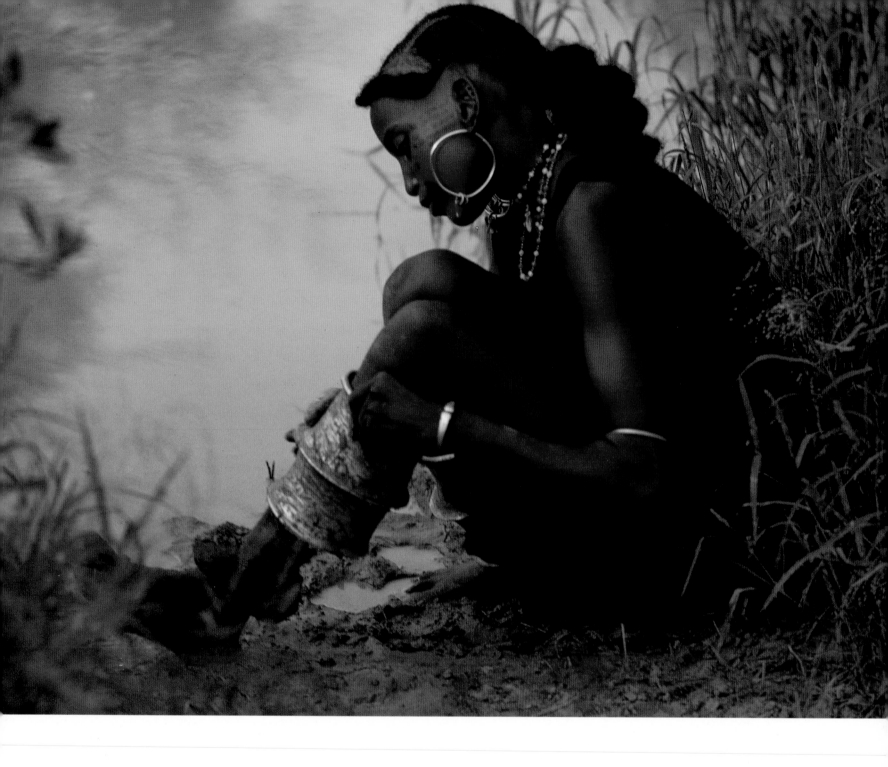

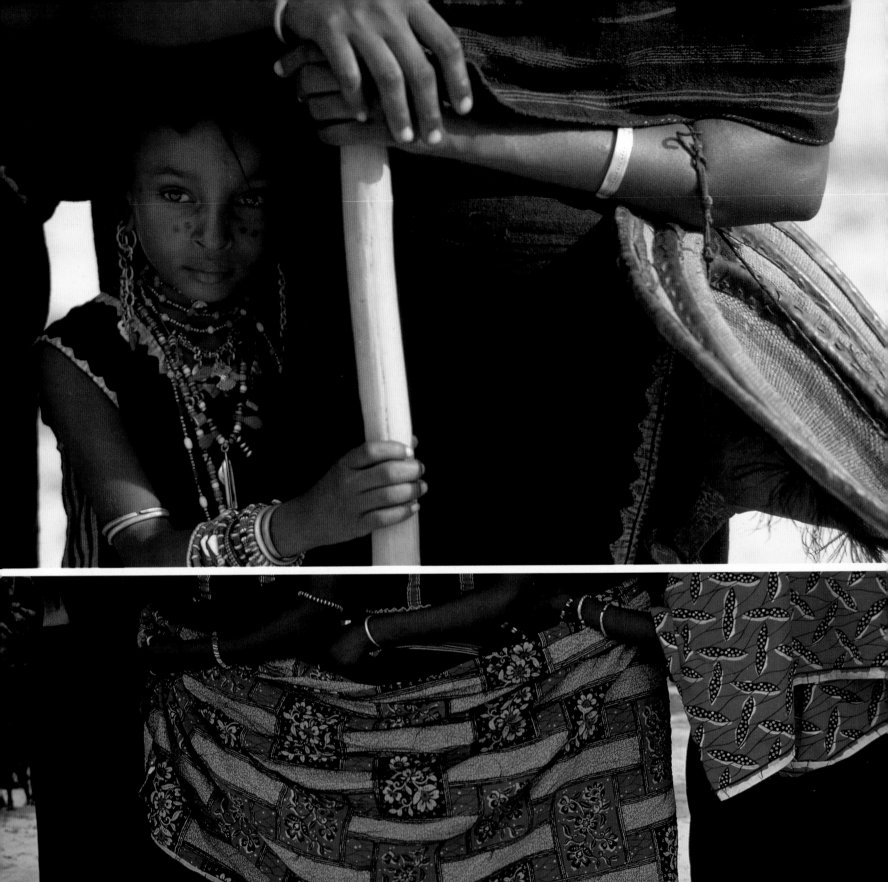

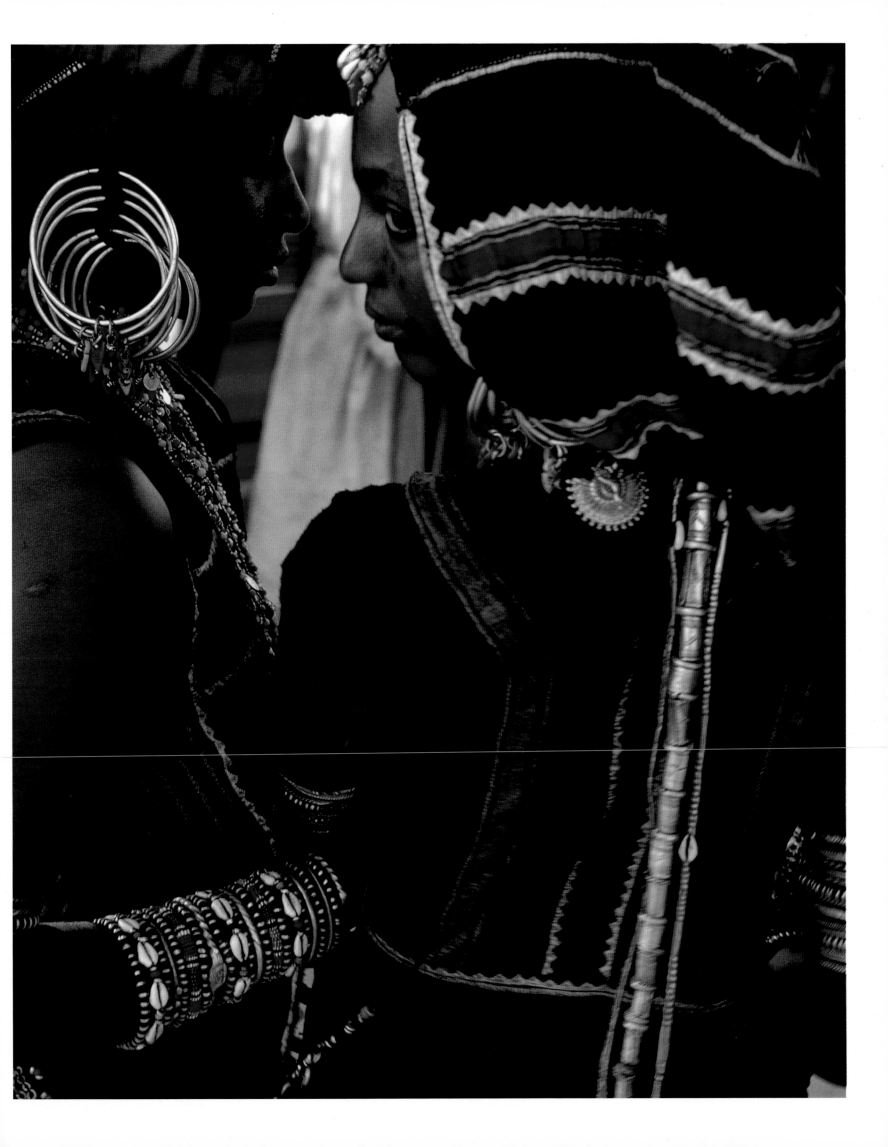

another donkey, leading the carrying ox; Mama walking behind, pulling a camel and carrying the day's milk in a calabash on her head. As they unload things near Mokao's saddle, Mama, who does much of the work, goes to fetch water and firewood.

Abdullah, Bamo, and I set up camp nearby at a place designated by Mokao. At first he would indicate a spot a hundred yards from his camp. Since then he has let us come closer until we are as near his hut as his own brother would live.

It is about noon, the temperature of hell. The cows gone and the calves safely in shade, Kabo collapses under a thorny tree, in a blotch of shade generously sprinkled with sunshine. He sleeps, smiling in a dream. Mama and her daughters busy themselves very slowly, starting to put things into place.

Daily, scouts roam the savanna to find new pastures, for the cattle must be kept in the best possible shape. How they fare during the two or three months of rain will determine their health during the rest of the year, perhaps their survival. Every moving day is much the same. We are in *terre salée*, of grasses rich in natron. We are getting closer, though so little at a time, to In Waggeur, a long chain of ponds flowing into each other during the rains but almost vanishing during the driest months. They lie in a large valley some eighty miles northeast as the crow flies. Mokao's people started their migration almost that far to the southeast, but rains in the north being irregular and unreliable, they have advanced cautiously, along a roundabout zigzagging way, and covered considerably more terrain.

I cannot estimate the cattle's numbers. A Bororo never confides such matters, and for me to try to count the herd would give offense. Before I joined Mokao, the shyness of the huge ze-bus was the cause of all the little conflicts I had with the Godje. They were so wild that, as soon as they saw me or caught my scent, they stampeded so wildly that even the Godje could not stop them. One afternoon, prudently passing among a few cows to enter a pond to bathe, I suddenly found myself surrounded by an immense herd of them. Frightened and threatening and displaying the longest and thickest lyre-shaped horns I have ever seen anywhere on an animal wild or tame, they closed in on me from all parts with shivering nostrils. For a while I felt as if I had just been trapped in a marsh by wild buffaloes. All the trees I could have climbed were on the other side of them, and there was nothing I could do but wait, immobile. Fortunately, a little boy of eight or nine appeared with a big stick. He did not use it, but spoke softly to the animals, and they relaxed. Then he led them away.

ANIMALS ARE LIKE THEIR MASTERS

Mokao's zebus, on the contrary, are quite tame. They would eat my tent if I let them; their urge for salt makes them lick anything I leave around. His dogs are just as sociable. "Animals are like their masters," he explains, and for lack of a better explanation I can only agree with him.

Mokao himself is a sophisticated man by Bororo standards. He often wears cotton robes over his leather pants; and through his intelligence, cunning, and broadmindedness—perhaps also through the prestige of relative wealth—he imposes himself upon his peers and gets along well with people of other groups, even the Tuareg, traditionally at odds with the Bororo.

Though after a long evening dance Mokao may disappear in the bush with another woman, he is monogamous. This is not the case with every Bororo. His eldest brother has three wives. Each has a hut of her own, as does his widowed mother, who lives with them.

Reticence defends family matters, such as Goshi's pregnancy. Perhaps she has left her husband to bear her first child with her mother's help, according to custom; perhaps she is unmarried. The Bororo's morals offer much scope to their neighbors' sarcasm, though no young woman wanders to a market unescorted, or ever extends her favors to outsiders.

But the Bororo have their own concepts of honor. They do not

call for help when attacked by a hyena or a man but fight courageously alone; they disdain any admission of hunger or thirst; they will not eat or drink in front of in-laws, or even name them; they do not laugh loudly and they hide pain. What they call "shame" strangely resembles pride.

As the shadows grow longer, life stirs again in Mokao's camp. Mama and Goshi set up a stand and arrange many calabashes on it by order of size. Later, while Goshi milks the cows, Mama starts building a shelter of limber branches and matting. Kabo drives two stakes in the ground, ten or twelve meters apart, and to them fixes the rope to which to attach the calves. Kassa gets on a donkey and rides it to the well to fill the family's goatskin. In other encampments along the way other girls on donkeys will join her.

Following Bororo tradition, the camp conforms to a rigid pattern. A *daangol*, or calf rope, running north-south along the entrance, separates the husband's area—the cattle corral—from the wife's, which is enclosed by a hedge of thorny branches opening to the west. In the rear of the wife's area are her calabash stand and the family's collapsible wooden beds, each made up of four short pedestals, supporting straw mats under a framework of thick sticks. In the front is the fire.

Mokao's family uses two beds. He and Mama sleep on one, sheltered by a hut, a small dome no larger than the bed, set up only during the rains; their daughters sleep on the other one, outside. Kabo sleeps on a mat on the ground; the children pull mats over their heads when it rains.

Camp Routine Follows the Sun's Path

Almost invariably I can tell what is happening in the camp by the height of the sun. After the first milking, at daybreak, Goshi makes butter by beating milk with a wooden whisk, then shaking it in a container made of two tightly fitting calabashes, rather like a big cocktail shaker. Since she is pregnant, she works mostly around the camp. Meanwhile Kassa goes to the pond for water. When the cattle have finished chewing the cud, they drink; Kabo takes them for water if the pond is far off. Whether they are thirsty or not, he will not let them leave the pond but with full bellies. By eleven o'clock, when the cows are back to feed their calves, there are generally visitors around.

On the corral side, sitting in the shade of a tree, men talk of cattle—naturally. On the women's side, under another tree, Mama, her daughters, cousins, in-laws, or friends sew, weave a mat, carve designs in a calabash, or braid hair. Like most nomads, the Bororo consider manual work below their dignity, and the women will not indulge in creative activities not directly related with their daily needs. The men limit their own to the bare necessities of herding, like plaiting ropes from tree bark or palm leaves. Rather than making themselves the things they need, they prefer to buy them from settled folk, even the men's leather pants, for which they provide the skins. It is unfortunate, for if they applied to handicraft or art the marvelous inventiveness they dedicate to the decoration of their bodies and clothes, we would see some amazing results.

Children play. Like children around the world they imitate their elders. Little girls shape small calabashes out of clay. They fill them with sand, which they imagine to be milk, and cover them with pieces of old mats to keep out flies and trash. Little boys use clay to fashion cows. They peel and carve twigs to give them the color and shape of zebu horns. They dig miniature wells. Like men, they dance and chant. But always they remember their duties—if calves get to the cows to suck between feeding times and rob the family of a milking, the children are to blame.

Boys begin watching the herds at the age of six or seven. Many spend their days with flocks of sheep and goats but, except Kassa's pet kid, this family has none. Abdullah scorns this, for people, he says, should have animals to slaughter to honor guests.

Often I lounge in the shade of my own tree, only half awake in the torpor of noon and hardly able to gather more energy than I need to move with the shade. Abdullah and Bamo slumber much of the time. Mokao frequently sits with us. Every day he asks for a magazine he saw me read to see a photograph of a Lebanese policeman with a red cap and an enormous lyre-shaped mustache. And every day he asks me whether this man has horns like a bull's under his nose. Then he snaps his fingers, shakes his head in disbelief, and gestures that he would flee if this strange creature ever came his way.

Though Bororo and Tuareg often fight bloody sword battles

around wells, sometimes a Tuareg passes by and stops to enjoy hospitality. He invariably pretends that he is looking for a lost cow, yet loses half a day or more drinking milk at the Bororo's expense. I suspect that these men do not even own cows.

The Tuareg are not alone in taking advantage of the Bororo. The Red Fulani do as well. But the Bororo resent most bitterly the *goumiers*, the mounted police who collect taxes from the nomads.

The Bororo Resent Tax Collectors

A dozen of them once passed through Mokao's encampment while I was there. At least they pretended to be *goumiers*. My feeling is that they were acting for their own benefit, stealing cows from the poor Bororo. They wore magnificent robes and red leather boots, were armed to the teeth and mounted on frisky horses. They stopped in the next valley and started rounding up cows.

Following Mokao, who had gone on their heels to try to arrange matters, I saw dozens of Bororo rushing from every point of the savanna with spears, swords, bows and arrows. They were in a mad rage, these pleasant people; their eyes were bloodshot, and they meant to use their weapons. They encircled the horsemen, who took fright and fired warning shots over their heads, attracting even more enemies. A bloody battle seemed inevitable, and I understood why the two Tuareg *goumiers* who had loaned me their camels in Abalak regretted that I was not armed against camel thieves. But Mokao kept shuttling between the groups, preaching calm. He finally reached a compromise with the *goumiers*, who left with only a few animals.

Though the Bororo pay taxes—I have seen papers for sums as high as $500—and understand justice, too often they are treated like second-class citizens. Against all government policies, they may be turned away, for example, from a bush clinic. Uneducated—they refuse to go to school—they have no representatives of their own.

To Dance and Be Beautiful: The Only Concerns During the Rains

To dance every day and to be beautiful seems, during the rainy season, their dominant concern. Usually they dance the *ruume*.

OPPOSITE TOP *Azaouak region. Bororo maiden adorned for a yaake dance. Seven brass earrings on each side frame her pretty tattooed face. She wears on her head the blanket she will later stretch in the bush under herself and her dancer lover.*

OPPOSITE BOTTOM *Bororo dressed and made up for the yaake dance. A straw-and-leather conical hat topped by a black ostrich feather rests on a small turban, from which hang, with his braids, two golden chainlike ornaments. His eyes and lips are blackened to emphasize the whiteness of his eyes and teeth.*

Sometimes, however, standing in a row instead of a circle, they dance the *yaake*. Shoulder against shoulder, slowly and gracefully swinging from one foot to the other, they clap their hands in rhythm with their songs. Their faces more mobile than their bodies, they posture rather than dance. In extraordinary grimaces, they roll their eyes to show their whiteness and, uttering kisslike sounds, strain blackened lips around bright white teeth. To an outsider arriving at this time, they would look like effeminate lunatics. In fact, they are simply trying to please the girls modestly observing them fifteen paces away in a standing parallel row in front of them, for the *yaake* is really a male beauty contest.

Some girls have been designated by the young men's leader to elect the best-looking dancers. Toward the end of the performance they slowly advance in pairs, one at a time, in the direction of the dancers. Eyes lowered, holding each other by the waist, they swing their right arms high as they walk. Within two paces from the dancers they stop and for a moment freeze their arms horizontally to reveal their choices, then swing around and return to their places while the next pair moves forward. Once, however, I watched a different reaction to the *yaake*, when old men stepped forward one by one and lifted a fist above the heads of their favorites.

After the dancers have scattered, the preferred ones gather around the girls that singled them out. Excited and smiling, they touch the girls' arms, caress their hair, whisper in their ears; with imploring expressions, they try to retain them by the wrists when they start moving away.

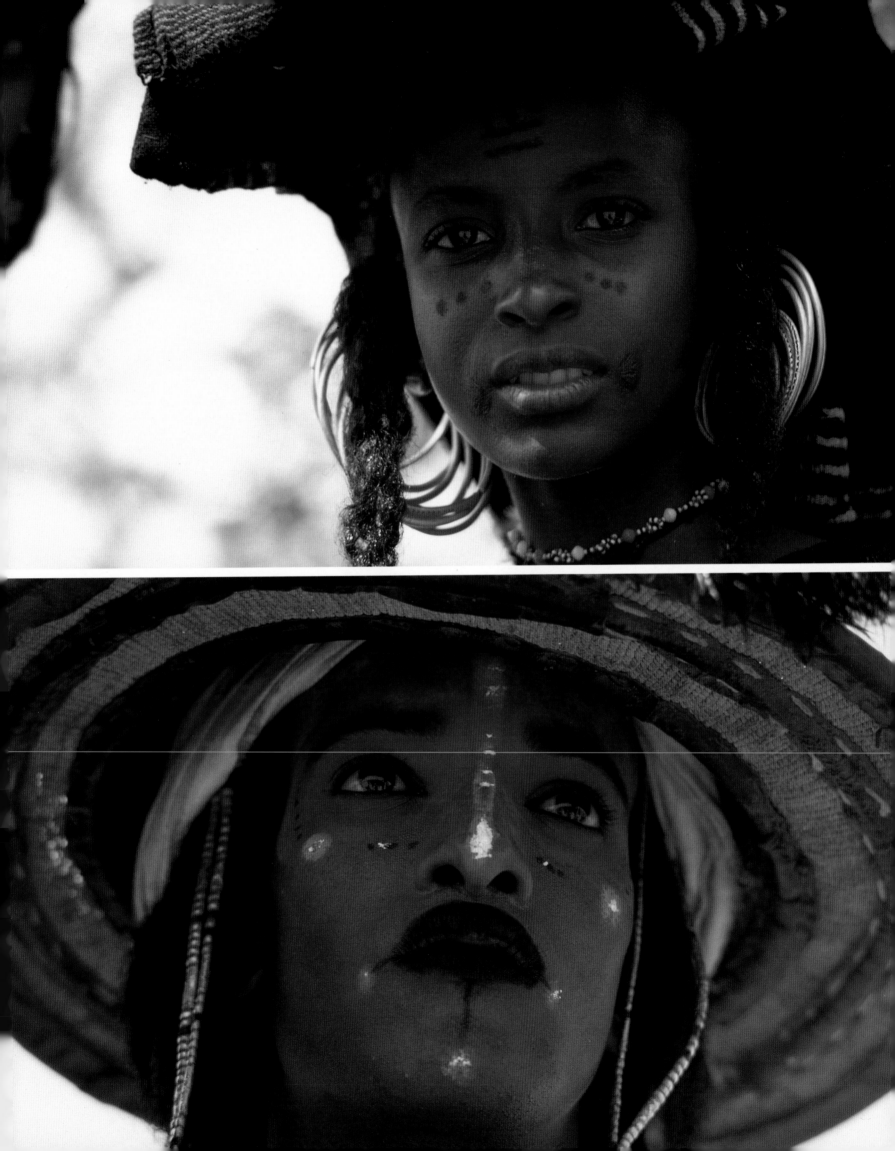

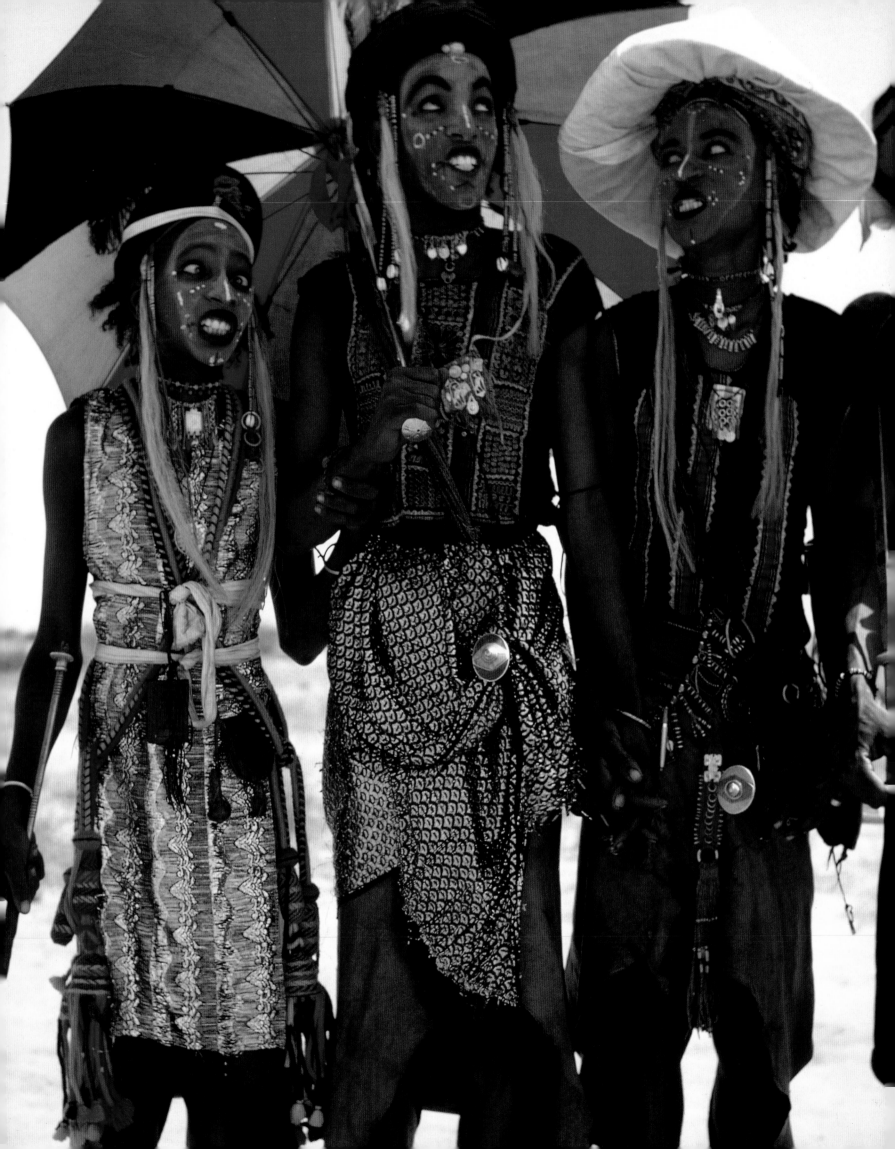

OPPOSITE *In funny grimaces, three Bororo nomads, part of a long line of* yaake *dancers, display the whiteness of their eyes and teeth.*

Not rarely, a thunderstorm breaks out in the middle of a dance. Yellowing the air and the sky with billowing clouds of sand torn from the ground, a great wind rushes over the land, pulling with it branches, pots, calabashes, and straw mats. Then violent sheets of rain wash the air, turning it white and flooding the savanna. Lightning irradiates from the horizon and thunder rumbles and explodes, scattering the cattle and sowing confusion in camp. The Bororo, who live nearby, rush home. The others crowd, twenty to thirty standing people under each straw mat or plastic sheet. But everybody laughs. Is this not what they prayed for the whole year?

Fire Links the Bororo to Their Cattle

At sunset, Mokao or Kabo lights a fire in the corral for the cattle and, one after the other, the cows come and take their places around it. Though less important the rest of the year, during the rainy season it protects them against the night's cold humidity. Fire and smoke also deter hyenas and mosquitoes.

"Do you know why the Fulani light a fire for their cows at night?" Bamo asks me one night. "I will tell you. A long time ago, before they owned cows, a Fulani was sitting next to a fire beside a river. A cow came out of the water and as soon as she saw the flames ran back into it. She returned the next day, but the Fulani and his fire were still there, and she fled once more. She was coming out to give birth and, some days later, instead of running back into the water, she lost consciousness. When she came to, she saw her calf and, crouching against it, the Fulani. Thinking them both her offspring, she licked them equally, and from that time the Fulani live with zebus and every night light for them a fire."

Abdullah, who rarely agrees with Bamo, cuts in with his own story of the Fulani. "Long ago (he does not start differently from Bamo, however) the cows belonged to the hyena. One day she found milk at the bottom of a calabash she had previously emptied. Milk drops running down the sides of the calabash had col-lected to form that little puddle at the bottom. But the hyena is a stupid animal, and thinking the calabash was now producing milk directly and that she no longer needed the cows, she chased them away. When she realized her mistake, she ran after the cows, but the Fulani had found them and would not return them to her. Since then, the hyena comes every night to claim them, but the Fulani keep her at bay by lighting a fire."

At sunset the cows are milked once more. When the last animal has stopped lowing, children can still be heard running and screaming. After another while, taking over from them, the insects start their immense, obsessive concert.

Except where scattered acacias, like inkspots, blotch it out, the savanna gleams under a crescent moon; and red embers, like a wound of the night, shine through the legs of the cattle. Fragments of a chant hover in the distance. Over there Bebe is attending a dance, and Mokao, who never misses one, is there too.

Thirteen-year-old Kassa is home with Mama, Goshi, and Kabo, where her father wants her to be, far from the temptations of such reunions. But on certain nights, when everybody is asleep and I am too happy to give up my consciousness, I see a man approach the camp furtively and then steal away with her. She comes back an hour later, alone. Bororo women always have their way, and when every man is more handsome than the next, many a wife runs away with a lover, never to return.

The Time of the *Geerewol* Dance

The grass, now knee-high, has lost the acidity of its green and rains have become less frequent. The word *geerewol* is on all lips and, to prepare for this great festival which will reunite the nomads, Mokao leaves one morning on camelback for the market of Kao to buy new clothes for himself and his family. He drives before him a cow to sell. Back after seven days, he learns that his second camel has been stolen, and he sets out to try to find it. Another seven days go by, but he reappears with his lost animal. And he tells us how, day after day, for more than sixty-five miles, he has patiently read the sand and isolated his camel's tracks among a hundred. He found his camel grazing in the midst of others—but not the thief.

From pond to pond the Bororo have finally reached In Waggeur. It is September and rains have become so rare that Mama

does not set up the little hut. Kassa's kid has become a goat and Goshi has given birth to a beautiful little boy.

The Bororo are all over the valley, and the dance of the *geerewol* begins. Spectators stand watching in a half circle, with men to the right and women to the left. Like the *yaake* it is danced in a row, but on this occasion the dancers have exchanged their leather pants for saronglike skirts and crisscrossed their bare chests with long strings of white beads. One of their ankles jingles from the rings of an iron anklet, and on their heads, held by bands decorated with *cauris*, are white ostrich feathers instead of the usual black ones. Few are the dancers, for only the most handsome dare face the critics, particularly harsh now.

Hour after hour, from early afternoon until sunset, chant succeeds chant. An old woman, pulling a donkey pack saddle at the end of a rope, threatens to put it on the back of any dancer who does not meet the standards. The young men stamp to a slow rhythm. Through the red paste on their faces seep droplets of sweat. They dance, erect and noble, without betraying their fatigue.

At the end of the afternoon, three girls, chosen by the old people for their beauty, approach with slow and grave dignity. They kneel midway between the dancers and the spectators, facing the former with eyes lowered. There they remain until an old man helps them to rise, one by one. Then, walking slowly and majestically, arms swinging high, they go up to the dancers and each discreetly indicates the man of her choice before returning to her place.

When the last girl has done this the dance ends abruptly and, in great tumult, the crowd moves a little farther to where other young men have started a *yaake*. Stopping only to gorge themselves with milk brought in large calabashes by long rows of young women, they will dance—the *ruume* this time—until late into the night.

While the rituals of the dance continue, the older men of each lineage convene for their yearly *worso*, discussions of affairs of common interest. Marriages arranged in childhood are celebrated now with offerings of cattle. Now the young husband whose wife has borne a child is free to take his cattle from his father's care; a new household is complete. Perhaps a family has lost its herd to famine or disease; now the patrilineal kin

OPPOSITE *Azaouak region. Striving for beauty, two Bororo* yaake *dancers exhibit the whiteness of their eyes and teeth, enhanced by blackened eyelashes and lips.*

NEXT PAGES *Azaouak region. An elder spurs a line of* geerewol *dancers into a brisker performance. Only the most handsome men have dared to face the critics, now particularly harsh.*

make *nanga na'i*, loans of healthy stock, so that life may go on as it should.

Celebrations over, distributions of cattle established, the nomads will scatter and start walking south again. Yet first, in Mokao's camp, there will be one more feast, for he will sacrifice two cows in honor of Goshi's little son and there will be many guests.

WELL PULLEYS CREAK AGAIN

More days have passed, and insects and the eager teeth of camels have undressed the trees and bared the long bony thorns, warning of cruel days ahead. The songs of men and frogs have died, replaced by the creaking of pulleys at the wells. Nights have grown cold and the children cough painfully, huddled under straw mats. Nobody lingers anymore under the palaver tree. Every two days Mokao takes his herd to a well and draws great quantities of water for the cattle, sometimes late into the night. Other days he spends on even more distant pastures. As for Mama, she often walks considerable distances to barter milk for millet, or even millet bran, in the villages.

By January or February, when water and grass will have become utterly rare, tribes and families will have dispersed for survival, and the sole concern of everyone will be to stay alive and keep the herds alive until the rains. Now every rib in the savanna, human or bovine, will be sorely apparent. Then one day, in May or June, all the cows will turn their heads to the northeast, and the Bororo will know the rains have come—somewhere at least. And a song will rise again to the sky.

With the nomads scattered far, I bid farewell to my friends. Mokao holds my hand in his and shrugs his shoulders as if wondering at life's surprises. "The wet and the dry season will come back again and again," he says, "but they will not erase you from our memory."

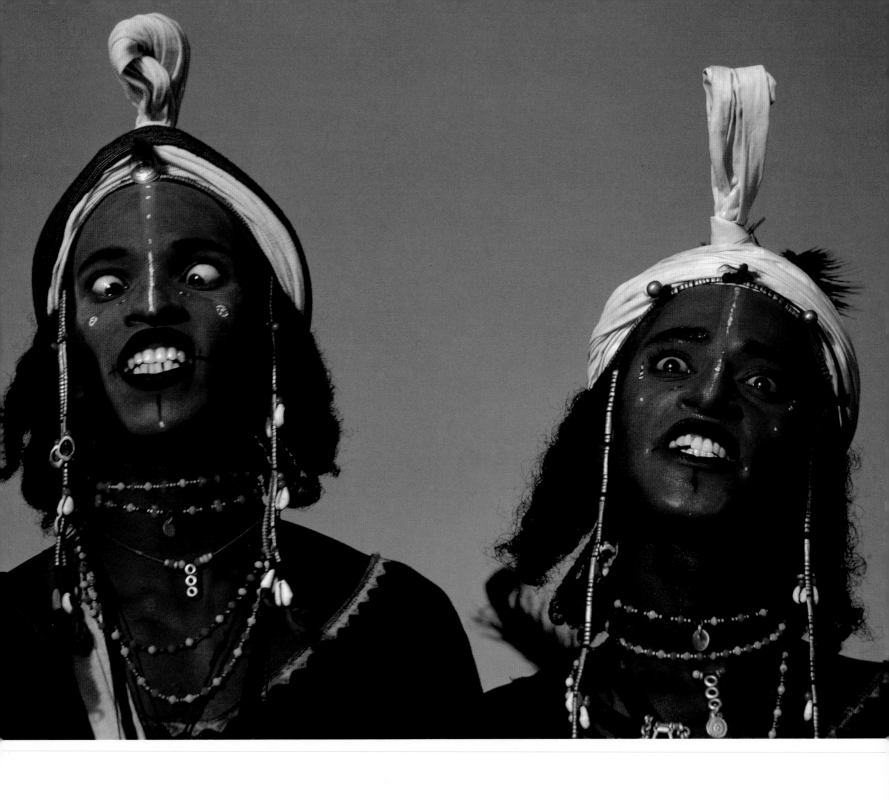

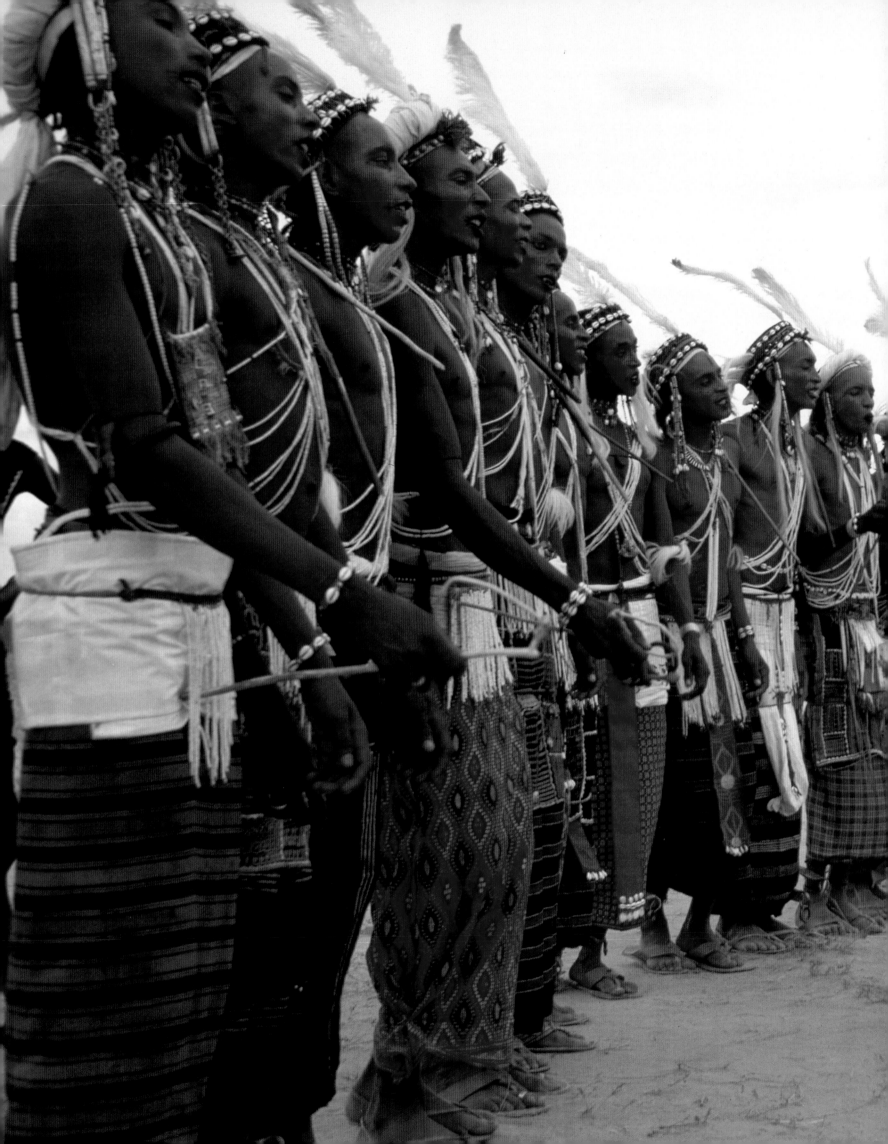

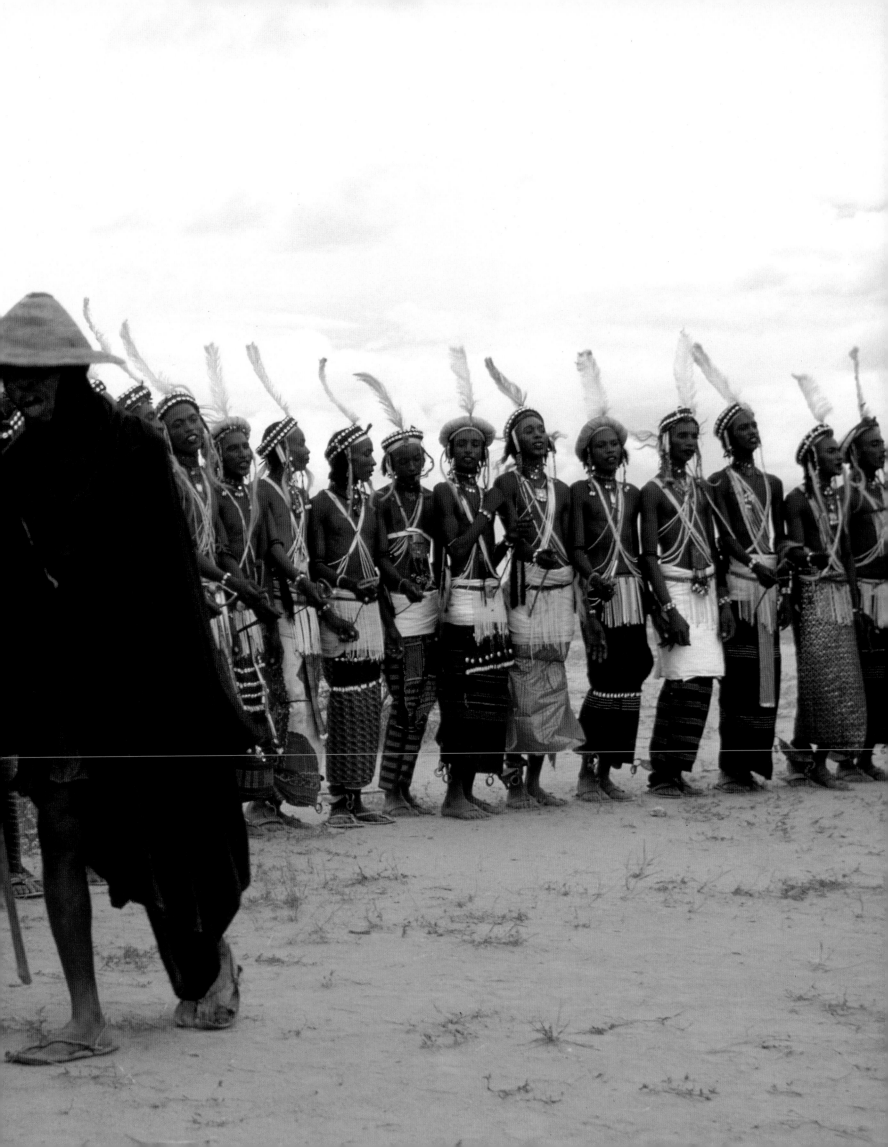

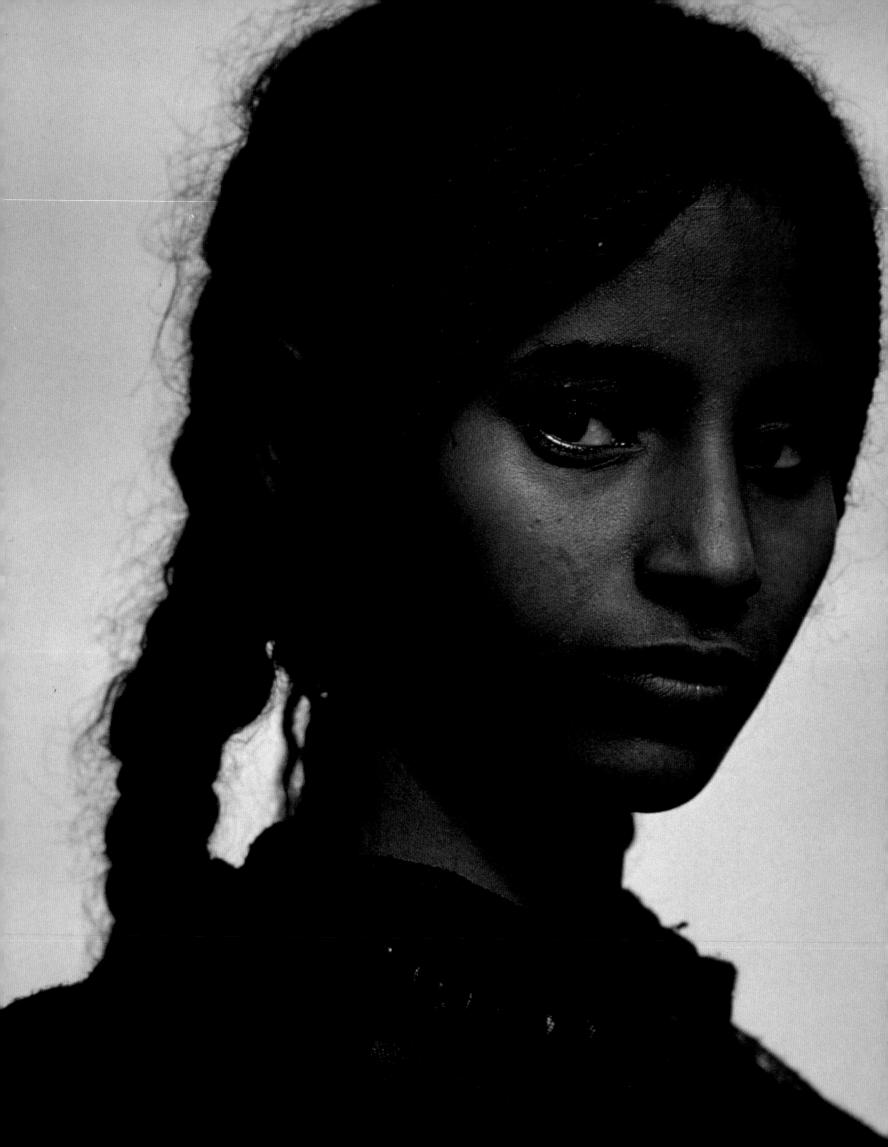

Part Four: The Danakil

OPPOSITE *Former French Somaliland (today Djibouti). Barren mountains near Randa.*

With camels, mules, drivers, an interpreter, and an armed escort, I am on my way into one of the most forbidding places on earth. In the northeastern corner of Ethiopia, under the auspices of Ras Mengesha Seyun, prince of Tigré, I have joined a large caravan bound for the Danakil Depression, a fantastic land of volcanic cones, brittle lava fields, dried salt lakes, boiling sulfur, and merciless desert. Much of the depression lies below sea level at depths ranging from 70 to 150 meters. The temperature may reach 65 degrees and the water is rare enough for nomadic tribesmen to fight and kill each other over it.

Those tribesmen, who call themselves Afar but are known to the rest of the world as Danakil, are a Hamitic people who have lived here for thousands of years. In Ethiopia 200,000 of them dwell in the depression, also called Dankalia or Afar triangle, and on its fringes. An additional 50,000 live in neighboring French Somaliland, today Djibouti. Though the coastal Danakil are faithful Moslems, those of the interior are much less religious.

Our caravan, which started in Makale in the Tigré highlands, is headed for Lake Karum in the depression, where we will pick up salt and get out as quickly as possible. Now, as we near the open desert, we stop at one last watering station, a couple of huts overlooking a trickle at the bottom of a deep gorge. While the camels and mules drink and their drivers fill the goatskins, I meet the cutest member of the Danakil.

She is a pretty little rogue, perhaps twelve years old; her dark skin and sharp features attest her Hamitic ancestry. Her eyes, suspicious and cunning, are devoid of innocence—no innocent creature survives in her hostile world. She emerges from a doorway and sits down to watch. Soon my eyes meet hers; we are both intrigued. After many minutes she beckons me to approach. But as I obey, she bounds to her feet, ready to run. The caravaneers laugh and reassure her. Still uneasy, she allows me to advance slowly. Watching my face from the corner of her eye, she puts a finger on my wristwatch. But it is my color that fascinates her—plainly, she has never seen a white man.

She lets her finger slip to my wrist, then pulls it back immediately as if it were burning. The caravaneers, amused by her reactions, encourage her to try again. Playful, she presses her finger on my skin to make white spots appear. She stares a long time at my blue eyes, at my nose, at my mouth. Finally she sighs, and says, through the interpreter, "You must be very young, for you have the color of newborn babies."

I realize she means Danakil babies, who are relatively pale at birth, and I smile. By now we are sitting next to each other. My hand is in hers, and she compares our palms, all the while commenting loudly to herself on her discoveries.

"I like you," she says, "will you be my brother?"

"Of course, I will."

Song Celebrates a Stranger's Gift

But my answer does not quite satisfy her. "Be my husband!" she commands. She is not surprised that I am already married and accepts an orange as compensation. She has never seen one before, so I show her how to eat it. She likes it very much, and when she has swallowed the last piece and wiped her mouth with the back of her hand, she improvises a short song which she repeats several times: "The red man has given me an orange / The red man is a good man." But the caravan has started up again. I have to leave my little friend.

Soon we reach open ground—stony desert dotted here and there by small thorn trees. Behind us, blue in the haze, rise the central Ethiopian mountains from which we have come. Far ahead, shining like a mirror in the sun, stretch the shallow salt flats of Lake Karum. In the noon heat the air vibrates before my eyes, and even a large straw hat and a slight breeze do not save me from dizziness. Yet I walk ahead of the caravan, increasingly fast to try to outdistance the four old soldiers walking on my heels, whom Ras Mengesha has made responsible for my safety. But though they sigh on my back they do not let me gain an inch.

Far behind, armed with a machine gun, Ghidey, Ras Menge-sha's secretary, whom the prince lent me as an interpreter, un-successfully entices his mule to catch up with us. Exhausted af-ter two hours of near trot, I finally slow down, while the old soldiers start singing as if sun, thirst, and fatigue did not exist.

Four hours bring the sun close to the mountaintops. The breeze becomes wind. We reach a place where other caravans have set up camp, and we join them.

MOON REVEALS A CIRCLE OF SINGERS

Night has come. The caravaneers gather in a circle in the center of their camp, their only light that of the moon. They sing and beat time to their songs by banging on enamel pots or by clap-ping pairs of stones together. In the middle of the circle, two or three men dance. The Ethiopians, who are among the poorest people on earth, never miss an opportunity to enter into a joy-ous dance. Ghidey and I watch from a distance, lying on our blankets and enjoying the cool night air. But now the circle breaks, and the men come to us. "Come on," they say, "it is your turn to dance now—you must pass the test."

Since we are going to the salt lake for the first time, we must, like passengers on their first crossing of the Equator, pass tests for the amusement of old-timers. As for them, they will sing and dance until very late and take little rest.

The caravaneers must reach Lake Karum, load their mules and camels with the salt mined there, and leave the same day if possible, for mules cannot stay long without drinking. The cam-els, of course, can go many days without water, even in this sear-ing desolation.

We are on the move again by three o'clock in the morning. Dawn finds us wading through Lake Karum, no more than six or seven inches deep where it has collected the water flowing down from the mountains during the short summer rains. Else-where, the lake has vanished, leaving the dry, hard-packed salt.

The early light unveils an extraordinary spectacle—a red sky to the east, a blue sky to the west, a flat, glittering white lake floor in between. Across this floor, stretching from one end of the horizon to the other, wind long strands of camels, mules, and men.

We reach dry ground as the sun rises. Were it not for the al-

OPPOSITE TOP *Ethiopia. Danakil Depression. Goat meat dries on the root of a Danakil hut, a framework of twigs supporting straw mats.*

OPPOSITE BOTTOM *Sitting outside her hut, a Danakil woman weaves a long strip of grass, which she will later sew into a mat. Fragile straw mats, used either to sit on or to cover a hut, need constant replacement.*

ready intense heat, even at this early hour, the scene could be the Arctic wastes. As far as one can see, the land is flat and of the purest white. The miners' low houses—salt igloos—add much to the illusion. Some of the miners are poor Ethiopians from the more heavily populated plateau, men who came with a caravan and stayed. Most of them, however, are Danakil, who over the centuries have grown used to the fearful heat.

The salt beds themselves were created over a period of thou-sands of years by the evaporation of sea water. This area was once an arm of the Red Sea that periodically dried up. Volcanic eruptions isolated it from the rest of the sea, and its water evap-orated, leaving behind the salt. As the area slowly sank, the sea flooded it again, until new volcanic eruptions isolated it once more. And thus on and on for ages, each time adding new layers of salt.

No one has ever probed the bottom of Lake Karum's salt de-posits, but estimates of their depth run to five or six kilometers. They provide pure white, ready-to-use salt for a large area of northeastern Africa, and a hard-earned living for scores of Dan-akil miners.

The work at Lake Karum is divided among several groups of men. One group, armed with long sticks, pries apart and lifts the large hexagonal slabs of salt created by the contraction of the deposit's surface as it is softened by temporary waters, then sub-mitted to punishing heat. Another group cuts the slabs roughly into manageable bricks, while a third group smoothes the bricks into final shape. For a day's work, each man receives the equiv-alent of 60 U.S. cents, one *ambasha* (large loaf of Ethiopian

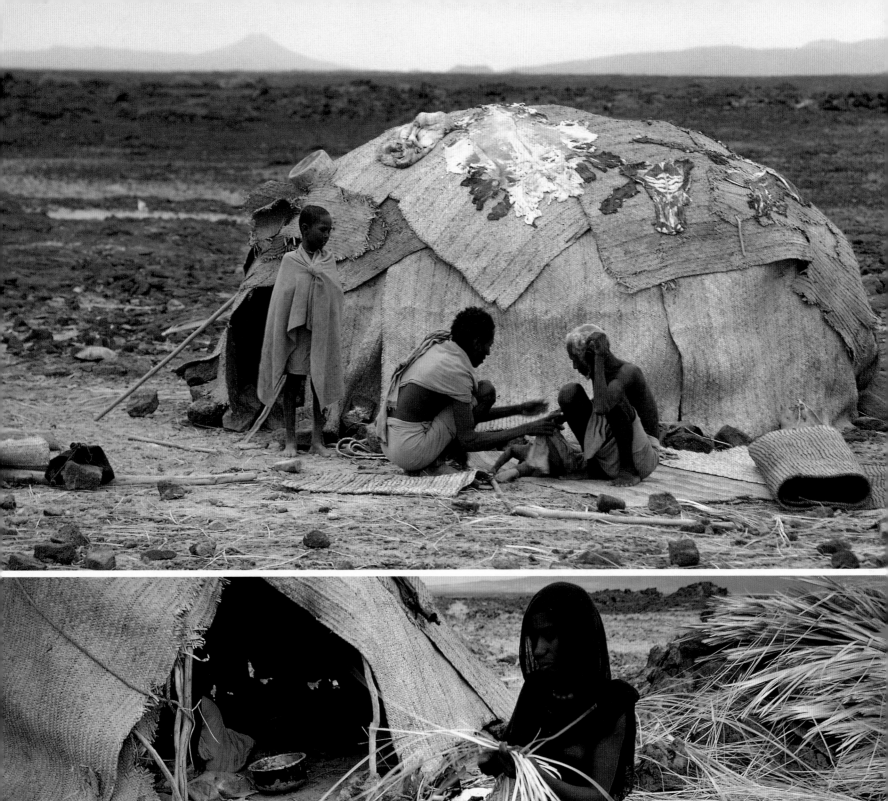
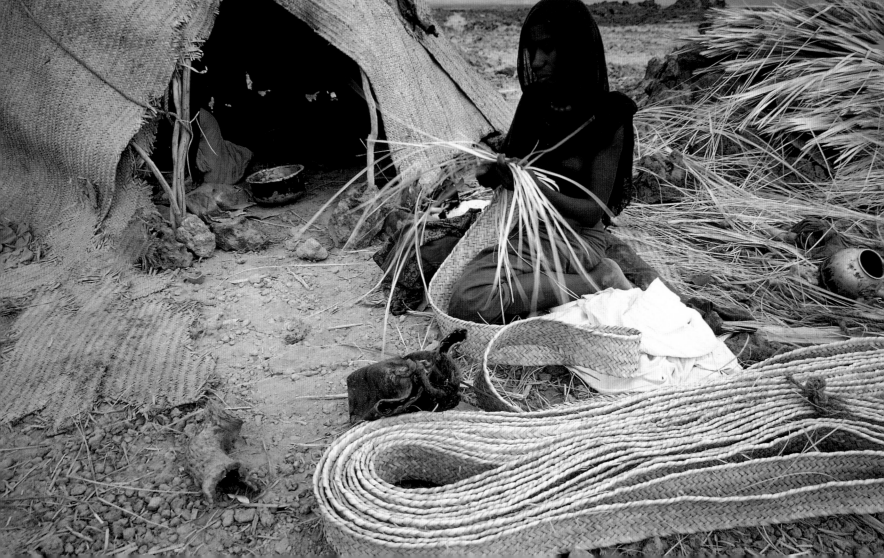

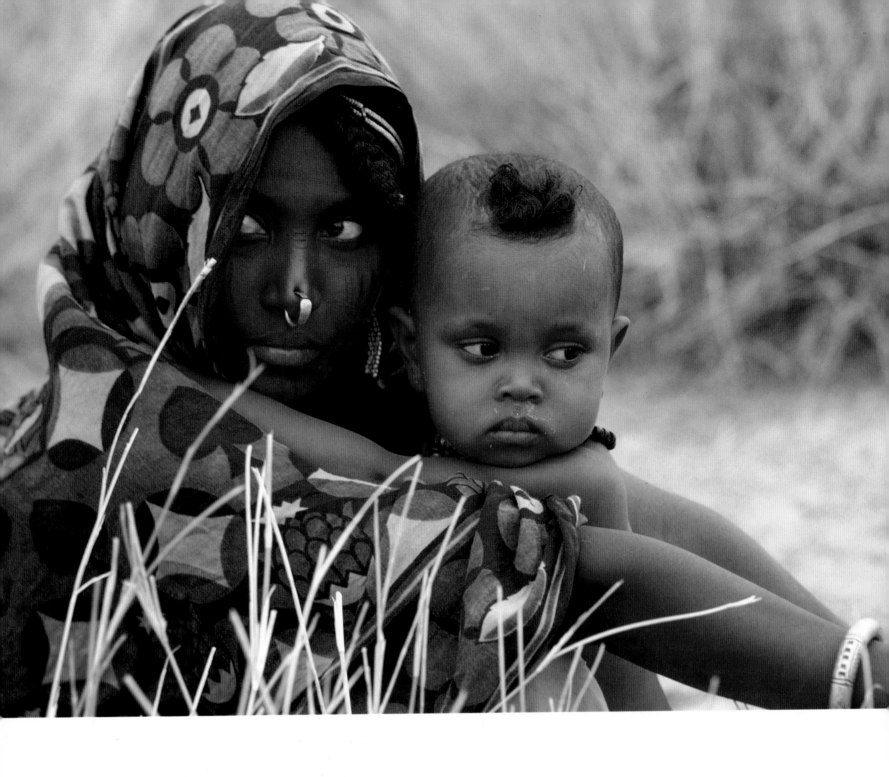

OPPOSITE *Ethiopia. Danakil Depression. A Danakil woman protectively hugs her baby.*

bread), and one goatskin of water. Each caravan brings its own money, bread, and water to pay the miners. Some Danakil organize their own caravans to the highlands.

Having greeted the miners, the caravaneers pass their orders. With precise gestures, the Danakil produce the required salt blocks—approximately twenty per camel, twelve to fourteen per mule, and six to ten per donkey.

Though elsewhere they enjoy less than friendly relations, along the salt route the Danakil and highlanders have learned to live in symbiosis. Besides producing salt for the highlanders, the Danakil also breed camels (only males to keep the monopoly) and plait mats and ropes for them. The highlanders, however, are progressively replacing the ropes with the stronger straps cut out of tires that they can buy in Makale.

By four o'clock we are off on the return journey to the cool beckoning mountains in the west. Several days later we will be back in Makale. From there the salt will be sold throughout Ethiopia and in neighboring countries.

Along the way, in a deep valley at Borhale, the caravans pass through makeshift gates where government employees count the animals one by one and, in Ethiopian dollars, tax my companions the Makale price of four salt blocks per camel load and two per mule load. Ghidey explains that the toll is to reimburse Ras Mengesha's administration for opening through the mountains an easier passage and that the caravaneers are glad to pay it. Years ago many of their camels broke their legs on the rocky descent or ascent or fell down the mountains. The caravans also lost precious time awaiting their turns to go up or down the dangerous escarpment.

SEEKING THE FIERCEST DANAKIL

The relative gentleness of the Danakil salt miners has baffled me, relieved and yet disappointed me. I have read so many frightful stories about the Danakil that, frankly, I doubted Ras Menge-

sha's word when he told me the escort was for protection against *shiftas*, bandits, as Ethiopians call the rebels fighting for Eritrea's independence. In my mind, the real danger had been the Danakil.

The Danakil are known mostly for one gruesome custom. To gain the heart of a woman, a young warrior must first prove his valor by presenting to her at least one pair of testicles taken from an enemy, dead or alive. Hostile as their environment is, it is only natural that a woman should consider toughness a desirable manly virtue.

A man who is unsuccessful in his trophy hunting loses the respect of the community. One who does not kill during a raid is derided by the women. His hair is plastered with cow dung, and he must provide the animals that will be sacrificed for the feast the night of the raid. A feather in the hair of a warrior says that he has killed one man. Silver or brass decorations on his weapons indicate more than one killing. An iron bracelet marks him as a mass murderer, one who has eliminated at least ten men. The women of those killers hang the trophies inside their huts.

Danakil men must give proof of their courage long before their first manslaughter. At age fifteen among the Asaimara, the ruling tribes, at age nine among the Adoimara, the tributary tribes, boys are circumcised publicly by a famous warrior while elders and braves, surrounding them on horseback, watch them, and the rest of the tribe stands close enough to hear any cry. After the operation, the boys must try to quickly shout the names of as many cows as their resistance to pain allows them to remember at that moment. All the cows they succeed in naming, rarely more than two or three, become theirs. After that, bleeding and aching, they must go hunting and bring back a dead animal, be it a bird, a rat, or a lizard. Not until evening that day, when there is a feast in their honor and girls sing their praises, are they allowed to eat.

Girls go through even more painful processes. While still young children, they are operated on by an old woman, who cuts out their clitorises, a male symbol, and sews their vulvae to keep them virginal until marriage. The sewing is done by rasping the vulva's delicate lips with a knife or a piece of glass before pressing them together so they may seal. In the end, this cruelty

is not infallible in guaranteeing a woman's virtue, as she can be, and occasionally is, sewn more than once.

To have a look at some warriors, I travel south to the Aússa sultanate, along the Awash River, at the base of the Afar triangle. Aússa, now ruled by Ethiopia, though not without some concessions, was once a powerful Islamic state. In the 16th century, under the conqueror Ahman Gran, it came close to dominating the Christian Abyssinian kingdom.

I catch my first sight of the Aússa Danakil in the dusty, oppressive village of Tendaho. Straight, lean, and handsome, they elegantly wear the traditional *sanafil*, a piece of undyed cotton falling below the knees, wrapped around the waist like a skirt, and knotted on the right hip. As extra luxury, most of them casually throw over their shoulders another piece of cotton cloth. In each man's belt rests a curved double-edged knife as broad as a miner's hand and almost as long as a saber. Some, who wear cartridge belts, also sling old Mausers over their shoulders. No hats protect their heads against the fierce sun, only butter, daubed on their fuzzy hair.

Had I not already known it, my past experience with Tuareg *imaheren* would tell me that these are Asaimara, predatory nobles. As I stroll about them, they glare with cruel eyes. I stare back and try a smile, but they look insulted. I begin to feel uneasy.

In Tendaho, an official advises me not to leave the safety of the village without a letter of protection from the sultan of the Aússa Danakil (their traditional ruler under Emperor Haile Selassie). This sounds reasonable, but the sultan is in Aissaita, 55 kilometers away. And then I meet a man who says, "The Danakil? Why, they are good people!"

I do not want to hear more. Before my courage wanes I decide to cross the desert to Aissaita and Lake Abbe to learn more about the Danakil. Fortunately, I have found a new interpreter and companion for the journey, a fifty-three-year-old Eritrean man named Mahmud, who speaks Danakil bèsides some other Ethiopian languages. Though he does not speak English, he understands enough of it to be useful. He will speak to me in Italian, which I manage to understand, though not to speak. Two Danakil will care for our two rented camels and act as guides. They are unusually scrawny and carry no weapons, so I suppose they

will not cut my throat, or anything else, during my sleep. But neither will they be of much help if I am attacked. As insurance, Mahmud goes to see a Danakil *balabat*, or local chieftain, who announces that I am under his protection.

One afternoon, watched by intrigued villagers who gathered to see us leave, we set out for Aisaita, observing the Danakil custom of leading rather than riding the camels. Outside Tendaho my Danakil guides, whom I judge to be about thirty and eighteen years old, fill our goatskins at a muddy irrigation ditch where men are bathing, women are washing clothes, and donkeys are wading.

For two hours we skirt cotton fields, then swamps. Suddenly, without transition, we face the desert. Fortunately, the sun is gone. We push on in the cool of the night until eight, when we come upon some tufts of grass on which to feed the camels. By then our murky water no longer seems distasteful.

BANDITS THREATEN THE "FOREIGNER"

At one o'clock, a crescent of moon rising from the horizon, we move on. Bitten by hundreds of mosquitoes, none of us has slept.

A couple of hours later, a party of five Danakil men overtakes us. They are surprised to see a *ferengi*, or foreigner. They make loud comments but seem friendly. One of them weighs my camera bags, picks my pockets, tests my biceps and my handshake. Satisfied, he walks hand in hand with me for half an hour, chattering happily in a language that I cannot understand. Such friendliness now makes me laugh at my past misgivings and discount the fearful stories of raiding and murder as something of the past. But I have unconsciously let my new friends pull me ahead of my own party, and a warning whistle from Mahmud stops me in my stride. Seemingly disappointed to go on without me, the five men drift off into the night.

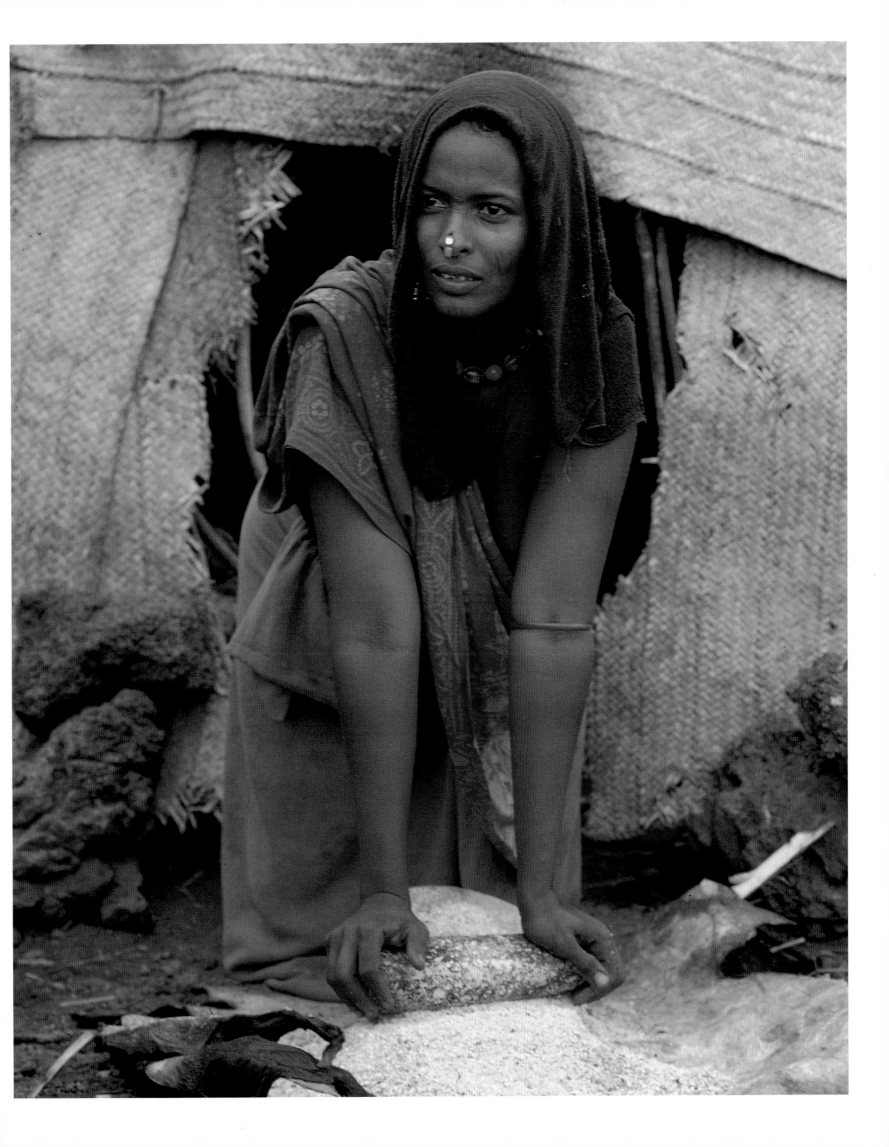

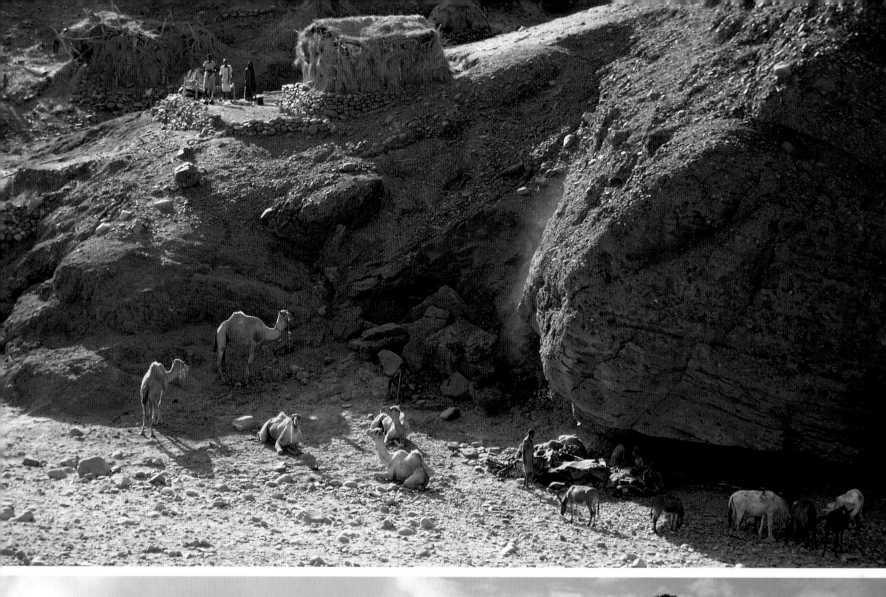
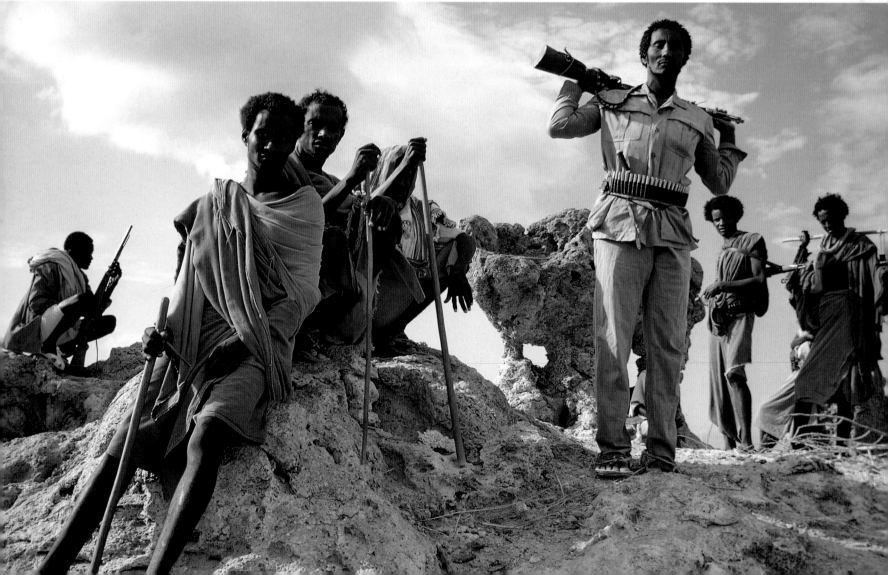

OPPOSITE TOP *Ethiopia. Eastern escarpment. A Tigrinya caravan, en route to the Danakil Depression to buy salt, camps in a canyon. On a ledge, a Danakil family lives from barter with such passing highlanders. From one of the huts emerged the little girl who had never seen an orange.*

OPPOSITE BOTTOM *Danakil Depression. Adoimara Danakil nomads surprised in the middle of a council on a volcanic outcrop. Their chief wears a military uniform.*

As Mahmud catches up with me, four more Danakil emerge from the night. These are young warriors, heavily armed, and in their eyes shines a menacing light as they ask Mahmud for cigarettes. I am worried, and it is too dark to study their ornaments for any clue of a murderous past. While Mahmud lights cigarettes and answers questions, our guides and camels plod past us and fade into the night. They are far ahead when we resume the march.

Mahmud is following me, and behind him come the Danakil, still pressing him with questions. The word *ferengi* bounces back and forth with increasing frequency and loudness. I sense trouble, but keep walking as casually as I can, lengthening my steps as imperceptibly as possible. Knowing that modern man's uncanny science, marvelous gadgets, and wondrous pills are often mistaken by tribal people as magic, I hope that my feigned self-assurance may be attributed to some trick up my sleeve. In any case, if I stop to take part in the squabble, the situation may well explode. I will lose dignity, perhaps betray my fear, certainly fall farther behind our guides. What help they might provide, I do not know, but without them the odds are against us. Once we have caught up with them, we will have to fight only one man each.

By now Mahmud's voice is shaking with rage and anguish. Proud and courageous, he resents his inability to put these four armed bandits in their place. "Make trouble, make trouble!" he forces himself to articulate in English. "I know, Mahmud, but keep calm," I answer without looking back, and trying to keep calm myself.

At last our camels are visible ahead. I walk faster. Mahmud, his throat knotted with emotion, calls faintly, "Ahmadu! Ahmadu!" the name of the older guide. Ahmadu stops, suddenly realizing our situation. I am eager to see how he will deal with it.

Ahmadu's eyes burn with fury as I reach him; such a mean look would frighten the Devil himself, I think. And indeed, he so overwhelms the young warriors with just a few harsh words that they go their way, only laughing sarcastically at us to keep face. Has he told them about the Danakil chief who befriended us in Tendaho? I cannot tell.

When I ask Mahmud what has happened earlier, he does not answer. An hour later he tells me. Having grabbed his cigarettes and a box of biscuits he was carrying for our breakfast, the warriors had decided to get my camera bag too. They had, of course, no idea of what was in it.

"If you touch the *ferengi* or his belongings," Mahmud had declared, "I promise you a lot of trouble." But they had chuckled.

"The man does not even carry a gun," they had scoffed. "We will cut his throat and yours, and your genitals, and *we* promise you nobody will worry about you." With that, one man had hit him on the head with a stick, he had swung around to retaliate, and the men had reached for their knives. That was when Mahmud had cried, "Make trouble! make trouble!"

The remainder of the journey proves peaceful, and we reach Aissaita on market day. Market was, apparently, what pulled our Danakil acquaintances so early out of bed.

MARKET BRINGS DANAKIL TOGETHER

Market day is highly important to the Danakil. Some of them cover great distances to sell cattle, camels, goats, sheep, butter, and straw mats, or just show themselves. In turn, they buy city goods—durra (a variety of sorghum), coffee, spices, sugar, matches, and soap. The square is crowded with splendid barebreasted Danakil women, trying on colorful saronglike skirts, and with men armed to the teeth. The women lump their small purchases into old clothes wrapped like belts about their waists. The men, leaning on spears or long herders' sticks, a foot resting on a knee, ostentatiously displaying their weapons, converse in small groups or haggle over a camel or a millstone. The women

graciously ignore me as I take their pictures. The men, no doubt scornful of my harmless little machine, casually clean their teeth with flayed sticks and spit on the ground as their truculent eyes follow me around.

I leave the market and drift toward the Awash River. The town, built of lava blocks, is drab, but here nature is at its lushest green, and from here to Lake Gamarri many poor Danakil have fallen back on agriculture—cotton, sorghum, sesame, and tobacco. They own small herds, however, and, like their nomadic counterparts, from whom they are indistinguishable, they live under flimsy huts made of straw mats thrown over thin bent sticks.

As the path between the walls of vegetation narrows, a young brave following on my heels suddenly grabs my shoulder from behind to force me to stop. Ready to defend myself, I swing around, but he smiles and lifts a hand in a gesture of appeasement. Then he points to a bees' nest I was unconsciously going to knock down—a nest of heat-weary African bees as dangerous as a horde of trophy-hunting warriors. Had I banged into the nest, he would have suffered a fate equal to mine.

In Aissaita I meet Hassan, a young relative of the sultan of Aússa, who guides me to Danakil encampments. When I visit the nomads without him, they suspect me of ill intentions. If I am in their pastures they think I am counting their cattle to report to the government. If I hang around their huts, they think I am after their wives. Their knowledge that Hassan has befriended me, however, keeps me out of trouble.

Through Hassan, I ask an old man to tell me why people call them Danakil rather than Afar, as they themselves do. "Dankali (singular of Danakil) was once the name of an Afar sultan and, by extension, of his tribe," he explains. "They dwelled in the area of Beylul Bay, and the Arabs there took to the habit of calling all Afar, Danakil."

THE RED AND THE WHITE NOMADS

"And what are the origins and meanings of the names Asaimara and Adomaira?"

"Long ago two brothers came from Arabia, and the Galla tribe that received them seated them, one on a red cow skin, the other on a white cow skin. The two Arabs took native wives, and their

OPPOSITE *Ethiopia. Aissaita. An Asaimara Danakil brave. Butter, which is smeared over his ringlets to protect them from the sun, runs over his face.*

descendants became known as Asaimara (Red Afar) and Adoimara (White Afar)."

Later, in Tiyo, a Danakil village on the Red Sea coast, I was to hear a different story.

"Our forefathers came from Arabia indeed," said Sheikh Said, a learned Moslem reputed for his knowledge of Danakil history, "but they were many. They migrated by waves, centuries ago, and mixed with the natives from whom they adopted the Cushitic language. If some Afar are called Asaimara, it is because the clay of their Aússa hinterland colors their *sanafils* red. The Adoimara live in sandy areas and keep their clothes more nearly white." Western historians think that the Asaimara invaded Aússa from the highlands and that through Danakil veins runs much less Arab blood than their Moslem religion makes them wish.

From Aissaita, with Mahmud and our two Danakil guides, I walk on to Lake Abbe, straddling the borders of Ethiopia and French Somaliland, where we finally part, them to go back, I to travel on into the French territory. Thanks to Hassan, I travel this time, through a safe conduct, under the protection of the sultan.

One morning at sunrise, on the French side of the lake, much contracted but surrounded by green spots, I watch Danakil shepherds arrive from the desert, as they do periodically, with hundreds of goats to graze. Above them as they walk, between the desert and the pastures, rise the most extraordinary natural monuments I have seen anywhere—hundreds of tall limestone chimneys and cones built up by hot springs and looming next to each other as high as thirty meters in the most fantastic shapes; tall reminders, if they were necessary, that in the Danakil

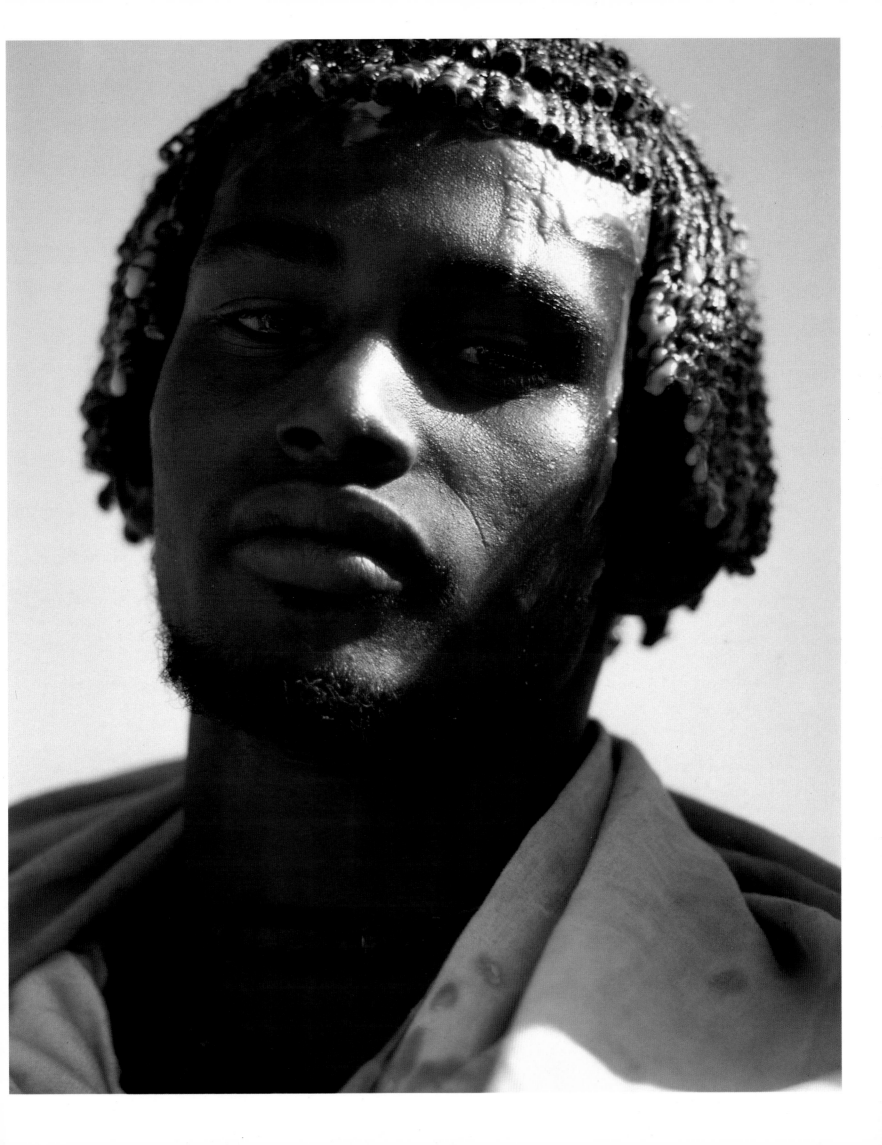

Depression nature produces nothing less remarkable than the other face of the moon.

From here to Djibouti I hitch a ride in the jeep of a Frenchman. Outside the village of Dikhil the Danakil are loading camels with merchandise they will smuggle into Ethiopia—textiles, sandals, soap, cigarettes, radios, etc. They will return with products from that country—*qat* (a mild narcotic), butter, spices, coffee, millet, durra, and beans. To let me take some pictures, my companion stops along the way in a Danakil encampment and at a well, where among the nomads' belongings appear some discarded French clothes and tin cans. What disappoints me even more is how poorly these Danakil compare in beauty with those of Aússa. They are Adoimara, vassals, but whether that explains why they look less good I know not.

To Another Salt Lake

In Djibouti I rent a jeep and travel to Lake Assal, another salt lake, where, at 153 meters under sea level, Danakil caravaneers arrive at sunset to mine their own salt in the relatively cool moonlight. They use no other tools than the cutting stones they find on the spot and the sticks they carry to beat the salt to powder before filling with it narrow jute bags.

On the way to Lake Assal I drive along the Ghoubet-Al-Kharab, the Abyss of the Demons, a bay as blue as the cloudless infinity above, but whose black lava banks, soaring vertically as much as 600 meters, give it a malevolent appearance which frightens the natives. They say that a very long time ago a mountain spitting fire was swallowed here by the invading waters, and since that ghastly cataclysm demons have inhabited the waters and pulled down to the bottom, 200 meters below, anyone bold enough to sail or enter them. The Ghoubet is at the end of a much larger bay, the Gulf of Tadjourah, to which it is connected through a narrow pass. With it and Lake Assal it must once have formed a single body of water. Today seven kilometers of lava fields separate the Ghoubet from Lake Assal, whose blue waters, where they have not been replaced by solid salt, contain 330 grams of salt per liter and would long have suffered Lake Karum's fate were it not fed by the sea through cracks in its floor.

But I must go back to Ethiopia to join a group of European scientists on the first of six annual geological expeditions to the Danakil Depression. This team will study the origin and nature of the depression by exploring the great chain of volcanoes dividing it on a nearly north-south axis.

An Ocean in the Making

Together with the Red Sea, of which it used to be part, and with the Gulf of Aden, the Danakil Depression constitutes a zone of collapse between the Ethiopian, Arabian, and Somali escarpments. Most scientists agree that this sunken wasteland is an ocean in the making—one which, two hundred million years from now, could spread as widely as the Atlantic Ocean. Only twenty-five million years old, a short geological time, it is being built, like all oceans, by its chain of volcanoes which, through constant eruption, keeps prying it apart. But its floor is unique in that it does not lie under abysmally deep waters, which makes it the best place on earth to study continental drift.

The Italian and French geologists, of various disciplines, are mostly young men in their early thirties. Their two leaders, Italian Professor Giorgio Marinelli and Polish-born, French-naturalized Professor Haroun Tazieff, are in their early fifties. Professor Tazieff is world-famous as a volcanology pioneer, explorer, and writer.

We meet in Makale and, in trucks and jeeps, drive down the same stony paths, wadi beds, canyons, and ravines treaded some weeks earlier by my salt caravan. Ras Mengesha, the same who patronized my caravan trip, leads the way in his own jeep. In his enthusiasm for the scientists' studies, he notified *National Geographic* magazine of their expedition, and the editors sent me here to cover it. Bright and ever-smiling, he does not fuss over his royal blood. He is so unpretentious, in fact, that on our first day out with him he gives Todorov, the Bulgarian M.D. he has taken along, a haircut. But our escorts, the armed *askaris*, and the highlanders we meet along the way revere him as a living God. He is, in fact, Emperor Johannes's great-grandson, and the husband of one of Haile Selassie's granddaughters.

For three weeks we will camp under wall-less hangars left years ago on the salt floor of Lake Karum, at As' Al'e, ten kilometers from the Danakil salt mine, by a salt-mining company.

We should have stayed there only three or four days, but the expedition's vehicles were detained in the Suez Canal, blockaded by the Six-Day War between Egypt and Israel. Meanwhile the scientists were lucky to be provided vehicles by Ras Mengesha.

The explanations I am getting from the geologists are giving me a unique chance to understand the rare phenomena that I witness each day. One of our first expeditions takes us nearby to Dallol, a dome several kilometers wide and less than a hundred meters high eroded into the phantasmagorical shapes of a wrecked city. The dome was formed by the lifting of the plain there under the pressure of potassium salts rising through denser chloride salts. The ruined skyscrapers, fortresses, towers, spires, and monuments were once built up by thousands of thin alternating layers of brown clay and white salt, which formed millions of years ago under the sea when the clay rushed into it from the mountains with the summer rains, and salt precipitations covered it before another layer of clay came pouring in, forever recording the alternation of countless summers.

From the ground at Dallol surge geysers whose sulfur deposits form green cones of tiered basins. Boiling water runs down, crystalline, from basin to basin, to spread at the basis of the cones, and for hundreds of meters the progressive oxidation of the sulfur colors the ground in bright patches of green, yellow, orange, and brown.

Little craters dot the ground and look like clear beckoning sources but turn out to be treacherous melted chloride. These geological sores are the manifestations of a volcanic activity choked by the weight of the five or six thousand meters of salt that have accumulated over it.

Thanks to Ras Mengesha, the geologists also get the occasional use of a helicopter. It gives me the opportunity to fly not only over the floor of an ocean, with its chain of active volcanoes, its lava fields formed both under and out of the sea, its green lakes existing in spite of the intense evaporation because of percolating sea water, and over the low coastal mountains protecting the depression from Red Sea flooding, but also over the image of what the earth may have looked like long before man set foot on it.

NEXT PAGES *Ethiopia. Bubbling springs and erosion have created on the outskirts of drying Lake Abbe these phantasmagorical monuments.*

HELLHOLE OF CREATION

With a 57-degree temperature in the helicopter's cabin at 50 meters above ground, which in some parts is 150 meters below sea level, and with such black chaos underneath, one cannot help wondering whether this is really our planet and how a people like the Danakil has adapted to it. What is made clearer is the title of a book written in 1935 by a British explorer who nearly lost his life at the hands of the Danakil: *Hellhole of Creation.*

From the air, Professor Tazieff has spotted a bluff of rhyolite, an oddity in this basaltic world that he wants to investigate on the ground. With him will go a rock specialist, a geochemist, and an armed *askari* to defend them against the Danakil. I, too, decide to follow him. He figures that the round trip, from where we will have to leave the jeep, will take us about seven hours. To avoid the day's greatest heat, we will walk in late afternoon.

We roll over the salt lake and the sandy plain up to the edge of a lava field, and by three o'cock are walking over a Dantesque black landscape of thick twisted ropes, flagstones that crash under our weight like brittle ice, scraping our bare legs as we sink through them, and over great scorias that roll under our feet, throwing us on hands and knees over countless basaltic needles and knives. Even so, the geologists walk fast. Hindered by my photographic equipment and canteen, I run ahead of them to keep them in my viewfinder. I even climb a small extinct volcano while the geologists rest. The ground, like heated steel, radiates visible waves of heat and generates oven-like temperatures.

Fast as we walk, night catches us long before reaching our goal. Falling like a curtain, it takes us almost by surprise on a spot so full of sharp asperities that we will be unable to stretch to sleep. Thus we sit in discomfort, without backrest, wherever

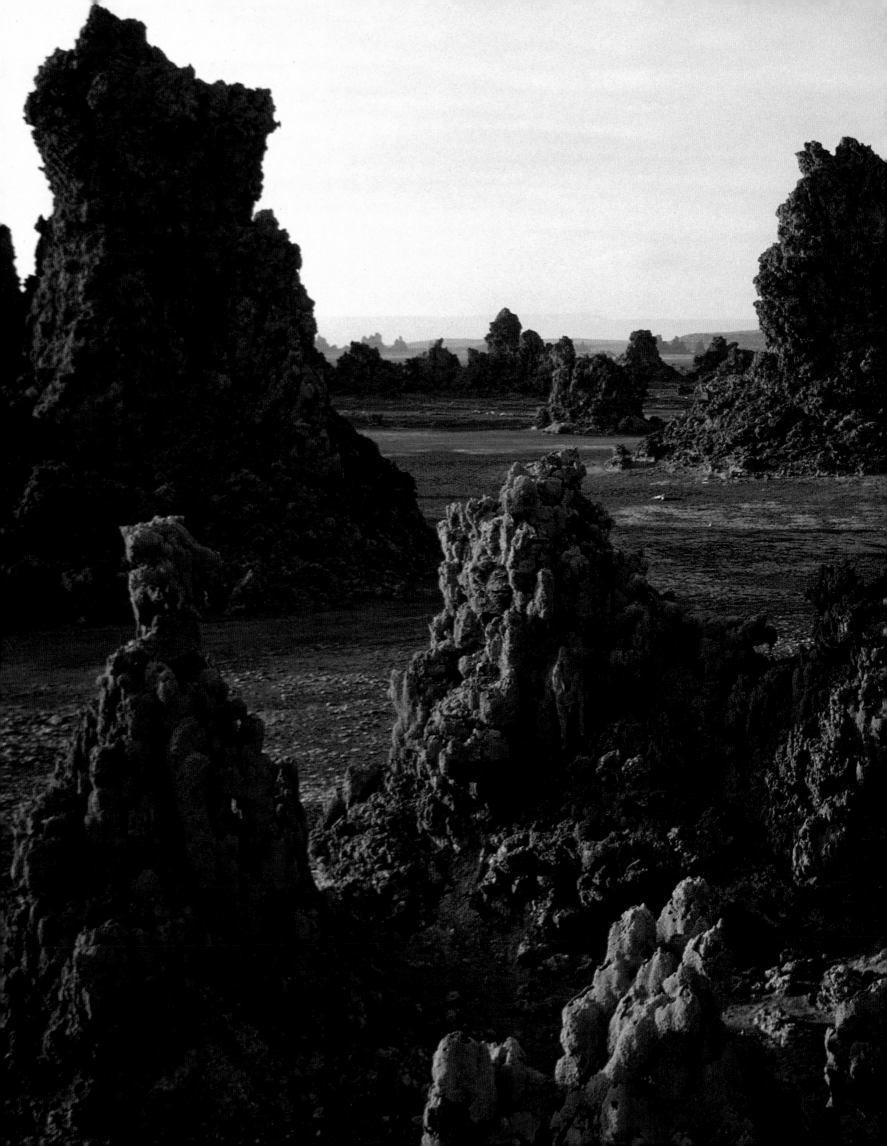

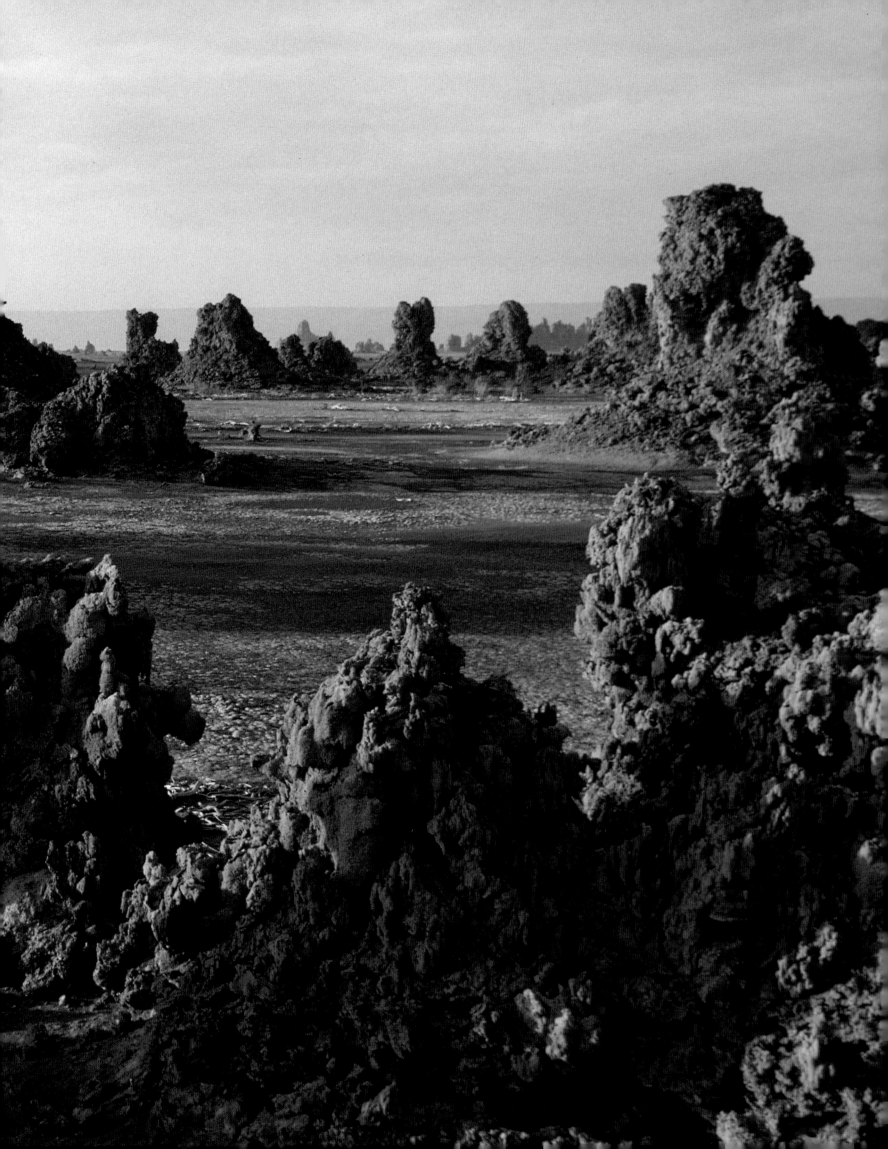

sitting is possible at all, chatting with increasing boredom, awaiting the end of the twelve-hour night, slowly filled with cold, unexplainable by a temperature reading of 18 degrees, except by comparison with the inhuman heat of the day.

During the first hours of night, my companions continuously sip at their canteens. Ever, in my naive mind, the great desert man, I smile to myself for finding the strength not to touch my own water. My throat is so dry, however, that I am unable to swallow the slightest piece of the bread and cheese we have brought along for dinner. I should hate myself for believing that I need less water than the geologists, that thirst, like pain, can be defeated by stoical endurance. Dehydration can only be fought with liquid, not with willpower.

At daybreak, my companions' water supply has dwindled dangerously; Professor Tazieff changes plans.

"There is not enough water for all of us to go on," he declares. "Only one of us will. The rest will quickly return to the Land Rover, where we have a twenty-five liter reserve. Franco," he tells the Italian rock specialist, "you will go. Take along Aberra, the *askari*, to help you carry the lava samples. We will each give you some of our water."

LAVA CUTS SHOES TO TATTERS

Having saved my water, I volunteer to go too. The sun rises with a vengeance. The sweat from our foreheads splashes on the ground like the heavy first drops of a downpour, only to be avidly drunk by the porous black lava. The sharp-edged scoria crumble and crash, tearing at our legs. My sneakers, almost new yesterday, are in tatters, and if I lose my soles I will be immobilized in this corner of hell. Not even a Danakil could walk barefoot in this terrain. Thus I must now walk with care, while Franco and Aberra, wearing high leather boots, lunge forward.

They gain considerable ground and, later, I watch them from a distance as they reach the cliff, hammer out pieces off it, and rush back. I head back too, but they overtake me. Aberra looks as serene as ever. Franco looks like a madman. His legs and hands drip with blood, and he eyes obsessively the eleven o'clock sun.

"This inferno will kill us if we don't get out of it quickly," he

says. "Sorry, but I can't wait for you. Keep Aberra to guide you back. I'll find my way by compass."

And having said so, he tramps forward again. When I reach the Land Rover, an hour after him, I am on the verge of collapse. Though I do not know it, I am dehydrated. Hardly have I swallowed a long draft of water that I feel much better.

We cannot get back to camp, however. The jeep's fan belt is broken. "This evening one of us will have to walk back to camp for help," Professor Tazieff says. Eager to prove to my companions that my poor performance on the lava field had nothing to do with my physical condition, I volunteer to return to camp, fifteen or twenty kilometers away, immediately.

"You are out of your mind," Professor Tazieff answers. "It's only one o'clock."

"With a Saharan caravan I walked in the midday sun day after day," I plead. "Walking back to camp would be nothing compared to some of the marches I did over there. My slow progress on the lava was due to my tattered shoes. In the sand they will not worry me. Let me go back, and in a few hours I will return with another vehicle."

Only half persuaded, Professor Tazieff accepts to let me go if Aberra agrees to accompany me. Naturally, he does. A white man's folly may not be readily understandable to him, but it never affects his goodwill, and certainly not the amazing endurance of his sinewy black frame, which once won Ethiopia's marathon.

We strike out briskly. The heat seems to have bewitched the desert into eternal stillness, and the glare penetrates our sunglasses. For two hours we rush side by side without a word, in-

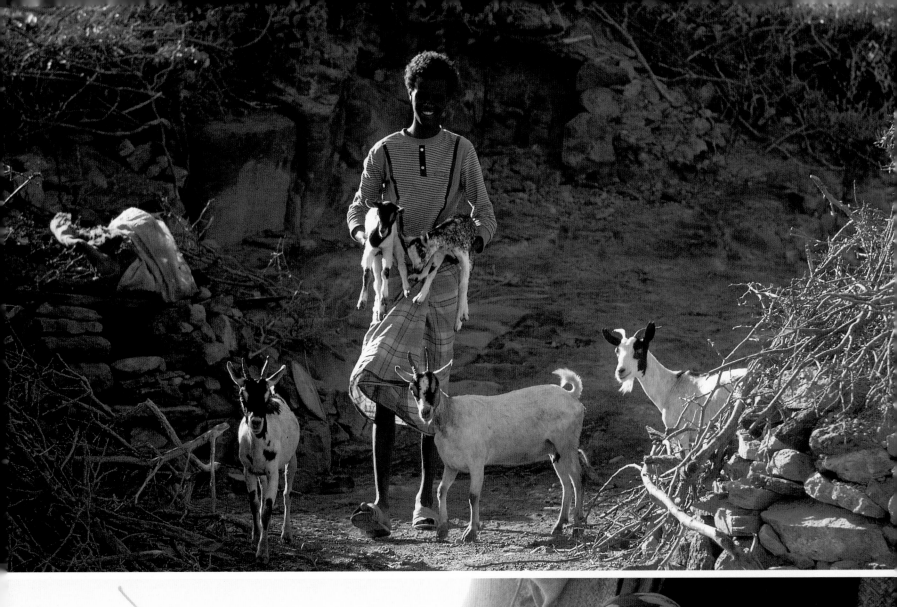

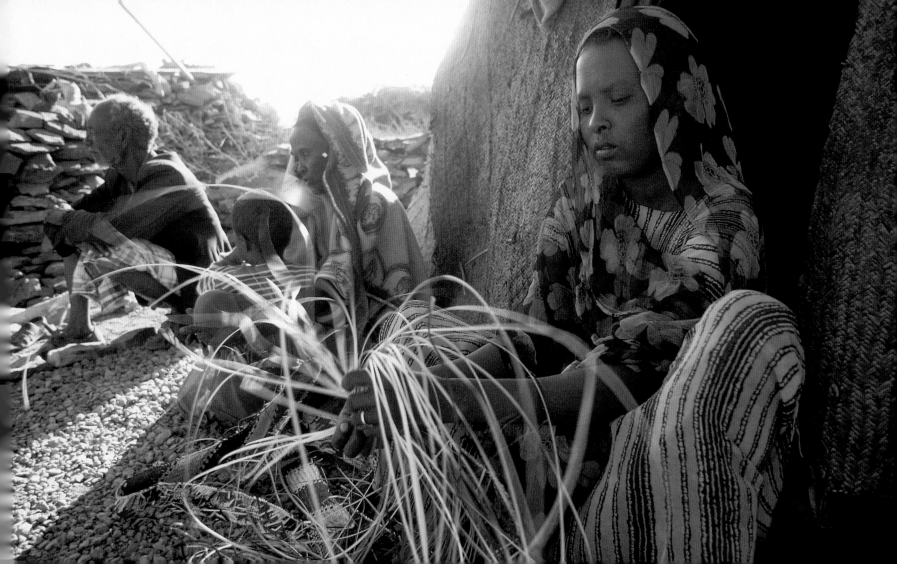

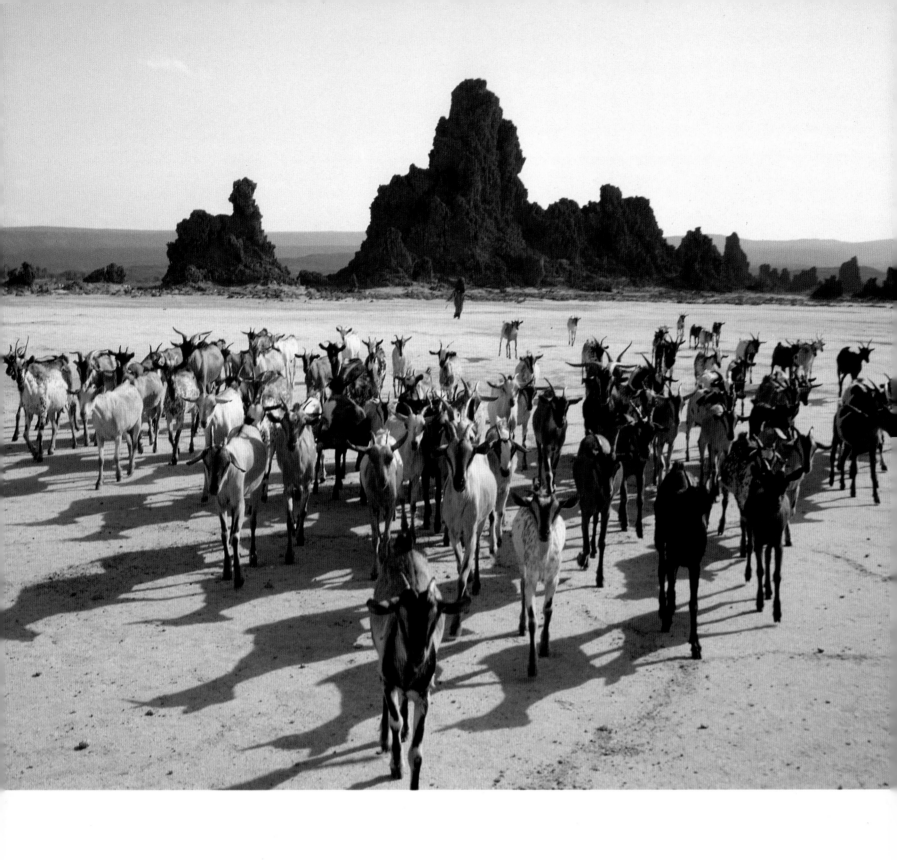

OPPOSITE *Straddling the border between Ethiopia and Djibouti, shrinking Lake Abbe produces on its fringes rich green grass, a magnet for thousands of hungry goats which, every morning, trot to it ahead of their Danakil herders. In the background, oddly shaped by erosion, rise sandstone castles.*

tent on saving saliva and energy. Then my ears start buzzing and my head begins to whirl with dizziness. Sinking deeply into the soft sand, my feet get heavier to pull out at each step, and I wonder how long I will keep up with Aberra.

TREK TURNS INTO AN ORDEAL

More time passes, and I am walking like an automaton, desperately forcing my legs to move at Aberra's rhythm. I long for rest, but there is not a square inch of shade anywhere around and the ground is too hot to touch. Fortunately, now I can see Lake Karum shimmering in the distance. Though its water is much more briny than that of the sea, I gain courage at the prospect of soon dipping my shirt in it and draping it over me.

But the lake never gets any nearer. Quite unexpectedly, I suddenly fall to my knees. The burning sand forces me to quickly get up, but now Aberra is walking ahead, and to follow him seems even harder. Although I did not rest last night, and I did not swallow any food in twenty-seven hours, it is dehydration that weakens me so. If I only knew it, I would drink. Instead, I keep my water for worse moments.

I walk more slowly, eyes on the ground. When I look up, I see that Aberra has entered the lake. I estimate that I shall be there myself in ten minutes and gather my last energy. In an effort to abstract myself from this difficult situation and forget about the ever widening gap between Aberra and me, I keep my eyes on the ground. When I look up again, however, the water has receded beyond my friend; he is on dry ground. The water was a mirage. I have no idea how far the lake may be.

Utterly drained, I drop to the ground and remain. To avoid burning, for a long time I roll side to side. Little by little, the sand, screened by my body from the sun above it, loses some of

its ardor, and I stay still. Aberra is now a dot in another mirage, a distant blade of grass reflecting into an inviting pool. He once looked back after I dropped, but wisely went on to get help.

I hear the noise of an engine and lift my head. A hundred meters away the scientists' jeep is slowly passing. But I cannot scream, I cannot get up. I weakly lift a leg, but nobody sees it. The heat is drying me. I can literally feel my moisture being absorbed by the ground below and by the sun above. I can feel my very life flow out of my body. Yet I feel no pain, no regret. And then I close my eyes and pass out.

I wake up as the sun reaches the horizon. A familiar noise in the distance pulls my head up. A salt caravan is coming my way, and the bellowing of its camels and the cries of its men fill me with a new desire to live. Now I may drink. I pick up my canteen and empty its contents to the last drop. The water seems to run through my veins, to inject me with new energy. I gather myself up and walk toward the caravan.

On the horizon, far behind the line of camels, a black point is moving fast. As it grows, it becomes a truck, and as it gets closer I can see Aberra on the running board. He is shaking in my direction a bottle of water.

Back to camp, I drink like a sponge. The geologists have not arrived and the truck goes back for them. Later I learn that, although more than once they had made some progress thanks to a makeshift fan belt, a piece of rope that ended up burning each time, they had finally got stuck for good.

A HOST IS SACRED TO THE DANAKIL

Not many of our expeditions muster so many members as this one. Most of the time my companions go out in pairs. I join one or the other, but mostly Todorov, the Bulgarian doctor, whom Ras Mengesha has assigned to visit the local Danakil, and who sometimes drives out to an encampment. The Danakil always offer us camel and goat milk. To my dismay, he turns it down and insists on my doing the same. He promises me all kinds of deadly illnesses for not listening, but I do not see the Danakil die of it, nor could I indulge, like he, in bad manners. Milk has such a symbolic importance to the Danakil that, by accepting it from them, I put myself under their protection. Were I killed under those circumstances, they would have to avenge my death.

137

The expedition's vehicles have passed the Suez Canal and, driven by some of the geologists from the harbor of Massawa, have finally reached our camp. Now we are moving south to Lake Giulietti, unlike Lake Karum, a real lake, with waves of foaming blue water washing on shore and dispensing life to swaying palm trees. Hot springs line its shores, and into it run short streams attracting nomads and their flocks daily.

Whenever possible, I follow those nomads back to their camp. Like all the Danakil who inhabit the depression, they are Adoimara. Less ferocious-looking than the Asaimara, the Adoimara at the end of the last century nevertheless massacred members of various expeditions. They wiped out, among others, Munzinger, a Swiss mercenary, and his Egyptian army in 1878; Giulietti, the Italian officer for whom the lake was named (the Danakil keep calling it Afdera), and his fifteen Italian soldiers in 1881; and Bianchi, another Italian, in 1884. Inhabiting a much more desolate environment than the Asaimara of Aússa, they are much poorer too. To save for their herds the scattered grass growing on the sand, they often camp on the inhospitable lava fields or even in small caves excavated from the soft lava rock.

As in many tribal societies, the men are more often found holding council than working. More active, the women are always plaiting straw mats when not nursing babies, milking goats, grinding durra, or cooking. They weave mats even on the move or while herding goats. They plait endless strips of them while walking, folding them and tying them on their backs as they grow, and later sewing them side by side to renew those they sleep on, cover their huts with, and sell at the market.

DANAKIL WOMEN SWEETEN THEIR MEN'S LIVES

The Danakil women wear the same cotton wraparounds as the men, but dyed brown and knotted on the left side. Thick braids, often hung with colorful beads, festoon their foreheads, while a veil covers their hair. Though usually black for married women, the veil is sometimes cut out of commercial cotton print. Their cheeks and the bridges of their noses are tattooed with vertical black lines. Bead necklaces and silver or colored-glass bracelets complete their personal ornaments. Their slender bodies, bright eyes, fine features, and engaging femininity are in these

OPPOSITE *Ethiopia. Borhale, a village in the eastern escarpment and an important stop on the salt caravan route. The caravan will camp here below a small stone schoolhouse.*

wastes an unexpected boon that must make their men's lives better than bearable.

Still, I cannot but marvel at the tenaciousness with which the Danakil comb the wasteland for patches of grass or scrub to keep alive their goats, and hence themselves.

"Why don't you look for greener pasture elsewhere?" I once ask a man through Aberra, who speaks some of their language.

"Because, as surely as we would kill outsiders settling on our land, they would kill us if we trespassed our own borders."

And would the Danakil be happier elsewhere? Probably not. Here, at least, they are rich of space, clean air, freedom, tranquillity. Anything more than the few things they own besides their herds—a flimsy hut, some skins or mats to sleep on, a stone mill, two or three goatskins of water, a makeshift wooden stand on which to keep them out of the path of animals, and a change of clothes—would burden them. I know they are happy because I am happy here myself, and I am not part of their world. They are certainly quick to laugh, and even to seize the opportunity for an impromptu dance.

The geologists are packing to go home. Pleased with the results of their investigations, they enthusiastically plan next year's expedition.

ALONG THE RED SEA COAST

The time to leave has come for me too, but I will not depart before seeing the rest of Dankalia: the Red Sea coast and the Danakil Alps bordering it. Thus I travel to Asmara, capital of Eritrea, and rent a Land Rover with a driver, a young easygoing Eritrean named Abdallah. Soon we find ourselves in Tiyo, a beautiful fishing village on the Red Sea, bluer here than the cloudless sky.

Along the sea, contrasting with the blue water and sky, stand white buildings which, on closer look, turn out to be the ruins

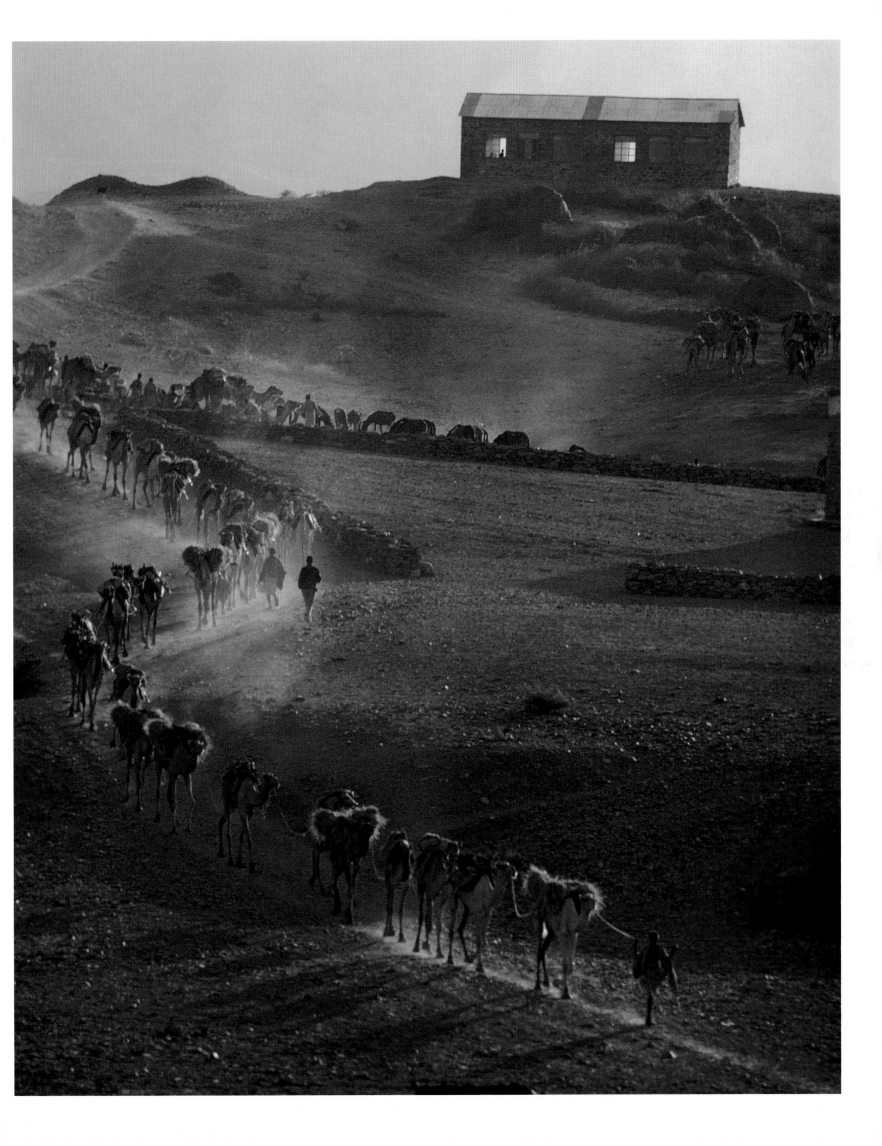

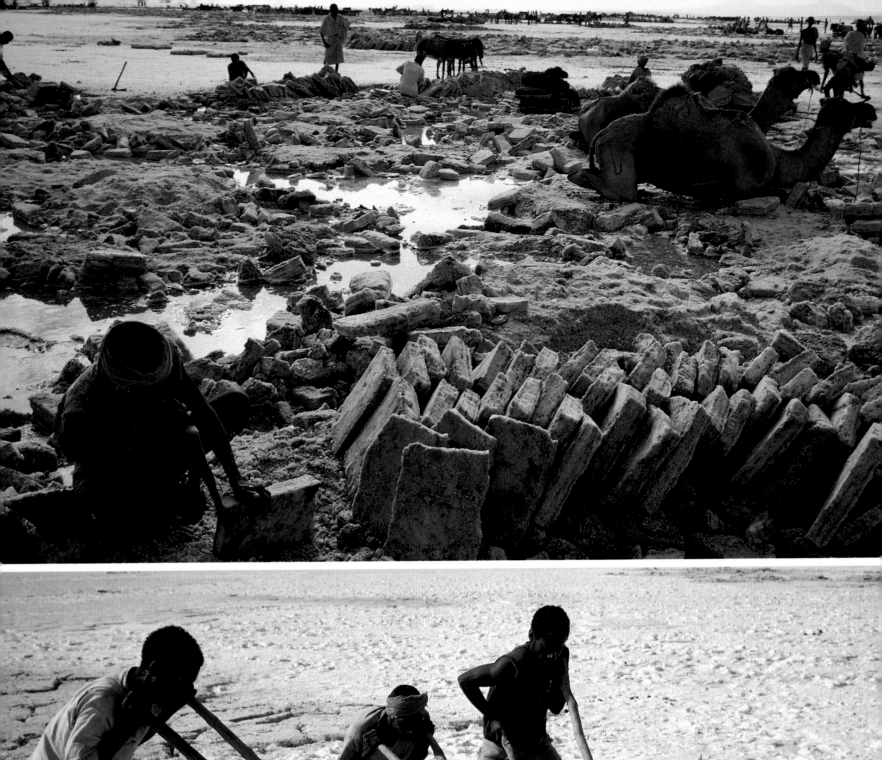

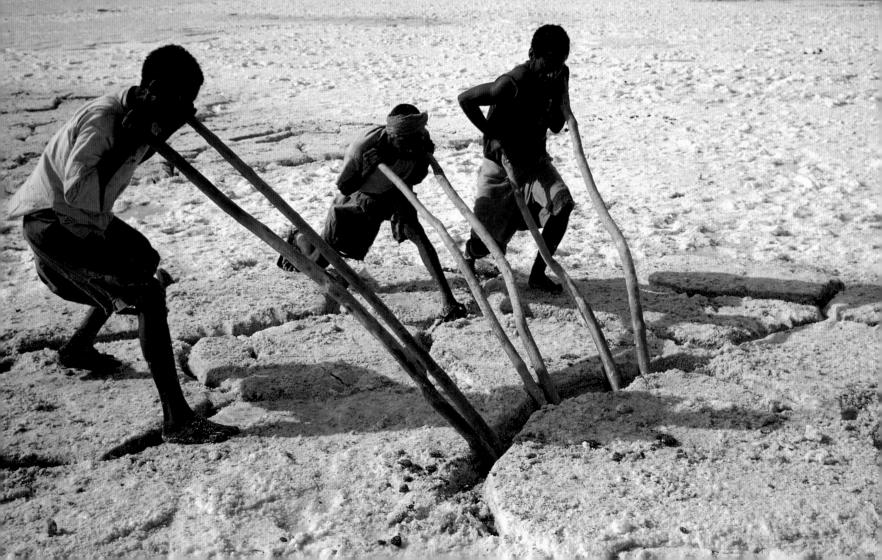

of Italian colonial buildings. Large rectangular huts of wooden frameworks covered with straw mats surround them. On the beach, not far from high square piles of salted small sharks drying in the sun, Danakil fishermen are repairing giant gill nets. Heads, bones, and skins of thousands of dead sharks litter the sand over several kilometers. The sharks' most valuable parts, their fins, were exported to Aden and on to the Far East, where the Chinese pay dearly for them to prepare a rare delicacy—shark fin soup.

"Once in a while the sharks take their revenge," an English missionary tells me. "Last week one of them pulled to sea a woman who was washing fish in shallow water. Another one last year left one of our young students with a buttock less."

Their contact with the Arab world as well as their lifestyle have made these Danakil a breed of men different from their nomadic brethren. They wear plaid *sanafils* instead of white ones and, often, on close-cropped hair, turbans. No knives or cartridge belts adorn their waists, and a gentle light sweetens their eyes. Some of their children attend mission school.

I spend a day at sea on a fishing boat with a crew of four men and two boys. We meet at dawn on the beach and, in shark-infested waters, wade out to where the boat is anchored. Today the color and stillness of the sea are of oil. The men take turns at the long oars, rowing toward the distant swell until at last a breeze springs up and they can hoist the sail. An hour later, black spots appear, floating on the water. They are inflated goat-skin bags, buoys for five or six nets.

Two or three men at the prow pull the immense nets in one by one, while the others remove the many small sharks snared in the meshes and fold the net carefully. By the end of the day

the bottom of our boat is full of fish, and the fishermen have returned to the sea a huge dead tiger shark, useless but for its liver, which will serve to oil the boat. Back on shore, the sharks are immediately cleaned, salted, and spread out to dry.

I Fall into *Shiftas* Hands

Although, on account of the *shiftas*, the missionaries have urged me not to travel farther south, I decide to ignore their advice. For three months I have heard nothing but similar warnings, and I still have to meet my first Eritrean rebel. Besides, the *shiftas* are not seeking independence from *my* people, and I doubt that they will resent a friendly neutral. At thirty-four, not a bit more mature than I should be, I still have to learn that some people behave irrationally.

Not long out of Tiyo, one early morning, with Abdallah at the wheel of our jeep, our trail in the bush peters out. For hours, trying to follow a course parallel to the invisible coast, we zigzag around low thorn trees in a vague south-southeastern direction. But by noon we are completely lost. We go on, however, and later pick up two Danakil nomads popping out of nowhere to flag us down. Unfortunately, they do not seem to understand that we want them to guide us to Ed, another fishing village on the coast, or even to care where we are taking them.

Oppressed by the inhuman heat, we have lapsed into a stupor that might rob Abdallah from his control over the wheel, and when he abruptly puts the brakes on, my first thought is that we have hit a tree. But almost as soon as I hear him whisper, "*Shiftas*," I see the men in army fatigues, perhaps a dozen of them, quickly surrounding us. Running bent from tree to low thorn tree with rifles and submachine guns aimed at the jeep, they are on us in an instant. But they keep low, looking behind us as if fearing the arrival of more vehicles.

Abdallah has stretched both arms through the window even before stopping the jeep. Naive and optimistic, I step out smiling, ready for presentations. But I am brutally thrown to the ground and ordered, by signs, to put my hands on my head. A madman, who has pulled Abdallah from his seat, savagely beats him with a stick on the head and face. "Donkey!" he insults him in English, probably for me to understand the insult, "Donkey!"

"Stop it!" I cry. "That man is an Eritrean like you."

"Of course, he is an Eritrean," the madman answers, "which is why I am not killing him. But you . . . , you, f . . . Israeli spy, you may say your last prayers, for you are going to die." And saying so, he drops his stick, pulls a revolver from his belt, and comes around the jeep to put it to my head. Too late, I now remember that the Israelis are training the Ethiopians against the rebels, who get their own help from Egypt's Nasser. He would not know the difference between an Israeli and me any more than I could tell him apart with certainty from an Ethiopian.

There is no time to extricate myself from this absurd situation, no time to think, which leaves me speechless as I strain against the shot that will end my life. But if the sluggishness of nightmares keeps my mouth shut, my glare bears down on the madman, and he wavers.

Algerian Visa Saves a "Spy"

"Wait!" The words finally forced their way through, and now they rush. "I'm a Belgian, let me show you my passport."

"I know Belgium," he answers, "any idiot can get a Belgian passport." But he relents, for his men, who have been searching the jeep and my luggage for weapons, hand him a knife as their only trophy.

"All right," he now says, "let me see your papers."

In my passport is a faded Belgian identity card which he studies carefully. It is ten years old, and its picture is almost that of a kid. What convinces him, in the end, that I cannot be an Israeli is that twice in the last four years my passport has been stamped for admission into Algeria, an Arab country.

"Get back in the car," he says, "and you, donkey, too, and do not get out of it under any circumstance, or we will shoot you. You are my prisoners."

Having said that, he waves away our Danakil passengers, and goes with his friends to sit under a tree. The heat in the stranded car is almost unbearable, and poor Abdallah, whose face is swollen and bloody, moans heartbreakingly.

"Do you realize this is Sunday, and I could be dancing in Asmara?" he asks, however, with a half smile.

"I know, Abdallah, it was stupid of me to want to come here. I should never have led you into this situation. I'm sorry."

"Presumptuous Christian!" he screams bitterly. "You had

OPPOSITE TOP *Ethiopia. Borhale. A caravan has set up camp outside the village, and its unloaded camels are eating cut forage.*

OPPOSITE BOTTOM *Ethiopia. Bati. A squatting Danakil nomad at the market tries to sell stone mills to young warriors.*

nothing to do with this. Don't you see that it was written, that you were only an instrument of my fate in the hands of Allah?"

We spend a bad night, and the wails of Abdallah, suffering more from his fear of being forcibly drafted into the Eritrean Liberation Army than from his very serious wounds, almost drive me out of the Land Rover.

At dawn the guerrillas hoist a flag on a rifle, present arms, and go sit under a tree a hundred meters away, leaving us in the Land Rover in dreadful suspense.

Large and red, the sun pops out of the horizon at ominous speed. Catching fire, it climbs the sky with evil purpose—irresistibly, pitilessly. Bearing down on our metallic roof, it raises the temperature inside our prison to an intolerable level. By eleven o'clock, I call out to the guerrillas to seek permission to get out, but they do not hear me. Preferring to risk death by a bullet than by roasting, fighting the embrace of Abdallah, who will not let me open the door, I get out in the sun and, hands up, slowly walk toward my tormentors. I call again, and this time they hear me. Their leader gets up and comes to meet me. He is holding my knife.

The Emperor Is the Shifta

"You may go," he says. "Here is your knife. You see, we are not *shiftas*. Haile Selassie is the *shifta*: he robbed our country. Go tell that to the Belgians."

Having asked him the way to the coast, we finally go on. But at the entrance of a fishing village another armed man stops us. He leads us into a large tent, and to four men behind a table Abdallah explains how we got here. They accept his story and wave us on. Now I really laugh at Abdallah's qualms.

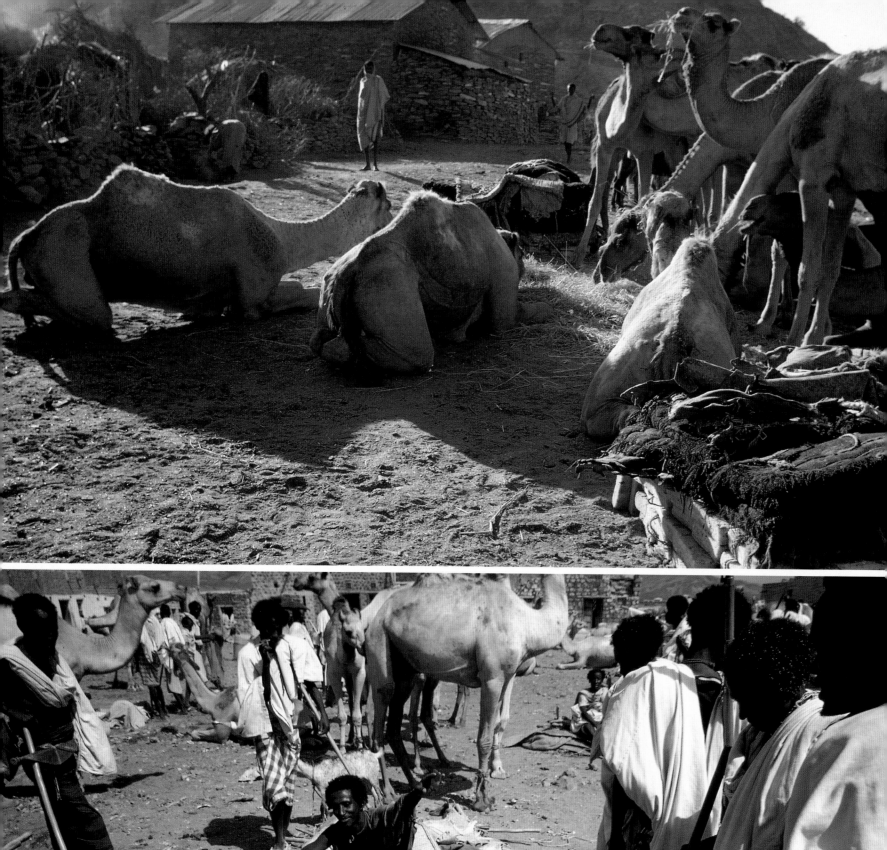
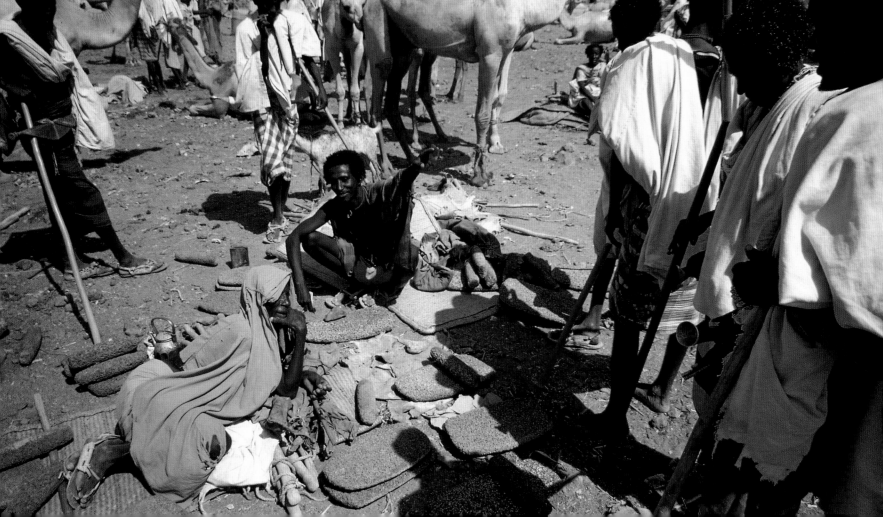

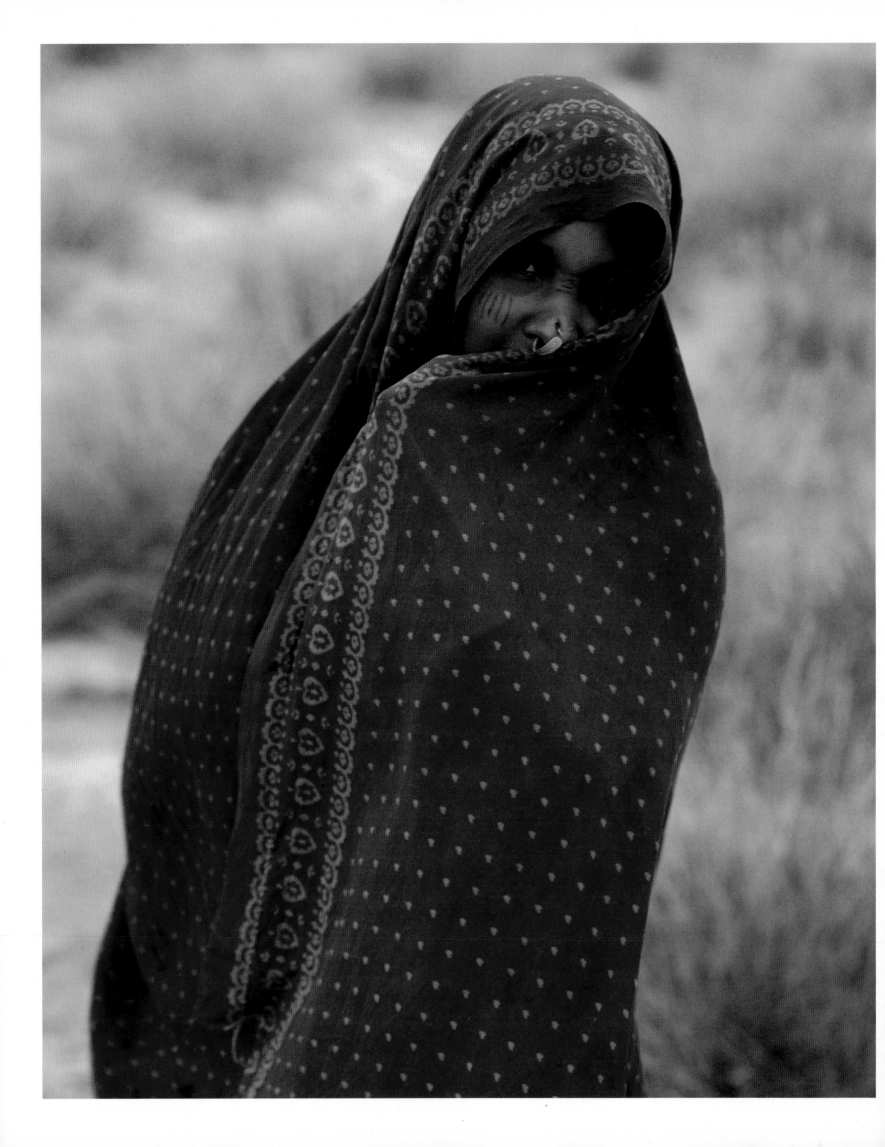

THE DANAKIL

OPPOSITE *Ethiopia. Danakil Depression. A shy
*Danakil woman hides all but a gold-ornamented
nose and two inquisitive eyes.*

As we reach Ed we see some twenty-five men run out of bar-racks, fall on their bellies, and aim their rifles at us. "Jump!" Abdallah commands, but I am already out of the jeep, hands up, and this time really frightened. A man comes running in our direction. He is an Ethiopian soldier. He checks us for weap-ons and takes us to an English-speaking captain who greets us warmly.

"You jumped in the nick of time," he declares gravely. "A sec-ond later, and we would have made a sieve out of your jeep. You must understand that we have not seen a single vehicle come out of the desert in three years. We thought we were being attacked by the *shiftas*."

Now I understand why we lost our way: in the last three years the trail must have become overgrown.

"What are you going to do now?" the captain asks. "To Assab, where you are headed, is a much longer distance than to Tiyo, and the mountains you now must cross are literally swarming with *shiftas*. You could leave with the next boat, perhaps several weeks from now, but without the Land Rover."

To my surprise, Abdallah wants to go to Assab by land. He would rather face unpredictable adventures than to have to meet our madman again. Besides, as terrified as he is by the guerrillas, he seems even more in awe of his Italian boss in Asmara to whom he would not return without the jeep. As far as I am concerned, I am still interested in seeing these mountains to the south, and trust in my good luck enough to accept this last challenge.

Thus we go on, up and down a narrow mountain trail. And though Abdallah spots a guerrilla behind every rock, he always disappears as we get nearer. Eventually we reach Assab and drive into the traffic without further interception.

On our way to Asmara, we climb out of the Danakil Depres-sion, and a sharp pinch of the heart upsets me. I do not think of the dangers I faced: had I been more reasonable, I would have avoided them all easily. But the savage landscape, the fierce no-mads, the boundless freedom offered something I would not soon find again—something intangible, but that has left on my brain and heart a mark forever indelible.

This is not a land of tourism, and it is fortunate, but to those who will, one day, follow the route of the salt caravan, I have a word of advice. If you are fond of pretty girls and poetry, bring an orange.

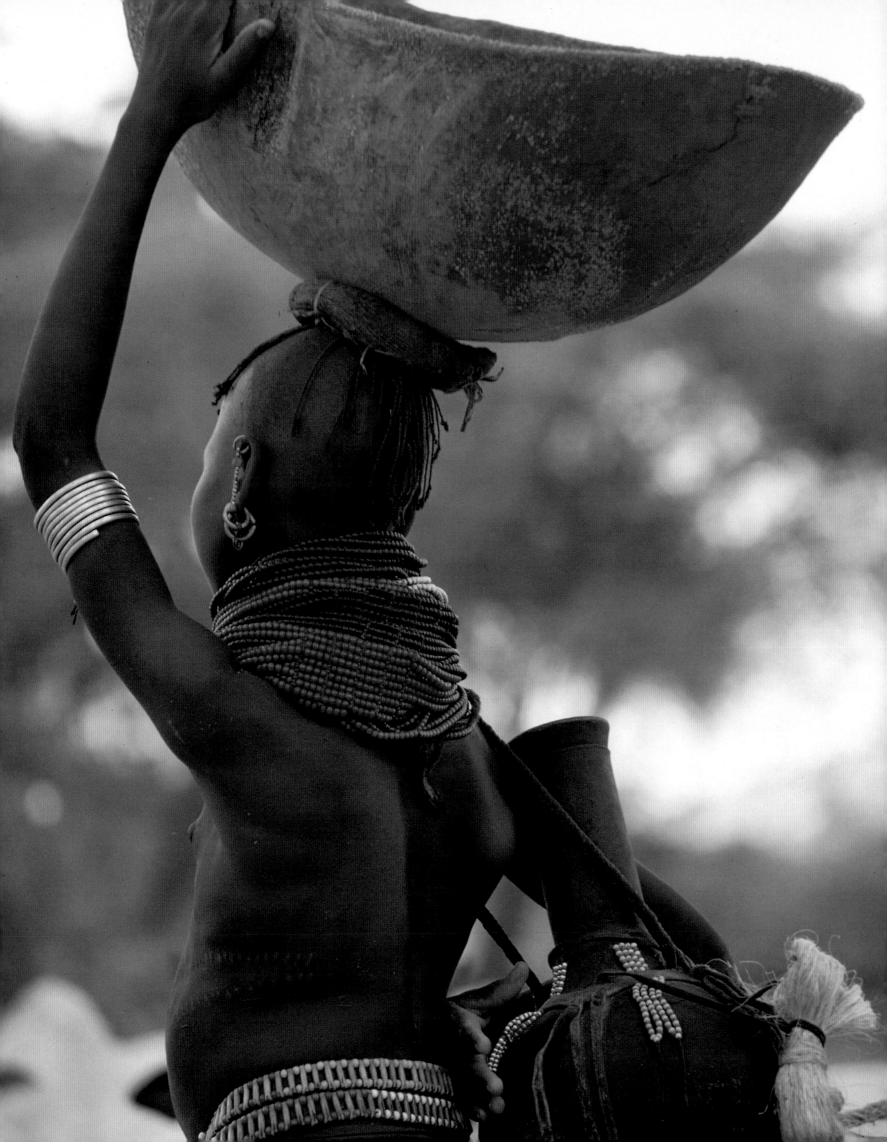

Part Five: The Turkana

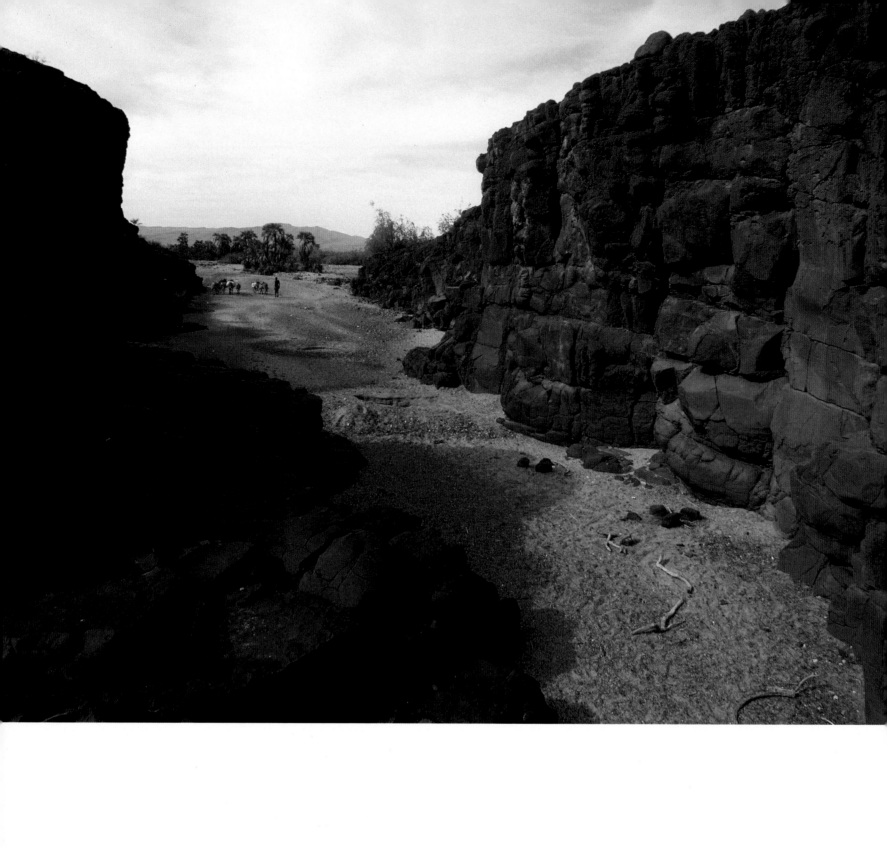

"Y ou can't go that way," the young anthropologist said. "You'll find nobody, no water, no shade. No one will guide you into the sweltering desert. No camels will carry your luggage. The Turkana nomads have not trained them for transportation. They use them only for milk and prestige. Do you imagine yourselves vainly scouring the scorched wastes behind a bunch of donkeys? Don't do it, take my word for it—if you don't want the sun soon to bleach your bones."

The young anthropologist was reacting to an itinerary through Turkana country that Jeff Barr and I had designed to take advantage of a small plane that flew irregularly from Nairobi, Kenya's capital, to Lake Turkana's area in the northwestern desert. To make the most of my American friend's limited time we hoped to fly to Lodwar, a small town west of the lake, walk around the lake's southern tip to Loyangalani, on the eastern shore, and there get back on a Nairobi-bound plane. The map showed plenty of water along the way, and in an emergency we would drink Lake Turkana's alkaline waters, never far from our route. But do not maps make all trips look easy?

"Assuming you get through the desert and over the Loriu Range, where hide Turkana bandits," the anthropologist continued, "you could not get to Loyangalani on time to catch the weekly flight, which anyway rarely flies weekly, for you would still have to cross the Suguta Valley, one of the hottest places on

earth. A volcanic chaos bubbling with boiling springs and carpeted with salt, it is an inferno even in the cooler season, and this is the peak of the summer. You'd be mad to do that."

The anthropologist knew the area, and we feared that, at least concerning the absence of nomads along our route, he might be right. But he spoke too dramatically to be convincing. And we knew that, like most of his colleagues, he was doing his best to protect what he considered *his* territory, *his* Turkana, from our "polluting" contact. Considering the fragility of tribal life, which is often threatened even by well-meaning missionaries, we understood, and even forgave, his attitude. We would not, however, give up our trek. Having, seventeen years before, spent a couple of weeks among the Turkana, I was decided to get to know them better. And Jeff, who had glimpsed them during a recent drive through northern Kenya's national parks, had been excited enough to have made up his own mind about coming with me.

THE GREAT RIFT VALLEY ATTRACTS ME AGAIN

But what was that Suguta Valley, we now wondered? The scientist's intriguing description reminded me of the Danakil Depression and did not dispute Turkana presence there, only our own survival ability. Looking at the map, we saw that the valley opens south of Lake Turkana, at the bottom of the same trough. Probably once part of it, before volcanic eruptions dammed it, cutting it from the flow of Ethiopia's Omo River—as volcanic eruptions once separated the Danakil Depression from the Red Sea—it extends between hills and plateaux, like the Danakil Depression at the bottom of the Great Rift Valley. The Suguta River snakes through it northward, past Lake Logipi's blue spot at the head of a yellow stretch of mud flat. And to our eager minds the brown areas of desert suggested the boundless spaces our eyes wanted to scan, and the dotted blue lines of dry stream beds failing to reach the river, soothing green lines of palm trees. To our keen imaginations, the valley's jumbled black lava walls rose right from the map to beckon us, and against our mentor's advice, we decided to heed their call.

Maps have a knack for firing your imagination. They show you the world before they guide you to it; they lead your fancy

from the gloomy abysses of the seas to the luminous peaks of lofty mountains, from searing deserts to steaming jungles, from hidden canyons to virgin islands. Sonorous or discreet, unforgettable or unpronounceable, their names are full of evocative significance. Listen to them, and they will sound for you the trumpets of battles or the fanfare of discovery, the music of Eden or the whispers of ancient secrets. String them together, and they will show you a trail that may change your life. For to plan a journey on a map is full of consequences. For better or worse, things will happen to you along the way that would not have happened at home, or on a different trip. The life of a traveler is a bit like the fiction of those children's books which put young readers into the story and, at a crossroad, offer them a choice of adventures. If the child decides to follow the left path, these adventures will be different from those challenging him on the right one, but either will be dangerous and exciting. And when he has gone to the end of one trail, he can always go back and find out what will happen to him on the other one.

A CIVIL WAR LEADS ME TO AN OLD FRIEND

The map, naturally, had brought Jeff and me to Africa—he came in 1989 to teach science and math in Mogadiscio's American school; I arrived a few days ago to try to re-kindle old emotions. We know each other from Colombia, where Jeff taught for five years in my children's American school, and where we traveled together through the rain forest. Having lost everything to the Somali Civil War, Jeff and Alice, his teacher wife, fled to Nairobi, where an American friend of ours, another acquaintance from Colombia, brought us together again. Although they were on the eve of a flight to London, planning to attend an annual teachers' convention that would generate new overseas jobs, Jeff offered me his company; or rather, was induced by Alice to do so. It would mean a lonely long trip back to Europe for her, but she generously wanted him to indulge for a while his love of tribal people. They would meet less than three weeks later in Iowa, at another teachers' convention. This was very fortunate for me, for he is the perfect traveling companion. Experienced, resourceful, good-humored, unselfish, and enduring, he accepts the moments I want to be alone, and he is never too tired

OPPOSITE *Kenya. Suguta Valley. Lotinget, wrapped in his blanket, and Abodo drive our donkeys over a pass toward an approaching sandstorm.*

to prepare a succulent meal while I am trying to get some notes written.

Forsaking the chancy flight, we hired from a Frenchman in Nairobi a jeep with a driver, journeyed north along the rim of the Great Rift Valley, and at the end of the day camped on the plateau north of South Horr.

JANUARY 25

This morning, through a chaos of brown lava blocks, we are winding down from the plateau into ever hotter depths that must once have looked Dantesque. But the interesting vegetation that is patiently taking over the sides of the valley, in spite of goats and camels and oxen, and the termite mounds pointing ever-stretching fingers skyward, greatly mellows the lava blocks. Short white bushes crop up here and there from the porous lava, blossoming acacia trees poke out like great glowing bunches of white flowers, and skeletal trees bleach in the sun. What gives the landscape a cheerful unreality, however, is a paunchy miniature tree so reminiscent, in its elephantine figure, of the enormous baobab tree, that but for its brighter colors it could be taken for its bonsai. Never as tall as we are, it always lets us look down on its small bright red flowers standing out on glossy green leaves above a shiny light gray bark or, more often, over a white glistening trunk undressed by the eager teeth of antelopes and contrasting against the dark surroundings. Not surprisingly, our driver calls it an "elephant tree."

We meet our first Turkana—six women and four children pushing ahead of them eight donkeys loaded with their belongings, including goat kids. They are moving camp while somewhere their men are gathering the herds. From among the blackened aluminum pots and few handmade household objects in the animals' wicker panniers stick out rolled cowhides and the graceful necks of wooden milk jars.

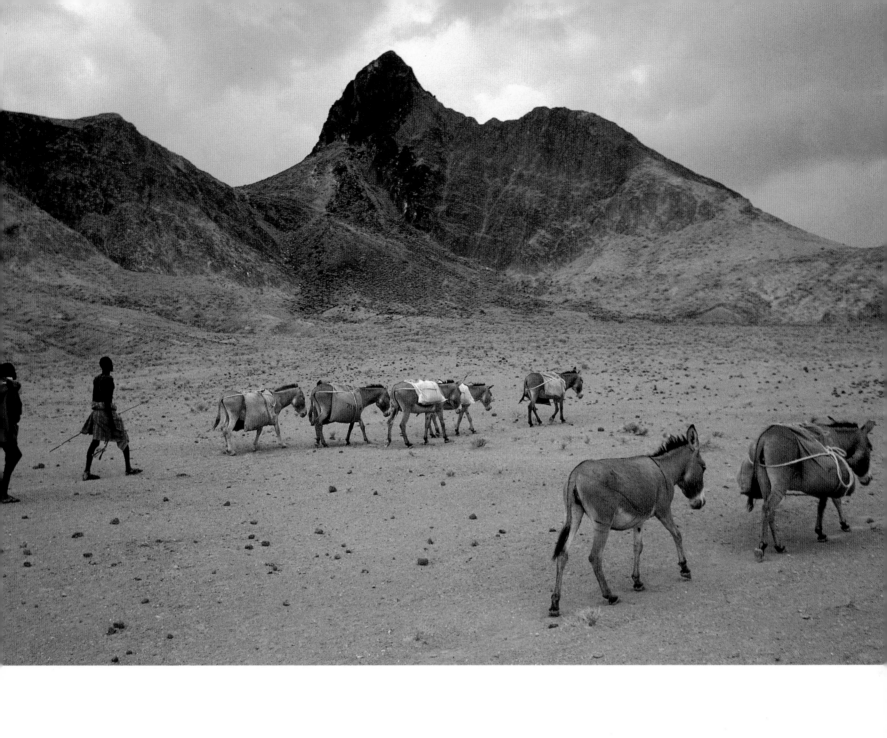

Except for one bare-breasted woman, they all wear long leather aprons that hang from their necks under the heavy rows of colorful beads adorning them. Stringy braids hang all round from the tops of their shaved heads and small iron rings from their ear lobes. Crude sandals made of discarded rubber tires, today common all over Africa, protect their feet against the cutting rocks.

Near the bottom of the valley, an ancient acacia grove shades a dotted stream which flows in and out of the earth in clear puddles reflecting the tall gnarled trees. Nearby are the seven little brick houses of the Parakati/Italian Mission School. We arrive here in the hope of finding a Turkana teacher who might serve us as interpreter. Presently, a tall skinny young Turkana in Western clothes comes to greet us in good English. He helps us unload the jeep, installs us in an empty classroom, and confirms that we will have to use donkeys to carry our luggage. Already employed by the missionaries as a teacher of Catholic religion, he cannot work for us, but he knows an English-speaking Turkana who will be glad to. We are astonished to see our search end so quickly, but our new friend, christened Peter by the missionaries, takes it in stride. He has seen more surprising visitors than us: a class of English children from Eton, for example, who came down by truck last year to measure the changes of temperature between the plateau and the valley.

To meet our prospective interpreter, we drive back with Peter out of the valley onto the plateau, where he presents us a thin man of twenty-six or twenty-seven, wearing shirt and shorts. Like Peter, he has lost his tribal identity, probably in school, where he says he spent six years. He speaks adequate English and can provide six donkeys and two young men, both relatives of his, to drive them. His name is Silale. Though the walk with his donkeys to the mission will take him several hours, he says he will not leave until well after sunset, when his animals have eaten a bellyful. "I'll wake you up when I get there," he says, realizing our eagerness to leave early the next day, "so that, knowing I have arrived, you may sleep better the second half of the night."

Back at Parakati, I walk to the cleanest puddle of the dotted stream, at the bottom of a hole, to fill the four plastic jerricans which, for lack of Saharan goatskin bags, we will have to use to transport our water. An old Turkana woman is filling her own old plastic jug, and I watch her deliberate movements with fascination, for these movements are those of all the tribal people I have observed on three continents. Unused to furniture, they all have developed the same way of comfortably squatting on their haunches to do anything and to use any means at hand to get things within their reach without changing a position that a stiff Westerner would find excruciating. And so, rather than getting up to retrieve her vessel cap which is floating away on the puddle, she throws stones at it, stretches inhumanly sideways to pick up a stick with which to reach it, and finally asks her daughter standing behind her to pass it to her. But she does not close the jug. Though it is as full as its slightly awry position permits, she keeps pouring water in it as if expecting that in the end, against all laws of physics, it will rise to the collar's higher side. Unless she does that to make me wait my turn longer. For by now I have started to shift my weight from foot to foot, and if she has sensed my impatience to take her place on the only square foot of ground low enough to get to the water, perhaps she wants to punish me for it. Whatever the case, walking finally away from the puddle without closing her jug, she carelessly spills along the way much more water than she was so long trying to get in.

Peter shares our dinner, then sits down with us over tea to chat. Flattered that we should be interested in him, he tells us about his life, only stopping occasionally to make sure we are not dozing away. "Are you with me?" he asks every time.

"I am married and the father of six," he says, "but I never finished paying for my bride. I still owe my father-in-law two hundred goats, ten cows, and five camels. By the time other Turkana men get married, in their early thirties, the animals they have received over their childhood years have multiplied, and they have successfully begged from relatives a few more and stolen or raided others. But I was an orphan raised by missionaries, and nobody ever gave me animals. While studying, what would I have done with them anyway? Without a herd of my own, my monthly 300-shillings (75 U.S. dollars) salary goes all into maintaining my family.

"Now my father-in-law has taken away my two eldest daughters as an advance. When they get older, he will marry them and

get two dowries for the one I never finished paying him. Soon the ten years he gave me to pay will have elapsed, and he will take back my wife, and the rest of our children."

Peter speaks in a matter-of-fact way, without bitterness, as if what is happening to him was the most natural thing in the world, which in Turkanaland it probably is. He does not complain. In fact, he does not really seem to care.

"Peter," I ask him, "what happens to a Turkana man who leaves a girl pregnant and does not have the means to marry her?"

"A man who 'pregnants' a girl must either marry her and pay the dowry or settle for a fine of twenty goats and ten cows. Unless he pays for the child too, however, he loses it to his future father-in-law. If another man marries the girl and wants the child, he can get it under the same conditions: by giving his wife's father ten goats and five cows for a boy and twenty goats and five cows for a girl. Many men see the child as an investment, both for its labor and for the dowry the girl will bring them in the future."

We wait for Silale late, and finally, no longer expecting him until tomorrow, we go to sleep under the moon. But at one o'clock he pulls my feet to announce his arrival. He did not start on his long march until 9 P.M. I get up for a look at the donkeys that are attached to a tree. Most of their ears have been shortened by half, supposedly to differentiate them, but most Turkana do the same, and how they distinguish one half-eared donkey from another is not evident to me. Poor donkeys, they stir none of the emotions I have felt in the past admiring the horses and camels that would carry me over thousands of kilometers. They are so humble, heads and ears down, so utterly removed from anything approaching nobility. Yet they alone will make our trip possible, and my last thought tonight is one of gratitude to them.

January 26

Though up before first light, we will not leave early. Silale immediately requests a big needle, and when we cannot produce one, he proceeds to quickly carve one out of a strong twig. With Peter's help, he then good-humoredly sews together in pairs the jute bags containing our food. Then he packs. The four jerricans go to two donkeys, the food and luggage to the other four. To avoid losing time looking for our things, Jeff and I have made a list of the contents in each bag, but in vain. To divide the loads equally between each animal and fairly balance them, Silale scatters and repacks it all.

Our two other companions have arrived and presented themselves as Aboto and Lotinget. The first is a tall slim boy of approximately fourteen dressed in dark shorts and a torn white shirt, which many washings in muddy water have dyed a dirty beige. Though not immediately apparent, his English, we will later discover, is better than that of Silale. The second, naked under a warm blanket which he periodically opens and rewraps around him for ventilation, is a young man of about twenty with a shaved head, high cheekbones, and thick lips.

Taking leave from Peter, we are gone by nine. Ignorant of the way, Jeff and I nevertheless walk eagerly ahead on the difficult rocky terrain. Our friends, keeping the donkeys tightly together, follow behind at a good pace. We pass the camp that yesterday produced the Turkana we saw around the school and the water hole, and with no further transition we enter the desert. Fortunately, the day is cloudy. A few drops of rain even fly in our faces.

The land is cut at intervals by depressions bristling with naked acacias. Thin termite mounds dot the land like clay chimneys. Low mountains mark much of the horizon, and on one of them, a flat corrugated-sided table called Nara Namorunyang, we have set our course. We climb down a black lava barrier, cross a dry lime-bottomed lake, scatter a herd of gazelles, and get over more black lava boulders before going down again, this time into a sandy valley.

The desert is beautiful. Most African deserts are. Their emptiness attracts like a vacuum—like the sea and the sky—like a planet to be discovered. I am drawn to them for their virgin vastness, their intimation of a time before man, their concert with God.

I run left and right and up and down taking pictures and slowing us down more than the slow-walking donkeys. When the sun comes out, causing the land to glare harshly, I put my cameras away and we walk faster. Anyway, by noon we must stop to let the donkeys rest.

We unload and lunch on bread and cheese, then while away

the hot hours in the sparse shade of a leafless acacia. A gust of fresh air tears us from our laziness, makes us sit up and look at each other. It is three o'clock. With the chewing tobacco we brought to distribute among the nomads and pieces of our last newspaper, our Turkana friends roll cigarettes. Ordered by Silale, Aboto gets up to gather the donkeys. In a few minutes they are loaded, and we go on.

Again we climb over the rubble of broken lava hills that are hard to the feet and into sandy plains strewn with thorn trees. The breeze that ended our siesta has turned into a cool wind that brings in gray clouds, then into a brief sandstorm that obscures the sky and softens hard lines into ghostly silhouettes.

From a ridge we descry Lake Logipi below, and in a sprinkling of rain scramble down to it. Our feet are so bruised by the uneven terrain that Jeff and I take our shoes off to find some relief for them in the water, but Silale stops us. "You might sink in boiling mud," he warns, pointing to the vapor rising from the lake in various places.

To the south, Cathedral Rock, as the table mountain that guided us here is also called, broods over the shallow alkaline lake, and thousands of flamingoes with their inverted reflections color it. Seen through a veil of slanting rain they are like elements of a Japanese print lost in a world's end chaos.

It is getting dark, and lightning flashes tear up the sky to the east. The rain falls more heavily as we watch the pots over the fire. Jeff is cooking rice and cabbage for us while our friends prepare *ugali*, a maize porridge with a sauce of tomato paste and onions.

"What will we do if the rain keeps falling?" I ask Silale, foolishly hoping he will come up with some magical solution, like a cave nearby. "I will cover your belongings with my blanket," he says seriously. His blanket is, besides his shorts and T-shirt, his only piece of clothing, and he needs it to protect himself against mosquitoes as much as against the cold night.

As we eat, the wind chases the clouds, a half moon appears, and the stars light up one by one. Fortunately we will be able to sleep.

The Turkana in their beds chatter and laugh like schoolboys sleeping at a friend's house. I think they are enjoying themselves even more than Jeff and I, and wake up cheerfully

OPPOSITE TOP *Kenya. Suguta Valley. Morocomock. Watched by her old husband, a Turkana woman sews a leather extension to the woven-grass collar of a camel-skin vessel. Shaped like a gourd, it will serve, when finished, to hold cooking fat.*

OPPOSITE BOTTOM *Equally at ease with materials as diverse as wood, leather, and straw, which they effectively combine to create original and graceful shapes and textures, Turkana women are skilled artists.*

every time they must deal with a donkey problem, leading to more chatting.

I wonder whether the donkeys sleep at all. Constantly, they stamp their feet to shake the mosquitoes off their backs. Mostly, they gnaw vigorously at an old stump, which I discover when I get up thinking they are eating away one of our plastic jerricans. "They are hungry," says Silale, who woke up too.

The night is full of noises. Intriguing, interesting, sometimes disquieting, they force me to open an eye, an ear, or both. Under the stars the mind too has a way to entertain your fancy away from sleep. Outdoors I always awake in the middle of the night to write my best notes. Naturally, the lack of light sends me to bed early, and the long tropical night makes up for awakenings and insomnia.

JANUARY 27

It is already hot before daybreak, when the shrill yap of jackals wakes us up, and we lose no time in getting on our way. In little more than half an hour we have loaded the donkeys and eaten the rest of last night's meal. The donkeys will not let us walk fast, however, and through the apocalyptic landscape the flamingoes' shrill cries accompany us for a long time.

Walking south, past white areas of salt covering the black volcanic debris like freshly fallen snow, we follow the eastern side of the mostly dry lake beyond a huge wall of rubble surrounding it like the rim of an ancient, gigantic crater. Black basaltic cones rise from the middle of the mud flat and mirror themselves in the great puddles surrounding them, but they seem to evaporate as we advance. Mirages do so much more than the rains to put a

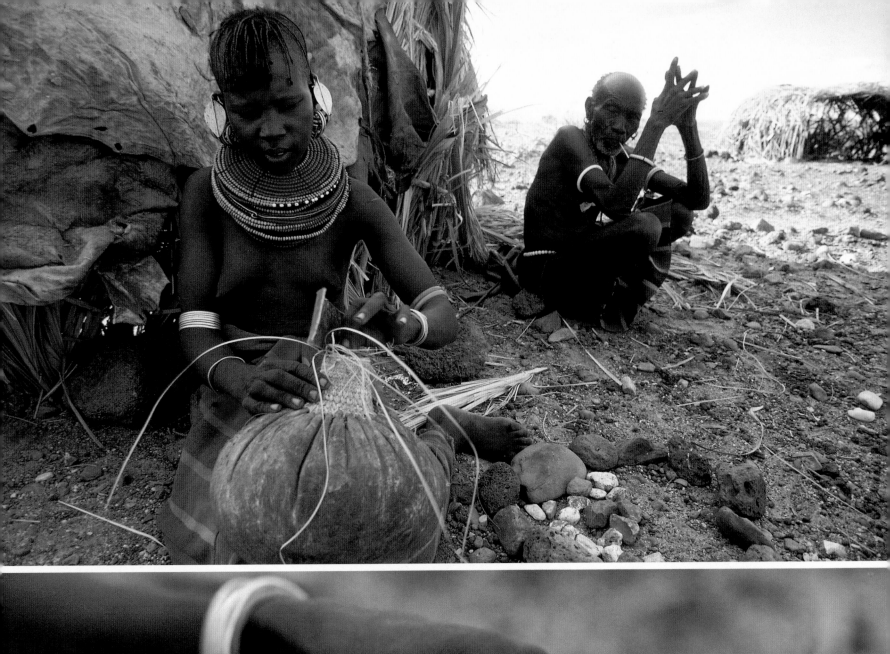

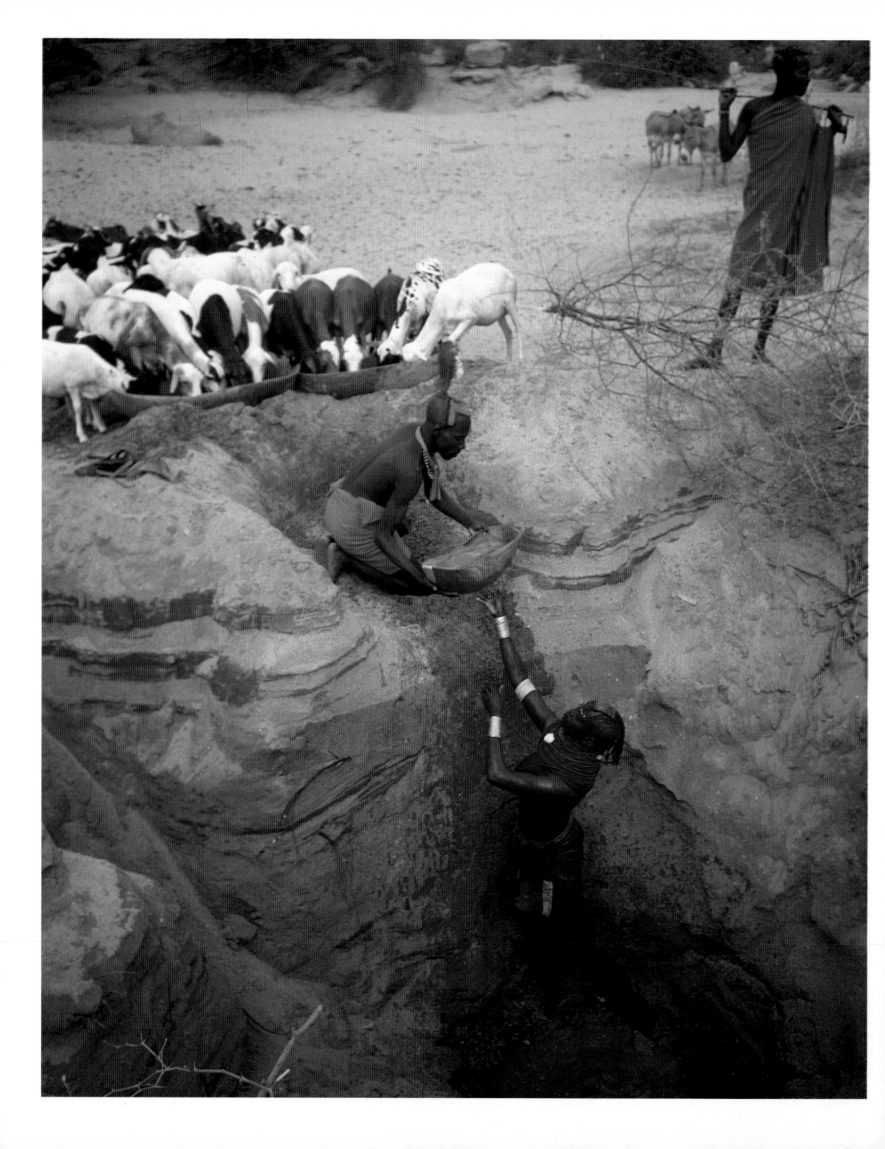

OPPOSITE *Kenya. Near Lokichar. In a dry riverbed, from the bottom of a sandpit, a Turkana woman hands to a man a bowl of water for their sheep.*

reflecting surface on the lake floor, though to judge by the clumps of doum palm trees rising here and there from patches of green grass, parts of the lake floor must still hold water.

By midmorning we are walking on the soft sand of what must once have been the lake's edge. Cut by many parallel wadis, in Kenya called *luggas*, slanting down from the volcanic ranges around, it is dotted by tall leafy bushes whose tiny purple berries Silale invites us to pick. Nature in Africa is so stingy that, but for his beckoning, we would have passed by without noticing them. While Lotinget pushes on with the donkeys, the rest of us gather the minuscule fruit, though more for diversion than for food. Their funny taste, not quite unknown to Jeff and me, is difficult to pinpoint. Eventually, Jeff describes it perfectly as that of sweetened horseradish.

Although the Turkana are said to have eaten all the wild animals in their territory, we see gazelles, a hare, and a variety of birds. While their Samburu neighbors have a taboo against eating game, the Turkana eat anything, from tiny desert lizards to Lake Turkana's great fishes and crocodiles, and they have long ago digested their last lion. But, contrary to the Samburu, who live in a greener world, they must survive in an unhuman furnace. For that matter, they could not care less if other tribes despise them for their eating and other uncivilized habits, including that of going through life uncircumcised. More often than not, anyway, in warfare they have the upper hand.

A great fresh wind suddenly raises the sand into a mild sandstorm, cooling the atmosphere. Before noon a downpour settles the dust, chases away the pervading heat, and forces us to seek refuge under a clump of doum palms. Within ten minutes a strong stream comes flowing down toward us, splits to circle our higher ground, fuses on the other side to run toward the dry lake, leaving us on a tiny palm tree island. By the time we have eaten lunch, the land is again dry and the sun fierce.

Our Turkana friends, who, but for their *pangas*, or small machetes, came on this trip barehanded, borrow everything they need from Jeff and me. But little by little they equip themselves with our discarded cans, and for spoons they use the hollow of palm leaf stems.

We leave at three o'clock. Sand and dust carpet the valley, relatively lush with scattered palm trees and the berry-bearing green bushes. We pass a couple of huts with their corrals. Though the Turkana could have built them in the shade of the tall bushes, they chose to live over the scorching lava blocks so as to leave the vegetation to their camels and goats. The huts are abandoned now. Silale says the lack of pasture forced the inhabitants to take their cows to the greener mountains, which they do each year in December or January, after the grass born during the rains of March, April, and May has all been eaten up. Since we are in January, the rains this year are ahead of time. Thanks to today's downpour, grass will soon sprout, and the Turkana may temporarily come back.

A canyon opens on our left, and we enter it. One of three holes dug in the sand there is full of water. We fill our empty jerricans and water the donkeys.

By five, at a place Silale calls Morocomock, we come upon a Turkana encampment and decide to pitch our camp next to it. The encampment is a double cluster of huts housing two families. One old man and his two young wives and children live in two huts in the center of the valley, another old man and his three wives and children in three huts two hundred paces away at the foot of the mountains.

Unloading fifty paces away from the two huts at the foot of a clump of palm trees, we startle a skinny little yellow dog sleeping in the trees' dark shade coiled like a snake. Sneakily, he gets up and, with a jackal gait, slips away. His strange attitude should alert us, but we are too busy greeting visitors and setting up camp.

Two young women are seated in the shade of a hut, each with a small child next to her. One woman is sewing a leather extension to the woven-grass collar of a round vessel made of camel skin. Shaped like a calabash, it will be used to keep cooking fat. The other one is sewing for herself a goat leather apron.

Joining their old husband, the women come sit with us with-

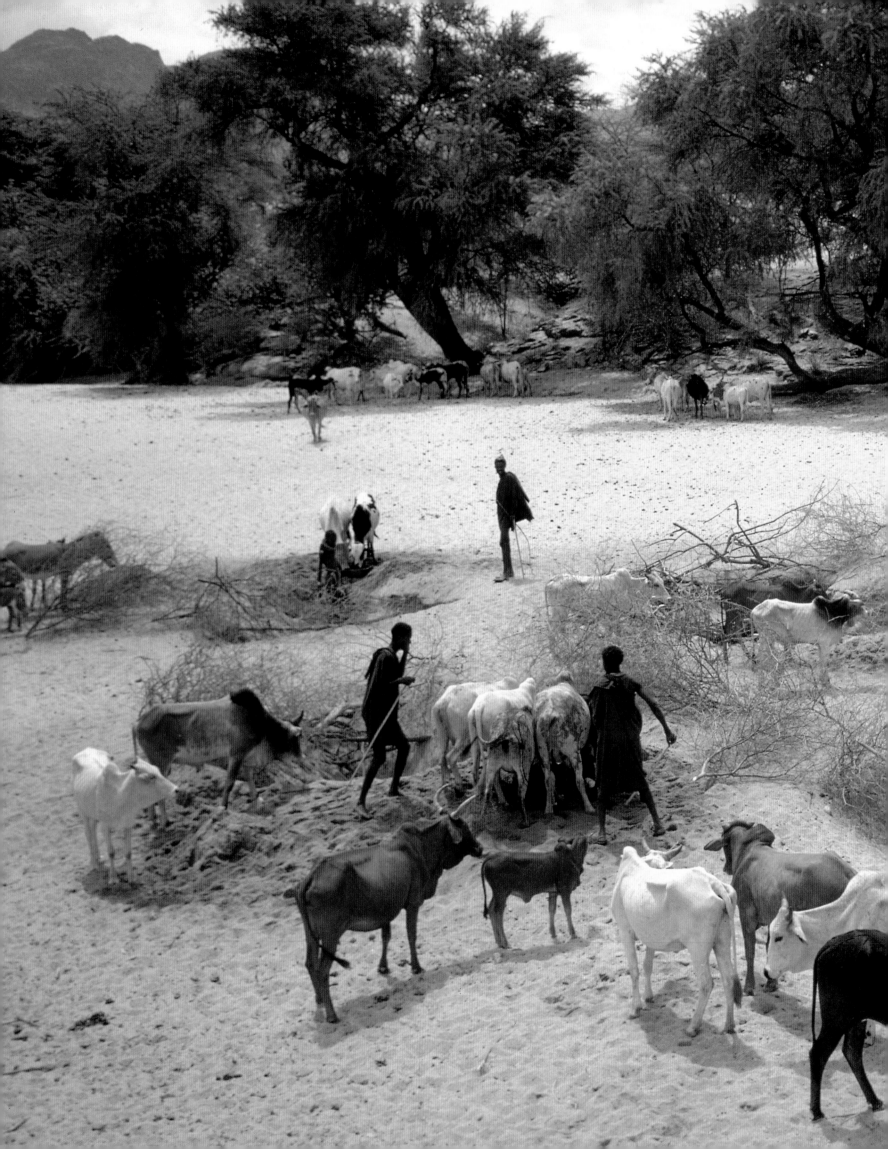

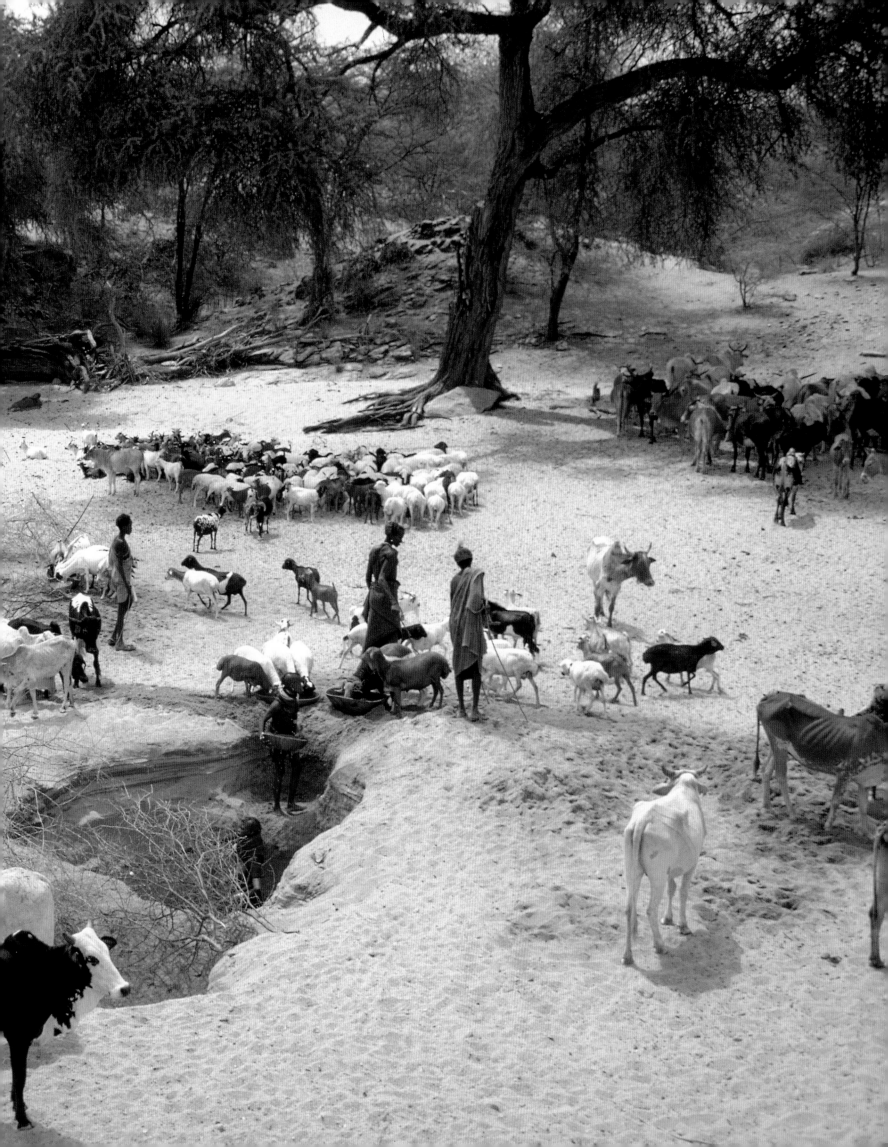

out interrupting their work. Their dexterity is fascinating and the beauty of their handicraft stunning. Their neighbors may call the Turkana "savages," but they could never duplicate the beauty of these vessels, whether carved out of wood or made of gourds or skin. I have never seen any as nice anywhere in Africa. It is the more striking considering that most African nomads consider manual work below their dignity. But then the Turkana are uninhibited practical people.

In spite of coarse features, the two women are pretty. Like them the old man is black, but he has the sharp features of an Arab. Though few Turkana men are as aquiline, most strike me as generally less Negroid than their women, no doubt the result of their mixed Hamitic and Negroid ancestry.

A nearly full moon has risen in the blue sky; while the sun, weakened by clouds, is still lingering. As the sun is melting near the horizon, the clouds turn into pink rags, and several streams come down our way. With cries of joy the children go meet them.

Soon the rest of the people, women and children, come home from pasture, first with goats, then with camels, and the animals are milked. The old man brings us a wooden pitcher of smoke-tasting milk. The Turkana smoke their milk pitchers every three days to disinfect them. Sitting with us, the elder catches a fat-tailed sheep and offers it for sale. Our black friends' eyes light up. We buy it for the pot, though we will let it live tonight.

Our Turkana are marvelous—cheerful and useful. Most of all Silale. He protects our interests as his own. He is intelligent, honest, straightforward, and he understands our needs. This we owe to the missionaries who educated him.

Tonight, to our surprise, our friends are not eating. They have cooked but do not touch the food. Two young Turkana are resting next to them, waiting to share their meal, but our friends have no desire to eat reduced portions. They have probably gone hungry too long to be generous with their food. The visitors do not believe Silale, who tells them that they cooked for breakfast. To try to convince them, the three close their eyes, and Jeff and I retire to our mosquito nets. Accepting the evidence that they will not sleep on full stomachs, the visitors finally leave. Almost immediately, our friends jump on the pot.

Around three o'clock I hear Silale run and scream after a dog

which he is pelting with stones. Thinking the dog is a thief which got away with some of our food, and unable to get quickly out of my mosquito net to help, I make noises to frighten it away.

Sweet Silale is mad with rage. "The dog bit me in my sleep," he says. "Do you imagine such insolence? Thank God, I was wrapped in my blanket."

An hour later, unable to go back to sleep, I get up to contemplate the moonlit landscape. I walk toward the closest stream to see what happened to it. Though the ground is still wet, the water is gone. Suddenly I hear a little girl's cry, then a couple screaming. They are kicking up a terrific row, and I wonder whether the man woke up at this unseemly hour to give one of his wives a thrashing. Everyone wakes up, including our three Turkana, who run toward the two huts. Suddenly they turn in my direction. Ahead of them runs the sneaky little yellow dog. In a flash of inspiration I understand that he is the one who earlier bit Silale and that now he must have bitten the child. He is rabid, I conclude, and as he dashes at me I strafe him with stones. But far from driving him away, it strengthens his resolve to bite me too. I jump sideways as he passes, and with my friends hard on his heels he does not try again. Fortunately, a blanket saved the little girl as it did Silale earlier. The little yellow dog made only a superficial scratch on her leg, and when he jumped on her face found her already covered.

An unearthly sound, different from the one jackals sometimes make at night, keeps us warily awake for a long time. Silale says the cry comes from the yellow dog.

162

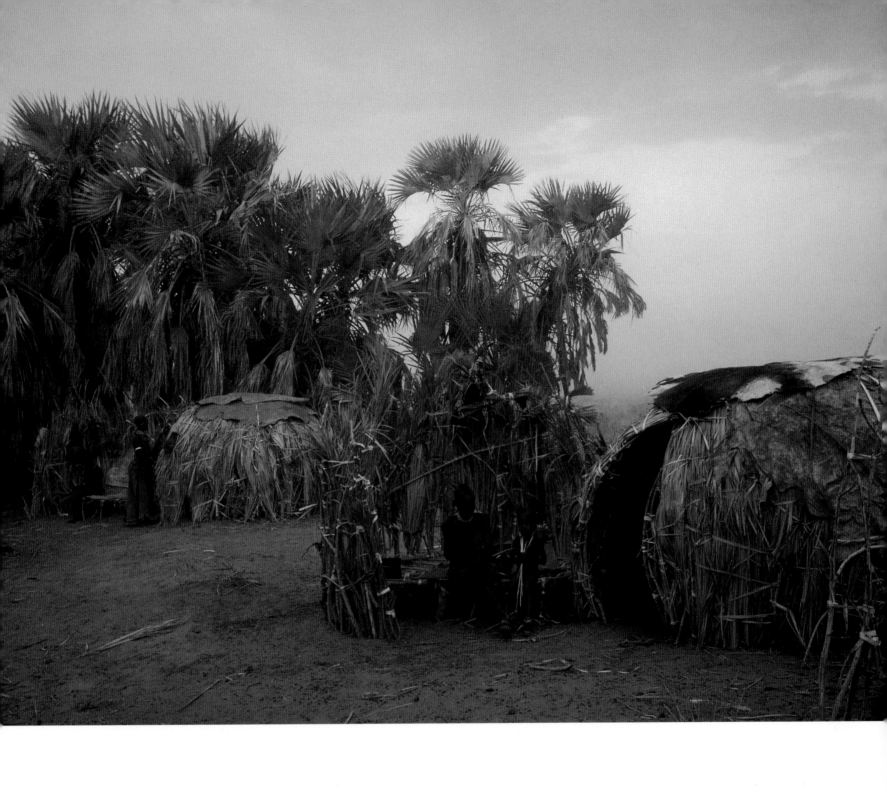

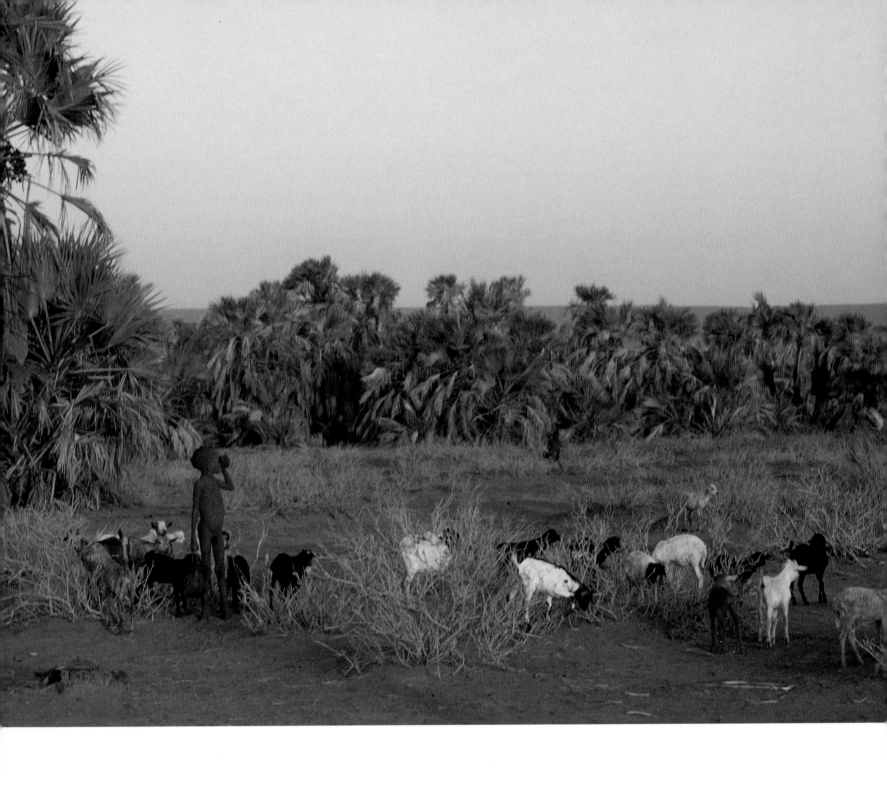

OPPOSITE *Kenya. Suguta Valley. In the reddish light of sunrise, outside a grove of doum palms, a Turkana boy empties a cup of milk from one of the goats in his charge.*

JANUARY 28

Next morning Silale greets us with a painful expression. "We are eating too much *ugali*," he complains, pointing to his stomach, as if this was not every living Turkana's wish. But it is his way to discreetly remind us of the sheep awaiting its fate at the end of its rope.

Because we know the butchering will leave Silale too busy to tend to us, Jeff and I hoped to delay it until the afternoon, but before his lust for meat we agree to let him have his way immediately. It takes Silale and his friends only minutes to kill, bleed, skin, and quarter the animal. With the sheep's blood they fill the calabash of a little boy who has been waiting on the side and send him next door to the two women who must have told them of their own yearning. They put on the fire all the pieces they know we will not touch, and soon are gnawing the sheep's head, chewing its viscera, and sucking the marrow of its bones. The whole day, however, will go into stewing one third of the meat, broiling another third, putting the rest of it on the branches of a thorn tree to dry, and eating.

Thanks to Jeff, who always stuffs his pockets with tabasco, mustard, and salt and pepper, we never eat bland food, even when rare circumstances impose upon us dry bread or cold rice. His spices and culinary know-how not only improve the mutton stew, but also earn our Turkana's gratitude. Because of his natural warmth, simplicity, and generosity, Jeff gets along exceptionally well with tribal people. He readily digs into their common pot and shares with them his personal belongings. He spontaneously joins them in songs and dances; entertains them with jokes, animal cries, and strange funny sounds; and constantly surprises and enchants them with tricks. He so obviously loves them that they love him in return.

While my companions have their eyes on the cooking meat, I watch our hosts fifty paces away. They got up before daybreak to milk some forty goats, two cows, and three camels. For lack of moisture in anything they eat, the goats give the nomads only three or four pints of milk in all, the two cows about the same, but the she-camels much more. She-camels, which can be milked four and more times a day, even in the middle of the night if at that time a nomad feels like having a drink of milk, give three times more milk than Turkana cows.

An hour after sunrise, with only some milk to sustain him until nightfall, a little boy of six or seven takes the goats away to pasture somewhere for the rest of the day. A little girl digs a hole in the mud left by last night's stream and fills a gourd with dark water. The women sit down to their handicrafts. And nothing more happens in the camp.

Jeff and I, who might have done something more interesting today had Silale been our translator or guide instead of a butcher and cook, wash clothes, reorganize luggage, read, and finally fall victim to the paralyzing heat.

At midday we get the visit of a good-looking man in his early forties. Silale says the man is his father-in-law, and he is looking for lost camels. Like Lotinget he only wears a blanket, but otherwise displays the trappings of an elegant man. His thin mustache is carefully shaped, two rows of red beads grace his neck, and two yellow bead pendants hang from his ears. His hair, matted in yellow clay, is accented with lines of orange and blue clay. His bearing is princely, even when, with four precise blows of a sharp stone, he breaks the sheep's skull, picked clean of meat on the outside by our Turkana friends, into halves to eat its brain. Paradoxically, noble carriage and manner are as common among tribal people as vulgarity is among so-called "civilized people."

Later, two young Turkana men also drop in. They sit down to silently listen to the first one, who seems to have an interesting story to tell. Fighting the stupor into which the heat has plunged me, I try to guess without Silale's help what the story is about. His long graceful hands speak with such precise and expressive gestures that I think it should be possible to understand him without speaking his language. But the heat saps my efforts.

When the two young men are gone, we invite the older one to share our lunch and serve him a big bowl of stew. A mild wet sandstorm envelops us as we eat.

"I would like to take a picture of you," I tell the man through Silale, and he agrees, but only against payment of a model fee. Even that far from the modern world, the Turkana have heard enough about the money the white man makes taking their pictures to want a part of that income, even after a good free meal. I understand that, but since he demands more money than we pay our donkey drivers for a whole day and I do not want to risk having to renegotiate their fees, I have to refuse. The negotiation of expensive model fees through low-paid interpreters will be from now on, in the new Africa I came to discover, my greatest headache.

At dusk the children come back to camp with the animals, and everyone is in bed early. I have been lying under my mosquito net for perhaps an hour when I hear a distant rumbling, like that of a freight train coming out of a tunnel. A few minutes later, chasing the heat but drowning us in clouds of dust, a great wind sweeps over us. I hang on to my mosquito net like a sailor to his sail, and if the wind does not tear it apart it is because it is fixed to flexible palm leaves. The wind comes in long gusts, drops for a few minutes, then, ever fiercer, comes rumbling again from the distant horizon. Still, I manage to fall asleep until the midnight moon, shining into my eye like a projector, wakes me up to an eerie calm.

January 29

"Too much sleep last night," Silale says as he stretches on his bed a last time, and he and his friends confirm it by being exceptionally slow this morning. But in the end it is my photography of the milking that delays our departure until after nine.

Always following the eastern side of the valley, we reach dry Lake Alablab, which for two months a year, during the rains, joins Lake Logipi in covering the whole flat cracked area. Here much wider, the streams that ran down two days ago have not dried up, but they are no longer flowing. Since the donkeys will sink into the moist clay lake bottom, we detour over the basaltic rubble.

In the distance a boy is driving a camel ahead of him toward the encampment we just left. Silale says his family will slaughter the animal for meat, for they have nothing to eat. Last year they had no rain, no food, and for the last several months they

survived on camel blood. The excessive bleeding has left the camels too weak to give any more blood, and this one must be sacrificed.

Up a broad black valley, at a place called Murukomol, we stop at a tiny clear stream to fill our jerricans and to refresh ourselves. Having wet our shirts and hats, we keep relatively cool. Reaching a clump of palm trees growing in and around a muddy pond straddling a pass, we wet our clothes once more. Though the sun is not vertical yet, we stop for lunch knowing we will find no shade farther on for many hours. Having earlier passed two huts, we are not surprised to receive the visit of a tall good-looking elder wrapped in a blanket. The skin of his stomach, which the heat makes him occasionally uncover, is as taut as that of any Turkana elder I have seen, as taut as that of any Turkana youth. He is not yet born, the Turkana who will show fat flabby skin around the waist. But Silale and his friends this time have no qualms in turning their backs on him to eat. I ask them why.

"I told him that if he wanted to eat with us you would demand that he first pose for a picture, but he refused, saying that model fees can be paid only in cash," Silale explains.

I never set such a rule, of course, and I give the man my own plate, to me inedible today, for to save our clear water for drinking Jeff cooked in the pond's thick muddy water.

The infernal heat makes us delay our departure until nearly four, then we once more descend toward the mud flats. Among a grazing herd of donkeys Silale finds a female he lost two years ago. A baby donkey walks next to her. For a while he tries to herd them along with our pack animals, but they keep running back to the herd. "They will flee tonight anyway," he sighs as he finally lets them go. "We'll get them on the return journey."

We skirt the empty lake above fourteen Grant gazelles that watch us approach within fifty paces before slowly moving on. Later we leave the mud flats behind to follow a stream which, together with those running into it at short intervals, has carved its bed through sedimentary layers apparent through a crust of

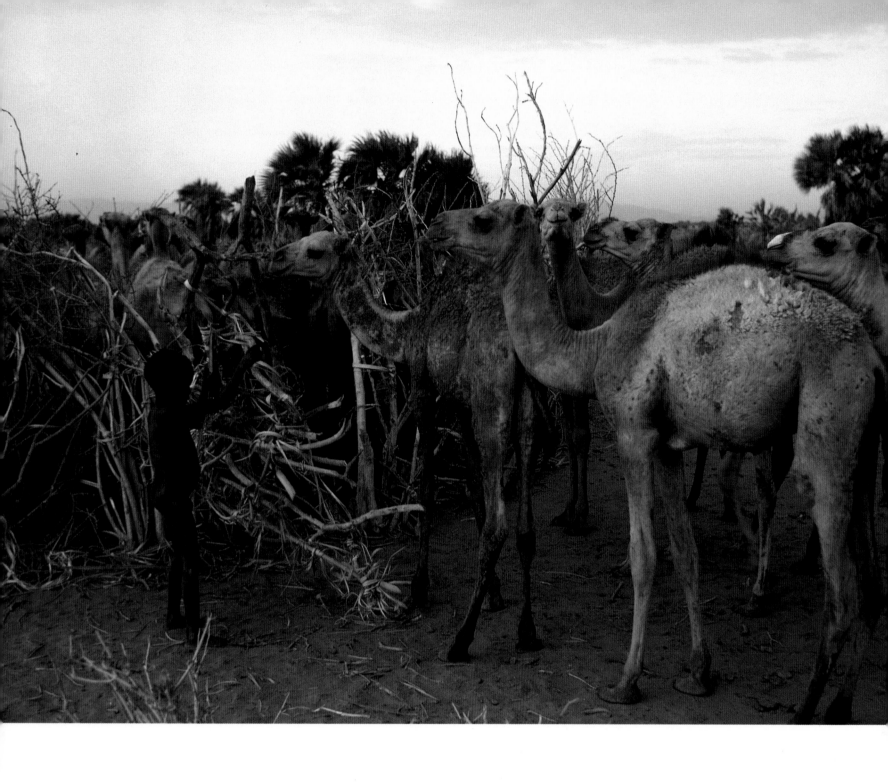

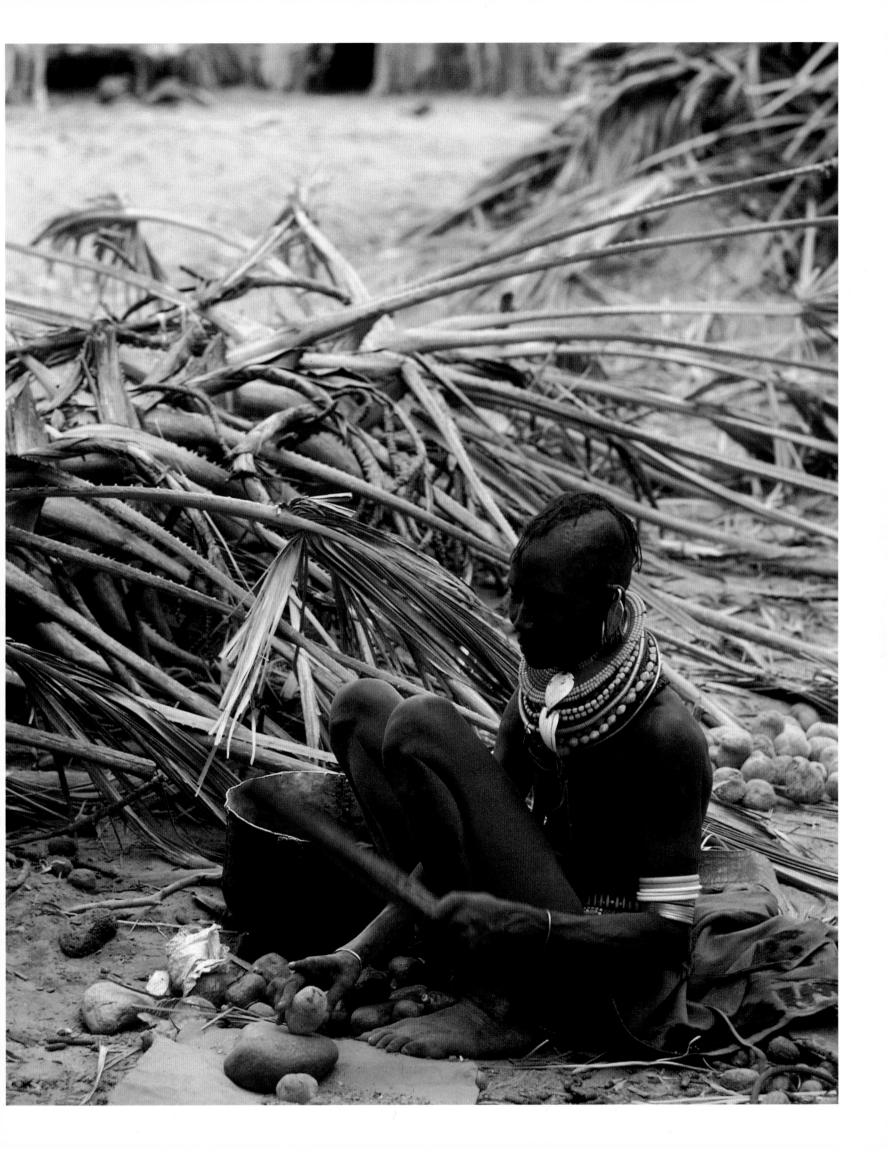

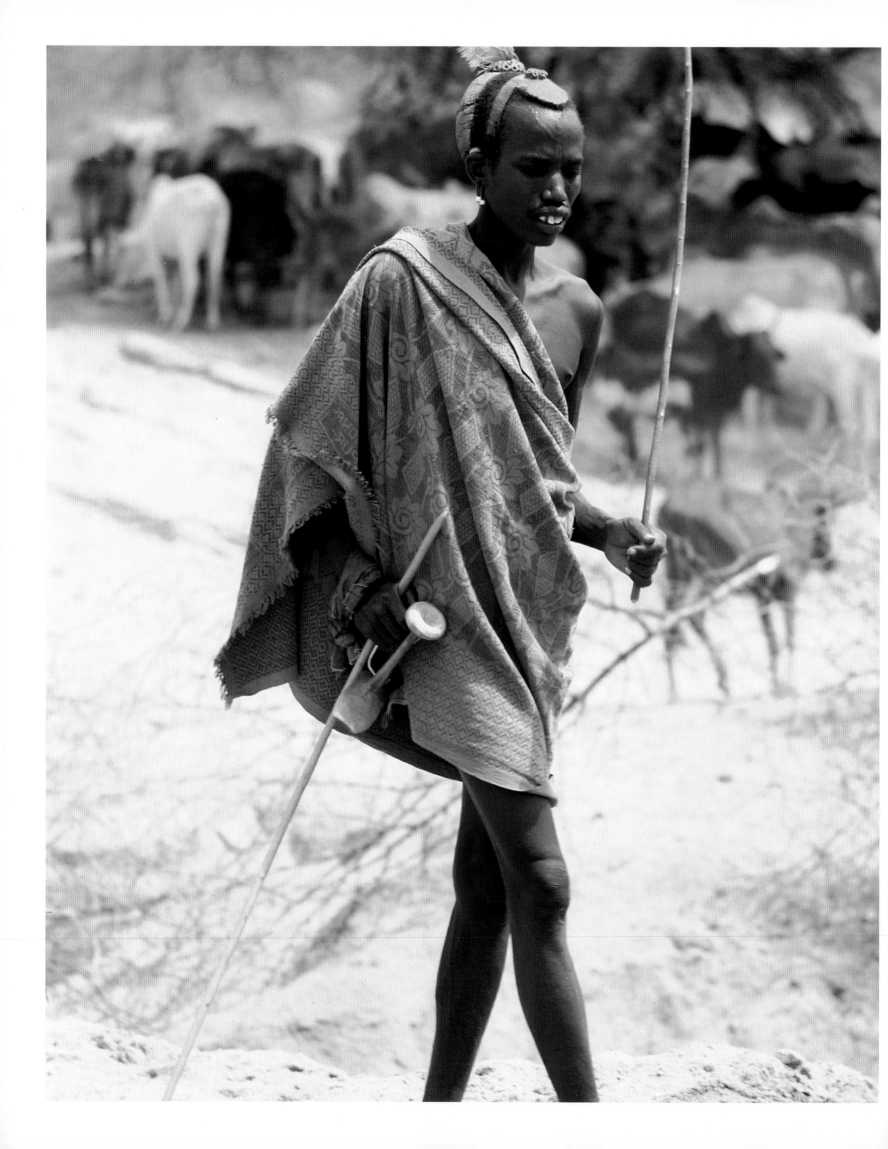

PRECEDING PAGES LEFT *Kenya. Suguta Valley. Turkana women beat doum palm nuts with sticks to break the hard, slightly sweet pulp that, mixed with milk, or blood, is their diet's main staple.*

PRECEDING PAGES RIGHT *Having chipped the skin of her doum palm nuts with patient blows of a stone, a Turkana woman now beats the hard pulp with a stick.*

OPPOSITE *Kenya. Near Lokichar. Wrapped in a blanket and holding a headrest and shepherd sticks, a Turkana watches over his cattle.*

salt. At a place called Ekipe, water boils in various holes. We try some and find its taste similar to that of soda bicarbonate. We go on through a vast plain covered with a thin film of salt. Hundreds of low bushes have died on it, and Jeff remarks how, but for the heat, one might think the vegetation was burned by frost.

At nightfall, on a stony plateau, at a place called Lodoketewoi, we reach five abandoned huts and adjoining kitchens where we decide to spend the night. Silale explains that the inhabitants, owners of many cattle, recently had to move to higher greener ground.

JANUARY 30

I did not sleep a minute last night. The wind raged with the force of a Patagonian gale and the moon shone constantly in my eyes. But it must be the large quantities of strong tea I ingested that kept me cogitating until I woke up my companions before the end of the night.

Racing against the coming heat, we do not let our men cook *ugali* but give them our last loaf of bread and put in our bags some crackers to nibble along the way. Their grim countenance says clearly how much they resent that decision. They may prefer meat to *ugali*, but they would rather eat *ugali* than bread.

We walk down the valley, about a kilometer wide and walled in as usual by volcanic mountains and heaps of volcanic boulders. A long string of palm trees runs through it like a green river, and gazelles and birds enliven it. Now and then our path crosses a stream in the process of vanishing, a chain of muddy reddish pools lined by the pretty patterns of drying mud. Yet a sense of tragedy seems to be hanging over it.

We come unexpectedly upon a river brown and shallow but running, about twenty meters wide. Its banks are green with bushes and clusters of palm trees. It is the Suguta. A Turkana herdsman wades through it to beg us for chewing tobacco. There is a camel camp nearby, and in a bend of the river, on a patch of green grass growing on alluvion, a man and two women are herding nine cows. One by one along the way Turkana men come to ask us for tobacco. Thin and tall, they stride haughtily, holding in their hands a stool, a spear, and a long thin herding stick.

Abodo loves to stop to chat with them, and when I wave him on he ignores me. The trouble is that he is almost always the one driving the donkeys now, and that when he stops they stop too. Considering how slowly they walk, this is frustrating.

Silale now often walks with us ahead of the donkeys to keep us on the right track. As I lost my toothbrush, he cuts a makeshift one from a bush, a short stick whose end I flay by chewing it. Most Africans use it, which may explain why they have such white teeth.

The plain is covered now with scattered clumps of grass as well as by the usual palm groves, and the camps we see far to the east on the volcanic slopes are inhabited. The plain is scoured by parallel gullies, many containing brown water or wet clay, and plowed by the passage of countless herds that have left their tracks in the dried mud. The Suguta Valley does not lack water. That it is bad water more often than not is, to the nomads, of secondary importance.

We pause for forty minutes next to a brown stream to bathe, wash pots and clothes, and let the donkeys graze, for they had little to eat last night. As usual after we unload them, the poor animals celebrate the temporary end of their labor by rolling in the dust. With delight, we drink the water of our canteens, which the sun has heated like soup.

We split the day in a cluster of palm trees, then change course in the hope of finding more people to the southwest, on the other side of the valley, far away. Dust devils rise swirling to the white sky. Mirages beckon on the horizon, jump left and right

as we approach; they would drive a thirsty man mad. Other than those fleeting natural phenomena, for two hours nature gives us nothing to hook our sights upon. Then low dunes planted with palm trees appear, reminding me of southern Algeria. Later, seeing a line of trees to the west hinting of possible water there, we cut in that direction. We pass through an extraordinary area of dried mud broken into complex and beautiful patterns surrounding islets of diminutive sand dunes topped by thorn trees. Now grass appears, and with it plenty of goats and camels. A Turkana shepherd takes us next to his camp, hidden among palm groves, and we unload. There is clean water nearby. After a summary dinner, more exhausted by the day's heat than by our march, we go to bed listening to the cries of playing children.

JANUARY 31

Long before daylight makes possible our exploration of the surroundings and discovery among the palm thicket of the camp's nine huts, the mournful cries of hundreds of animals waiting to suck or to be milked have told us of the importance of this camp, where the baby camels alone number over thirty.

The interaction, first in the blue light of dawn, then in the golden light of sunrise, of so many people of both sexes and every age, with so many animals of all sorts, offers a biblical spectacle of such rare beauty and drama that we decide to stay a day here so we may watch it again tomorrow morning. Hundreds of goats and sheep already milked are parked to the side under the guard of an old woman and two or three girls. Little boys will take them to pasture as soon as they have had their breakfast milk. Right now the boys are in charge of the moaning baby camels inside two thorn enclosures or helping their mothers to milk the she-camels. Those who guard the corral gates let two or three baby camels out at a time. The young animals look for their mothers, suck them for a while, and then are pushed aside by the milking women. Young children crouch outside the corrals waiting for their mothers, who commute between the children and the animals, to replenish their milk pitchers. Meanwhile, the men, in noble postures, rest on their sticks or spears, or stand with a stick across their shoulders, a foot up against a thigh, watching the scene, crying orders, and only occasionally giving a paternalistic hand. Finally, as in a great exo-

dus, boys and girls drive away the goats, the men whip away the she-camels, and a little later teenagers take away the baby goats, sheep, and camels.

If cyclical droughts often dramatically reduce the milk supply, one staple food seems unlikely to fail the Turkana here: the abundant nut of the thousands of doum palms growing around. But being as hard as stones, its preparation is a never-ending chore. Immediately after milking, the camp's nine women sit together, each in front of a flat stone, to beat with a small stone the lemon-sized nut until, piece by ever small piece, they have peeled their unyielding leathery skin. That labor is interrupted only as long as new nuts need to be brought down from the trees. And three or four hours later, after the first nuts have dried, they go over them again, this time to beat the hard pulp with a stick until it is completely broken into bits. The Turkana mix these pieces with milk or blood when they do not eat the peeled nuts directly, as one would a very hard apple. They are quite good, and their pits provide excellent charcoal. One woman gets up not to come back. We find her later scraping with a *panga* a goatskin that is stretched and pegged to the ground to dry. A kid goat is roasting whole on the embers of a fire nearby.

While the women, surrounded by their small children, work restlessly all day, the men do nothing. They observe Jeff and me when we are around, and otherwise sleep all day in the shade of a tree, sitting up only for short conversations when a neighbor drops by.

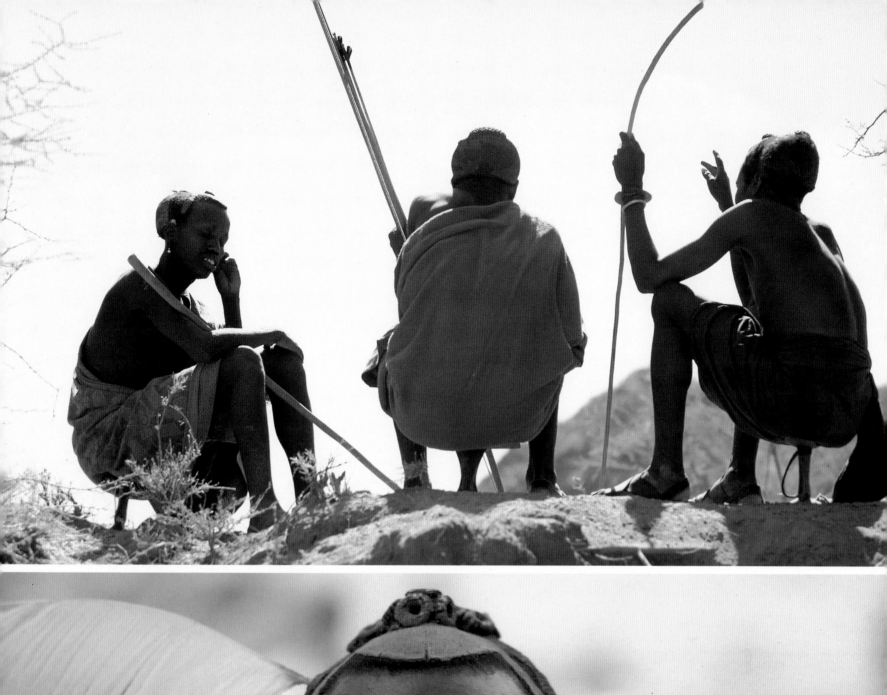

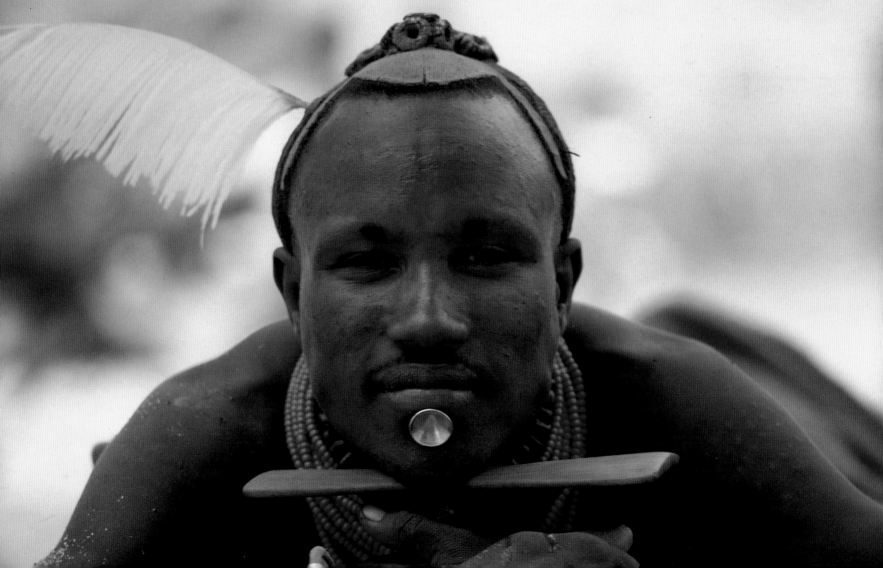

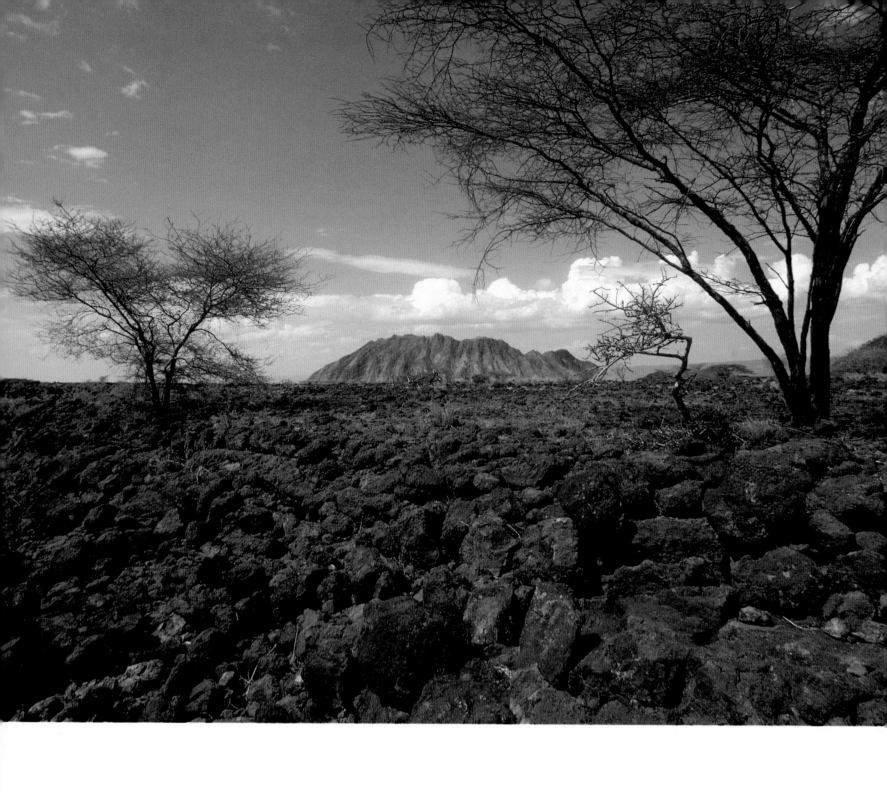

To help both our hosts and our crew, the first to earn some cash for purchases, the second to fill their bottomless stomachs, we buy another sheep. This time we give Silale unequivocal instructions not to butcher it before 3 P.M. Meanwhile, we go get water and wash our clothes at one of a few clear puddles remaining from a temporarily dried river. But when we return an hour later, around 9 A.M., our friends are already digesting some of the animal. We know better than to get mad at them.

An old woman shows us her belly. "I am hungry," she tells us through Silale. We promise her a piece of meat, but she wants *ugali*. "I don't like meat," she lies, so we give her maize. A little later she returns for meat anyway, but the Turkana men who keep us company chase her away with loud jokes.

Distant thunder and a wet sandstorm prompt the women in late afternoon to cover the huts with cowhides. Each hut has an unmovable big bed built outside, but during the rare rains everyone crouches inside.

FEBRUARY 1

Leaving the camp the next day, we cross a searing plain whose palm trees on either side are visible only as distant black lines. But the trees seem to walk with us for, two hours later, they have closed in on us again. Another hour, and we cross a red river, actually called "Red River"—"Nakipiarengak" in Turkana. The bushy palm trees support many nomads. Everywhere we see their great herds, whose steady nibbling will inevitably bring about the next drought.

We have reached a broad *lugga* cutting straight through a forest of palm trees like a boulevard. A few puddles of water still shine in it, waiting from the sky the miracle that will let them temporarily grow enough to run into each other. Young Turkana men converse while they sit on their headrests on the shady side,

and the clomp-clomp of nut-cracking resounds in the distance. All along under the palms, their ribs painfully prominent, hundreds of small zebus rest, for it is noon and the sun is almost unbearable. There is not a blade of grass in sight anywhere, and I ask Silale where such skinny animals may feed. "Oh, they do find browse," he says philosophically.

At the end of the boulevard we hit once more upon the Suguta River, its shallow red waters running fast. A hundred storks are wading in a bend, and we waste no time in doing the same. We could not walk farther if we wanted. Like our donkeys, we have intolerably hot feet. In my camera bag, my photographic equipment is too hot to touch, and from now on I will have to maintain a wet towel over it. The river, nearly boiling, cools us only after we leave it, and the water on our bodies evaporates.

We drop in the shade to prepare tea, but even our Turkana friends find the heat too oppressive to cook lunch. Like us they content themselves with canned corned beef and crackers. Five herdsmen sit next to us, and we give them the chewing tobacco they request. But our three friends are in no conversing mood, and to try to forget their misery, they resolutely cover their heads under their blankets. Unmoved, our visitors unsheathe the sharp blades of their spears or arm knives and, in the usual Turkana way of busying hands, shave their herders' sticks.

Dizzy from the heat, we leave past three, though not before Silale repairs his tire sandal with the key of a corned beef can, which he nails down with a stone, then bends flat.

For a while we walk through palm groves, then enter the open desert of lava gravel. To escape mosquitoes, empty Turkana huts stand high on lava slopes. Those built lower are raised 1.5 meters above the ground.

We have been underway for twenty minutes when we hear a herdsman running after us. We left a donkey behind, he says, and to our surprise he is right. That this could have occurred has for Silale a simple explanation. "The heat is the culprit," he says.

We walk at the bottom of a canyon, harassed by flies. One sits on my nose and comes back to the same spot each time I chase it away. I walk holding my nose, but then it chooses a spot on my forehead. I wipe my face with repellent, but to no avail.

We climb out of the canyon and camp on a volcanic plateau. The rugged terrain has tired us all, but a great wind blow-

ing much of the night saves Jeff and me the effort of putting up our mosquito nets, a time-consuming operation where the absence of vegetation for support must be compensated with piles of luggage.

FEBRUARY 2

We get up at 4 A.M. hoping to leave early, but even at that time the heat is stifling. While, in the light of three quarters of a moon, Silale and Lotinget go for the donkeys, Abodo prepares tea and Jeff and I pack. But by sunrise, three hours later, our men have not come back. They finally appear without donkeys. All that time they followed the wrong tracks to the wrong donkeys. We now find ours five minutes away in the opposite direction.

We brace for the day's heat, but it diminishes. A weak breeze carries us forward, and for the first time since Parakati we see elephant trees, a sign that we are going up. We go temporarily down to the Suguta River, however, which now winds between green grass banks among sand dunes. Not only doum palm trees but all sorts of acacia trees dot the valley.

This time clear and knee-deep, the river flows impetuously over rocks. Now we are really climbing, and the breeze takes force and is almost cool. We have seen the last of the doum palms. Far below in the haze the Suguta Valley is possessed by dust devils.

By noon on the plateau the heat catches up with us. The black lava vomits hot air in our faces, and though the hot wind pushes us forward, our feet are sore and afire, and we would love to stop for a rest. But there are only leafless acacia trees around, and their lacy shade is useless. By 12:30, as I am about to stop to make a tent out of my sleeping bag, some green spots in the distance attract us farther on. They are palm trees. I did not think we would find more. As we near them, water becomes visible on our left: the Suguta River, immediately recognizable. Four wild pigs leave it hastily as we approach. Because we are so much higher than we were two or three hours ago when we crossed it, I suppose it cascades down the rocks somewhere back, which Silale confirms. In a minute we have taken our clothes off and are lying at its bottom, with plenty of running water above us. Surprisingly, it is cool now. "Sometimes there are crocodiles here," says Silale, spoiling our pleasure.

After lunch, through thorny country, we walk hard to Lomelo, the site of a nomad boarding school.

FEBRUARY 3

Today, our last day, brings mixed feelings. We could not say whether we are happy or not. Though the Suguta Valley was a difficult place, it rewarded us in so many intangible ways that we already know we will miss it. We leave in the dark on a broad easy path. The night was uncommonly cold, and the morning sun is long in imposing its dominion. A two-hour walk brings us again to the Suguta, ever green in its small islands and bordering palm trees. We ford it through clouds of flies over cutting lava blocks.

By midmorning the sun is searing our feet and throats, and at midday we must hang our sleeping bags between acacia trees to shade our lunch. Soon after resuming our march we come upon the Suguta once more; here the river is shaded by tall ancient trees and is very broad and beautiful, though nearly too hot to enter. I have walked fast ahead of my companions, and for ten minutes, while awaiting them, I lie in it fully clothed. It so drains my energy that I get out of it dizzy.

From now on everything changes. We see some agricultural fields, a growing number of huts, ever more people on our path. As we near Kapedo their costume changes. We have reached a crossroad where Turkana, their Pokot neighbors, and other people wear cotton pants and dresses. Some ride bicycles.

We enter Kapedo, a one-street adobe village. In a shop we order sodas and learn that a bus will leave at 3 P.M. We give our friends the things we will no longer need and buy them a last sheep before going to sleep. We find them still eating when we get up to board the bus. It was good for them to have come this way. And whatever the anthropologist said, it was also good for us.

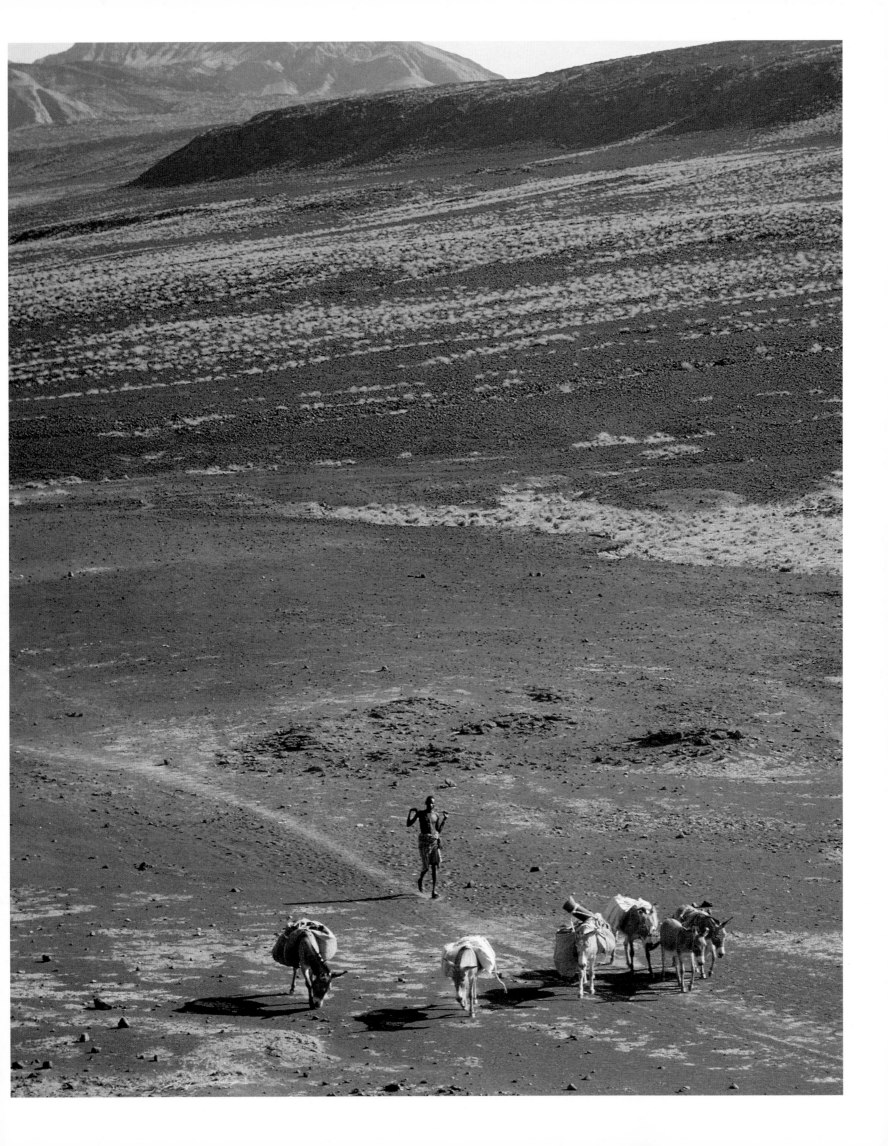

Epilogue

In 1973, a terrible drought in the Sahara and the Sahel, between the Atlantic Ocean and the Red Sea, changed the lives of African nomads forever. Droughts have always occurred in the Sahara and the Sahel, killing nomads and animals alike. The loss of life relieved the pressure on the environment, and while human and animal populations grew again, nature also restored itself. But in 1973 it was different. Modern medicine and several decades of peace had fostered excessive population growth. When grass disappeared, the nomads cut the branches of thorn trees to put them within reach of their animals, and they cut more branches and trees for firewood. The drought struck so hard that great numbers of nomads were left without enough animals to rebuild their herds. And now they had an alternative: relief camps or a meager survival in a town.

That year, in 1973, I was visiting the Tuareg again. Coming from the north, I stopped first by my friend Amud's encampment. He was not there, and, at first, knowing he had lost his *iklan*, I thought he must be herding his camels himself somewhere. But reality was as distinct as it was improbable. Amud was working in Tamanrasset as a bricklayer. My noble Kel Rela friend Amud, who all his life had despised the Kel Aïr's hardworking habits, a bricklayer! For all I know he might have shed his robe and *tagilmust* for a cap and some discarded dungarees. His brother Bukush was in the desert, but he, too, would soon go to Tamanrasset to try to find a job, and he would take his whole family with him. I suppose they would pitch their tent outside town, joining and forming with others a waterless shantytown where they would soon make piles of the refuse of a consumer world. They would inevitably fall from their state of haughty desert lords to that of illiterate proletariat.

The rains in Bukush's area had failed for seven consecutive years. Even in 1970 I had noticed the absence of the thick desert plants which had carpeted the desert sand some years before. Now even the small thorn trees had disappeared. No baby camels animated the camp each morning, crying mournfully for their mother's milk. There was no milk, either for them or for the nomads, and the scrawny children constantly begged me for food. Bukush told me of Tuareg who had gone mad or had com-

mitted suicide. The tents clacked lugubriously in the wind, flying sand filled our eyes, buried our luggage, and obscured the sky. Except for the little girls and boys playing soundlessly inside my Land Rover, no life stirred anywhere.

Arab trucks, on their way to Tamanrasset, bulging with tents and collapsible beds, loaded with thin nomads and sheep, stopped occasionally to exchange news, and I invited the passengers to tea. Questioned, the Tuareg explained that their animals were dying of hunger and that they wanted to avoid for themselves the same fate. Some of their youngest children were skeletal and apathetic. But they did not complain. As always, they laughed and teased, and they still smiled when they went on their lonely way. Young Europeans in cars of all makes and ages passed every day. Seemingly in a mad rush to cross the awesome desert, they had no eyes for the Tuareg. But Bukush made me notice that they were always eating as they went.

I temporarily left Bukush and his family to head south and find out how my Iullimiden friends were faring. And there, too, I sorrowed in a sun-seared world's end where no animal life moved, not even a bird. So much of the brush had been cut for animal forage by desperate herdsmen that the sand had moved in and covered the dead roots. Nothing would grow there for years, if ever again. Salt caravans no longer plied the desert, and even the Tree of the Ténéré was gone. Two European women had driven their vehicle against it, and now it rose in shriveled disgrace out of a split oil barrel of dirt in the Niamey Museum.

Along the way I stopped in the camp of Ilbakan Tuareg, *imrad* of the Iullimiden, where Hamiada, the chief's son, received me. He had lost a few cows, but before many had died he had sold the rest and with the proceeds bought rice, millet, noodles, sugar, and tea, making a handsome profit. He planned to move to an adobe house and wanted to buy my Land Rover. Because, under French pressure to bring their children to school, many *imaheren* had sent *imrad* children instead, the *imrad* were generally better prepared to face a changing world. It is not only the drought that is altering the nomads' lives.

My Iullimiden friend Mohammed, whom I saw afterwards, had lost many animals, but he was still rich from all the plundering he had done in his youth. When I told him about Ha-

miada's plans to build a house he was not surprised. "We, too, have houses," he said, "many houses: in Niamey, Tahoua, Tchin-Tabaraden. But we prefer to live out here. One day, I suppose, we will have to live in town while our shepherds herd the flocks. This will be hard for the women, for they love tent life better even than we do. I have bought a Land Rover to hunt and traipse around (his noble station did not allow him to use it for trade, at least not yet), but one day I may use it to commute between town and pasturage."

On my way back to Bukush's camp several months later, I saw a beautiful twelve-year-old Tuareg girl with an uncouth European truck driver. The child was his wife; he had paid the traditional bride price, in this case the equivalent of about 200 U.S. dollars. To my Western mind, it appeared a sale, arising only from distress, and I wanted to take the girl back to her family. But a Tuareg companion told me that it would be useless. "The mother would only send her back to him," he explained. "There is no father anymore. The mother is desperately poor and refuses to see her daughter die of hunger." There are times when only tears can help your state of mind.

As I returned later to Bukush's encampment, dead camels marked the trail. I passed five in a neat row, like a blasted caravan. They belonged to Bukush, whose family was packing to leave with the next Arab truck. He did not think that many Tuareg would return to a nomadic life.

Other African nomads have fared less badly, though not by much. I never saw the Bororo again, but have been shown tourist magazine ads offering "Bororo Dancing Festivals," which tells me enough about them.

In Ethiopia, war raged for many years, and with it famine. Even in better times the Danakil Depression may still be a little too wild and hot for ordinary tourists, and I suppose that the Danakil that have not fled into neighboring Djibouti or died from bullets or hunger have found no alternative to carrying on their age-old nomadic activities.

Since I first visited the Turkana in 1973, the Norwegians built a road into their territory and, until they were expelled by the Kenya government for criticizing it, gave them, I heard, all kinds of assistance. Now the opportunistic Turkana have

spread even more widely. Little encumbered by taboos, they survive doing anything.

Years ago, tribal people were always assured of a dignified place within the relatively comfortable confines of their often communistic societies. Suddenly, the gates of the surrounding world have been flung wide open around them, exposing them to never imagined perils. As their tribes are breaking apart, they must look after themselves and their families without the support they used to enjoy from their fellow tribesmen. They must fight for survival in a complex, competitive, and difficult world that they do not fully comprehend. Some are boldly taking the right steps. Others, less educated, daring, or imaginative are pitilessly being swept among the basest layer of a Third World population. The rules of the game have changed, and many who excelled before as warriors or caravaneers are now at a disadvantage.

If only we could understand how much there is to learn from tribal people, not only about their knowledge of the natural world which, in some places, includes that of certain medicines or the mastery of narcotic drugs, but even about such things as children's education, we would never allow them to be evicted as they are now from their lands and to fall into disgrace. No lack of superior qualities have kept tribal people from "developing." Their strength comes mostly from time-tested social and moral values, a lack of greed, and a deep respect for our Mother Earth, which may explain why, in Kenya for instance, many tribal people become anthropologists, geologists, naturalists, rather than engineers. Unfortunately, we have devised such irresistible toys and gadgets that we are now forcing many of them to reconsider their priorities.

Be that as it may, there are today too many nomads for the desert or the savanna to support. Ideally, as is happening in some places, children with few animals to inherit will get an education and move to town, leaving pastoralism to others. Only by herding can the desert be put to good use. And only if herdsmen keep peopling the desert will we find in it the guides we need to show us around, and the camps where we can drink the solace of shared sweet tea.

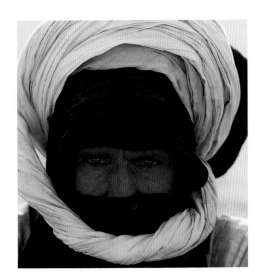

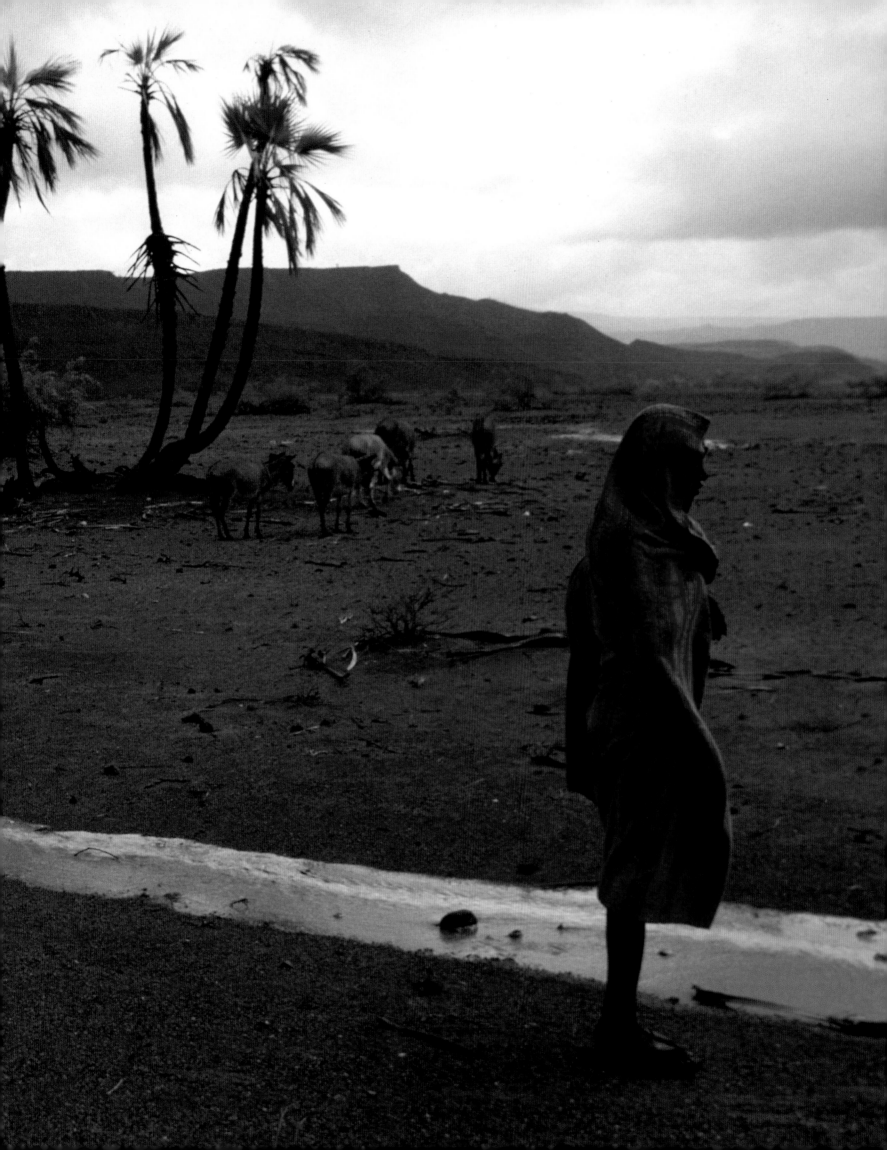